Nikos Stangos
studied philosophy at Wesleyan University,
Connecticut, Denison University, Ohio, and completed his
graduate work at Harvard University. He has co-authored
and edited a number of books including David Hockney by
David Hockney and Hockney's That's the Way I See It, John
Berger's essays, The Look of Things, and The Thames and
Hudson Dictionary of Art and Artists. He has published five
books of poetry and
translation.

This famous series
provides the widest available
range of illustrated books on art in all its aspects.
If you would like to receive a complete list
of titles in print please write to:
THAMES AND HUDSON
30 Bloomsbury Street, London WCIB 3QP
In the United States please write to:
THAMES AND HUDSON INC.
500 Fifth Avenue, New York, New York 10110

Concepts of Modern Art From Fauvism to Postmodernism

Third edition, expanded and updated edited by NIKOS STANGOS

139 illustrations

Any copy of this book issued by the publisher as a paperback is sold subject to the condition that it shall not by way of trade or otherwise be lent, resold, hired out or otherwise circulated without the publisher's prior consent in any form of binding or cover other than that in which it is published and without a similar condition including these words being imposed on a subsequent purchaser.

Original edition © 1974 Penguin Books Ltd Second edition, revised © 1981 Thames and Hudson Ltd, London Third enlarged and updated edition © 1994 Thames and Hudson Ltd, London Reprinted 1995

All Rights Reserved. No part of this publication may be reproduced or transmitted in any form or by any means, electronic or mechanical, including photocopy, recording or any other information storage and retrieval system, without prior permission in writing from the publisher.

British Library Cataloguing-in-Publication data

A catalogue record for this book is available from the British Library

ISBN 0-500-20268-0

Printed and bound in Singapore by C.S. Graphics

Contents

Preface Nikos Stangos	6
Fauvism Sarah Whitfield	11
Expressionism Norbert Lynton	30
Cubism John Golding	50
Purism Christopher Green	79
Orphism Virginia Spate	85
Futurism Norbert Lynton	97
Vorticism Paul Overy	106
Dada and Surrealism Dawn Ades	110
Suprematism Aaron Scharf	138
De Stijl Kenneth Frampton	141
Constructivism Aaron Scharf	160
Abstract Expressionism Charles Harrison	169
Kinetic Art - Cyril Barrett	212
Pop Art Edward Lucie-Smith	225
Op Art – Jasia Reichardt	239
Minimalism Suzi Gablik	244
Conceptual Art Roberta Smith	256
Postmodernism and the Art	
of Identity Christopher Reed	271
The Plates	295
List of Illustrations	402
Selected Bibliographies	410
ndex	416

Preface

It is therefore necessary to develop a counter-discourse in relation to contemporary art practice and theories of representation. The full significance of painting in the $twentieth\ century\ will\ not\ emerge\ before\ such\ a\ counter-discourse\ is\ adopted.\ I\ would$ suggest that at least six substantive issues need to be addressed. Firstly, it is necessary $to \, break \, once \, and \, for \, all \, with \, a \, chronological \, `movements' \, based \, approach \, to \, twentieth$ century painting. The teleological legacy of positivism can never be overcome while its historical forms and procedures remain fetishized. Secondly, we need to understand the complex symbolic role of the 'artist' as it has been constructed since the eighteenth century, not simply as a sub-species of the specialist-professional, but as a distinct type of person, someone who supposedly gives access to the 'truth' of our 'nature', the measure of individualist identity at its most extreme. Thirdly, we need to know far more about the regulation and de-regulation of sexuality and sexual fantasy in patriarchal societies. In this sense modernism appears as a site of perpetual struggle between shifting definitions of the licit and the illicit, the representable and the unrepresentable. Fourthly, we need to understand the ways in which different art historical apparatuses construct regimes of images in the name of national, racial and gender characteristics. How, in other words, does modernism articulate some social differences while it overrides others? Fifthly, we need to question the rigid hierarchy of signifying practices which is constituted within the curriculum of modernist studies, just as in an earlier age it was necessary to question the hierarchy of genres. And lastly, we need to dramatically problematize the entire modernist separation of the verbal from the visual, together with that picture of human consciousness which such a separation presupposes. None of this work can however proceed until art historians are prepared to think a lot harder about the nature and effects of ideology, which is the sine qua non for any progressive contemporary work in representational studies.1

In the twenty years since this book was first published in its original form (subsequently updated), a number of transforming developments have taken place in our awareness and understanding about the ways we look at art, think and write about it. My brief introductory comments in the original and subsequent editions seem to me now at such variance from my present understanding, that I would probably have to concede that the title of this book is a misnomer in that I must now question the words 'concepts' and 'modern art' as at best vague, at worst misleading or confused. Although my original opening sentence that 'the purpose of this book is to present to the general reader the main

concepts and developments of art from about 1900 to the present' is in some ways still valid, it needs to be qualified. The fact is that the reader must be clear that the 'history of modern art' this book proposes is presented in terms of unquestioned conventional, historically related, but not conditioned, chronological art movements rather than genuinely in terms of the 'concepts' which hide behind them or underlie them. Furthermore, the designation 'modern art' in this book, which begins with Fauvism and now ends with postmodernism, also needs to be clarified because it immediately raises questions as to what 'modern' means, whether it is a chronological designation or something else, a rubric that contains a host of ideological and programmatic, overt or concealed, presuppositions. Attempts to untangle the use and misuse of 'modern'. let alone 'modernity', vary greatly both in terms of dating and in terms of meaning and content, as well as in terms of how the 'modern' can be identified pictorially or stylistically, if that is at all possible. Is it a question of what a work of art purports to depict, or how? Is it true, after all, that 'throughout the history of art, style has been one of the most effective indices to the existence of a timeless truth in the work of art'?2

Art 'movements' have served attempts at an historical account of art in the twentieth century as convenient, albeit distorting and simplifying labels (as all labels are), but they do contain a conceptual orientation. To most people, twentieth-century art movements serve to crystallize underlying concepts. Often these movements were concurrent, which is another reason why a linear, developmental history, based on presuppositions of progress, would be misleading, indeed distorting: art in this century is characterized by an enormous richness, complexity, contradictoriness, self-reflectiveness compared to art in previous centuries. It is arguable whether an overriding historicist view of Western art in the twentieth century which attempts to inform and account for art's diverse manifestations would not in fact be a gross reduction, a distortion of its exuberant diversity and contradictoriness. In this sense, the notion of a 'coherent' account of twentieth-century art would seem a negation of the very character of art in this century, a relapse into historicism and single categorical principles which ignore, indeed distort, the individuality of the contradictory ideas which prompted the developments we call 'modern art'. Accordingly, what informs this collection of essays is the belief that there is not one universal, but many 'histories' of Western twentieth-century art, each of which could be written from a different point of view, none privileged, each valid, each perhaps remarkable in its own contribution, provided it does not become dogma, that is, assume the mantle of the one and only right history.

It is therefore important that the newly commissioned essay for this revised edition, on Postmodernism and the Art of Identity, should be offering a powerful challenge to the raison d'être, the questionable wisdom, of the arrangement of the essays in this book. Postmodernism is not a movement but more of a description of the sort of concerns and methodologies that entered the domain of art once the hidden, underlying concepts – or dogmas – of modernism as a whole were exposed to be perhaps other than what they had appeared to be. It precipitated the demise of modernism's now revealed secret tenets: the separation of art and life, the emphasis on form versus content, the creation of new canons which excluded all those who might not subscribe to rigid, formalist principles or to other tyrannical party lines. Thus, modernism is now revealed to be not entirely the liberating force it had been thought to be. Instead it is seen as being responsible for, among other things, the denial of representational meaning, the fixation on authenticity and originality, specifically of the aesthetic experience,³ the denial of intention and expression in the purely visual, the distinction between verbal and visual arts by the 'partitioning [of] the aesthetic field into discrete areas of specific competence', the belief in the absolute autonomy of the work of art.

It is conveniently thought that around the beginning of this century the seemingly steady and leisurely developments in Western art appeared suddenly to become shattered. In fact, the roots of modernism lie in about the middle of the nineteenth century, in Baudelaire's art criticism, in Gustave Courbet and Realism, in depictions of 'modernity', i.e. of contemporary life, of the fragmentary, in the challenge to established art institutions and canons, in turning against the distinction between 'high' and 'low' art, in identifying an affinity with contemporary militant politics and in inventing the notion of the 'avant-garde'. The trends which Realism set in motion reached a high point in the late nineteenth century in France, in a new, increasingly dominating urban context, in works which defined to begin with the issues of modernity.⁵ It is at the end of the nineteenth century that the debates, which still go on, about representation, the politics of representation, its mechanisms, meaning/content as opposed to form have their origin.

The accelerating changes at the beginning of the twentieth century, the questioning of systems governing value, the quick succession of perceptions, viewpoints, meanings and, therefore, the opening up to questioning and investigation of every assumption – very much as today – undoubtedly reflected a similar change in world views as a whole. Social, political and economic changes paralleled philosophical and scientific developments and the collapse of traditional, authoritarian systems and values, not in their actual loss of power but in their self-assured security and long-term survival. In the arts, the tradition of the past – or at least an unquestioning adherence to it – was challenged from all sides. The questioning and rejection of the past amounted to a veritable militant revolution which was suitably expressed in its characterization as avant-garde. In relation to the indiscriminate use of the designation 'avant-garde' still today, it is

important to note that 'the historical [my italics] avant-gardes were explosive, expansive, transgressive; every boundary was a frontier to be crossed, a barrier to be shattered, an interdiction to be broken. Hence their demand for the destruction of the frame \dots – The historical avant-gardes called for the dissolution of art as an institution (meaning its constitution as a separate sphere of activity, its autonomy) and the reintegration of artistic into social practice. By the end of the 1960s, however, it had become apparent that this demand had, at best, been premature, and that, at worst, avant-garde practice had all too easily been contained. The cultural politics of the late '60s was a politics of cultural containment'6 - that is, the absorption and neutralization of avant-garde $transgressiveness\ within\ a\ commercially\ dominated\ cultural\ context\ which\ could,$ and did, transform it into commodity value.

Early twentieth-century art, reflecting other similar attitudes in society, became an explosive liberating force against the oppression of assumptions and established hierarchies accepted until then. The notions of history as progression unfolding in time and of development in time were reduced from long, linear, leisurely and steady stretches to short, fast, multiple and simultaneous spurts and fragments, or so it seemed. Where up to then the arts were customarily viewed in terms of broad categories of a posteriori classifications, or what art historians call styles, at least as seen from a distance, now they developed in terms of 'movements' which seemed to succeed one another with ever-increasing acceleration until they became so short-lived as to be practically imperceptible, except to the specialist. Concepts and a preoccupation with theory and ideas, which often preceded, conditioned and pre-defined the nature of the art object itself (if not in temporal terms, at least in conceptual ones), started emerging as chief constituents of artistic activity. Furthermore, the boundaries between media categorization became increasingly blurred.

Art movements were intentional, purposeful, directed and programmed from the start. They were accompanied by declarations, manifestos and a plethora of documents. Each movement was deliberately launched to make a point; artists and often critics, and artists as critics, formed platforms to launch movements, to proclaim concepts. The role of the critic, the theoretician, became especially important in shaping and validating new artistic activity (see, for instance, Abstract Expressionism). It should be pointed out, at the same time, that the various movements did not necessarily contain, in any exclusive sense, some of the major artists: an obvious example would be Picasso, who either moved in and out of movements or simply transcended them, or Léger, who is, ironically, hardly represented in this book.

The new essay included at the end of this revised edition differs in significant terms from the previous ones: it constitutes an interjection to the otherwise conventional structure of the book. Not only is it not about another 'modern movement', it constitutes a critique of such an approach altogether. It provides a lucid account of postmodernism which is itself a critique of modernism. And, as one aspect of the postmodernist critique, it elucidates feminism and other responses to art which are based on issues of identity, the issues, that is, which modernism had excluded as irrelevant to art and which began to define a new art practice in the 1970s and '80s.

Nikos Stangos, 1993

Notes

- Simon Watney, 'Modernist Studies: The Class of '83', Art History, Vol. 7, No. 1, March 1984, p. 109.
- 2. Craig Owens, Beyond Recognition Representation, Power, and Culture, 'Honor, Power, and the Love of Women', Berkeley, Los Angeles, Oxford, 1992, p. 151.
- 3. Thomas Crow, 'The Return of Hank Herron', in *Endgame Reference and Simulation in Recent Painting and Sculpture*, Exhibition Catalogue, The Institute of Contemporary Art, Boston, 1986.
- 4. Craig Owens, op. cit., 'Towards a Theory of Postmodernism Earthwords', p. 46.
- 5. '. . . the hard-core theory of modernism had two major moments of crystallization throughout this century: the first moment, outgrowing from cubism, reached its climax at the beginning of the twenties, in the texts of the first abstract but non-expressionist painters . . . It occurred right before what is called today the "return to order," which is characterized by a world-wide academization of artistic practice (Picasso's Ingresque period, Matisse's Nice period, the transformation of Futurism in Pittura Metafisica [metaphysical painting], Neue Sachlichkeit [the New Sobriety], Socialist Realism). The "return to order" has many different looks, but its main characteristic is a general call back to traditional modes of representation, a global dismissing of the experimental nature of the avant-garde art of the previous decade: it has a lot in common with the current practices of the neoconservative postmodernism . . . The second moment of crystallization of the modernist theory dates from the post-war period and is constituted by American formalist criticism, that is, the writings of Clement Greenberg and his followers.' Yve-Alain Bois, 'Critical Evaluation', Art Criticism, Vol. 3, No. 3, State University of New York at Stony Brook, 1987, p. 58.
 - 6. Craig Owens, op. cit., 'From Work to Frame', pp. 128-29.

FAUVISM Sarah Whitfield

During the brief period, 1904-7, Henri Matisse, André Derain and Maurice Vlaminck, together with a small band of fellow students, evolved a style of painting that earned them the name Les Fauves (wild beasts). Its apparent freedom of expression through the use of pure colours and exaggeration of drawing and perspective dazzled and bewildered those seeing these works for the first time. They were, for a few years, the most experimental group of painters working in Paris. Yet, of all twentieth-century art movements, this was the most transient and possibly the least definable. Van Dongen, a member of this loosely defined group denied the existence of 'any kind of doctrine'. 'One can talk about the Impressionist school', he said, 'because they held to certain principles. For us there was nothing like that, we merely thought their colours were a bit dull.' There may not have been a common doctrine but we know from their letters, notes, and of course the works themselves, that Matisse, Derain and Vlaminck did have firm beliefs and ideas on painting at this time, but they were highly individual and personal to each painter, and only shared for brief periods. What is certainly true is the lack of direction experienced by fellow students who exhibited with Matisse and the others and whose works were regarded as part of Fauvism. In many cases the momentary excitement that held these painters buoyantly aloft and allowed them the maximum of freedom, deserted them as their work developed and matured. The hangover that followed accounts for the unsatisfactory conclusion of Fauvism as it trails off into hesitant gropings after new means of expression. Matisse was clearly the leading painter, if not the leader; he was recognized as such through the undeniable superiority of his work and by his seniority, but he made no attempt to create a movement. Almost unwittingly he opened up new visual possibilities to younger painters, and in trying to follow them through, they formed a loosely-knit group. From 1905 they exhibited together at the two major exhibitions of modern art held annually

12

in Paris, the Salon des Indépendants and the Salon d'Automne and accordingly, their contemporaries looked at their work as part of a movement. Apollinaire, for example, refers to them as such in describing Fauvism as 'a kind of introduction to Cubism'.

However, the major fauve works were painted by Matisse, Derain Vlaminck, and for a brief time, Braque. Obviously there are difficulties in grouping four highly individual and independent artists under one heading, especially as they all contributed different qualities to the style we recognize as Fauvism. Occasionally they drew close to one another; Derain worked with Vlaminck at Chatou and with Matisse at Collioure and as early as 1901 Matisse recognized in the work of both Derain and Vlaminck aims similar to his own. However, their differences are always clearly visible throughout these years, and by 1907 it had become apparent that they were independent of each other.

Matisse entered the studio of Gustave Moreau in 1895. There, already enrolled, were five students who were later to exhibit as Fauves: Rouault, Marquet, Manguin, Camoin and Puy. This studio played a great part in forming the careers of these painters, for, unlike other studios attached to the Ecole des Beaux Arts where academic principles were strictly practised, Moreau actively encouraged his students to question his own work, even to react against it, and above all to exert their independence. Matisse later recalled the effect of Moreau's influence: he 'did not set us on the right roads but off the roads. He disturbed our complacency. With him each one could acquire the technique that corresponded to his own temperament.' He opened their eyes and minds to works in the Louvre, urging them to look at these as much as possible and to form their own opinions. This liberal attitude is not so surprising when one realizes that the strange blend of mystical and romantic imagery that haunted the symbolist writers of the 1880s and 1890s found visual expression in Moreau's elaborate and encrusted visions. He exhibited at the Salon, but was alienated from most of his contemporaries and knew what it was to pursue a solitary course. His subjects were often as far removed from reality as was the life led by Des Esseintes, the 'decadent' hero of Huysmans's novel A Rebours,

through whom Huysmans transmitted his very personal interpretation of Moreau's art. Despite Moreau's precautions to the contrary. these extraordinary paintings had a considerable effect on his pupils. Rouault's deep religious sense was in harmony with Moreau's own convictions and he formed a strong attachment to his teacher's work. These students were more aware of the range of this work than were any of the public, or indeed, many of Moreau's own contemporaries. They could see how he experimented in the preliminary oil sketches which are not only far freer and more exciting than the finished works, but altogether different. The colours are purer and the paint is more lavishly applied so that the subject becomes almost submerged and unimportant. His methods were often highly unorthodox; for example he squeezed the paint directly from the tube, and in his watercolours let the paint drip and run. Maybe it was these flashes of technical originality that led Rouault to make the illuminating observation about the emphasis Matisse laid on the role of decorative painting, saying that he had inherited this from Moreau's own luxuriant use of texture. A similar observation could perhaps be made about Rouault's later works. Moreau's death in 1898 released his pupils into a less sympathetic environment.

Matisse enrolled at a studio where the academic painter Cormon exacted strict regard for principle from his students. Matisse's painting was by now advanced for its time; his figure studies show a powerful three-dimensional quality expressed in strong dashes of colour, and he was also experimenting with quick sketches painted in pure colours. None of this evidence of an independent mind appealed to Cormon and Matisse was asked to leave. Rouault's paintings at this date were not unlike those of Matisse; their palettes were both strong and resonant and they both chose to outline their figures heavily to create a more convincing solidity. Temperamentally, though, they were far apart. Rouault's growing friendship with the Catholic propagandist, Leon Bloy, is an example of the direction his work was to take. Perhaps he saw himself as the visual interpreter of this crusading fanatic whose lurid prose was intended to whip up the public conscience against the very real poverty and exploitation of his time. When he painted M. and Mme Poulet, an illustration to one of Bloy's novels, the writer was violently opposed

to it. Possibly he mistook the element of distortion used by Rouault to dramatize the characters as a vulgar caricature of his own intentions, or maybe he was merely offended by what he considered a grossly ugly painting. Moreau had prophesied a lonely career ahead of Rouault, recognizing that not only was he thoroughly alienated from a Salon career but that he also had little in common with his fellow students except a desire to use paint and linear distortion for expressive means. But his deeply religious and social commitment found no response in their works; in that respect his work compares better with what Picasso was doing in the early 1900s. Early on though, the public thought of him as a fauve painter because he exhibited with the rest. Matisse, on the other hand, together with his friend Marquet, preferred to go out into the streets and make factual impressions of the life around them in a series of rapid sketches. Evidently Marquet was especially accomplished at this for Matisse had great admiration for his abilities as a draughtsman. They painted the streets of Paris, the bridges, the river, the same subjects in fact as the Impressionists had chosen in the 1860s and 1870s, but treated in an entirely new manner. The paintings Matisse made of Notre Dame have little to do with the atmospheric effects sought after by Pissarro and Monet; the broad areas of paint and reorganization of space indicate the new interpretation of reality that the Fauves were shortly to pioneer.

In Chatou, on the outskirts of Paris, two young painters were experimenting with landscape in a similar way. One of them, André Derain, attended classes at a small studio in Paris where the students' work was corrected by the painter Eugène Carrière. It was there too that Matisse enrolled after his brief encounter with Cormon. Matisse was eleven years older than Derain, a far more experienced painter and naturally Derain came to admire his work and benefited from his more intellectual approach to pictorial experiments. But Matisse himself remarked that he had been surprised by how similar their intentions were, how both Derain and his companion from Chatou, Maurice Vlaminck, were striving after effects of pure colour. In character, Vlaminck was the exact opposite to Derain. He came from a more carefree background, and at the age of sixteen he had left home to earn a precarious living as a racing

cyclist and as a violinist in night-clubs and cabarets. His approach to painting was entirely spontaneous, he never attended art school or had any formal training, yet his knowledge of contemporary painting and literature was considerable. Derain, on the other hand came from a middle-class family who regretted their son's chosen career as an artist until Matisse, who never conformed to the popular image of an artist, visited them and convinced them of Derain's talent. Derain first introduced Vlaminck to Matisse in 1901 at the retrospective exhibition of Vincent van Gogh held at the Goupil Gallery. The two younger painters later recalled the colossal impact that this show had on them, but their paintings at this period reflect none of this enthusiasm. Several years later however, one can see how Vlaminck, especially, was susceptible to these harsh, blazing canvases as his own work develops. The gulf that can be seen later to separate his work from that of Matisse has its roots in Vlaminck's subjective and passionately held admiration for Van Gogh, and Matisse's more detached preference for the cooler paintings of Gauguin. 'Gauguin's paintings always seemed to me cruel, metallic and lacking in general emotion', wrote Vlaminck, 'he is always absent from his own work. Everything is there except the painter himself.' A criticism that illustrates so clearly what it was Vlaminck looked for in painting. But if it were not for the letters exchanged between Vlaminck and Derain from 1901-4, the period Derain spent in National Service, one might assume they had never seen any Van Gogh paintings until several years later. This can be accounted for by neither of them being yet totally committed to painting as a career.

Derain's hesitation and grave doubts about his own ability come across very clearly in these letters; so too does his inclination to become a writer. Vlaminck, despite a tendency to play down his intellect, was extremely well read and probably played an important part in forming Derain's literary tastes. They both greatly admired Zola, indeed certain passages from Derain's letters describing barrack life could come straight out of one of Zola's novels. Vlaminck, in fact, went on to publish several novels, described by himself as 'pis que du Mirbeau'. Also during these early years he became a minor political activist, a role not shared by Derain. Like

many of his contemporaries of the late 1890s, Vlaminck was on the fringe of the anarchist uprisings that stirred Paris with bomb throwings and numerous other disturbances. He contributed articles to anarchist newspapers and journals but never became more deeply involved. Obviously the possibilities of anarchy suited his uneven temperament and easily aroused enthusiasm; in fact when writing about his early artistic aims, his language has a distinct political ring to it. It was precisely this quick-fired enthusiasm that proved to be both his strength and his weakness. For a few years, both he and Derain were completely caught up with the possibilities of being able to dispense with the limitations of local colour, and more importantly, the limitations of their own vision. Vlaminck, looking back years later wrote,

My enthusiasm allowed me to take all sorts of liberties. I did not want to follow a conventional way of painting; I wanted to revolutionize habits and contemporary life—to liberate nature, to free it from the authority of old theories and classicism, which I hated as much as I had hated the general or the colonel of my regiment. I was filled neither with jealousy or hate, but I felt a tremendous urge to re-create a new world seen through my own eyes, a world which was entirely mine.

This genuine urge induced Vlaminck to paint some of the best works of his whole career and of Fauvism, but both he and Derain, before the others, felt the initial impact begin to flag, they seemed to find it increasingly difficult to prolong an enthusiasm which was becoming, for them at least, artificial. This dwindling excitement revealed in Derain the confusion of a man caught up in a style that was unsuited to his temperament. His mind was too disciplined to be content with the consequences of colour used purely as an expressive agent, and then he was, too, more firmly attached to tradition. But first, how did Fauvism really come about?

When Derain was released from military service in 1904, Matisse was working on Luxe, Calme et Volupté [illustration 1], a painting that was to establish his authoritative position among the younger painters. It was virtually a manifesto of what was to become Fauvism. Superficially it appears to be a variation on a familiar theme by the Neo-Impressionists, employing the pointilliste

technique developed by Seurat and dogmatized in Signac's book De Delacroix au Néo-Impressionnisme; the juxtaposition of dots or small strokes of primary colours methodically laid on the canvas. During this summer of 1904 Matisse was staying at St Tropez where Signac had a house, not far from where another Neo-Impressionist. Henri-Edmond Cross, was living. Certainly this theory was much in evidence, but Matisse was not a vulnerable young painter susceptible to other painters' styles: this is a very free interpretation of Signac's intentions conveying as much enthusiasm for Cézanne's Bathers and Gauguin's Tahitian scenes. It is a synthesis of what the Post-Impressionists had to offer, freely manipulated into a personal exercise. To us now it looks tame compared with what was to follow, but to the circle of painters around Matisse, paticularly Othon Friesz and Raoul Dufy, it was a revelation. 'In front of this picture I understood all the new principles; Impressionism lost its charm for me as I contemplated this miracle of imagination produced by drawing and colour,' recalled Dufy. Matisse had used colour more subjectively than he had ever done before (although of course several older painters had used paint more freely and boldly for nearly two decades) but it was the drawing that astonished most people. The forms of the nudes are drastically simplified so that they take on a purely decorative function; one is more aware of them as shapes than as female bodies. The whole painting seems to question the landscape tradition; everything in it plays a decorative rather than descriptive role. The tree, boat and shore-line are read as linear patterns which unify the picture surface into a single spatial plane. It anticipates Matisse's belief in the primarily decorative function of art that he was to express verbally several years later. It also reveals Matisse's great imaginative powers as a colourist, the subtle combinations of pinks, yellows and blues are quite unexpected and evoke the lyrical atmosphere of the scene which had been inspired by the lines from a poem by Baudelaire:

> Là-bas, tout n'est qu'ordre et beauté, Luxe, calme et volupté.

The title of the poem, Voyage à Cythère, suggests the escapism so eagerly sought after by the Romantic writers and which began its

own curious tradition through the paintings from Delacroix to Gauguin and which certainly haunted the generation of painters of the 1890s and early 1900s. This painting, like *Joie de Vivre* which followed soon after, shows how surprisingly close Matisse was to the literary currents of his time in these attempts to create an imaginary land, or state of mind, where everything is as Baudelaire proposed.

Luxe, Calme et Volupté created a great stir when it was exhibited at the Salon des Indépendants in 1905. Although most critics were not yet able to fully understand just what it was Matisse was trying to do, most of them recognized his gifts as a painter. Signac laid his seal of approval by purchasing the painting for himself and transporting it back to St Tropez. Naturally Derain was among the vounger painters who looked to Matisse to lead the way, and the following summer he joined Matisse at Collioure, on the coast, where they painted the works that were shortly to provoke the nickname of Les Fauves. These were particularly fruitful months for both painters. Derain began to experiment with a pointilliste technique and his paintings became lighter both in colour and in touch. The very small brushstroke the technique demanded, encouraged a more delicate method and soon he was able to suggest air and light by leaving areas of the canvas unpainted so that the white ground becomes as much a part of the composition as the paint and creates a sense of fluctuating space. The watercolours painted during this summer are possibly the most ambitious and finest he had yet attempted. The more fluid technique loosened his imagination as well as his brush and for a while he equals Matisse's marvellous achievement of using only the essentials in line and colour to achieve his purpose. But however much he may have benefited from this taste of collaboration, by the end of July he was writing to Vlaminck,

noted, when working with Matisse, that I must eradicate everything involved by the division of tones. He goes on, but I've had my fill of it completely and hardly ever use it now. It's logical enough in a luminous harmonious picture. But it only injures things which owe their expression to deliberate disharmonies.

It is, in fact, a world which carries the seeds of its own destruction when pushed to the limit. I am quickly going to return to the sort of painting I sent in to the Indépendants which, after all, is the logical one from my viewpoint and agrees perfectly with my means of expression.

His rejection of the theory of Neo-Impressionism, the division of tones, is absolutely in keeping with his general distrust of art theories. Several years before he had written to Vlaminck, 'Our race enjoys a quality that may develop into a conflict, the cultivation of principle and our limitation by it.' However it was not only the theories of Seurat and Signac that preoccupied these painters in Collioure. During their stay, they were able to study the works of Gauguin which were kept by Daniel de Monfried, Gauguin's close friend, in his house not very far from Collioure. These were comparatively unknown at this date and from them Matisse and Derain would have been able to see how Gauguin dispensed with conventional perspective and concentrated on bringing the picture surface together, making it a decorative unit. They would have seen, too, how little his choice of colours owed to natural appearances and how much to Gauguin's own imagination.

When they returned to Paris, they sent their works to the Salon d'Automne, and it was there in the company of their friends that they presented the public with their first taste of Fauvism. Derain exhibited his landscapes, glowing with shrill reds, greens and vellows, executed with a disregard for finish that the critics deplored. Their frank sketchiness and brilliant but arbitrary colours which gave them their unique freshness and spontaneity condemned him in the eyes of most critics. But it was Matisse who bore the brunt of the inevitable furore. His portrait of his wife wearing an enormous hat was interpreted as being in inexplicably bad taste, a caricature of femininity. Even the more perceptive critics felt that Matisse had over-reached himself - they acknowledged his gifts as a painter but regarded his new found freedom of colour and free interpretation of familiar subjects as evidence of outright eccentricity. Flamboyant as this portrait is in colour and execution, it is not so startling as the next portrait Matisse was to do of his wife [illustration 3]. Even to our eyes, over sixty years later, the impact is still colossal. The power of the colour is undiminished and excitement still generates from the loud line of green punctuating the nose. The studied juxta20

position of colours, the orange and green for example, we possibly take for granted now, so widespread has Matisse's influence been in this direction, but if for a moment one can empty one's mind of recent painting and think back to before 1905, one can begin to share the pure shock of this treatment. Already Matisse had gone beyond Gauguin and Van Gogh in the intensity of expression, but like Cézanne he makes his colours work and re-work upon each other, although the effect is more exaggerated. The orange and green on either side of the face give a feeling of artificial depth, the orange bringing the background right up to the sitter so we feel that there is no gap between it and the head, whereas the green recedes, carrying with it a completely contradictory spatial effect. The kind of notoriety resulting from this exhibition had its own advantages, and immediately these painters found themselves regarded as the most advanced in Paris. Several made contracts with art dealers, both Derain and Vlaminck for example found an invaluable patron in Ambroise Vollard. This was especially advantageous for Vlaminck as it meant he could now devote all his time to painting. Matisse was taken up by the Stein family, Leo, his brother and sister-in-law, Michael and Sarah, and his sister Gertrude. Leo Stein bought the first infamous portrait of Mme Matisse, but even he had his reservations. 'It was the nastiest smear of paint I had ever seen,' he wrote later, 'I would have snatched at it at once if I had not needed a few days to get over the unpleasantness of the putting on of the paint.'

Vlaminck's paintings, although apparently close to Derain's, were conceived in a totally different way. He was the only one of the group who had no patience, nor indeed use for art school training or colour theory, although he had learnt a great deal from studying painting of all periods. His passion for the work of Van Gogh might have sprung from a recognition, as he thought, of primitive impulses that motivated the swirling lines of impasto and the resonant colours, because at this date the misconceptions and legends that surrounded Van Gogh's illness were very confused. Vlaminck seems to have deliberately tried to work with a primitive's intuition (albeit rather sophisticated) and disregard for conventional ways of seeing. His visual sources were found not so much in the post-impressionist

works that fired his friends with enthusiasm, but in altogether unexplored contexts, such as chromo-lithographs collected from packets of chicory and in African sculpture. He describes his paintings of this period as follows: 'I heightened all my tone values and transposed into an orchestration of pure colour every single thing I felt. I was a tender-hearted savage, filled with violence. I translated what I saw instinctively, without any method, and conveyed truth, not so much artistically as humanely. I squeezed, ruined tubes of aguamarine and vermilion . . .' He goes on to announce that 'It was due to my chance encounter with André Derain that the school of Fauvism was born.' Even if this statement is not to be totally credited, his awareness of African art did contribute a very definite aesthetic stimulus to painting and sculpture. Vlaminck claimed that it was he who first 'discovered' African sculpture in 1904; whether he did or not is not a crucial issue here, what is important is that Matisse and Derain both became equally appreciative of this type of art, although it was only Matisse who began seriously to collect primitive sculpture. On the whole, the interest of Derain and Vlaminck remained on an appreciative level - it did not radically alter their style of painting as it was to do with Picasso a few years later. Yet it was an expression of Vlaminck's dislike of formal theory and aesthetics and his imperative need to react against orthodoxy. There were, however, other elements of non-European art in Fauvism, which reveal themselves most clearly in the work Matisse was doing from 1906 onwards. In March that year, he visited Algeria and brought back a good collection of local pottery and textiles. Their bright undiluted colours and bold patterns obviously appealed to him and he began to use them in still-lives, such as his Still-life with Pink Onions [illustration 5]. An anecdote attached to this painting shows how Matisse was trying to keep the simplicity of decoration that he saw in these pots. He tried to pass it off to Jean Puy, also a fauve painter, as the work of the local postman in Collioure, but Puy was not taken in - he recognized it at once as Matisse's painting. There is a deliberate naïvety in the way in which the subject is presented, but, as Puy saw, a very subtle degree of organization was required to achieve this simplicity. The flat areas of paint with little or no modelling and the silhouette of the jugs emphasize the primarily decorative function of the work. It is almost as though this were a piece of textile design. This paring down of essentials, reducing the number of pictorial elements with which to work, is a crucial development in Matisse's career and one which can be traced back to his first contacts with non-European and primitive art. But he was the only painter among the Fauves to react so positively to these new influences; years later Othon Friesz defined his idea of what Fauvism was, an idea far removed from what Matisse was aiming at. Friesz wrote, '[Fauvism] was not just an attitude, a gesture, but a logical development, a necessary means by which we could impose our will on painting while still remaining within the bounds of tradition.' However, some, like Friesz himself, were limited by this very dependence on tradition, whereas Matisse, and to a certain extent Derain and Vlaminck were able to improvise on traditional themes, to reorganize preconceived ideas. Maybe it is the degree of assimilating tradition that makes us aware of the gulf that separates these three painters from the rest of the fauve following (Braque was not yet painting his 'Fauve' works). Of course it would be misleading to dismiss the work of these other painters whom Vauxcelles has labelled 'Fauvettes'; in the years 1905-7, there are some very fine landscapes and portraits by Marquet, Valtat and Van Dongen, but there is always the feeling that their strong, vibrant colours, which were recognized as the theme of Fauvism, too often served to disguise, not always effectively, the solidly nineteenth-century landscapes and figure scenes that lurked underneath. Their adoption of a new painting technique was not always radical enough to make up for lack of imagination and vision. Even the black and white reproduction out of the 1905 number of L'Illustration [illustration 2] shows how almost reactionary the two landscapes by Manguin and Puylook in comparison with the works by Rouault, Matisse, and Derain. They could go along so far, and to many that was already too far, but the fundamental ideas and aims that Matisse was striving after were simply not within their vocabulary.

Nineteen hundred and six was a triumphant year for the Fauves. The movement reached its climax at the Salon des Indépendants, where Matisse, as before, dominated the exhibition. He exhibited only one painting, *Joie de Vivre* [illustration 4], which goes far

beyond his work of 1905. In retrospect, though, we tend to regard the importance of this canvas in its relation to Picasso's Demoiselles d'Avignon, painted the following year, which seems to directly challenge everything Matisse had vet done. One aspect of Matisse that Picasso's painting makes us aware of is his affinity with the literary traditions of the 1880s and 1890s. Just as Luxe, Calme et Volupté had sprung from the writings of Baudelaire, so too does Joie de Vivre depend on the hedonism so often found in certain symbolist poets. Matisse was a product of the symbolist era, this after all was the age in which he had grown up, and one is frequently reminded of these roots during his early career. What is so extraordinary is how he uses this tradition, too often prone to anaemia, to declare a very radical and positive idea of painting. One has only to compare it with any of the Bathers themes painted by Maurice Denis, who also grew out of the same generation, to appreciate the extent of what Matisse has done. Picasso, of course, was part of a totally new literary group headed by Apollinaire, Max Jacob and André Salmon, none of whom shared this respect for the Symbolists. Joie de Vivre is clearly not a Fauve painting, at least not in the sense of the 1905 works; it is a step beyond, indicating Matisse's solution to the problem of where and what Fauvism was leading to. (Although it is open to question whether Matisse ever regarded this as a problem, unlike the other Fauves.) It is a beautifully controlled painting, every line, every space contributes to the expression of calm and tranquillity - there is nothing superfluous. The mood of languid sensuality is a perfect visual equivalent of Baudelaire's imagination, admirably conveyed by the soft pinks and greens and the supple contortions of the embracing couples. Everything is as weightless as possible, even the swaying trees in the background look as impermanent as the mood they express. One feels so strongly that Matisse's work is the result of years of patient experiment and study, for he commands such order and precision on his compositions that nothing can have been left to chance. Two years later he published a characteristically lucid definition of his aims:

What I am after above all, is expression . . . Expression to my way of thinking does not consist of the passion mirrored upon a human face or betrayed by a violent gesture. The whole arrangement of my picture is

expressive. The place occupied by figures or objects, the empty space around them, the proportions, everything plays a part. Composition is the art of arranging in a decorative manner the various elements at the painter's disposal for the expression of his feelings. In a picture every part will be visible and will play the role conferred upon it, be it principal or secondary. All that is not useful in the picture is detrimental. A work of art must be harmonious in its entirety; for superfluous details would, in the mind of the beholder, encroach upon the essential elements.

Clearly, such a statement and the works that preceded it would be unthinkable without the example of Gauguin and Seurat, both of whom aimed at simplified yet formal compositions. Like Gauguin, Matisse believed that colour harmony should be directed towards the same principles as those governing music: 'I cannot copy nature in a servile way', he wrote. 'I must interpret nature and submit it to the spirit of the picture. When I have found the relationship of all the tones, the result must be a living harmony of tones, a harmony not unlike that of a musical composition.' And certainly this painting suggests a visual interpretation of a Debussy composition. His manipulation of paint has its roots firmly planted both in the poetic aspirations of Gauguin and the quasi-scientific analysis of Seurat. It is both visionary and analytical, an awesome combination that is the result of years of study. On one level, the senses are lulled by his harmonies of line and colour, but on another level this very harmony proves disquieting. The simplicity and apparent ease of execution provoke a chain reaction of questions. How, for example, does he manage to suggest and negate a sense of space at the same time although perhaps this sort of curiosity is prompted more by the works done after 1908 than those within his so-called Fauve years. Picasso's comment on Cézanne, 'It is the man's anxiety (inquiétude) that concerns us' could well be inverted to fit Matisse because it is his lack of anxiety that is absorbing. It is also his perception and imagination, qualities that he uses in very much the same way as Cézanne did. His profound admiration for Cézanne stemmed perhaps from a sympathetic understanding of how he looked at things around him. They both enjoyed jolting the orthodox sense of reality and playing around with the spectator's credulity. In the paintings Matisse was doing around 1900-1902, his technique, the actual

application of paint is very close indeed to Cézanne's late paintings. The Bathers, in the National Gallery, London, an astonishing work, even for Cézanne, is more startling in use of colour, distortion of figures and spatial ambiguities than any Fauve work ever was, and clearly Matisse learnt more consistently from him than from any other painter of that generation. In Le Luxe of 1907, for example, Matisse again attempted a new interpretation of this theme of figures in landscape, but here he extracts the figures from their context with disturbing results – something he works out more precisely in later paintings such as Red Studio and Blue Window. The size of Le Luxe strengthens the decorative intention of Matisse's work and in this sense it can be seen as a prelude to the two large panels, Dance and Music painted in 1909-10 for a specifically decorative commission. Matisse's growing conviction that his work should fulfil a decorative role seems to echo the intentions of several of his contemporaries - Pierre Bonnard and Maurice Denis for example.

Although it was Denis who had declared in 1890 'remember that a picture before being a battle horse, a nude, or some anecdote – is essentially a flat surface covered in colours assembled in a certain order', it was left to Matisse to realize this potentially revolutionary concept. Denis's quiet and modest paintings, often of a religious nature, hardly begin to explore the possibilities implied by this statement; indeed, Matisse's interpretation of a decorative art was a long way from Denis's own intentions. Nevertheless Denis's paintings together with those of the other Nabis painters which were exhibited in Paris during the early years of the century, perhaps had more impact than they are generally credited with. Throughout the 1890s and into the first decade of the century they were all concerned with reviving large-scale paintings which often took the form of decorative panels for private patrons. These were not simply enlarged easel paintings; in them Bonnard and Vuillard especially were tackling a new pictorial problem of using impressionist discoveries into effects of light and a tightly organized surface pattern.

For Derain and Vlaminck, too, 1906 was a successful year. In Chatou, Vlaminck was painting more exuberantly than ever. For him the paint was the sole expressive agent - squeezed straight out of the tube into the swirling lines of impasto that characterize his

work. He encourages the spectator to become aware of the paint as a physical part of the painting, so that these landscapes are not merely records of the river and country around Chatou, but first and foremost, vehicles of expression. Yet, to read Vlaminck's comments on his own work one might expect more radical and explosive paintings, perhaps a style nearer to the German group of Die Brücke who were working in Dresden at this time. Vlaminck's use of paint and drawing suggest the word expressive, but do they really communicate any particular expressive idea apart from an evident enjoyment of bright colour? His spontaneous delight in the works of Van Gogh ignored the reasons behind the Post-Impressionists' experiments with arbitrary colours and definitions of space; it was, after all, the results of these researches into the emotive power of colour that struck him, rather than the ideas behind them. This use of colour was liberating and exhilarating for all the Fauves, not just Vlaminck, and largely it is true to say that they needed no more justification for painting as they did than the sheer visual pleasure of pure colour. Vlaminck's radicalism, however, did not extend beyond the surface. His choice of subjects and his compositions have a solid precedent in Impressionism, and indeed, his method of distributing compositional elements is very close to the Impressionism of Pissarro. This is not the work of 'a tender-hearted savage' as he would have us believe, but of a rebellious student of the Impressionists.

If Vlaminck's debt to Impressionism was largely unconscious, Derain, around the end of 1905 or the beginning of 1906 was making a deliberate re-assessment of a project worked on by Monet, that is, a series of paintings of the river Thames which had been commissioned by Vollard. During this time in London Derain produced some of the most outstanding examples of Fauvism. He reacted acutely to the varying qualities of light and to the gradations of fog and mists that hung over the river, yet these are not merely impressionist responses re-worked, but re-interpreted in a characteristically subjective manner. 'No matter how far we moved away from things in order to observe them and transpose them at our leisure, it was never far enough,' Derain wrote. 'Colours became charges of dynamite. They were supposed to discharge light. It was a fine idea

in its freshness, that everything could be raised above the real.' The idea of transcending what lay before him, above reality, perhaps establishes the direction he was taking away from the nineteenth century. Just as for Vlaminck so for Derain colour is the theme of his paintings, and it is through this medium that he attempts to leap-frog the snares of representation. In these Thames paintings his colours have rarely been so powerful and resonant, yet he avoids any note of discord, the 'clashes' and 'charges of dynamite' are perfectly controlled.

Whereas Matisse's work of around 1907 shows his consistency with what had gone before, Derain seems to deliberately repudiate his Fauve works. The exact chronology of his work around 1906-7 is uncertain, which is not surprising when he is seen to be experimenting with several different styles, apparently simultaneously. A painting like The Dance [illustration 7] is very far in conception from his Thames scenes, yet they were probably painted around the same time. Derain worked on several similar subjects and in them one sees very clearly the two streams of subject matter that appear in Fauve painting. On the one hand, an attempt to interpret nature in a subjective manner while keeping a tenuous link with naturalism as Derain had been doing in his landscapes and river scenes, and on the other, the blatantly lyrical scenes which Matisse had pioneered in Joiede Vivre, and which demanded plentiful imaginative resources. From the awkwardness of The Dance, it seems that Derain found this particular style of painting far from easy; it was certainly not an easy transition to make, for his earlier work had not equipped him to tackle imaginary subjects. Perhaps because of the obvious difficulties that he faced, these figure paintings are among his most intriguing works. This same awkwardness is partly deliberate; the strange cavorting gestures of the figures who move across the picture surface are all part of the primitive surroundings in which Derain has placed them. Yet his primitivism is a little self-conscious, it is not for him a reflection of a way of life as it was for Gauguin, but more of an act, an assumed attitude. Possibly he did share the curiosity that Vlaminck and Matisse had for primitive sculpture, but he only investigates these new forms in a casual way. As borne out by the figures in this scene, they are more a generalized idea of primitivism

than the result of a deeper interest. This aspect of the subject blends uneasily with the traditional Bathers theme from which it derives; the seated nude in the background has no real part in the ritual being played out before her. The hints at exoticism are contradicted by the sophisticated art-nouveau style with which the whole canvas is treated. It is a decorative work, but not sufficiently monumental to allay the suspicion of pattern-making, it is perhaps a little 'stylish'. But it is inconsistencies like this that are the intriguing part of this painting, partly because they are peculiar to Derain in his attempt to find an alternative to his other work. For Matisse, of course, this dichotomy never arose. There is no real break between his still-lives or landscapes and the other strongly lyrical works he executed at the same time; in fact they relate very much one to the other. There seems little doubt that Derain sought a way out of the impasse of Fauvism through these figure subjects, seeing in them a way of constructing a more solid and tangible reality than that made possible through fugitive effects of colour used for its own sake. A brief comparison between La Danse and Matisse's Le Luxe, shows how wide the distance has become between these two painters in a short space of time. It is surprising to recall that only a year before they were both spoken of as Fauve painters, now there seems very little to link them together. By this time, 1907, Picasso and Braque were suggesting new visual possibilities by their research into what was shortly to become Cubism, and Derain found himself naturally in sympathy with their aims, although he never committed himself to Cubism as a movement. In his account, The Cubist Painters, Apollinaire remarks that 'the new aesthetic [i.e. Cubism] was first elaborated in the mind of André Derain', a remark that has to be reconciled with Derain's avowed distrust of theory. In fact Apollinaire shies away from elaborating this statement by saying '... it would be too difficult today to write discerningly of a man who so wilfully stands apart from everyone and everything'. Apart from sharing Picasso and Braque's desire to question not only the representation of objects but our way of actually seeing and looking at these objects, Derain shared their enthusiasm for Cézanne, whose work had received a rare showing at a large retrospective exhibition organized in 1907, the year after his death. Presumably

he saw how Braque had made the transition from his brief experiments with Fauvism in 1906 to the strong monochromatic landscapes of 1908, but for Braque this transition was not the deliberate choice that Derain faced, it seems to have followed quite logically. After all, he had never been committed to a style in the way that Derain had been for a few years. Braque's few Fauve works where he experiments with light dashes of pure colour were very close in technique and expression to what Matisse and Derain had been doing in Collioure. In them he achieved effects of light and space of unparalleled freshness and spontaneity that are one of the joys of Fauvism. But, as he stated later, this was a necessary period of experimentation that liberated his imagination and helped to free him of many preconceptions; he always regarded it as a transitional phase, and perhaps this is how we too should view Fauvism. It was never a movement with aims that could be realized such as Cubism was, but a spasmodic process of experiments with possibilities suggested by the post-impressionist painters. Too often they were merely repeating what these artists had already said, in louder, shriller voices, but paintings such as Matisse's portrait of his wife or Derain's Collioure watercolours justify the commotion. When the Fauves had ceased to roar', wrote Apollinaire, 'nobody remained except peaceful bureaucrats, who feature for feature resembled the officials of the rue Bonaparte in Paris. And the kingdom of the Fauves, whose civilization had seemed so powerful, so new, so astounding, suddenly took the aspect of a deserted village.'

EXPRESSIONISM

Norbert Lynton

All human action is expressive; a gesture is an intentionally expressive action. All art is expressive – of its author and of the situation in which he works – but some art is intended to move us through visual gestures that transmit, and perhaps give release to, emotions and emotionally charged messages. Such art is expressionist. A lot of twentieth-century art, especially in Central Europe, has been of this kind and the label 'Expressionism' has been attached to it (as also to comparable tendencies in literature, architecture and music). But there was never a movement called Expressionism.

Nor, of course, is this heightening of expressive power peculiar to twentieth-century art. Periods of crisis especially seem to produce artists who channel the anxieties of their time into their work. Once the personality of an artist was admitted as a factor determining the character of a work of art, as it was increasingly during the Renaissance, art could function more and more openly as a means of self-revelation. In the context of modern individualism this could be taken to extremes, but the only true innovation that modern Expressionism can show was the discovery that abstract compositions could serve at least as effectively as subject pictures. The subject, having served as the vehicle for expressive gestures (to some extent as the acceptable sugar coating round the pill of meaning), could, it was found, be abandoned entirely. The expressive power of colours and shapes, of brushstrokes and texture, of size and scale was shown to be sufficient.

This last development was stimulated by artists' awareness, increasing since the early nineteenth century, of the directly affecting character of music. Here was a form of creativity that communicated without benefit of narrative or description, without even any appeal to associational reflexes. *Ut musica, pictura*. Romanticism also permitted a growing awareness, often impelled by nationalism, of the freedoms enjoyed by extra-academic artists of previous centuries. Some of these could be seen as heroic forerunners, offering alternative traditions to those of the academies.

The art of Dürer, Altdorfer, Bosch and others on the eve of the Reformation is marked by expressionistic qualities and particularly by an apocalyptic anxiety that appeals strongly to our century. Their contemporary Grünewald, painter of the famous Isenheim altarpiece of about 1515, has inspired admiration and direct imitation in our time. A book, published in Munich in 1918, went further back in time, offering German illuminations from the eighth to the fifteenth centuries as exempla for modern Expressionists and their public: its title, translated, is Expressionist Miniatures of the German Middle Ages. The same public, by that time, could look to a growing body of literature on folk art, on non-European art, on many sorts of primitive art and the art of children and the insane, all familiarizing readers with alternatives to classical idealism.

But even the classicism-centred traditions of western art, so powerfully nurtured in Italy and France that other countries could claim retrospectively to have had their native genius masked by alien fashions, contained elements that support Expressionism. The Venetian tradition of dramatic lighting, rich colours and personal, sometimes impassioned brushstrokes, was to some extent an expressionist tradition. From it derive such painters as El Greco (whose excessive fame dates from the beginning of this century) and Rembrandt. Even in Central Italy, where classical theory was defined and academies were founded to propagate it, the personal urgency that had led Michelangelo into vehemence and distortion was imitated by generations of lesser men with rapidly diminishing returns. Both examples, of supercharged pictorial means and of compositional and figurative distortion, are important to modern Expressionism.

The Baroque was concerned with audience response. In so far as, in the service of church or crown, art was intended to confirm faiths and loyalties, expressionist methods were used to impersonal ends. The special efficacy for this of the *Gesamtkunstwerk*, the composite work in which many arts collaborated to one end, was exploited by the Baroque, sometimes in forms that could be transmitted to later centuries. But it was also an age of great individual artists. The openly emotional qualities of Rubens's art made him an ideal model for successors unwilling to adopt the cooler disciplines of classicism; not long after his death, Rubens had been made into the unwitting

champion of modernism and self-reliance. The Dutch school mean-while developed new types of painting without benefit of academic prestige. Its interest in what might be called low-content subject matter – such as landscape and still-life – is an important factor in the nineteenth century's exploration of expression through manner rather than through subject. Rembrandt's use of colour, chiaroscuro and the brush, of line and contrast in his drawings and etchings, of subject matter even, was subjective to an unprecedented degree. As his fame has increased, from around 1800, knowledge of his career has enabled us to represent him to ourselves as the original modern outsider, the genius rejected by society because he knew its grain and worked largely against it.

Eighteenth-century enlightenment valued order above individualism but this was reversed with the coming of Romanticism. Goya, Blake, Delacroix, Friedrich, were outstanding contributors to a campaign of introspection, and to some extent of social questioning, that swept through all fields of art. In Turner this inwardness was combined with a fierce love of the energies of nature and the energies of paint on canvas. The modern concept of artistic creation being rooted in unconscious personal and super-personal forces was proposed and discussed; the paradoxical convention that unrestrained individualism could produce universal truths was born. Classicism itself was transformed. Re-established in a particularly purposive form by David, Classicism became idiosyncratic and increasingly abstract in the hands of Ingres and others. It was in the classicism of Ingres, not the Baroque Romanticism of Delacroix, that primitivism made its first major stylistic contribution.

The renewed romanticism of the later nineteenth century became the immediate basis of modern Expressionism. Gauguin's rejection of European civilization and his celebration of an alternative existence in emotional form and colour; Ensor's sudden revulsion from fine painting in favour of an intentionally shocking technique in which to present shocking subjects; Munch's use of hallucinatory images in which to give public form to his private miseries; Van Gogh's passionate yet controlled deformation of nature and intensification of natural colour in order to create a powerfully communicative art – these were the immediate models for twentieth-century

painters seeking expressive means. The example of Rodin, who could convey emotion forcefully through the surfaces and the strained poses of his figures, offered a similar basis for modern sculpture. The camera had meanwhile made straight naturalism a commonplace. Art Nouveau, around the turn of the century, took remarkable liberties with normal appearances in order to exploit the expressive, as well as the decorative, capacities of line, colour and form, while psychologists tried to explain how our affections respond to such elements. Support and inducement came also from many other directions - from the world of suffering and abnormal sensibility made graspable in the books of Dostoyevsky, from the aggressive manner and content of the plays of Ibsen and Strindberg, from Nietzsche's hard bright vision of a world without God and the challenging rhetoric in which he offered it ('he who would be a creator . . . must be a destroyer first and shatter values'), from the mystical movements of the last hundred years and in particular theosophy and Rudolf Steiner.

Expressionism has flourished most abundantly in modern Germany. The Sturm und Drang movement of the later eighteenth century had been a pioneering attempt to break the hold of Mediterranean culture on a Northern people, and German Expressionists of the early twentieth century were steeped in its literature and ideas. Politically and socially, modern Germany has been the most disturbed of European countries, with extremes of right- and left-minded citizens using extreme methods in their battles for supremacy and disastrous wars to add to the miseries occasioned by over-rapid industrialization and urbanization.

The German art world was, and is, fragmented by the fact of German federalism. The cultural life of each major town tends to be in some degree separate from, and in competition with, the others'. After 1900 Berlin became more and more the focal point of all the arts, but Munich too was a centre of international importance, and not far behind it came cities such as Cologne, Dresden, Hanover. Each had its academic establishment, balancing the opportunities each could offer to avant-gardists. Thus Berlin, while clearly the meeting and displaying point, sooner or later, for any new movement, was also the citadel of artistic reaction and firmly kept such by the

personal involvement of the Kaiser. After he went, in 1918, the general collapse of government in Germany greatly weakened the position of official art and groups and movements multiplied freely. Meanwhile the press took profitable interest in cultural adventures and skirmishes, and there were always patrons to give some support to new artists. Officialdom in Germany was over-eager to denounce these as subversive. This forced them into allegiances that did not necessarily spring from any deep political engagement on their part, and gave Expressionism the character of a movement of political protest though in fact surprisingly few of the works usually thought of as expressionist make political points. It also guaranteed artists an interested public among left-thinking people. Where local governments were progressive it could help them to places in public collections that avant-garde artists in other countries had to wait decades for. Changes in the political balance could produce sudden changes in cultural policy. Galleries and journals could offer partisan backing to artists and groups, but throughout Germany artists also worked as their own impresarios, bringing their art before the public through collaborative organizations and publications.

Expressionism is associated principally with two informal groups of artists: the Dresden group that called itself Die Brücke (the bridge), formed in 1905 and dissolved in 1913, and the Munich artists who exhibited under the aegis of an almanach entitled Der Blaue Reiter of which only one issue appeared, in 1912. Other artists are usually grouped with these, such as Kokoschka from Vienna and Feininger, the American-German. Some of the artists working at the beginning of the century at Worpswede, near Bremen - particularly Paula Modersohn-Becker - are sometimes seen as pioneers of this wave of Expressionism. The fauve movement in Paris, associating Matisse, Derain, Vlaminck and others (they exhibited together for the first time in 1905), is in many ways a related manifestation and probably had more influence on the Germans than they have been willing to allow. The war of 1914-18 ended the careers of some of the leading Expressionists and left a very different Germany behind it, and after 1918 historical primacy in art is usually given to the Dada movement, particularly effective in Berlin during the first post-war years, to the art-and-industry essays of the Bauhaus, and to the movement against Expressionism of the twenties which was called *Die Neue Sachlichkeit* (the new objectivity). Thus the climax of expressionist painting came before the war, though the main expressionist activity in literature and (what there was of it) in architecture came after it.

The story is, of course, much more complicated than this summary allows. Above all, it must be said again that there was never a movement or a group that announced itself as 'expressionist' and defined its expressionist aims. The label itself came quite late - in 1911, when the Berlin Secession exhibition included a gallery of work designated as by Expressionisten - all of them from Paris: Matisse and the Fauves, plus Picasso in his pre-cubist manner. By 1914 the label was put on Die Brücke artists and others. It tended to be applied to a whole gamut of international tendencies since Impressionism and thought to be anti-Impressionist. Thus Herwarth Walden's book Expressionismus, published in 1918, is subtitled 'the turning-point in art' and deals with modern movements in general. What he and others hoped to find in the new art they supported, to contrast with both the realism and the hollow idealism of the nineteenth century, was what they called Durchgeistigung, the charging of every action with spiritual significance, with soul. The word Expressionism tended to mean nothing more precise than anti-naturalistic subjectivism. It may be argued that this general tendency is characteristic of German culture, at any rate of German culture at moments of stress, when its liaison with Hellenism falters. 'The Germans really are a strange lot', said Goethe to Eckermann in 1827. 'They make life unnecessarily difficult for themselves by looking for deep thoughts and ideas everywhere and putting them into everything. Just have the courage to give yourself up to first impressions . . . don't think all the time that everything must be pointless if it lacks an abstract thought or idea.' Impressionism itself never flourished in Germany.

The young men of *Die Brücke* had no stylistic intentions. They came together in 1905 – Ernst Ludwig Kirchner (1880–1938), Erich Heckel (born 1883), Karl Schmidt-Rottluff (born 1884) and Fritz Bleyl. Kirchner had spent some months studying painting in Munich; they were all architecture students. Switching from design

to art they were moving in the opposite direction to that favoured by several of the leaders of Art Nouveau and Jugendstil, but their intentions were in a way similar: to address themselves to a wider public. They had no theories. What they had to offer was youth and impatience. Their pictures, prints and occasional sculptures recaptured some of the vigour that had gone out of German art since the Renaissance came north. They had no programme. 'Everyone,' wrote Kirchner in a manifesto of 1906, 'everyone belongs with us who, directly and without dissimulation, expresses that which drives him to create.' They hoped that all sorts of artists would join, yet they give us no impression of expecting interest and friendship from any side: they were, by definition almost, without allegiances and affiliations. They knew something of the Fauves; they admired Munch and gradually discovered Van Gogh; they became passionately interested in African and other primitive arts. But the only thing they shared was a desire to act energetically, manfully. Thus they hoped to get through to a public unable to respond to the polite and anaemic art of the academies. A few others joined the group for varying lengths of time: Nolde, Pechstein and Otto Müller are the best known.

Emil Nolde (1867-1956) is regarded as the most powerful painter among them. His membership lasted only a few months, from 1906 into 1907. Of peasant origin, from Schleswig in the extreme north of Germany, his view of the world was marked by a nordic pessimism that looks bad-tempered beside the enthusiasm of Kirchner, Schmidt-Rottluff and Heckel (Bleyl contributed little and left the group in 1909). Their portraits, interiors, landscapes with nudes, and cabaret entertainers, for all the challenge they offer to notions of polite and craftful art and the social implications of such art, are affirmative statements and even suggest a modern Arcadianism. They worked often with bright colours and assertively primitive form, and there is at first no sign in their work of direct social comment or even of personal anxieties. In 1911 the three moved to Berlin, where Max Pechstein and Otto Müller joined the group. Here Kirchner's work changed considerably, becoming more nervously agitated and gothic in manner, and generally their work lost much of its warmth. It may be that their relative isolation in Dresden had been the source of their strength. Now these erstwhile amateur painters found themselves in the maelstrom of German art and art politics. From now on they are seen at their best in their graphic work, especially in their woodcuts, indebted both to German prints of the Reformation period and to Gauguin's and Munch's revival of the medium as a very personal means of expression.

By 1913, when Die Brücke was dissolved, expressionist work was being attacked by conservative opinion as 'endangering German youth' and as 'the daubs of lunatics'. Wilhelm von Bode, famous director of the Berlin museums, feared that the Expressionists worked 'not out of innocent desire to create but with the ambition to be noticed at all costs'. Impressionism was still to many the archenemy of artistic decency; this wilder art that had come to replace Impressionism was even worse and confirmed their fears. In 1910 Nolde, Pechstein and others had formed a splinter group of the Berlin Secession in order to emphasize their opposition to the hesitant Impressionism of Max Liebermann and his friends. This was the Neue Sezession; Kirchner and the others joined it on arriving in the capital.

Another organization came into being about this time: Herwarth Walden's journal and publishing house Der Sturm started in 1910, and his art gallery of the same name opened in 1912. Der Sturm became a major force in publicizing German or Central European avant-garde trends, but Walden achieved more than that: he brought to Germany exhibitions of foreign art that were both influential upon and symptomatic of German interests. His first exhibition, in March 1912, combined a one-man show of the Austrian Oskar Kokoschka with a group show from the Blaue Reiter painters of Munich. The next month Walden showed the Italian futurist exhibition that had recently made its debut in Paris; here, in Berlin, these works attracted much more attention and many of them were bought. The remaining months of 1912 were devoted to shows of modern French graphic art, paintings rejected from the Cologne Sonderbund exhibition, the 'French Expressionists', Belgian painters including Ensor, the Berlin Neue Sezession, and oneman shows of Kandinsky, Campendonck (associated with Der Blaue Reiter), Arthur Segal and others. (The Cologne Sonderbund exhibition.

of May to September 1912, was in itself a major avant-garde event, including as it did avant-garde work from all over Europe, such as sixteen Picassos, five of them of 1910-11, a room each for Cézanne and Gauguin, and no less than 108 paintings and seventeen drawings by Van Gogh; the rejected paintings were largely Blaue Reiter works but mostly by artists well represented in the exhibition by other works.) During the same year the Sturm journal published, among other things, futurist manifestos, excerpts from Kandinsky's Concerning the Spiritual in Art, Apollinaire's essay 'Réalité et peinture pure' and Léger's 'Les origines de la peinture contemporaine'. The following year there were exhibitions of work by the Russian sculptor Archipenko, by Robert Delaunay, Klee, the French Cubists, Franz Marc, the Italian Futurist Severini and others, plus a large show entitled the First German Salon d'Automne (Erste Deutsche Herbstsalon, borrowing the name of the free Paris exhibition established in 1903 by Matisse and others): it consisted of 366 items by more than eighty artists working in America, Germany, France, Italy, Russia, Switzerland, Spain, etc. Thus Walden brought to Berlin as much as he could of international modernism, and his public was better informed about recent developments than anyone was likely to be in Paris or Milan, let alone London or New York. His range of interests included poetry and poetic drama and music, fields to which he personally contributed. His activities, complemented by those of other German individuals and centres, made Germany the leading showplace for the European avant-garde during the years just preceding the First World War.

The most controversial among the individual artists he backed was certainly Oskar Kokoschka (born 1886). Viennese Art Nouveau tended to support escapism and decadence, and the young Kokoschka had used violent gestures to free himself from its embrace. He took pleasure in drawing to himself the anger of the Viennese public, occasioned by his writings as much as by his pictures. Today it is a little difficult for us to see anything radical in the nervously elegant portraits of those years. His drawings have a sharpness (comparable to Schiele's) that is more emphatically expressionist, but his direct contribution to the wider world of Expressionism lies in his plays. Murder, Hope of Women (produced in 1909) and The Burning

Thornbush (produced in 1911) are milestones in the early history of the expressionist theatre. Kokoschka arrived in Berlin in 1910, helped by the Viennese architect and writer Adolf Loos, and there he found not only a number of rebellious artists but also a well-known dealer, Paul Cassirer, who was ready to be interested in his work, and a friend and subsequently a promoter in Herwarth Walden. His portrait of Walden, painted in the same year, is one of his finest works.

Kokoschka has impressed himself on the world as the Expressionist par excellence. This is at least as much a matter of personality as of production, and some credit must go to chance and circumstances. Vienna offered just the right balance of sluggish philistinism and spasmodic brilliance that the young man needed to develop his sense of mission. His Czech background seems to have guarded him against the inturned irony that prevents the Viennese from seeing themselves as heroes. In Berlin, in the Café Grössenwahn (=megalomania) he was able to meet artists and writers of comparable fervour and here too he could stand out, untrammelled by Berlin rationalism. Fate added such stories as the stormy love affair with Alma Mahler, widow of the composer, which Kokoschka celebrated in the painting Bride of the Wind (1914); even the wounds he suffered in the war, a bullet in the head and the Liebestod of a Russian bayonet thrust into his body, seem like tributes from the cosmos to its favourite son. Later the Nazis confirmed Vienna's opinion of the young man in denouncing him as degenerate - as they denounced almost all unconventional artists - and he publicly embraced the epithet in his Self-Portrait of a Degenerate Artist (1937). His arrogation of uniqueness - as man as well as artist, as sufferer as well as creator - is archetypal. He might have said what the poetess Else Lasker-Schüler wrote to Walden, her second husband: 'Ich bin nie mit anderen Menschen zu messen gewesen' - 'it has never been possible to measure me in terms of other human beings'.

Individualism of this sort was asserted in varying degrees and with varying justification by many Expressionists. If indeed Expressionism means anything it means the use of art to transmit personal experience. The exploitation of personality appears to be essential to it, and this calls for a certain amount of conscious or

unconscious posing on the part of those artists not too markedly endowed with personalities of their own. This helps us to see why there could be no style or group or movement that properly embodies Expressionism. It also illuminates a major distinction between Expressionists. Artists like Kirchner, Kokoschka, Nolde, and so on, appear to have relied on more or less immediate self-expression on the assumption that this, if sufficiently forthright, will readily communicate itself to an unprejudiced spectator. Other artists felt the need to test their means and their urges, and gradually to fashion a controllable language in which to formulate their personal messages.

The artists of *Der Blaue Reiter* (the blue rider) were of this second sort. *Der Blaue Reiter* was the name of the almanach which appeared in Munich in May 1912. Its editors were Kandinsky and Marc and they, 'the editorial board of *Der Blaue Reiter*', also organized two exhibitions in Munich, opening in December 1911 and February 1912. These two painters, and their closest painter friends – Macke, Javlensky, Klee, Gabriele Münter and Marianne von Werefkin – are the artists thought of nowadays as forming the *Blaue Reiter* group. The exhibitions included them, but also ranged quite widely over modern European art.

Wassily Kandinsky (1866-1944) had arrived in Munich from Moscow in 1896 in order to make a late start on his career as artist. He found himself in a city of lyrical naturalism and of Jugendstil, and in his first paintings he combined the two. Gradually, under the influence of Russian and Bavarian Primitivism, and following the example of Fauvism (which he studied at first hand in Paris), Kandinsky reduced the naturalism in his art and greatly extended its lyrically expressive power. Glowing colours and somewhat fervent brushstrokes were sufficiently communicative for him to depend less and less on subject matter. At first he had tended to subjects that now seem rather cloyingly romantic, but by 1910 he was able to be much more affectingly poetic through paintings of simplified landscapes, and in the same year he made his first experiment with completely abstract art: his well-known abstract watercolour in which patches of colour and gestures of the brush are intended to carry the work's meaning directly to the spectator. The spectator has to feel his way into the composition rather than read it. During the following years Kandinsky developed this subjectless art further, not necessarily eschewing all hints of figuration but placing his emphasis on the total expressiveness of his pictures and at times using semi-improvisatory techniques to get the greatest possible immediacy.

Franz Marc (1880-1916) attempted a comparable move from an object-orientated art to an art of lyrical expression. The role that music played in Kandinsky's creative life, leading him into theoretical analysis as well as encouraging him in his pursuit of direct expression, was played for Marc by animals. In their eyes he saw an innocence lost by man, a oneness with the rhythms of nature from which man had been estranged, and he painted them as symbolic images and also as objects of contemplation through which to reach enlightenment. He painted them continuously - first more or less impressionistically, then more in the manner of icons with unnaturalistic colours and hieratic staging, and then, under the influence of Delaunay, within a loosely geometrical structure. Never very radical or forceful, supported by stirring but not very profoundly written observations on life and art, and perhaps a little glamourized by the sad accident of his death in the war, Marc has the distinction of being a popular modern artist.

The example of Delaunay was of especial importance also for August Macke (1887–1914) and for Paul Klee (1879–1940). Kandinsky and Javlensky leant principally on the relatively open emotional art of Fauvism; Marc, Macke and Klee found in Delaunay a poetic and constructive sort of Cubism. When Kirchner and others were influenced by Cubism, they learnt from it mainly formal and compositional means of disruption and edginess, whereas these Blaue Reiter artists valued Delaunay for his harmonies of colour and structure. They saw him as a builder and thus as the direct son of Cézanne.

Kandinsky, Marc and some of the others had been members of the recently formed Munich 'New Artists' Society', but resigned from it in 1911 over its reluctance to accept Kandinsky's move into abstraction. By this time Kandinsky and Marc were already planning their *Blaue Reiter* almanach. It was to be a compilation of articles to elucidate their own attitudes, to present like-minded work

in other places and other media, and to illustrate the place of these activities within the wider context of human creativity. Not just civilized 'fine art' but also primitive art and design. Not just art as the sport of civilization but art as the vehicle of human hopes and fears, religious art. Not just art, but music also, poetry, drama and so on. Not just German work but contributions from Russia, France, Italy all linked by the desire to find new means of expression through which to transmit the inner essence of humanity.

Der Blaue Reiter contains essays by Kandinsky, Marc and Macke, by Arnold Schoenberg and others on music, by David Burliuk on Russian art, and by Erwin von Busse on Delaunay. There are illustrations to show a range of primitive art, from Bavarian folk art to Egyptian shadow-play figures, to show sophisticated art of many periods from east and west, and to show modern works by Blaue Reiter artists and by others including Cézanne, Gauguin, Van Gogh, Rousseau, Matisse, Picasso, Delaunay and Arp (who was working in Munich at the time). There are music inserts by Schoenberg, Berg and Webern. The book is dedicated to the memory of Hugo von Tschudi. Tschudi had died in 1911 after directing the Bavarian Galleries in Munich. Previously he had directed the National Gallery in Berlin, until violent disagreements with the Kaiser over his buying of French nineteenth-century art led him to resign in 1908. The specific occasion of his resignation was apparently the Kaiser's insistence that Delacroix could neither draw nor paint.

The name of Wilhelm Worringer is often invoked in connection with Kandinsky's move into abstraction and with the general attitudes shown by him and by his Blaue Reiter colleagues. Worringer in 1907 submitted, and in 1908 published, a doctoral dissertation entitled Abstraction and Empathy: a contribution to the psychology of style. In 1911 he issued another influential work, Form in Gothic. In these books he distinguished between the outgoing attitude to nature characteristic of classical art and the tendency to abstraction noticeable in the artifacts of northern man, living in a more inimical environment. His analysis served to make northerners more aware of the alien character of southern traditions, and though he was mostly concerned with the distant past, his conclusions seemed to envisage radical departures from these traditions. Yet it seems that

Kandinsky and Marc were not aware of Worringer's support. In February 1912, when they were planning a second Blaue Reiter volume, Marc wrote to Kandinsky: 'I have just been reading Worringer's Abstraction and Empathy – an acute mind that we could well use. Marvellously disciplined thinking, taut and cool, very bold even,' implying that neither of them had known the book previously or its author. It would seem that the common elements in Worringer and in them belonged to that time and place, partly on account of Munich's special role as a leading Jugendstil centre, and partly through the teaching at Munich University of Worringer's master, Professor Theodor Lipps.

Kandinsky's thinking in particularly reflected many of the ideas and intimations of his time. His Russian and Orthodox background encouraged in him a leaning towards the occult, and he had lived in Paris and there absorbed various creative influences, including that of the philosopher Bergson. He was interested in theosophy and attended lectures given by Rudolf Steiner in Munich. Faced by developments in science and technology he chose the opposite path to that travelled by Futurists and Constructivists: he turned his back on the material world, or at least sought to redress the imbalance caused by the world's emphasis on material progress by committing art to the world of the spirit. His book, On the Spiritual in Art, written in 1910 and published in December 1911 though dated 1912, had a significant success. Two further editions appeared in 1912. In the last days of December 1911 parts of it were read and discussed by the Congress of Russian Artists in St Petersburg. In 1914 extracts from it appeared in Wyndham Lewis's BLAST and a full translation into English, by Michael Sadler, was published the same year in London and Boston. In 1924 a Japanese translation appeared in Tokyo, and there have been many more editions of it, including translations into French, Italian and Spanish.

Kandinsky sought to connect the visual matter of art directly to the inner life of man. Abstraction was not essential to this, but rather the tuning of pictorial means to the emotional or spiritual urge within the artist. Instead of reinforcing the false values of a materialistic society, art thus used would help people to recognize their own spiritual worlds.

The 'first exhibition of the editorial board of Der Blaue Reiter' was similar in purpose to the almanach: to offer a meeting place for all those efforts, in Kandinsky's words, 'so noticeable today in all fields of art, whose basic tendency is to extend the previous limits of the possibilities of expression in art'. Apart from Blaue Reiter paintings it included several foreign works, among them pictures by the Russian brothers Burliuk, by Delaunay and by Henri Rousseau (two paintings, recently acquired by Kandinsky). This was Delaunay's first showing in Germany; in 1913 he had a one-man show at the Der Sturm gallery in Berlin. The second Blaue Reiter exhibition was confined to graphic art and included items by such invited foreigners as Picasso, Braque, Delaunay, Malevich, Larionov and Goncharova. The years 1912–14 saw groups of Blaue Reiter paintings exhibited in several German cities, especially in Berlin and Cologne. Apollinaire's lecture on Orphism at Der Sturm, in 1912, reinforced the Blaue Reiter artists' self-identification with an international movement of constructive yet lyrical art.

Then came the war. Macke and Marc lost their lives. Kandinsky returned to Moscow and soon found himself involved in political and cultural revolutions that affected his art. Klee, always detached, withdrew even more into himself. 'The more fearful this world becomes, as at this moment, the more art becomes abstract,' he wrote in 1915, echoing Worringer. Yet many other artists moved in the opposite direction. While the experience of war led many artists, especially in western Europe, to disengage their art from the struggle for modernism and to return to comforting aesthetic traditions, some German artists were moved to use their art as a means of protest. Most of these came from the descriptive art of German semi-Impressionism. They adopted the energetic manners of Brücke Expressionism, as well as symbolical devices that go back to the time of Dürer, in order to state forcibly their revulsion at the events of their time. Many of these artists are rarely heard of today; on the whole their diatribes lacked the artistic qualities that could have given them permanent value. But from now on, until totalitarianism calls a halt, protest art of this sort continues while other movements rise and fall around it.

German art of the post-war years tends to be grouped under

such labels as Dadaism, New Objectivity and Elementarism (I use Elementarism to indicate the several movements that became effective in Germany from 1920 on which were concerned with exploiting geometrical form as such, under the influence of Russian and Dutch radicalism). These labels, or the thoughtless clinging to them, interfere to an exceptional extent with any proper understanding of what the artists were doing. In Germany particularly the divisions which they imply did not exist and were rarely felt to exist at the time. German artists of contradictory persuasions collaborated through associations and groups, moved freely between them, felt at liberty to change their allegiances and did not attach overmuch importance to their declarations of vesterday. Thus Richard Huelsenbeck's swingeing and fairly accurate attack on Expressionism published in the Dada Almanach of 1920, did not prevent artists associated with German Dada from acting like Expressionists. The art of George Grosz (1893–1959) could not have existed without the example of Brücke and Blaue Reiter graphics. If it was the purpose of Dada to challenge civilization by showing up the pointlessness of culture, then Grosz was not really a Dadaist. He used his art to denounce rottenness of the social structure within which he lived, and his method was a semi-naturalistic exaggerating of situations where this rottenness becomes blatant – which sounds very much like Expressionism. The photomontages of John Heartfield (1891-1968) are closer in character to German Expressionism than to the Cubism from which in theory they derive. The New Objectivity of the mid twenties was intended to offer a return to naturalism in opposition to the supposedly obscure art of Expressionism, yet this art no longer looked particularly obscure and was if anything already too conventionally accepted a part of the modern art scene. The best of the painters associated with the New Objectivity was Max Beckmann (1884-1950). He had been weaned from Impressionism by the impact of war. His paintings of around 1920 are undoubtedly works of protest, but the power of his imagination, working through a complex style which is an amalgam of many modern and ancient influences, lifts them above the emergencies of the moment. They are images of human existence amid extraordinary internal and external pressures. In a book of 1925 entitled 'Post-Expressionism' (Nach-Expressionismus), Franz Roh proposed the label Magic Realism for the variety of semi-naturalistic works assembled as New Objectivity in a Mannheim exhibition the same year. Yet it would be difficult to draw any firm lines between the work of Beckmann, Otto Dix, and others and the figurative works of Die Brücke. What the new grouping did stress was the rejection of abstract art, both the lyrical abstraction of Klee and Kandinsky and the apparently more radical Elementarism brought in from Holland and Russia.

Little need be said of German sculpture under this heading. Both the dignified though pathetic figures of Wilhelm Lehmbruck (1881–1919) and the more folksy, medievalizing figures of Ernst Barlach (1870–1938) could well be part of the New Objectivity movement though they mostly belong to the previous decade. Expression through some degree of distortion, though without loss of harmony and without abandoning honoured traditions of sculpture, appears to be the limit of this art, and slightly less well-known sculptors (such as Georg Kolbe, 1877–1947) of the same generation stayed well within the same limit.

Some German (and Dutch) architecture has been described as expressionist. It is difficult to find a useful definition of architectural Expressionism, but at the same time there can be no doubt that certain architects emphasized their individuality in ways that seem more or less comparable to those of expressionist artists. Erich Mendelsohn (1887-1953) is the outstanding example of this: a man whose sketches are visionary and whose executed buildings tend to have a monumental and expressive character. The war and immediate post-war years gave architects more opportunity to dream great dreams than to realize them in constructed fact. Mendelsohn was fortunate in being commissioned, in the Einstein Tower of 1920-21, to design a functional building that at the same time was to celebrate the greatness of a scientist. Similarly Hans Poelzig (1869-1936) was lucky to be asked by Max Reinhardt to transform a former warehouse and circus into the Grosses Schauspielhaus (1919); again an opportunity to give physical reality to some part of the fantastic projects that had to remain on paper. In 1919 an exhibition at the J. B. Neumann gallery in Berlin, the 'exhibition of unknown

architects', brought together sketches and models of a generally visionary sort. There could be no stylistic coherence, and generally the influence of Jugendstil was still very strong, but the exhibits promised a new architectural world of light and colour, joy and excitement - a counterpart, perhaps, to the lake-side romps promised by many Brücke pictures. One of the organizers, the architect Bruno Taut, during 1920–22 published a journal Frühlicht (=early light, dawn; it was first a supplement to an architectural magazine, then an independent publication), that gathered in illustrations and articles of the same sort. It is noticeable that the later issues of Frühlicht (1921-2) are more and more concerned with practical problems and with realizable projects. Some continuation of expressionist visionary design can be found in the stage and studio sets of the German theatre and cinema in the early twenties. In every respect other than the fine arts, the years 1918-23 mark the climax of Expressionism.

It was in 1919 also that Walter Gropius opened the Bauhaus in Weimar. This was to become famous as the school that pioneered the teaching and practice of modern industrial and architectural design, but initially the Bauhaus too stood under the sign of Expressionism. Gropius (born 1883) had been involved in the Neumann gallery exhibition and he also contributed to Frühlicht. The staff he assembled in Weimar consisted almost exclusively of painters and the most important of these - Feininger, Klee, Kandinsky - are Expressionists. But they are Expressionists of the constructive sort, the Blaue Reiter sort. This applies too to the painter who dominated the school during its first four years, Johannes Itten (1888-1967). Itten, of Swiss origin, had turned to painting from scientific studies after looking at Blaue Reiter art in Munich and at Cubism in Paris. He had then studied in Stuttgart under Adolf Hölzel who based his teaching on the affective power of colour and form, as separate from subject matter. In 1916 Itten opened a private painting school in Vienna. He was the entire teaching staff of this school, and his students varied considerably in abilities and inclinations, and thus Itten discovered what has become known as the basic or foundation course, an initial course designed to familiarize the student with the character of the materials he handles and the

potentialities of the means of his art. Gropius brought Itten to Weimar to run a similar course at the Bauhaus. Itten retrospectively stressed another function of his course, 'the self-discovery of the individual as a creative personality'. This sounds very much like the first step towards being an Expressionist. What we know of the exercises Itten set his students, as well as of his own work in painting and typography, shows clearly that he was advocating an art of expression, both through the abstract means of art and also through subject matter and dramatic emphasis. He resisted Gropius's attempt, in 1922–3, to lead the Bauhaus from its concern with artistic self-expression towards an objective involvement in socially useful design, and early in 1923 he had to be asked to leave the school.

The two most famous *Blaue Reiter* painters, Klee and Kandinsky continued to teach there: Klee until 1930, and Kandinsky from the end of 1922 until the school closed in 1933. For this purpose both of them had to attempt some formulations of their understanding of art and creativity. Klee's teaching has now been published in part, as *The Thinking Eye* (edited by Jürg Spiller). Kandinsky's didactic text, *Point and Line to Plane*, was published as one of the 'Bauhaus Books' in 1926. It is an attempt to codify the sensual and emotional value of colours and forms so as to enable the artist to control the expressive means at his disposal. Kandinsky's own work, in the 1920s, lost much of its impetuous character and became more controlled and, it would seem, more lastingly effective. His book, or perhaps merely its title, has the distinction of having misled art teachers of later generations to take a rather simplistic and mechanical view of what a basic course might entail.

It would be possible to go on and point to large and small outcrops of Expressionism in subsequent art and design. To what extent are Rouault, Chagall, Soutine, Sutherland Expressionists? They are probably better seen as expressionists, not part of the broad trend that warrants the capital letter. At another level of argument one might wish to prove that so obviously unExpressionist an artist as Mondrian was driven by a passionate need to find the most concentrated, minimal vehicle through which to communicate his rather recondite understanding of life and nature, and that this

too is expressionism of a sort. Since the Second World War there has been a succession of expressionist waves, in modelled and constructed sculpture as well as in painting, figurative and abstract. It was to some extent the American trend known as Abstract Expressionism that drew our attention back to Kandinsky's generation.

CUBISM

John Golding

It is hard to build precise boundaries around periods in art history, but in the case of Cubism it is possible to say that the movement was ushered in, cataclysmically, by the *Demoiselles d'Avignon* [illustration 17], conceived by Picasso towards the end of 1906 and abandoned in its present state during the course of the succeeding year. It is a disturbing and daring painting today – sixty years ago it must have seemed nothing short of incredible. It certainly dismayed and baffled even Picasso's warmest supporters. Braque, an intelligent and open-minded young painter, was frankly horrified when he first saw it; yet some months later his great female *Bather* (now in a dealer's collection in Paris) was to demonstrate conclusively that despite his original revulsion the *Demoiselles* had altered the entire course of his artistic evolution.

Even before he began it, Picasso seems to have realized that the Demoiselles was to be no ordinary work. It was the largest canvas that he had yet tackled, and he took the unprecedented step of having it lined before he began it – a procedure usually reserved for the conservation and restoration of the great works of the past. The poet André Salmon, a close friend of Picasso at the time, has left us an account of Picasso's state of mind. 'Picasso was unsettled. He turned his canvases to the wall and abandoned his brushes... during long days and nights, he drew, giving concrete expression to the images which haunted him, and reducing these images to their essentials. Seldom has a task been harder, and it was without his former youthful exuberance that Picasso started on a great canvas that was to be the first fruit of his researches.' Other contemporary accounts suggest that Picasso was dissatisfied with the painting, and he seems to have considered it unfinished. And yet, despite its obvious inconsistencies and changes of style, the Demoiselles has come to seem, like all the greatest art, splendidly inevitable. The fact that we could not now visualize it altered in any way serves to underline the fact that in dictating its own laws, it created new canons of aesthetic beauty, or, to put it differently, it destroyed traditional distinctions between the beautiful and the ugly. If Fauvism had belonged as much to the nineteenth as to the twentieth century, this painting heralded a new age in art. It remains the major turning point in Picasso's career, and the most important single pictorial document that the twentieth century has yet produced.

The Demoiselles is not, however, a cubist painting. Both the subject matter, with its disturbing, erotic overtones (originally the picture was to have included two clothed male figures among the naked women), and the technique, with its often savage, expressionistic use of paint, were to prove alien to the cubist aesthetic. If it was extraordinarily forward-looking it also inevitably sums up Picasso's past achievement. His work in the preceding years had often been strongly charged with emotion; it had been influenced by social preoccupations, by literature, and by an astonishingly wide range of visual sources. Cubism, on the other hand, was above all a formalistic art, concerned with the re-appraisal and re-invention of pictorial procedures and values. Its development was, it will be seen, remarkably free from outside influences. It had links with contemporary literature, but it avoided all literary allusions. The approach of the two original creators of the movement, Picasso and Braque, was, it is true, intuitive, and one often senses an undercurrent of excitement in their work, but it was also deeply thoughtful and informed by a high degree of intellectual content; and generally speaking Cubism was to be a calm, reflective art. But if the Cubists were to reject so much that the Demoiselles stood for, with its revolutionary stylistic innovations it posed the pictorial problems which Cubism was to solve.

The sources on which Picasso drew to create this remarkable work have been frequently discussed and analysed. Without the achievement of Gauguin, for example, such a painting could never have come into existence. In the angular, elongated forms and harsh, white highlighting there is a reflection of Picasso's interest in El Greco. There are elements drawn from Greek vase painting, from archaic sculpture and from Egyptian art. Then there is a direct reference to the facial conventions of Iberian sculpture in the heads of the two central figures. But viewing the painting as a prelude to

Cubism, one's attention must be focused on the two major influences that went into the creation of the *Demoiselles*, for these were the same two art forms that were to condition the early development of the movement.

In the first place, the closest prototype for this type of composition of naked and partially draped women is to be found in the work of Cézanne; indeed, the squatting figure in the bottom right-hand corner, with its extraordinary deformations, was originally based on a figure in a small Cézanne owned by Matisse. Ultimately the Cézannesque features in the *Demoiselles* (which are even more marked in the studies leading up to it) were to be overlaid by other, stronger influences; but it would not be inappropriate to see the painting as a sort of homage to the master of Aix. Cézanne had been an influence on contemporary painting since the beginning of the century, but it is this painting that makes Cézanne an honorary twentieth-century artist, and it was in the years following its execution that Cézanne's reputation as the greatest and most influential figure in nineteenth-century art was firmly laid.

And yet, even more important from the point of view of Picasso's subsequent development as an artist is the fact that while he was working on the Demoiselles he came into contact with African sculpture. The mask-like face of the 'demoiselle' at the extreme left, and above all the savagely distorted and gashed faces of the two figures at the right, bear witness to its impact upon him. It is hard to pin down particular examples of Negro art which might have influenced him, for he quickly amassed a large collection and his figures of the following year have the quality of all African sculpture. And if in the Demoiselles the debt to African art was primarily a visual and emotional one, Picasso was intuitively drawn to it at a deeper and more intellectual level. Although cubist painting was from time to time to reflect the influence of certain stylistic African conventions, it was the principles underlying this so called 'primitive' art that were to condition the aesthetics of one of the most sophisticated and intellectually astringent styles of all times. To begin with, as opposed to the western artist, the Negro sculptor approaches his subject in a much more conceptual way; ideas about his subject are more important for him than a naturalistic depiction of it, with the result that he is led to forms that are at once more abstract and stylized, and in a sense more symbolic. Certainly Picasso seems to have realized almost at once that here was an art that held the key to the young twentieth-century painters' desire to emancipate themselves from visual appearances, in that it was an art that was simultaneously representational and anti-naturalistic. This realization was to encourage the Cubists, in the years to come, to produce an art that was more purely abstract than anything which had preceded it, and which was at the same time a realistic art, dealing with the representation of the material world around them. Secondly, Picasso saw that the rational, often geometric breakdown of the human head and body employed by so many African artists could provide him with the starting point for his own re-appraisal of his subjects.

If Picasso approached Negro art at a more profound level than any of his contemporaries, this was because for some time he had been dissatisfied with the traditional western approach to the painting of forms or objects. Here in the Demoiselles we have, albeit in a tentative and clumsy fashion, a new approach to the problem of representing three-dimensional volumes on a two-dimensional surface. It is in this that the painting's supreme originality lies. In the heads of the three figures in the left-hand half of the composition, Picasso's intentions are stated in a crude, schematic way: the heads of the two central figures are seen full-face and yet have profile noses, while the head seen in profile has a full-face eye. But in the squatting figure to the right, the most important part of the painting, and the last to be painted, this sort of optical synthesis is more imaginatively applied to the whole figure to produce one of the most revolutionary and compelling images in all art. The figure is posed in what is basically a simple three-quarter view from the back (with the breast and the thigh visible between upper leg and arm), but with what amounts to an almost physical assault Picasso has split or hinged the body down the central axis of the spine and the far leg and arm have been pulled around and up on to the picture plane suggesting also an abnormally distended or splayed out view from directly behind; the head, too, has been wrenched around to stare straight out at the spectator. For five hundred years, since the beginning of the Italian Renaissance, artists had been guided by the principles of mathematical or scientific perspective, whereby the artist viewed his subject from a single, stationary viewpoint. Here it is as if Picasso had walked 180 degrees around his subject and had synthesized his impressions into a single image. The break with traditional perspective was to result, in the following years, in what contemporary critics called 'simultaneous' vision – the fusion of various views of a figure or object into a single image.

Nor is this all. If we are told more about the figure than we could have learnt by viewing it from a single viewpoint, the way in which it has been unfolded or pulled up towards us has the effect also of making us very aware of the flatness of the surface on which the painter is working, and this sensation is furthermore reinforced by the fact that the drapery around the figures has been treated in the same angular, faceted way as the figures themselves. The naked women become inextricably bound up in a flux of shapes or planes which tip backwards and forwards from the two-dimensional surface to produce much the same sensation as an elaborate sculpture in low relief. Throughout the nineteenth century painters had become increasingly anxious to respect the integrity of the picture plane, and it is proof of the ambitions and complexities of Cubism that, while its painters sought to give the spectator an ever fuller inventory of the formal properties of their subjects, they carried this preoccupation to new lengths. For one of the major concerns of the Cubists was to unite the subject with its surroundings in such a way that the whole pictorial complex could be constantly forced or related back to the flat canvas with which the artist had been originally confronted.

Negro sculpture and the art of Cézanne were the two major influences in the formation of a style which was otherwise unusually self-contained. Negro art was to condition very directly the appearance of Picasso's work in the year and a half following the painting of the *Demoiselles*, and again later in the first stages of his evolution towards a more 'synthetic' procedure: but its legacy to Cubism was, in the last analysis, that of a new aesthetic outlook, an intellectual force. And it was the art of Cézanne which more immediately held the answer to the problems which the *Demoiselles* had posed. In

this great canvas Picasso had approached Cézanne in a spirit of anarchy, one might say almost of aggression; and it was left to a gentler, more methodical artist to put to the paintings of Cézanne the questions they were waiting to be asked. This artist was, of course, Georges Braque, and it was out of his collaboration with Picasso that Cubism was born. The two painters were introduced by the poet Apollinaire almost immediately after Picasso had finished work on the Demoiselles, and during the following years they worked together in a collaboration of unprecedented closeness. 'C'était comme si nous étions mariés,' Picasso once remarked;² and it is true that a spiritual, artistic marriage existed between the two. Neither could have accomplished a revolution of the magnitude of Cubism without the other's help. On the other hand, as we distance ourselves from the movement it becomes increasingly possible to distinguish the individual contribution of each artist.

Picasso approached Cubism through an interest in three-dimensional form. Of the works of his 'Negroid' period he once said that each figure could be easily realized in terms of free-standing sculpture;³ his occasional experimental sculptures executed in 1907 and the following years testify to the fact that he conceived of cubist form in sculptural terms. Braque's approach was more painterly, more poetic; significantly, of all the major cubist painters only he retained an interest in the evocative properties of light. And he was the technician, who through patient research was to solve many of the pictorial problems that arose in the creation of this extraordinarily complex style. Most immediately he created a new concept of space that was to complement Picasso's new treatment of form. And the spatial sensations he tried to evoke were, he realized, latent in the late canvases of Cézanne, just as Picasso had sensed that Cézanne's mysterious distortions of form suggested a new language of volumes.

The first thing that fascinated the Cubists about Cézanne was the fact that the objects in his paintings conveyed an astonishing sense of solidity, while violating all traditional systems of illusionistic procedure. What his art had in common with Negro sculpture was that it explained and informed without deceiving. Cézanne's jugs, bowls and apples are so solid that they seem almost tangible, but they remain also pre-eminently 'painted', and on examination we

find that they are almost invariably highly distorted or abstracted; it might be fair to say that Cézanne abstracted form to the degree which Van Gogh and Gauguin had abstracted colour and space. Cézanne's concern with achieving a sense of solidity and structure in his painting led him, in the first place, to reduce objects to their simplest basic forms - his 'cones, cylinders and spheres'. Then his desire to explain further the nature of these forms led him to look at each one in its most informative position. By tipping an object up towards the spectator he tells us what it looks like from above as well as from in front; sometimes he seems to edge around objects so that we glimpse a side view as well. Cézanne, we know, returned to his subject again and again, and it seems very likely that his obsessive fascination with objects led him unconsciously to move up on them, shifting his position slightly at every new painting session, so that we find in certain passages the same sort of optical synthesis which Picasso had consciously and violently achieved in the squatting 'Demoiselle'. The fact that he found himself so often looking down on his subject also had the effect of limiting depth and pressing the pictorial space up on to the picture plane.

In the summer of 1908 Braque made a pilgrimage to L'Estaque, a favourite haunt of Cézanne's, where he produced a series of landscapes and still-lives, the paintings, which, when they were shown at Kahnweiler's gallery later in the year, were to earn Cubism its name. In these works the colour and immediacy of his earlier fauve manner have been sacrificed to produce a more conceptual, disciplined and geometric kind of painting. The influence of Cézanne is strong, but following the lead set by Picasso in the Demoiselles Braque has put Cézanne's methods of composition and the inconsistencies in his use of perspective to new ends. Forms have been drastically simplified, and in the landscapes particularly a whole series of devices have been adopted to negate the sense of recession that is almost necessarily implicit in the subject. Buildings, rocks and trees are piled on top of each other rather than arranged behind each other, and they generally reach the top of the canvas so that the eye is left no escape into a limitless space beyond. Atmospheric and tonal recession are deliberately negated, and objects supposedly furthest from the eye are given exactly the same value as those in the foreground; there is

no single light source, and lights and darks are arbitrarily juxtaposed. At intervals the contours of forms are broken so that the space around and between them seems to flow up towards the spectator.

Space. Braque was to insist over and over, was his major pictorial obsession. In one of his most revealing and lucid statements he said: 'there is in nature a tactile space, a space I might almost describe as manual', and again, 'what most attracted me and what was the governing principle of Cubism, was the materialization of this new space which I sensed'. The rejection of traditional, single viewpoint perspective was as essential to Braque's materialization of the spatial sensations he sought to convey as it was to Picasso's desire to convey a multiplicity of information in every painted object. With the dismissal of an illusionistic space the objects in a painting and the space around them could, it has been seen, be unfolded upwards on to the picture surface. For Braque the areas of 'empty' space, what one might call the 'Renaissance vacuum', became as important as the subjects themselves. In his first cubist paintings, and indeed in all his subsequent work, it was Braque's purpose to bring this space forward towards the spectator, to invite him to explore it, to touch it optically. The analysis in terms of intricately hinged planes or facets which Picasso was to apply to three-dimensional forms in his canvases, Braque applied to the spaces that surrounded them. Both the use of a variable viewpoint and the realization of a tactile use of space had been implicit in the canvases of Cézanne. But the differences between his work and that of the early Cubists do not lie simply in the fact that they pushed his discoveries further; it was one of intention. Cézanne, one suspects, was often unconscious of the pictorial distortions that his vision involved. Picasso and Braque, though they worked intuitively, were aware that they had made a break with the past. Significantly, whereas colour had been the focal point and the basis of Cézanne's art and technique, the Cubists now abandoned colour in favour of an almost monochrome palette, in Picasso's case because colour seemed secondary to the sculptural properties of his subjects, in Braque's because he felt it would 'trouble' the spatial sensations with which he had become obsessed.⁵

Picasso was perhaps too impetuous and violent a nature to come to terms immediately with the extreme subtlety and complication of Cézanne's art; certainly he was more immediately excited by his discovery of African art. There can be little doubt that when, in the latter part of 1908 and early 1909, Picasso turned again to the work of Cézanne, it was largely through Braque's example. The monumental nudes of late 1908, which mark the climax of his 'Negroid' phase, show his earlier 'rational' or African inspired analysis of volumes being tempered by a more empirical, more painterly approach. The Negroid striation of forms, used by Picasso to model the body, becomes married, almost imperceptibly, to a Cézannesque technique of smaller, parallel hatchings or brushstrokes which feel their way over and around volumes. In these nudes, however, the use of a variable viewpoint is only implicit; and it is understandable that after having made, in the Demoiselles, a gesture or discovery of the most revolutionary kind, he felt the need to retract momentarily to gather together his resources and digest his discoveries. And it is in the series of still-lives and landscapes, begun at La Rue des Bois in August 1908 and continued on into the winter, the most strongly Cézannesque of all his paintings, that Picasso works towards a more consciously anti-perspectival art in which every object depicted synthesizes various viewpoints; thus the bowl of a fruit dish will be seen from above, its base from a still higher viewpoint and its stem at a lower, eye-level position. Finally, sure of his premises, Picasso returned to a more revolutionary treatment of the human form. A nude of 1908-9, for example, is seen in a threequarter view, from in front, but the far buttock and a section of her back, which would be hidden from view in a naturalistic rendering, are swung around on to the picture plane to the right of the figure, while the far leg is bent unnaturalistically and forced up on to the surface of the picture at the left; the head is bisected and combines a pure profile with a distended three-quarter, almost frontal view. Whereas in the Demoiselles we are acutely aware of the pictorial distortions employed by Picasso, we are now faced, quite simply, by a new formal idiom.

But it is in the series of figure paintings executed by Picasso during the summer of 1909 at Horta del Ebro, in Spain, that the

new cubist concept of form reaches its fullest and most lucid expression, precisely because it is these works that show the most perfect marriage of the principles derived from African art with the more painterly lessons learnt from Cézanne. It is as if each head and body depicted had been completely rotated before our eyes to leave behind a static, composite image of unprecedented complexity and strength. On his return to Paris Picasso transposed one of the Horta heads into bronze; and yet this sculpture, fine though it is, tells us little more about the subject than its pictorial predecessor. Indeed, the sense of 'sculptural completeness' conveyed in Picasso's pictorial images of this period made sculpture itself seem, for the moment, redundant. It was only in the later phase of Synthetic Cubism, when painting had once again become flatter and more relaxed, that Picasso's experimental constructions in wood, tin and cardboard laid the foundations for a truly cubist school of sculpture.

For some time now critics have distinguished between two major phases in cubist art; an early 'analytic' phase and a subsequent 'synthetic' phase – a distinction originally worked out in the art and writings of Juan Gris, the third of the triumvirate of great cubist painters. But if one accepts this distinction, it is almost equally important to subdivide Picasso's and Braque's Analytic Cubism into an early formative period, strongly flavoured by the influence of Cézanne, and, in the case of Picasso, of African art, and a later development that might be labelled the 'classical' or 'heroic' period, which was marked by a further and more decisive break with natural appearances. Because some of the paintings of this period are at first hard to 'read' this is also referred to sometimes as the 'hermetic' phase of Cubism. It was, in fact, a moment of perfect poise and balance, which lasted approximately two years, from mid-1910 until the end of 1912.

The technical and stylistic innovations which marked this new development in Analytic Cubism can be traced most clearly, perhaps, in the work of Braque, although the period of most intense collaboration between the painters had begun, so that every individual discovery must be seen as the result of a mutual interchange and stimulation. As a Fauvist Braque had been predominantly a landscape painter, and landscape continued to play an important role in his first cubist manner. But by the end of 1909 he had become, and was to remain above all else a painter of still-lives. It was in these arrangements of musical instruments, goblets, fans and newspapers, the objects of daily experience, which immediately evoke a tactile sensation through their associational values, that Braque felt he could best control and explain the thrusts and counterthrusts of cubist space. Even in his earliest cubist painting Braque, it has been seen, had evolved a technique of occasionally breaking the contours of his subject in order to let the surrounding space flow up on to the picture plane; however, in these works it still remains possible for the spectator to reconstruct for himself the subject in its naturalistic entirety. His work of 1910 shows him feeling his way towards a new type of compositional procedure by which the painting is built up in terms of a much looser, more linear grid or scaffolding of interacting vertical, horizontal and diagonal lines (suggested in part, at least, by the subject), from which semitransparent, interacting planes and facets are hung. Out of this complex of compositional elements the subject emerges slowly only to be lost again in the overall spatial activation of the surface, so that a sort of dialogue is established between the objects depicted and the spatial continuum in which they are embedded. It was perhaps of these works that Braque was speaking when he said, 'I was unable to introduce the object until after I had first created the pictorial space.'6

Picasso's art was moving in much the same direction as Braque's, but it is characteristic that his excitement with the possibilities of a new technical idiom impelled him to push it to its most extreme conclusions; and in the summer of 1910 he produced some works which come very close to total abstraction. This series of paintings conveys a great sense of urgency, but if, as Kahnweiler tells us,⁷ Picasso was dissatisfied with them it must surely have been because he felt that formal experimentation was leading him away from the particular pictorial reality that he was trying to evoke. 'Our subjects', he said slightly later, 'must be a source of interest'⁸ – and the images in this particular series can, it is true, be 'read' only with difficulty; some of the subject matter cannot be reconstructed

without the help of earlier, more realistically legible drawings and sketches. Picasso soon realized that the value of the new techniques lay in the fact that they allowed him greater freedom in conveying the principles evolved over the preceding years; different viewpoints and aspects of an object could be superimposed over each other in a free, more calligraphic fashion and subsequently fused into a single, 'simultaneous' image.

The art of both Picasso and Braque during the classical phase of Cubism derives its character from the very careful balance between representation and abstraction which they sought to maintain. Both artists were distressed when critics and spectators tended to ignore or overlook the representational aspect of their work. Certainly it is true that not only their statements at the time, but all their subsequent work, which used the discoveries of Cubism to produce a new, often highly anti-naturalistic, but always obviously figurative style, confirmed the realistic intentions of the movement. These intentions were furthermore underlined by the iconography of Cubism, which was established from the first and which was enriched but never fundamentally altered as the movement matured. From the start the painters had rejected all literary and anecdotal content, and they avoided all forms of symbolism. They turned to the subjects nearest to hand, to objects which were part of the mechanics and experience of their daily lives, to objects which were, to use a phrase of Apollinaire's, 'impregnated with humanity';9 they recorded with affectionate objectivity the life of the studio and the artists' café. But it is also true that their concern with the purely pictorial problems involved in the evolution of a new approach to space and form, had brought their work to the threshold from which many of their contemporaries were to cross over into pure abstraction

And as the means of Cubism seemed to be becoming progressively more abstract, the painters began making use of a series of intellectual and pictorial devices which not only added a new richness to the surface quality of their paintings, but which also served to reaffirm the realism of their vision. Thus in all but the most truly hermetic of Picasso's canvases we become aware of the presence of a system of keys or clues which enable us to reconstruct the subject:

a lock of hair, a row of buttons and a watch-chain, and we become aware of the presence of a seated figure; a sounding hole and the strings of a guitar enable us to detach the presence (if not the total image) of a musical instrument from the compositional fabric into which it is woven. The stencilled letters which appear for the first time in Braque's work of 1911, and which were subsequently to become such an important and distinctive feature in cubist painting, perform much the same function. Thus the name of a musician or the title of a song is used only in conjunction with musical subject matter: the word 'BAR' can conjure up the atmospheric setting for an arrangement of a bottle, a glass and a playing card.

In the sense that these pictorial clues and stencilled letters act as touchstones for reality they are a prelude to the more important technical innovations made by Picasso and Braque in 1912, when they began incorporating strips of paper and other fragments of matter into their paintings and drawings. In a more obvious way than even the letters, these bits of newspaper, cigarette packages, wallpaper and cloth are related to our daily life; we identify them without effort, and because they form part of our experience of the material world around us, they make a bridge between our customary modes of perception and the artistic fact as it is presented to us by the artist. In Braque's own words he introduced foreign substances into his paintings because of their 'materiality'; 10 and by this he was referring not only to their physical, tactile values, but also to the sense of material certainty they evoked. Indeed, Aragon remembers hearing Braque talk of the fragments of paper that were soon to be assimilated into his drawings as his 'certitudes'.11

It is indicative of the differences in temperament and talent between the two painters that Picasso should have been the discoverer of collage, which can be described as the incorporation of any extraneous matter on to the picture surface, while Braque was the inventor of papier collé, a particularized form of collage, in which strips or fragments of paper are applied to the surface of a painting or drawing. The intellectual and aesthetic implications of collage are wider and potentially more disturbing; there is, for example, a greater element of shock in identifying a piece of chair caning embedded in the painted surface of a canvas than there is in

the realization that the wooden panelling behind a still-life is not a painted background but a piece of cut out and pasted paper. And from the first Picasso's use of the new techniques and materials was to be more fanciful and daring than that of Braque and Gris; for whereas in their work the fragments of collage are used logically and for the most part naturalistically, Picasso delights in using them paradoxically, turning one substance into another and extracting unexpected meanings out of forms by combining them in new ways. In a work by Braque or Gris, paper printed to simulate wood-graining will tend to be incorporated into the depiction of, for instance, a table or a guitar, objects themselves fashioned from wood. Picasso, on the other hand, turns a piece of flowered wallpaper into a table cloth, a piece of newspaper into a violin.

Picasso's collages and the heavily textured canvases of 1913-14 are perhaps the best and most obvious illustrations of the Cubists' obsession with the 'tableau-objet', that is to say with the concept of the painting as a built up, constructed object or entity with a separate life of its own, not echoing or imitating the external world, but re-creating it in an independent way. In conversation with Françoise Gilot, Picasso once said,

the purpose of the papier collé was to give the idea that different textures can enter into a composition to become the reality in the painting that competes with the reality in nature. We tried to get rid of 'trompe l'œil' to find a 'trompe l'esprit' . . . If a piece of newspaper can become a bottle, that gives us something to think about in connection with both newspapers and bottles, too. This displaced object has entered a universe for which it was not made and where it retains, in a measure, its strangeness. And this strangeness was what we wanted to make people think about because we were quite aware that our world was becoming very strange and not exactly reassuring.12

The sombre, disturbing side of Picasso's talent, which is underlined by the last sentence of his statement, had during the past years been very little in evidence. The intensity of the discipline involved in the creation of a new formal idiom had involved the suppression of certain aspects of his artistic personality. Now his mordant wit and his capacity for iconoclasm were to give some of his work (particularly the figure pieces) a new and slightly different emphasis. It might even be true to say that while he continued to work in a purely cubist idiom, his work is occasionally informed by an aesthetic that was foreign to a movement which had hitherto been experimental but also classical in its concern to achieve a sense of balance and harmony. The static, pyramidal figure compositions of the previous years, for example, bear analogy with those of Corot, who had in turn gone back to Raphael for inspiration. This new undercurrent in Picasso's art was what was to endear him in future years to the Surrealists. It is not surprising that in the twenties André Breton, the movement's spokesman, was to welcome Picasso unreservedly into the surrealist fold, while expressing grave reservations about what he felt to be the limitations of Braque's talent.

Braque's use of papier collé naturally reflects many of the same concerns as Picasso's, although the element of pictorial alchemy, so characteristic of Picasso's work, is less marked. His was a profoundly philosophical temperament that was in later life to bring his thought and art into a realm of abstract speculation that at times bordered on mysticism. But his Cubism remained untroubled by the new intellectual currents which were beginning to affect Picasso, and as one might expect from an artist so restrained and singleminded in approach, the new pictorial devices went hand in hand with an extension of his spatial preoccupations. Of the stencilled letters he said, 'they enabled me to distinguish between objects which are situated in space and objects which are not'. 14 In other words, by writing across the picture surface Braque is emphasizing its flatness and telling us that any space existing behind the letters is not an illusionistic space, but a painter's space designed to make tangible the spatial voids in the material world around us. The papiers collés were spelled out by experiments in paper sculpture, which were undertaken in order to find a way of achieving a sensation of relief without recourse to traditional forms of pictorial illusionism; thus a piece of paper cut out in the form of a guitar, pinned at its base to a piece of wallpaper and bent outwards, will stand forth from it and obviate the use of a painted shadow. In practice this sort of relationship became increasingly rich and complex and at times deliberately ambiguous. Sometimes cubist paintings are illusionistically painted to imitate papiers collés; having dispensed with the need for illusionism by incorporating fragments of external reality into their paintings the Cubists then gave themselves the intellectual pleasure of replacing these fragments by $trompe\ l'$ wil effects. Or in other words, they sometimes painted paintings of paintings that dispensed with traditional techniques and procedures. But the original idea behind the $papiers\ coll\'es$ and the paper constructions was a simple one, and the logical result of the painters' initial dismissal of illusionistic perspective.

Papier collé provided, too, the solution to a problem that had been bothering the Cubists for some time; that of re-introducing colour into cubist painting. To the extent that the painters were intent on depicting their subjects in a detached, unemotional fashion, their intentions were realistic: but the means they had evolved were strongly anti-naturalistic. Clearly colour, too, must be used in a way that struck the desired balance between pictorial abstraction and representation; a close examination of many of the canvases of Picasso's classical phase show that he tried to reintroduce colour in a quasi-naturalistic way (cracks in the surface paint show, for instance, that some of the figures of 1912 were originally painted in heightened, fleshy pinks) only to paint it over again in the characteristic cubist monochrome. A simple example will suffice to show how papier collé, and the flat painted shapes derived from it, released colour from the conventions of naturalism, while allowing it to play a cardinal role in the representational properties of the pictorial complex. By drawing a bottle over a piece of green paper, the paper becomes related to it: it informs us of the bottle's colour and it gives the bottle a sensation of weight and bulk - by analogy it becomes the bottle. But because its contours do not correspond exactly to those of the object drawn over it, it remains simultaneously a flat, abstract area of colour, unmodified by the form of the bottle and acting independently in the compositional and colouristic harmonies of the painting. If we mentally slip the piece of green paper to one side, the bottle continues to exist, but in a weakened, less informative way (we no longer know its colour), while the piece of paper becomes, once again, just an abstract pictorial element. 'Form and colour do not just merge into each other', Braque once said, 'it is a question of their simultaneous interaction.'15

Most important of all, while Picasso and Braque were manipulating the strips of coloured paper and other collage elements, they conceived of a totally new procedure. The canvas, they now realized, could be built up by assembling a series of these abstract shapes, or in terms of a few bold overlapping compositional areas suggested by them. These forms could be marshalled together to suggest a subject (and the subject could then be further particularized by the incorporation of the earlier keys or clues), or else the subjects could be superimposed on to the abstract pictorial substructure. In the paintings of the classical cubist phase the compositional break-down of the surface was conditioned by the nature of the subject; the picture surface was then elaborated in a more abstract fashion and the subject was once again drawn up out of the formal and spatial complex by the means already described. Now the process was simpler and bolder and the results more immediately legible. A piece of brown paper or a large, flat area of brown paint can become a guitar if one of its contours is suitably shaped, or if a guitar is drawn over it; a white compositional plane is transformed into a sheet of music when the appropriate signs are drawn over it, and so on. In the early stages of Cubism the painters had begun with a more or less naturalistic image which was then fragmented and analysed (and thus to a certain extent abstracted) in the light of the new cubist concepts of space and form. Now the process was reversed: beginning with abstraction the artists worked up towards representation. The transformation from an 'analytical' to a 'synthetic' procedure had been achieved.

In many ways collage was the logical outcome of cubist aesthetic and after its discovery the working methods of its two creators began to differ perceptibly, although their friendship remained as close as ever. And Picasso's Synthetic Cubism was of a slightly different order from that of Braque. Braque tended to work up slowly from abstraction towards representation, finding his subject in an abstract pictorial substructure of interlocking spatial planes, or marrying a subject to it. The canvases of this period are thinly painted and in many of them it is possible to see pin marks in the corners of the main compositional elements, an indication that the composition was first established in terms of overlapping strips of

paper which were then pinned to the canvas, drawn around in pencil, and subsequently removed and rendered in paint; afterwards these shapes suggested a subject to Braque or else he superimposed his images over them. Picasso on the other hand, tends to assemble abstract forms to create an image; his method is more direct and in a sense more physical and immediate. This was for Picasso a period of renewed interest in African art, and an analysis of the principles underlying the ceremonial masks of certain tribes along the Ivory Coast serves equally to describe his new creative process. Thus for the Negro, two circular shells or cylindrical pegs can come to represent eyes, a vertical slab of wood can become a nose, a horizontal one a mouth, and so on, while the rectangle of wood to which these elements are fixed becomes the underlying structure of the human head. Or in other words, abstract, non-representational shapes or forms can be made to assume a representational role by their symbolic arrangement or their suggestive placement in relationship to each other. In the same way Picasso groups and manipulates a few flat forms, variegated in colour and shape, to suggest or become the figure of a man, a head or a guitar. The recurrent shapes in his paintings and constructions are now often made to serve more than one purpose - for example a double curve can be made to evoke the side of a guitar or to suggest the side and back of a human head swung around on to the picture plane. In Braque's work abstract substructure and superimposed subject are fused together and act reciprocally, but it is possible to conceive of each existing independently from the other, albeit in a debilitated form. In Picasso's Synthetic Cubism, abstract elements are welded together to form a representational whole from which they become indissoluble.

Even more obviously than the paintings, Picasso's surviving constructions in wood, paper and tin, are based on the same principles of 'assemblage', on the technique of bringing together and manipulating very disparate elements, some of them with a strong 'readymade' character. These constructions of the immediately pre-war period remain in many ways the most inventive and stimulating of all cubist sculptures, and they were the works which laid the cornerstone for a cubist school of sculpture, of which Laurens and Lipchitz

were to be the major exponents. But it was the features which Picasso's Synthetic Cubism had in common with that of Braque, rather than those which set it apart, that conditioned the development of cubist sculpture. If we were to transpose mentally the flat, slab-like shapes of their synthetic cubist canvases into three dimensions, angling them out from and through each other, the resulting images would come very close to the first, wartime experiments of their slightly younger sculptor colleagues. Another important and influential aspect of cubist sculpture, the replacement of the solid by the void and of the void by the solid, can be found not only in Picasso's constructions, but in the contemporary paintings of both men. Thus Braque cuts the shape of a pipe out of a piece of newspaper, throws away the pipe shape and incorporates the newspaper into a still-life in such a way that we become aware of the pipe by its absence. In a construction by Picasso the hole in the sounding board of a guitar can be a positive, cylindrical or conical shape that projects towards us, rather than an empty, negative space. Similarly in the nudes of Lipchitz, Laurens and Archipenko (a more peripheral figure), one breast will be represented by a protruding, convex shape, while the second will be a concave form hollowed out of the torso, or quite simply a hole cut through it. Despite its wide influence, however, cubist sculpture never rivalled cubist painting in importance.

So far little mention has been made of Juan Gris, the third great creator of Cubism, and a consideration of his work has been deliberately reserved until now, because his very independent and unremittingly intellectual approach serves in many ways to underline and elucidate the achievements of the movement, and because it is in his art that the principles of Synthetic Cubism reach their purest and most logical conclusions. If Picasso was the revolutionary, whose Michelangelesque talent had overturned traditional values, and if Braque was the movement's craftsman and poet, Gris was its spokesman and the embodiment of its spirit until his death.

Gris, who was in any case slightly younger than Picasso and Braque, did not begin painting seriously until relatively late, and it is only in 1912 that he emerges as a mature and fully cubist artist, with his highly personal variant of the more linear, more abstract kind of painting evolved by Picasso and Braque during the preceding two years. But whereas in their work this new technique had led to a more fluid, suggestive sort of painting in which forms and the space around them interpenetrate and lock, Gris's art crystallizes at once into something much more expository and programmatic. Each object in his still-lives is bisected along its vertical and horizontal axes, and each of the resulting segments is examined from a different angle of vision. The object is subsequently re-assembled to produce an image that is more systematically analytical and more literal than anything in the work of Picasso or Braque. Gris never discarded colour to the same extent as they did, and his use of it is once again more naturalistic and descriptive. There is no single light source in his paintings, but within individual areas light, too, is used naturalistically to produce a sensation of modelling.

In the years immediately after the war, when Cubism was beginning to gain acceptance among a wider number of people, a certain amount was written about a legendary figure called Maurice Princet, who was an amateur mathematician, versed in recent theories about the fourth dimension. It is uncertain whether Gris knew him, but his speculations (induced one suspects by looking at the paintings of Picasso and Braque) are worth quoting, for they give us some idea of the terms in which Gris might well have discussed his early cubist works. Princet is regarded as having posed this question to his painter friends:

You can easily represent a table by a trapezoidal form, to produce a sensation of perspective and create an image to correspond to the table you see. But what would happen if you decided to paint the table as an idea ('le table type')? You would have to lift it up on to the picture plane, and the trapezoidal form would become a perfect rectangle. If this table is covered by objects also perspectively distorted the same corrective procedure would have to be applied to each of them. In this way the oval opening of a glass would become a perfect circle. But this is not all: seen from another intellectual angle the table becomes a horizontal band a few inches thick and the glass a silhouette with perfectly horizontal base and rim. And so on ... 16

If this argument describes to a certain extent Gris's early procedure, it is proof of his stature as an artist that his deep seriousness and his concern for purely pictorial effects rescue these early paintings from becoming merely academic and documentary exercises.

At the time when Picasso and Braque had evolved a purely synthetic idiom, Gris, by his own definition of the terms, was still working in an analytic way. That is to say, he was still beginning with a preconceived idea of his subject and with a naturalistic image, which he consciously analyses and abstracts according to the principles of 'simultaneous vision'. Later, Gris was to turn against his early work, and indeed against his whole pre-war produce. The objects in his paintings were, he felt, too naturalistic, too close to prototypes in the material world. And it is true that by comparison with objects in even the earliest cubist paintings of Picasso and Braque, Gris's subjects seem much more literal and particularized – one has the sensation, often, that they were derived from identifiable models.

The seeds for Gris's later, synthetic manner lay in his so-called 'mathematical' drawings, the preparatory studies for paintings executed from 1913 onwards; these were the drawings which Gris, towards the end of his life, asked his wife and his dealer to destroy, presumably because he felt that they made his creative process seem too cold and schematic. The examples that have survived are in fact of considerable beauty, and they have baffled scholars precisely because despite the fact that they have clearly been executed with the aid of geometric instruments (rulers, set squares and calipers) they appear to conform to no consistent mathematical or perspectival systems. The drawings are nevertheless significant in that they indicate a desire to systematize cubist procedure, and because working with simple geometric relationships Gris became aware of the possibility of achieving a harmonious composition in purely abstract terms.

This feeling must inevitably have been reinforced by the large series of *papiers collés*, which account for most of his output during 1914, and which are the most elaborate and complex examples of the technique to be executed in a cubist idiom. Gris, like Braque, said he was drawn to collage because of the feeling of certainty it gave

him. By this he meant, one suspects, that the fragments of collage gave him the sensation of retaining contact with the material world around him, and also that the very carefully 'tailored' pieces of paper he was incorporating into his paintings gave them a sense of greater precision and authority. Because his work had never reached the same degree of abstraction as that of Picasso and Braque his need to verify his vision by the insertion into his art of elements of concrete reality was less strong. And the importance of papier collé for him lay ultimately in the fact that the abstract properties of the medium reinforced his desire for an art of greater formal perfectability.

In the years between 1921 and his death in 1927 Gris formulated his ideas in a series of essays of great clarity and depth, by far the most important of the written attempts to explain the preoccupations of Cubism in the later stages of the movement. Painting, for Gris, was now made up of two interacting but completely separate elements. In the first place there was the 'architecture', by which he meant the abstract composition or substructure of a painting, conceived of in terms of flat coloured shapes (the shapes originally suggested to him by his geometric experiments and by the angular strips of papier collé). This 'flat coloured architecture' was the means. The end, on the other hand, was the representational aspect of the canvas or its subject; this was sometimes suggested by the flat coloured architecture itself, but on other occasions could be imposed on to it. There is little doubt as to which of the two aspects of painting Gris gave primacy, both in the technical sequence of constructing the painting and for its own sake: 'It is not picture X which manages to correspond with my subject', he writes, 'but subject X which manages to correspond with my picture. '17 The subject, however, was important and indeed vital, because he felt that as the abstract shapes became objects they became in some way particularized and hence more powerful, and because the subject gave the painting an added dimension; abstract painting he compared to a cloth with threads running only in one direction.

This procedure of working from abstraction to representation Gris defined first of all as 'deductive' and subsequently as 'synthetic'. The difference between a synthetic as opposed to an analytic approach he elucidated in his famous comparison between Cézanne's methods and his own.

Cézanne turns a bottle into a cylinder . . . I make a bottle, a particular bottle out of a cylinder. Cézanne works towards architecture, I work away from it. That is why I compose with abstractions and make my adjustments when these abstract coloured forms have assumed the form of objects. For example I make a composition with a white and a black, and make adjustments when the white has become a paper and the black a shadow.¹⁸

He then qualified this statement in a very revealing aside: 'What I mean is that I adjust the white so that it becomes a paper and the black so that it becomes a shadow.' In other words, the subject modifies the abstract, more coldly calculated substructure.

If Gris's drawings cannot be analysed in strictly mathematical or geometrical terms, the technical procedure behind the paintings is even more mysterious. For all his desire for certainty his method remained empirical; he was an artist before he was a theoretician, and the countless small adjustments that are visible in almost all his paintings testify to the fact that he was unwilling to accept any readymade solutions to compositional problems. But while the Cubism of Picasso and Braque, despite its high intellectual content and its later sophistication, remained true to the early twentieth-century doctrines of instinct and intuition, tempered by a Mediterranean sense of discipline, Gris's intellectual approach to formal problems relates his synthetic Cubism to the work of artists like Mondrian, Malevich and Lissitzky, with their Platonic belief in the perfectability of form.

Like a lot of artists, Gris was always convinced that only his latest work was really valid, and as the term 'synthetic' came to acquire for him a talisman-like quality, he tended to apply it only to his most recent production. But the evolution towards his synthetic manner can be traced in his art from 1913 onwards. First there was the awareness of the possibility of achieving a composition in abstract terms. Next, in his work of 1915, the objects in his paintings become rendered in a freer, less literal way; they are now products of his mind and not depictions of particular objects. Finally, by 1916 the subjects become inextricably bound up with the architectural

breakdown of the canvas, and the desired balance between abstraction and representation has been struck. Even before the war it had been Gris who had explained Cubism to the minor figures of the movement – Metzinger, Gleizes and Herbin had all felt his influence. Now Laurens and above all Lipchitz who were transforming Cubism into a sculptural style turned to his work for guidance. In 1915 his art had left a deep imprint on Matisse, and after the war the young Purists acknowledged their debt to him. Even Picasso and Braque paid tribute to him in some of their post-war canvases. It is perhaps no exaggeration to say that for a brief while he was one of the most important single influences in European art.

If the uncompromising and indeed occasionally somewhat didactic nature of Gris's art made him the ideal figure for transmitting the principles of Cubism to many of the minor figures involved in the movement, the purity of his approach also serves, by comparison, to show how other major and influential artists who were originally classified as cubist, had in fact simply adopted or adapted certain aspects of the style to their own individual ends. As a movement Cubism burst on the public at the Salon des Indépendants of 1911. However, since neither Picasso nor Braque nor Gris showed in the celebrated and controversial salle 41, the picture of Cubism initially received by the public was highly misleading, although in succeeding years as their discoveries began to be appreciated by an even wider circle of painters and critics these came to be seen as the distinguishing characteristics of the style. Of the painters exhibiting in the original salle Cubiste Delaunay and Léger were undoubtedly the most important, and of the two Léger was, in turn, perhaps the stronger artistic personality. On the other hand, perhaps for the very reason that his temperament was quicker but slightly more superficial, Delaunay represented the most revolutionary and up-todate tendencies of the cubist faction at the Salon des Indépendants in so far as his exhibit (one of the Eiffel Tower series) was the only one which showed a total and conscious rejection of traditional, single viewpoint perspective, with certain resultant innovations in the treatment of form and space. During the following years, as he became more familiar with the work of Picasso and Braque his painting became, superficially at least, increasingly cubist in appearance. His series of Fenêtres, begun in 1912, the most beautiful and characteristic of all his works, might with some justification be seen as brilliantly tinted variants of classical Cubism. But his iconography had never been truly cubist, and in the Fenêtres the subject, as such, had virtually ceased to exist or to matter - or to put it in other words, the luminosity and the spatial relationships evoked by the interaction of pure prismatic colour areas had become the subject matter of his art. Ultimately his debt to Cubism lay primarily in the fact that the compositional procedures of Analytic Cubism suggested a new way of organizing or breaking down the picture surface. And before the outbreak of war in 1914 this aspect of Cubism had influenced directly or indirectly almost every significant young artist working in Europe, from Mondrian and Malevich to artists as temperamentally opposed to them as Chagall, Gontcharova and Larionov, and from the Italian Futurists to such Blaue Reiter figures as Klee, Marc and Macke.

Léger's relationship to Cubism was deeper and stronger than that of Delaunay, although once again very few of his works could be called truly cubist. He was deeply influenced by Picasso's Analytical Cubism, but his approach to his subjects remained much more matter of fact, much less inquiring: in his canvases figures and objects are often simplified and disjointed, but the resultant dislocation of form is not so much the result of an attempt to analyse their structure as a desire to imbue them with a sense of greater vigour and movement. In the same way he accepted the classical cubist methods of composition which resulted from the dismissal of traditional systems of perspective as a means of animating the surface of his paintings, while retaining, in most of his works, strong perspectival elements. His concern with purely formal values coupled with his passion for contemporary life and for everything dynamic and vital, made his work the ideal bridge between the art of the Cubists and that of the Futurists with its insistence on speed and the machine - with the 'dynamic sensation itself'. 19

Of all the movements which drew inspiration from Cubism, Futurism was the only one which was in turn to make an impact back upon it. The influence of the Italian movement could already

be seen at the Section d'Or exhibition of 1912, the most concentrated and important of the early cubist demonstrations. The exhibits of the two Duchamp brothers, Jacques Villon and Marcel Duchamp, who had recently entered the cubist orbit, in particular showed strong analogies with certain aspects of Futurism. Villon was to revert subsequently to a more purely cubist idiom, but Marcel Duchamp whose work at this time could already be described as proto-Dada in spirit, soon rejected both Cubism and Futurism in favour of the creation of his own personal mythology with its strong intellectual bias. On the other hand it could be argued that it was in Léger's immediately post-war paintings in which the principles of both Cubism and Futurism had been assimilated and married to a more rational, Nordic approach to urban and machine aesthetic, that what was most positive in Futurism, from a visual point of view, reached its fullest expression. But it is proof of Léger's genuine and continuing understanding of Cubism that the principles of composition and the use of colour in these works should now be derived from synthetic rather than from analytic procedures. Very few of the other figures originally associated with Cubism worked through to anything approaching a truly synthetic idiom, perhaps because they had never fully submitted to the intense discipline of the earlier phases, and were hence unable to cope with the greater freedom of expression implicit in the latter. In its own way Synthetic Cubism was to be as important for the development of post-war painting as Analytic Cubism had been for pre-war painting: but its influence was more diffuse, less purely visual and hence harder to pin down. Yet the flat, brightly coloured, self-contained shapes that characterize so much of the painting executed in Europe immediately following 1918 relate more than superficially to those already found in immediately pre-war Cubism.

Gris's work evolved slowly and steadily through the war years. Picasso's development, on the other hand, became increasingly restless and many-sided. He now found himself isolated from his friends both physically and by the fact that he had become fully established, both financially and artistically. The days of communal bohemian existence which had left their stamp on early cubist painting and

aesthetics, were over, for him, for ever. During 1914 there was a steady flow of gay, highly coloured paintings, so strikingly decorative that one critic was prompted to use the term 'rococo' to describe them, but in the following years he reverted to a simpler, more monumental style. This was the period in which the visual as opposed to the intellectual implications of papier collé were most fully digested; canvases are now built up of a few bold, overlapping and interlocking flat, coloured forms to produce an effect of almost architectural economy - the colours tend to be sombre and elegant. Subsequently, after his association with the Diaghilev Ballet, which began in 1917, there was a renewed interest in the decorative possibilities of Cubism, and the two streams in his art, the architectural and the decorative, fuse in the early twenties to produce such masterpieces as the two versions of the Three Musicians now in the Museum of Modern Art in New York and in the Philadelphia Museum of Art. Generally speaking, however, after the war Picasso's most important achievements in figure painting were realized in his new, neoclassical style, while Cubism tends to be reserved for his essays in still-life: these reach a climax in the monumental series of still-lives before open windows executed in 1924.

Braque, who had served at the front and been wounded, hesitated briefly before recovering his sense of direction, but the post-war Guéridons, a series of large, upright paintings of still-lives seen on full length tables, are in many ways the culmination of the synthetic phase of his Cubism. And in these paintings and the smaller stilllives which surround them, Braque for the first time gives full play to a sensuous aspect of his talent which had been at least partially suppressed since his early experiments in Fauvism. The construction is still synthetic cubist, but its complexity is disguised and softened by the flowing curvilinear outlines which are so unobtrusively and discreetly played off against the angularity of the structure underlying them. In the same way the browns and greys which dominate in so much pre-war Cubism are enriched and enlivened by variations of fawns, siennas, ochres and soft, velvety greens. The severity, the intellectual content and the discipline so obvious in Braque's pre-war Cubism invite an analysis of his artistic means and intentions; the effect of these paintings, on the other hand is so immediate that we no longer study the stages by which the ends are achieved.

The year 1925 is the one that truly marks the end of the cubist epoch. Gris, it is true, remained a Cubist until his death, but his health was failing and his output was diminishing. During the twenties Braque's work was becoming too personal to be fitted into any rigid stylistic category. And in 1925 Picasso painted his Three Dancers (now in the Tate Gallery), which in its violence, and the sensation of obsessive neuroticism that it produces, carries Picasso through into Surrealism and points ahead to some of the great experimental American painting of the 1940s. Around 1920 the Demoiselles was sold, and in 1925 it was photographed for publication in a surrealist periodical. During the preceding years Picasso, in his large and very beautiful neo-classical Maternities, had come as close to bourgeois conformity as was possible for an artist of his temperament, and it is tempting to think that when he looked again at the Demoiselles and produced this new landmark in his art, he was reassessing the cubist achievement and gathering up his resources for fresh endeavours.

Cubism was an art of experiment that had stood still for only one brief moment, in 1911. It had fearlessly confronted and produced a new kind of reality. It had evolved a completely original, antinaturalistic kind of figuration, which had at the same time stripped bare the mechanics of pictorial creation, and had in the process gone a long way towards destroying artificial barriers between abstraction and representation. It remains the pivotal movement in the art of the first half of this century.

1967

Notes

- 1. La Jeune Peinture Française, Paris, 1912, p. 42.
- 2. In a private conversation, reported to the author.
- 3. Julio Gonzalez, Picasso sculpteur, Cahiers d'Art, Paris, 1936, p. 189.
- 4. Dora Vallier, Braque la Peinture et Nous, Cahiers d'Art, Paris, 1954, p. 16.
 - 5. ibid., p. 16.
 - 6. ibid., p. 16.

- 7. Der Weg zum Kubismus, Munich, 1920, p. 27.
- 8. Statement to Marius de Zayas, published in *The Arts*, New York, 1923, under the title *Picasso Speaks*.
 - 9. Guillaume Apollinaire, Les Peintres Cubistes, Paris, 1913, p. 36.
 - 10. Vallier, op. cit., p. 17.
- 11. Aragon, La Peinture au défi. Preface to the catalogue of an exhibition of collages at the Galerie Goemans, Paris, March 1930.
- 12. Françoise Gilot and Carlton Lake, *Life with Picasso*, London, 1965, p. 70.
- 13. The massive exhibition of Corot's figure pieces mounted at the Salon d'Automne of 1909 may, indeed, have influenced the Cubists both formally and iconographically; for example, the motif of the female figure holding or playing a musical instrument is a recurrent one in Corot's work.
 - 14. Vallier, op. cit., p. 16.
- 15. In an interview by Alexander Watt, *The Studio*, November 1961, p. 169.
- 16. Quoted by René Huyghe in La Naissance du Cubisme, Histoire de l'Art Contemporain, Paris, 1935, p. 80.
- 17. Juan Gris, Notes on my Painting, first published in de Querschnitt nos 1 and 2, Frankfurt, 1925, pp. 77–8. Reprinted in D. H. Kanhenweiler, Juan Gris, London, 1947, pp. 138–9.
 - 18. Notes in *L'Esprit nouveau*, no. 5, Par is, 1921, p. 534.
- 19. The phrase occurs in the Technical Manifesto of Futurist Painting (Futurist Painting: Technical Manifesto), April 11, 1910.

PURISM

Christopher Green

Purism came after Cubism and was launched with a book published in 1918, Après le Cubisme. Cubism, declared its authors Amédée Ozenfant and Charles-Edouard Jeanneret (Le Corbusier), had ended by not recognizing its own significance or the significance of the postwar epoch: it was 'the troubled art of a troubled time': Purism claimed it would take Cubism to its proper conclusions, those of a cooperative and constructive epoch of order. It was a very ambitious movement, which had a brief life (seven years) and only through the architecture of Le Corbusier did it gain a large international reputation. Purist paintings were shown, within its lifetime, as far away from Paris as Prague, but the great post-war impact in painting and sculpture came from De Stijl, Constructivism and Surrealism. The high years of the movement were the years of Theo van Doesburg's first Parisian sermons on De Stijl, and of André Breton and Tristan Tzara (1920-25). It was, at the same time, against such competition that Purism was able to offer a genuine and independent alternative both to the post-war Cubists of the Paris School and to De Stiil.

Clarity and objectivity were central to the Purist theme, art moved 'vers le cristal'. Yet Ozenfant and Jeanneret gave their declarations the repetitive insistence of prophets offering revelation: Après le Cubisme was a passionate declaration of belief, and most of the editorial opinion of their magazine L'Esprit nouveau (1920–25) was put across with manifesto force. Their final undertaking La Peinture Moderne (1925) sharpens that force. What Cocteau dubbed 'The call to order' was made by Ozenfant and Jeanneret with fervour, a feeling of revolutionary purpose, and a full appreciation of cultural guerrilla tactics.

Yet, the dynamism of purist publications freezes when one confronts the ideas they represent, and the calm exactitude of Purist works [illustrations 28 and 29]. The movement seems calculated to create opposition. So many of those modern aesthetic ideals least loved by popular opinion are there: the beauty of functional effi-

ciency, the importance of intellect, the unimportance of individuals. the value of precision. They lie behind De Stijl and Constructivism as well as Purism, but combined with them, in L'Esprit nouveau, is a hostility to extremes which is alien to those movements and which antagonizes informed opinion: the elemental abstractions of De Stijl make the bottles and jugs of purist still-lives seem timid: Mondrian is dramatically quiet, the Purists are simply quiet. Though mild to the informed, the movement seems extreme to the uninformed: it is after all Puritan and restrictive in precisely the same way as De Stijl. The dogmatic certainty behind its campaign for order, like that of De Stijl, merely serves to emphasize, by means of the equally dogmatic reactions caused, the existence of more than one directive force in human nature. Those who believe in instinct see in a passionate declaration of the power of reason only a negation of instinct, while those who believe in reason see in a passionate declaration of the power of instinct only a negation of reason. It is difficult to gain widespread sympathy for Purism because it is so easy to see it for what it is not: a Le Corbusier villa too easily arouses the Borromini in us, an Ozenfant still-life, the Rubens in us. Only when we have accepted what Purism is not, with understanding rather than regret, can we begin to see and enjoy what it is.

It was Puritan, but Ozenfant and Jeanneret were not kill-joys: they distinguished between joy and pleasure and they preached the end of pleasure in art, the supremacy of joy: pleasure, they believed, is unbalanced, joy is balanced, pleasure pleasing, joy elevating, pleasure satisfies appetites, joy satisfies the need for order in life, pleasure satisfies passing whim, joy satisfies something constant in us. Their aim was to give art an unchanging foundation, and in this sense they were classical. There is in art, Purism tells us, an essential factor to which we all aspire. That factor is Number: the way in which we are shown the order of numerical division in the structure of our thoughts, our work and the works of nature - proportion. The past and the present is conceived of as a pyramid: at the top of the pyramid are found all together Poussin, Ingres, Corot, Pericles, Eiffel, Plato, Pascal, Einstein, etc: the implication is that Poussin, had he lived to see the paintings of L'Esprit nouveau, would have admired them, just as the Purists admired his, that the quality of great art, great living and great thinking does not change, that

the pyramid has the same apex in every era and every sphere. Such hierarchical thinking implies a certainty analogous with that of Renaissance Humanism. For Daniele Barbaro, Aristotelian thinker and contemporary of Palladio, the laws of harmony in proportion represented the true laws of life, therefore science, which explored these laws and the arts which used them, dealt with certainty. Ozenfant and Jeanneret aimed their art at a definite point, but they did not claim that in this was revealed some objectively valid Truth. Ozenfant was adamant: we cannot, he says, be certain that the order revealed to us by reason -i.e. science -existsapart from us, is more than a reflection of the structure of our own minds and senses.³ But we can be certain that this order constantly found in our surroundings and our actions satisfies a genuine human need - the need of our minds to conceive equilibrium and our senses to perceive it. Science and art are proof of the constancy of this need: the Parthenon and Einstein's equations both fulfil the same human function. In this light functionalism becomes a new extension of Renaissance Humanism with the emphasis on proportion, based on a retreat from God into the sphere of Man alone. The proportions which give men beauty in their thinking, in their listening and their seeing are thought of as directly related to the order of their bodies, the structure of their sense organs and of their minds, but they are no longer related to God.

Functionalism in engineering, in industrial design, in architecture and in painting is presented altogether by Ozenfant and Jeanneret in humanist terms, and at its root lies the notion of 'Sélection Mécanique'.⁴ The starting point for this notion is the same as that of the Renaissance, the human body: in itself it is believed to reveal the order men search for. Every organ is the result of constant adaptation to functional needs: 'One is able to ascertain a tendency towards certain identical features, responding to constant functions.' The tendency is towards greater and greater economy of effort as the harmony between form and function is perfected. From the human body Ozenfant and Jeanneret move to those objects which men make solely to answer their functional needs, and find too that certain 'objets types' have been perfected to answer constant needs: glasses, bottles, etc. 'These objects associate themselves with the organism and complete it'; they are in harmony with Man.

Architecture, engineering, industrial design are all concerned with constant human needs - for dwellings, utensils, communications thus, the logical conclusion is that a functional approach to them is humanist: the proportions of a humanist art are the proportions determined by human need. However, by function Ozenfant and Jeanneret mean more than utility, they mean aesthetic function too, because among man's basic needs is for them, as we have seen, the need for art. Jeanneret puts his position like this: an engineer is presented with alternative ideas for a bridge each as efficient as the others and he becomes an artist only when he selects the one most clearly harmonious in its proportions. Art is not useful but it is necessary, that is why paintings are painted and buildings are built as 'architecture' and not simply as 'machines for living in'.

The machine was important to Purism, but in a supporting rather than a leading role: it represented an answer, always new, to a constant human need for order. Art, on the other hand, represented an answer, never new, to the same human need. Each new machine superseded an old one and would be superseded by another: no work of art could be superseded by another. Art, we are told, is based on the unchanging physiological structure of the eye, mind and body in response to form, line and colour.⁵ Science and the machine are based on the changing fabric of knowledge. The machine might create L'Esprit nouveau - a new awareness of precision and complexity within the old theme of order - but it can never be a work of art, being on the technological plane alone, because it can never be of constant value in an advancing technology.

A grammar and syntax of sensation is elaborated by the Purists as the foundation of art. 6 Form, line and colour are seen as the elements of a language which does not change from culture to culture because it is based on invariable optical reactions. The Purists are strict rulemakers: their focus is on constant factors. Therefore colour (seen as a surface factor) is subordinated to form, whose integrity it can so easily destroy, as, for instance, in Impressionism. Form itself is categorized as either primary or secondary, either capable of a constant effect, free of secondary associations, or not: a cube carries the same 'plastic' meaning for everyone, while a freely spiralling line might make one man see a snake and another a whirlpool. Primary forms are established as the basis for composition, disciplined by the invariably stable dominance of the vertical and the horizontal; and composition is defined as secondary elaboration on a primary formal theme.

So full a development of a formal language, and so strong an emphasis on the abstract ideals of harmony and precision, might seem to lead somewhere very different from the bottles and guitars of purist paintings: a strictly architectural painting seems at first the most logical result - an elaborated but muted version of De Stijl. Yet, Purism's insistence on the old subject-matter of Analytic and Synthetic Cubism is no compromise; it, too, is the result of a strict investigation of the means and ends of art. The subject-matter of their still-lives in fact binds the humanism of Ozenfant and Jeanneret into a complete whole, putting their painting into direct contact with the practical world of engineering and 'objets types', constructing a bridge between the practical and the aesthetic spheres. An art which did no more than elaborate on primary formal themes was, for the purists writing in L'Esprit nouveau, merely ornamental; it lacked something which they defined in La Peinture Moderne as 'an intellectual and affective emotion' expected of art.⁷ That emotion was called 'passion' by Jeanneret in the articles on which his internationally influential book Vers une Architecture was based. 'Passion' was the artist's ability to grasp order intuitively in the disorder of his surroundings, to find art in the material world of nature and man-made objects. The scientist could construct beneath the chaotic surface of nature an intricate and balanced system of laws; the artist was so gifted that he could intuitively discover objects in the external world which demonstrated such a system outwardly in their form. The bottles and guitars of Purist paintings are therefore objects in which order has been found. The qualities of that order are clear, for the objects of Purist paintings are of course 'objets types'. They are the qualities of a humanist functionalism: the qualities that follow from absolute efficiency—precision, simplicity and proportional harmony.

From the Purist viewpoint there was about the 'objet type' a banality which placed it above the human figure as the subject of great art: the human figure too easily appealed to particular feelings: the 'objet type', so common that it was hardly noticed, free of all possible literary associations, could never appeal to such feelings – it

is difficult to lust after a bottle. Thus, the 'objet type' joined the generalized, formal emphasis essential in art, to the material world without danger of distraction, and it is in the final analysis the Purist approach to the object that demonstrates conclusively Purism's independence from both De Stijl and Cubism. Ozenfant and Jeanneret dismiss pure abstraction for its lack of 'passion', just as they dismiss the photographic realism of Meissonier for its lack of structure, and they give a new clarity to the cubist method of shifting viewpoint analysis. Like the ideal cubist following the rules of Gleizes and Metzinger's 1912 Du Cubisme, they shift viewpoint in order to move from one 'essential' aspect of an object to another, from, say, the circular base of a glass [illustration 28] to its tapering profile, to its circular top, thus translating it into a simple formal theme. A firm grip is kept on their 'objet type' starting point and in this way the practical order of functional efficiency is joined to aesthetic order: cubist method loses all trace of ambiguity: it becomes the instrument of a philosophy as all-embracing as De Stijl, but independent of it.

Notes

- 1. Après le Cubisme, 1918. Ozenfant and Jeanneret.
- 2. L'Esprit nouveau: founded in 1920 by Ozenfant, Jeanneret and the poet Paul Dermée. In all twenty-eight numbers were produced. Contributors included Maurice Raynal, Waldemar George, Pierre Reverdy, Blaise Cendrars, Fernand Léger, Jean Lurçat, Léonce Rosenberg, Ivan Puni and many others.
- 3. L'Esprit nouveau, 19, 1923. Ozenfant 'Ce Mois Passé', subtitled 'Ce qui vaut d'être fait'. L'Esprit nouveau, 22, 1924. Ozenfant 'Certitude, No 1'. L'Esprit nouveau, 27, 1925. Ozenfant 'Certitude, No 2'.
- 4. L'Esprit nouveau, 4, 1920. Ozenfant and Jeanneret 'Le Purisme', pp. 373–6.
- 5. L'Esprit nouveau, 18, 1923. Ozenfant and Jeanneret 'L'Angle droit'.
- 6. L'Esprit nouveau, 1, 1920. Ozenfant and Jeanneret 'Sur la plastique'. L'Esprit nouveau, 4, 1920. Ozenfant and Jeanneret 'Le Purisme'.
 - 7. L'Esprit nouveau, 4, 1920. Ozenfant and Jeanneret 'Le Purisme'.

ORPHISM Virginia Spate

Orphism can briefly be described as a tendency towards abstract or – as it was called at the time – 'pure' painting which manifested itself in Paris between late 1911 and early 1914. As a movement, it was the creation of the poet, Guillaume Apollinaire, who christened it at the exhibition of the Section d'Or in October 1912. He was attempting to categorize the various tendencies in Cubism (defined very loosely) and used the phrase 'Orphic Cubism' to define a group of painters who were moving away from recognizable subject-matter.

Orphism has never received serious attention largely because Apollinaire's definition was so ambiguous and because the differences between the painters he named – Robert Delaunay, Fernand Léger, Marcel Duchamp, Francis Picabia and, probably, Frank Kupka – are at least as obvious as their similarities.² Only Picabia and Delaunay accepted the designation and Delaunay tried to restrict it to his kind of painting. The painters' negative response led Apollinaire eventually to admit that his classification 'laid no claim to be definitive as to the artists themselves'.³ Nevertheless, Apollinaire did discern the beginnings of something that was real: an art which would dispense with recognizable subject-matter and rely on form and colour to communicate meaning and emotion (just as Orpheus has done through the pure forms of music).

Perhaps a more important reason for the neglect of Orphism has been an over-rigid determinism applied to the history of abstract art in general. It has been based on the assumption of a more or less unbroken, inevitable progression towards abstraction considered almost as the climax of Western art: the Orphists who did not – like Mondrian, the hero of abstraction – pursue a consistent path towards abstraction, or who were 'less abstract' than they apparently claimed, have been implicitly condemned by this standard. However, none of the early abstractionists set out to 'become abstract': they sought to express certain states of consciousness which drew them towards abstraction, but this did not preclude

interest in expressing other things for which a recognizable imagery would be more appropriate. In fact, the term 'pure painting' (which Apollinaire used as a synonym for Orphism) did not necessarily mean completely non-representational painting: it signified painting which had its own internal structure independent of naturalistic structural devices. This description is broad enough to allow the variety of expression found in Orphism which ranged from the powerful physicality of Léger's works (Woman in Blue) to the ambiguous immateriality of Picabia's (Dances at the Spring II) [illustration 35]. As will be shown, this range of expression corresponded to a wide range of meanings.

Despite stylistic differences, by autumn 1912 the paintings of Delaunay, Picabia and Léger had reached equivalent degrees of purity - they still represented recognizable images, but broke them down into dynamic non-naturalistic structures. Kupka had reached this stage earlier. By late 1911 he was the first to achieve a fully nonnaturalistic structure in the Disc of Newton series [illustration 33] and by the late summer of 1912, after months of studies, he completed the huge Amorpha, Fugue in Two Colours [illustration 34], exhibiting it in the Salon d'Automne and probably influencing Apollinaire's perception of the new tendency. Delaunay, Picabia and Léger reached this stage in the spring and summer of 1913 with paintings composed of evenly weighted forms floating freely in indeterminate space and with no 'heavier' tones to settle at the base of the painting and suggest gravity or the presence of a spatial area in which figures or objects can exist. They thus justify Apollinaire's description of them as 'a new world with its own specific laws'.4 However, Léger and Delaunay also painted more figurative works and, by late 1913-early 1914, Picabia was turning to more explicit identification of sexual and machine processes in a way that foreshadows Surrealism (as in I see again in memory my dear Udnie, Museum of Modern Art, New York). Thus even before the outbreak of war, there was a slackening in the French tendency towards abstraction which virtually ceased during the war. If one follows these shifts and changes in terms of a response to specific pressures in a specific society at a specific moment in time, one can better appreciate that it was the artists' struggle to express certain forms

of consciousness rather than any theoretical dedication to abstraction which caused them to develop non-representational form.

Each Orphist responded to a sense that 'modern consciousness' was radically different from that which preceded it – as Delaunay put it: 'Historically, there really was a change of understanding, hence of technique, of modes of seeing'. Each sought alternatives to figurative art because he found that the figurative kept the mind in the conceptual sphere which he wished to transcend. Changes in contemporary life caused the Orphists to conceive the world as composed of dynamic forces rather than of stable objects in static, finite space. They believed that this change was accompanied by a change in consciousness, which they also conceived as dynamic either as expansive and all-embracing or as intensive and selfconcentrating. This change of consciousness was central to their development, for they found that if they depicted the external world - even if they did so dynamically - they lost their sense of the continuity of their own consciousness. They sought more profound contact with this consciousness through the act of creation, developing modes of painting in which they could detach their minds from the external and absorb themselves in the very process of creating form - a process which gave them a sense of their own inner being and of its relationship to the external world.

The Orphists' concern with the workings of consciousness led them away from the painting of the external manifestations of human life: they dispensed with the human figure or broke it down into a dynamism of line and colour; they replaced the specific human emotion with something more tenuous and elusive. This rejection of humanism occurred in other contemporary arts and can be paralleled in contemporary philosophy, for example in Bergson's intensive, almost poetic, attempt to penetrate to the core of non-conceptual consciousness.

These changes had much to do with contemporary scientific developments - for example, the atomic theory of matter and new concepts of time, space and energy finally achieved the long work of displacing the idea of the human being as unique, the centre and climax of creation. The dominant artistic response to these discoveries was to give up human separateness and to seek fusion in the

forces which pervaded all being – a tendency strengthened by contemporary technological change, for example by the dizzy speed of modern transport. More fundamental were changes in contemporary society – the strengthening of mass movements in the rapidly growing industrial cities encouraged the development of literary and artistic attempts to express the consciousness of being submerged in collective experience. It is noteworthy – in the context of the acceleration of industrialization and of the conflicts which were so shortly to lead to mass war – that all these cultural movements tended to the undermining of individual will, the fusion of the self with some larger, more powerful, indeterminate, quasi-mystical force.

This is true of all the Orphists – even though they differed in the *nature* of the force to which they sought to surrender their separate consciousness: Kupka to a mystic life-force; Delaunay and Léger to the dynamism of modern life; Picabia to his internal psychic dynamism.

Kupka provided an essential link between nineteenth-century Symbolism and anti-symbolist abstraction. As was typical of the Symbolists, he had an extraordinarily diverse knowledge - ranging from modern science to Eastern mysticism - which he fused into a synthesis owing much to the synthetic procedures of Theosophy. Like Kandinsky and Mondrian (whose works could also be seen in Paris) Kupka found confirmation of mystic belief in modern science - above all in the discovery that matter is not inert but is pervaded by energies which animate all being. The relation between these three artists is not fortuitous - they were older than Delaunay and Léger and received their training in the 1890s and early 1900s in parts of Europe (Kupka studied in Prague and Vienna) where the discipline of seeing and the discipline of structuring were less deeply rooted than in Paris; where Symbolism was stronger and more genuinely visionary and where the impulse to abstraction was more radical than in Paris. In early works, the three artists tried to express mystic intuition through naturalistic images, then through specific symbols of abstract shape, line or colour as codified in Kandinsky's On the Spiritual in Art and as justified by the Theosophist beliefs which deeply affected them all. However, in each case, the actual process of painting made each artist realize that he could rely on his forms to communicate meaning without having to translate them into the alternative language of verbal symbols (as Kandinsky suggested in his book). Kupka discovered his 'personal form' through his serial exploitation of a limited number of themes. As with all the painters interested in modern life, he was obsessed with the imaging of movement. He explored the movements of objects circling in space and sequential, ground-based movement. In both cases, he found certain forms - the circle and the vertical plane recurring with such insistence that he came to ascribe profound meaning to them.⁶ For example, he believed that the personal meaning he found in circular forms (which appeared spontaneously even in casual scribbles and more or less clearly in his naturalist-Symbolist works) was confirmed by its recurrence not only in other forms of visual art - probably including contemplative images from the East - but also in mystic beliefs and in contemporary science, literature and philosophy. Poets like Apollinaire, Cendrars and Barzun made an analogy between the molecular structure of matter and the solar system - they used the image of the circular dispersion of light as a metaphor for the power of the mind to expand to embrace all being. Similar images were used by Bergson in his attempt to illuminate the processes by which consciousness evolved (specifically in L'Evolution créatrice of 1907). Thus the evolution of form became to Kupka a means of revealing the content of his inner consciousness in forms which aroused associations of universal significance such as the evolution of life - in terms of human sexuality considered as a life-force and in terms of the genesis of matter itself. He believed that all life consisted of a single essence - which split into the specific forms we know - and he sought a means of returning to that original unity. Such associations were fairly explicit in some of the studies for the Amorpha, Fuque in Two Colours, but during the long genesis of the work, Kupka purged all specific references from the huge image so that one may contemplate it as one might contemplate an Eastern meditative device which empties the mind of the specific and makes one aware of the movement of consciousness. In terms of the mysticism which Kupka found meaningful this movement could concentrate in the infinitely small or expand to absorb all being (for example in the Vedanta, which he had read, he could have found the following: 'Concealed in the heart of all being is the Atman, the spirit, the self; smaller than the smallest atom, greater than the vast spaces'7).

As was characteristic of the younger generation of painters, Léger and Delaunay, influenced by the Impressionists' and Cézanne's anti-Symbolist emphasis on sensation, put the Symbolists' literary influences and mystic systems behind them. The same is true of Picabia, but he remained influenced by the Symbolists' emphasis on inner experience. Both Léger and Delaunay had a more straightforward sense of the modern. They shared with the Salon Cubists such as Gleizes and Metzinger, with whom they were close in 1911-12, a sense that the modern world was of such complexity that it could not be embodied in structures which show only finite objects in one moment in time and they tried - in works like Delaunav's City of Paris [illustration 30] and Léger's Wedding (Musée National d'Art Moderne, Paris) painted in late 1911 to early 1912 - to express the mind's simultaneous grasp of an infinite number of objects, thoughts, sensations and states of mind. They used the Cubists' modes of suggesting 'the life of forms in the mind' - to use Metzinger's phrase.8 As a result of painting these works, they recognized that they could not embody the 'new consciousness' simply by jumbling objects and parts of objects together and they immediately began painting simpler subjects like Léger's Woman in Blue and Delaunay's Simultaneous Windows [illustration 31]. These works were still close to Cubism (justifying Apollinaire's description 'Orphic Cubism'). but Delaunay's colour-structure began to eliminate the gravitational, centralized structure and to melt the object-sensations into its ceaseless mobility. In two essays written that summer, Delaunay developed a rationale for 'pure painting':9 recognition of the subject keeps the mind in the world of finite objects, measurable distance and time, and verbal understanding; only a pure pictorial construction which could fully involve the eye and mind in its continuous mobility could give the mind intuition of its simultaneous concentration in itself and expansion to 'embrace the whole world'.

Delaunay interrupted his exploration of this art with his next major Salon painting, The Cardiff Team (Musée de l'Art Moderne de

la Ville de Paris), shown in the Indépendants of 1913 – a compendium of modern images (sport, posters, Eiffel Tower, aeroplane). This was a regular pattern in his work - in the paintings shown to a wider public in the Salons he used recognizable images (see also the Homage to Blériot (Kunstmuseum, Basle) shown in the Indépendants in 1914), while reserving the abstract images, in which he explored wordless states of being, for his friends, a small circle of admirers and for small exhibitions in Berlin for a public which he felt to be more sympathetic than the Parisian. That the demands of the Salon were important is suggested by the fact that Léger began work on his small experimental 'pure paintings', the Contrasts of Forms, after being offered a contract by Kahnweiler, who had been impressed by the Woman in Blue in the Salon d'Automne of 1912. Only Kupka and the heroic and stubborn Picabia (who had private means and was less thin-skinned than the equally lucky Delaunay) showed major non-representational works in pre-war Salons.

Delaunay's Sun, Moon. Simultaneous series [illustration 32] was probably begun in spring 1913.¹⁰ They were his first non-representational paintings, in which he finally broke with Cubism's objectbased structures. As in the case of Kupka, the circular movements which he now made the basic structure of his paintings can be found in his earliest paintings, gradually assuming a dominant role; the internal meaning of this formal configuration attracted other meanings, other associations which were themselves internalized in the act of painting. In these paintings - like Léger in his Contrasts of Forms - Delaunay improvised directly onto the canvas, becoming so involved in the 'demands' made by the material that the structure seemed to be generating itself. In this process, Delaunay attained that state of being which he generalized as characteristic of 'modern consciousness'. Delaunay believed that the circular generation of light was the fundamental principle of all being (in this he was like Kupka, but he found confirmation of his belief in specifically modern terms; for example, he was influenced by the poets' use of the radio at the top of the Eiffel Tower which emitted invisible waves around the world as a metaphor for the infinite expansion of human consciousness). 11 Absorption in the uniquely concentrated world of the painting was a means of attaining consciousness of this

first principle. Characteristically more straightforward, Léger believed that the essence of the modern was found in universal dynamism. This dynamism was manifested in terms of a conflict of forces quite unlike Delaunay's harmonies: Delaunay created densely interwoven, complexly modulated colour structures, while Léger overwhelmed the specificity of objects in clashing contrasts of colour, line and tone. The purely sensational experience which he expressed can also be found in the poetry of his friend, Blaise Cendrars:

> Le paysage ne m'intéresse plus Mais la danse du paysage La danse du paysage Paritatitata Je tout-tourne 12

The circling mobility, the oscillating ambiguities of structure of Picabia's Udnie, American Girl (Dance) [illustration 36] are stylistically related to the structures of Amorpha, Fugue in two Colours, Sun, Moon. Simultaneous and Contrasts of Forms. Picabia's methods of improvising on a linear skeleton are related to those employed by Léger and Delaunay; however, he was interested in using these methods to register invisible emotional or mental states. In the crucial summer-autumn of 1912, he was influenced by Duchamp's evocations of the states of being that were invoked by sexual memories and fantasies (as in the King and Queen surrounded by Swift Nudes and the Passage of the Virgin to the Bride - both in the Philadelphia Museum of Art). Apollinaire suggestively evoked Duchamp's processes when he wrote in Les Peintres cubistes:

All the men, all the beings who have passed by us have left traces in our memory and these traces of life have a reality which one can scrutinize. ... These traces acquire together a personality whose individual character one can indicate by a purely mental operation.

Picabia visited New York in early 1913 and there he was in contact with artists and intellectuals interested in Freud's ideas. It was there that he painted a series of watercolours on the theme of New York and of a sexual encounter with a dancer which, he said, he improvised like a musician, allowing the form to generate itself and thus to register his elusive states of mind. He spoke of 'a state of mind approaching abstraction', indicating the mental processes operating during the processes of creation. When he returned to Paris, he made use of these procedures in his major non-representational works, *Udnie*, *American Girl (Dance)* and *Edtaonisl, Ecclesiastic* (Art Institute of Chicago). The spectator's experience of these works is related to one's experience of the non-representational works of the other Orphists: absorption in the mobile structures would induce 'a state of mind approaching abstraction' in which one could intuit the subconscious – and necessarily non-verbal – experiences which had moved Picabia. However, the sceptical Picabia did not claim such experiences as mystical.

One's experience of these works is quite different from that involved in the recognition of specific forms, however abstracted. For example, if one compares Delaunay's Simultaneous Windows with his Sun, Moon. Simultaneous, one can see that even the vestigial Eiffel Tower demands a kind of attention different from one's constantly shifting awareness of the wholeness of the 1913 painting. The presence of the Tower crystallizes a number of 'clues' which we interpret in terms of gravity and of our location in relation to the object. In the 1913 painting, there is no structural relationship to the external world, so that as a spectator one cannot 'measure' one's distance from what is represented, cannot 'know' its scale. One's involvement in the structure does not make one lose a sense of the 'otherness' of the painting. One is thus forced back to an awareness of one's own consciousness (compare again the Simultaneous Windows, where one loses this sense in speculating on the reality of the object-clues). All the Orphists were aware of the nature of this selfawareness as unspecific and unconnected with specific emotion or concept, and all believed that it was in it that the meaning of their art could be found.

By the time Picabia exhibited his *Udnie* in the Salon d'Automne of 1913, Apollinaire had lost interest in Orphism, though the word had been taken up by other critics and the Delaunays were extending its meaning in their own way. Robert's wife, Sonia Delaunay-Terk, had given up her strong Fauvist painting for the crucial years, 1909–13, and had been making objects like a bed-cover, book-bindings

and cushions. It was probably under her influence that Robert began to assert that he had discovered the essential principles of colour construction which could be applied to all forms of the visual arts from painting to clothes and interior design. Although this idea was probably influential (it was the first of the twentieth-century attempts to deduce a total environmental ideal from a pictorial discovery), it was not central to Orphism, the creation of abstract form for contemplation. Robert Delaunay also surrounded himself with disciples, including his wife – whose earlier pictorial personality had suffered from three years' inactivity - and the Americans Patrick Henry Bruce and Arthur B. Frost. In October 1913, two other Americans, Stanton MacDonald-Wright and Morgan Russell. launched their abstract colour movement which they called 'Synchronism'. In their catalogue they claimed that it was different from Orphism, but it was clearly dependent on Kupka's Discs of Newton series and Robert Delaunay's Sun, Moon. Simultaneous series. However, it was significant in introducing the idea of large-scale abstract colour-painting into the United States. These tendencies were obviously closer to Robert Delaunay's work than to that of the other Orphists and from this (and the Delaunays' determined propagandizing) has resulted the erroneous and persistent belief that Orphism was essentially Robert Delaunay's creation. It is. however, true that Delaunay was more influential than the other Orphists - his ideas on colour influenced Chagall and, in Germany, Klee, Marc and Macke.

Reading the contemporary newspapers which contain reviews of the Orphists' work and the little journals with which they were closely associated, one becomes uneasily aware of the great chasm between their preoccupations and contemporary life. The press was full of the crises which again and again brought Europe to the brink of war, yet the Orphists continued to express their delight in the modern world, without a hint of the irresolvable conflicts which would result in the débâcle (only Picabia expressed pessimism and that was of a purely personal kind). In Paris, the complex society of art was seemingly self-sufficient, and the artists whom I have discussed had inherited the Symbolists' sense that they had insights inaccessible to the society in which they existed. They believed that

naturalistic art - that favoured by the public - was inadequate to deal with the vastness and complexity, the new states of consciousness of the modern world. Like the Symbolists they turned inwards. becoming obsessed with the nature of their own consciousness. Painting came for them to be an act of self-identification (to the moment when, in Delaunay's words, 'l'homme s'identifie sur terre '14). They were not interested in examining the specific nature of existence in modern society, but in becoming absorbed in the larger than human forces which animated life, or in responding to those subconscious urges which, though experienced through the self, seemed to come from beyond the self.

Despite their inconsistencies, the Orphists grasped the raison d'être of abstract art: for the artist, confirmation of his or her being through the act of painting; for the spectator, consciousness through the self-forgetting, yet self-aware absorption in the 'otherness' of the painting. Orphism rested on the assumption that the act of seeing, insofar as it creates consciousness, is in itself meaningful and that the painting which demands this 'pure' seeing is not simply decorative. Apollinaire drew attention to one of the essential aspects of the new art when he wrote in 1913 that it was 'not simply the prideful expression of the human species'; 15 it was anti-intellectual and antihumanist in that it did not concern itself with thought or human conduct. It was concerned with a consciousness which transcended rational constraints to seek oneness 'with the universe'.

1980

Notes

- 1. The terminology of abstraction is complex. I have used the word 'abstract' to indicate the general tendency towards works of art whose structure is - with varying degrees of purity - independent of the natural world. 'Non-representational' is used for works which are completely independent.
- 2. The best account of the complex genesis of the term is in the edition of Apollinaire's Les Peintres cubistes, edited by L.-C. Breunig and J.-Cl. Chevalier, Paris, 1965.

- 3. Mercure de France, 1 March 1916.
- 4. G. Apollinaire, *Chroniques d'Art*, ed. L.-C. Breunig, Paris, 1960, p. 56.
- 5. Robert Delaunay, Du Cubisme à l'art abstrait, ed. P. Francastel, Paris, 1957, p. 80.
- 6. Kupka discussed these ideas in a book he was writing in this period, published only in Czech in 1924. There are several ms. versions.
 - 7. The Upanishads, trans. J. Mascaro, London, 1965.
- 8. Jean Metzinger, Note sur la peinture, 1910; trans. E. F. Fry, Cubism, London, 1966.
- 9. 'La Lumière' and 'Réalité, Peinture pure', in *Du Cubisme*, pp. 146-9, 154-7.
- 10. The punctuation of the title is Delaunay's. Reasons for dating these works to 1913 are given in Appendix C to my book on *Orphism* (Oxford, 1979).
- 11. See H.-M. Barzun, 'Apothéose des forces' (1913), quoted in Spate, Orphism (note 85 of chap. on Delaunay).
- 12. 'Ma danse', Du monde entier: poésies complètes: 1912–1924, Paris, 1967.
 - 13. Quoted in Spate, Orphism (note 72 of chap. on Picabia).
- 14. See Delaunay, *Du Cubisme*, p. 186. See also Spate, *Orphism* (note 58 of chap. on Picabia).
 - 15. Chroniques d'art, p. 298.

FUTURISM

Norbert Lynton

In several respects Futurism was unique among modern art movements. It was Italian. It originated in a view of civilization and found expression first in words; rather than springing from some dissatisfaction with inherited idioms of art and from an ambition to create a new idiom, it started with a general idea and found artistic expression only with difficulty. In some ways it was the most radical, noisily rejecting all traditions and time-honoured values and institutions. It propagated its ideas very rapidly throughout Europe, from London to Moscow, and it was short-lived – a meteoric episode, the lasting importance of which has usually been underrated. It chose its own name – unlike movements like Fauvism and Cubism which were so dubbed by antagonistic critics – and went to great lengths to provide its own rationale in literary form: the modern tradition of artists' manifestos stems primarily from here.

The poet Filippo Tommaso Marinetti (1876–1944) invented the movement. In the autumn of 1908 he wrote a manifesto which appeared first as preface to a volume of his poems, published in Milan in January 1909. It was, however, its appearance in French on page one of *Le Figaro* on 20 February the same year that gave it the sort of impact he was after and that is usually taken as the birthdate of Futurism.

Marinetti had hesitated between Dynamism, Electricity and Futurism as the name of his movement. The alternatives suggest where his interests lay. More conscious than most writers and artists of the burgeoning world of technological power, he wanted the arts to demolish the past and celebrate the delights of speed and mechanical energy: 'We declare', he wrote in his manifesto,

that the splendour of the world has been increased by a new beauty: the beauty of speed. A racing car, its body ornamented by great pipes that resemble snakes with explosive breath . . . a screaming automobile that seems to run on grapeshot, is more beautiful than the Winged Victory of Samothrace [the famous Hellenistic sculpture in the Louvre]

... Beauty now exists only in struggle. A work that is not aggressive in character cannot be a masterpiece . . . We want to glorify war - the world's only hygiene - militarism, patriotism, the destructive act of the anarchists, the beautiful ideas for which one dies, and contempt for women. We want to destroy museums, libraries, and academies of all kinds, and to make war on moralism, feminism and on every opportunistic and utilitarian vileness. We shall sing the great crowds excited by work, pleasure or rioting, the multicoloured, many-voiced tides of revolution in modern capitals. We shall sing the nocturnal, vibrating incandescence of arsenals and shipyards, ablaze with violent electric moons, the voracious stations devouring their smoking serpents . . . the broadbreasted locomotives that paw the grounds of their rails like enormous horses of steel harnessed with tubes, and the smooth flight of the aeroplanes, their propellers flapping in the wind like flags and seeming to clap approval like an enthusiastic crowd. We launch from Italy into the world this our manifesto of overwhelming and incendiary violence, with which today we found Futurism, because we want to liberate this land from the fetid cancer of professors, archaeologists. guides and antiquarians.

There is more in the same vein. Marinetti's vehemence is commensurate with his impatience at Italy's uncompleted national development, at the vast burden of grandiose tradition which pressed on Italian culture more inhibitingly than in any other country – Italy had contributed next to nothing to nineteenth-century developments – and also perhaps at the confusion in his own mind and in the minds of his friends that came from a rather sudden confrontation with a variety of contradictory trends in modern literature and art. The first decade of the century had seen Italy made aware, through new magazines and through exhibitions, of Impressionism, Post-Impressionism of various sorts including early works of Matisse and Picasso, Symbolism, varieties of Art Nouveau, and so on. One way to overcome the confusion was to cut through it by proposing a new view of the world that would supersede them all.

Much the same sentiments were expressed in much the same words in a manifesto addressed 'to the young artists of Italy'. This was composed directly under Marinetti's supervision by three painters: Umberto Boccioni (1882–1916), Luigi Russolo (1885–1947) and Carlo Carrà (1881–1966). Dated 11 February 1910 though written in the

last days of February, and made public for the first time by Boccioni's declaiming of it from the stage of the Teatro Chiarella in Turin on 8 March, the *Manifesto of Futurist Painters* firmly demanded a new art for a new world and denounced every attachment to the arts of the past. What character this new art should have became clearer in another manifesto, Boccioni's *Technical Manifesto of Futurist Painting*, published as a leaflet early in April:

Everything moves, everything runs, everything turns rapidly. A figure is never stationary before us but appears and disappears incessantly. Through the persistence of images on the retina, things in movement multiply and are distorted, succeeding each other like vibrations in the space through which they pass. Thus a galloping horse has not got four legs: it has twenty and their motion is triangular . . . At times, on the cheek of a person we are speaking to in the street, we see a horse passing in the distance. Our bodies enter into the sofas on which we sit, and the sofas enter into us, as also the tram that runs between the houses enters into them, and they in turn hurl themselves on to it and fuse with it . . . We want to re-enter life. That the science of today should deny its past corresponds to the material needs of our time. In the same way art, denying its past, must correspond to the intellectual needs of our time.

Boccioni gave little in the way of specific instructions as to how this multiplicity of sensations was to be incorporated in a picture, but he did stress as an essential basis the system of colour divisionism developed a quarter of a century earlier by the Neo-Impressionists.

It was to take some time for the futurist painters, early on augmented by Giacomo Balla (1871–1958) and Gino Severini (1883–1965), to find the pictorial vehicle for their ideas. When Boccioni showed forty-two works in Venice in July they were quite well received by the critics, not striking anyone as particularly revolutionary; indeed, one commentator noted the wide gap between Boccioni's bold words and his temperate pictures. At this point the Futurists' knowledge of avant-garde art north of the Alps was negligible. For lack of more adventurous forerunners they admired the pictures of Segantini and Previati, and they stirred their imaginations through reading Nietzsche and Bakunin. Their paintings of this time prove their interest in urban and preferably violent subject matter, and there were some interesting experiments (particularly by Boccioni,

Carrà and Russolo) at painting electric light, but their methods were entirely those of the 1890s. Meanwhile Marinetti and they, together with a growing variety of other adherents to the basic futurist beliefs such as the musician Pratella, effectively propagated their theories through publications and personal appearances. In a lecture of 1911, Boccioni formulated the painters' concept in these words: 'We want to represent not the optical or analytical impression but the psychical and total experience,' undoubtedly the most clearsighted definition of, at least, his own intentions, stressing his divergence from the essentially visual concerns of so many modern developments. He went on to speak of the possibility of temporary forms of painting, such as might be executed with searchlights and coloured gas.

The first major showing of futurist paintings took place in Milan, opening on 30 April 1911. Boccioni, Russolo and Carrà sent fifty works to an open exhibition (that included also a show of child art). It was still the subject matter rather than the idiom of their work that was new. Subjects like A Brawl in the Milan Galleria (Boccioni), A Moving Train (Russolo) and The Funeral of an Anarchist (Carrà) are emphatically futurist, but they were presented in more or less traditional ways. Ardengo Soffici's cutting criticism of their pictures, published in the Florence magazine La Voce, was characteristically dealt with by violence: Marinetti, Carrà and Boccioni descended on Florence and attacked Soffici as he sat outside a café. After the police had delivered the Milanese raiders to the railway station the next morning, the editorial staff of La Voce appeared on the platform to expedite their departure and the police had again to intervene in the ensuing battle. The outcome, surprisingly, was friendship between Soffici and most of his colleagues and the Futurists, but this in itself did not give greater substance to futurist art. Severini, who had for some time been working in Paris, at this point arrived in Milan and insisted that it was essential for Boccioni and the others to familiarize themselves with recent developments. Marinetti was persuaded to finance the trip and so Boccioni, Russolo and Carrà followed Severini to Paris for a fortnight's visit. Severini introduced them to Picasso, Braque and others, and showed them some of the galleries. The three visitors were deeply impressed by what they saw, especially Boccioni who, now a warm friend of Severini, stayed on for a few days after his friends had left.

Back in Milan they all worked feverishly, bravely re-orientating their efforts in accord with what they had learned, especially about Cubism which at that time was almost totally unknown outside Paris. They now pinned less faith on the power of new subject matter and strove to complement their colour divisionism with formal fragmentation of a cubist sort. They painted new pictures and repainted old ones, and with astonishing speed and foolhardiness they assembled an exhibition to appear in Paris itself. It opened in the Galerie Bernheim-Jeune on 5 February 1912. Subsequently it travelled around Europe. In March it was at the Sackville Gallery in London; in April and May it showed at the Der Sturm gallery in Berlin, where a banker bought twenty-four pictures out of the thirtyfive shown. The exhibition went on to Brussels (May-June), and the banker's futurist collection was subsequently seen in Hamburg. Amsterdam, The Hague, Munich, Vienna, Budapest, Frankfurt. Breslau, Zurich and Dresden. These tours, backed as they were by publications and lectures, were to amount to the most emphatic act of proselvtism modern art has witnessed. It was further extended in 1913-14. The banker's collection was shown in Chicago; Marinetti lectured with great success in Moscow; and there were several futurist demonstrations and appearances of various kinds in Italy and elsewhere. As a result Futurism found disciples and effective supporters in other countries and its basic ideas were applied to an ever-increasing range of concerns. A Frenchwoman, Valentine de Saint-Point, in spite of Marinetti's original dismissal of women in general, joined the movement, wrote a Manifesto of Futurist Women ('Instead of putting men under the yoke of miserable, sentimental needs, drive your sons, your men, to excel themselves. You create them. You can do everything with them. You owe humanity heroes. Provide them!'), and followed it up with a Manifesto of Pleasure. Others wrote new statements of futurist views on politics, literature, music, but more important than these from the point of view of art was the support the movement got from the leading avantgarde critic and poet, active in the chief citadel of modern art: in June 1913 Apollinaire wrote his essay The Futurist Anti-Tradition,

102

published in the magazine *Lacerba*, Florence, the following September. It set out very graphically the hates and loves of Futurism and the means whereby the cultural world might be renewed, and ended by wishing *merde* on the heads of almost everybody, from critics to Siamese twins via Dante and Bayreuth, and by blessing a list of people that joined such artists as Picasso, Delaunay, Kandinsky and Matisse to the Futurists themselves.

What was Futurism offering to the world? Its basic views, amounting to an insistence that the growth of technology and concurrent developments in society and thought required expression in new, bold, art forms, were not unique but had never been presented so vehemently. Moreover, here was an art movement that put idea before style, thus challenging not only traditional artistic values but also the aesthetic ambitions of most avant-garde art. Futurist paintings tested and proved the possibility of using art as a means of capturing non-visual as well as visual aspects of an environment recognized as dynamic rather than static. They also, by showing bright colour joined to cubist broken forms, encouraged the lesser Cubists of Paris to move away from the more or less monochromatic idiom of Picasso and Braque, and may also have pushed these two into the less limited, more outgoing manner of Synthetic Cubism. Sometimes their compositions offered viable alternatives to the centralized arrangements of the Cubists, and there are a few futurist works that, in describing specific movement, turn the picture area into a section only of what must seem a continuous motion: the action passes through the painting and has no centre.

But it is dangerous to generalize too much about the productions of the Futurists: they varied in their interests as in their abilities. Balla's work, for instance, tends more readily to abstraction. Although he was the painter of the famous Dog on a Leash (1912; Goodyear Collection, New York), the closest Futurism ever came to imitating the photographic studies of movement done by Muybridge and others in the last decades of the nineteenth century, a great proportion of his work is devoted to finding more or less intuitive evaluations of movement through abstract patterns. In a series of paintings entitled Iridescent Interpenetrations (about 1913–14) he even turned from the movement of things to the optical

mobility or instability of contrasting tones and colours, an isolated forerunner of the Op Art of the 1960s. Carrà remained closest to Cubism, Analytic and Synthetic, until, during the war, he moved to a poetic sort of realism, subsequently attaching himself to the giants of the early Renaissance. Severini also, more involved in Paris than the others, was deeply attached to Cubism but for a while combined cubist planes with divisionist colour notation for pictures that look abstract but have explanatory titles such as Ballerina + Sea. Several of Russolo's paintings explore what we have learnt to call shock-waves as symbols of movement and energy, but his contribution to history was less as painter than as revolutionary composer. He aimed at creating a music fit for an age of mechanical power by inventing various noise machines and composing pieces for them with such titles as The Awakening City and The Meeting of Aeroplanes and Motorcars. Concerts of this music were given in Italy, provoking the predictable fury of critics and audiences, and in June 1914 the first noise music concert outside Italy took place at the Coliseum in London.

Boccioni was undoubtedly the most gifted artist amongst them, and also the most inventive. His paintings vary a great deal. At times, in pictures like the night scene Forces of a Street (1911–12; Hängi Collection, Basle), he seems to give perfect expression to the basic themes of Futurism: metropolis, light, energy, mechanical movement and noise, urban pleasure-seeking, all fused into one visual experience. He also researched into more limited themes, such as the interpenetration of single, stationary figures and their environments. In his great triptych entitled States of Mind (No. 1: The Farewells; No. 2: Those who go; No. 3: Those who stay. 1911–12) he fused the futurist interest in trains, crowds, movement and multiple sensations into a poetic work of remarkable epic power.

Even more impressive, however, is Boccioni's triumphant venture into sculpture. In March 1912 he again visited Severini in Paris. This time he was thinking about sculpture. He met Archipenko, Brancusi, Duchamp-Villon and others, and soon after he wrote his *Manifesto of Futurist Sculpture*, backdating it to 11 April 1912. Revolted by the jungle of bronze and stone statues and monuments with which sculpture seemed to be stifling itself, and also by the

Greco-Michelangelesque tradition behind it, he demanded total renewal:

Let us get rid of the lot, and let us proclaim the ABSOLUTE AND FINAL DISCARDING OF THE FINITE LINE AND OF THE CLOSED FORM STATUE. LET US TEAR THE BODY OPEN AND LET US INCLUDE ITS SURROUNDINGS IN IT... Thus a figure may have one arm clothed and the other naked, and the varying lines of a vase of flowers may chase each other freely between the lines of a hat and of a neck. Thus can the transparent planes of glass, of sheet metal, wires, electric outside and inside lighting indicate the planes, the directions, the tones and the half-tones of a new reality.

To this end all sorts of materials should be brought into sculpture: 'We list only a few: glass, wood, cardboard, iron, cement, horse-hair, leather, cloth, mirror, electric light, etc.' He mentions the possibility of built-in motors to give sculptures actual movement.

His sculptures were almost as revolutionary as his words. Already in June/July 1913 he held an exhibition of sculpture at the Galerie La Boëtie in Paris. He used the occasion to develop his manifesto in a catalogue introduction and to give a lecture (in bad French). Several pieces have been lost and are known only through photographs. Some of them use much the same kind of interpenetration of dissimilar objects (head, window, frame, light) that we find in futurist painting. Others, like Unique Forms of Continuity in Space (1913; really a statue of a man striding forward, and not at all unlike Marinetti's maligned Winged Victory of Samothrace), and Development of a Bottle in Space (1912), show a more essentially sculptural attempt to open form out in order to reveal the energies implied in its structure and to fuse it with the surrounding space. The most impressive work is the Horse + Rider + House in wood and cardboard (1914), a coloured sculpture of abstract appearance whose open, spatial forms belong to the world of Constructivism.

One other extension of futurist creativity remains to be recorded. In 1914, in the person of Antonio Sant'Elia (1888–1916), architecture entered the futurist sphere. A *Manifesto of Futurist Architecture*, dated 11 July 1914, presented his ideas, which were also more graphically expressed in a large number of imaginative drawings,

some of which were exhibited under the title *The New City*. With a vision that suggests science fiction – which is not to say that it was unpractical or impracticable – Sant'Elia proposed a new kind of metropolis, designed without backward glances to historical styles but in accord with the new materials and structural inventions of engineering to meet new concentrations of population in an age of rapid transport. His drawings suggest a sense of form owing much to the influence of Art Nouveau and this is supported by his rejection (in the *Manifesto*) of perpendicular and horizontal lines, static bulky forms, and his demand for an architecture of 'reinforced concrete, iron, glass, textiles and all those substitutes for wood, brick and stone that permit the greatest elasticity and lightness'.

The 1914–18 war spelt the end of Futurism. The 'world's only hygiene' removed Sant'Elia and Boccioni in 1916. The remaining futurist artists moved into more traditional styles and attitudes. Marinetti fulfilled his political ideals by helping Fascism to take power in Italy. Some younger adherents of the movement, such as Prampolini, were able to carry aspects of Futurism into the 1930s but various attempts to refurbish Futurism after 1918 had little impact.

Yet its influence was of fundamental and long importance. Because Futurism was deeply involved in Cubism, its conquests were conquests also for Cubism. Without the Italians' activity, Cubism could never have played so big a role in modern art. More specific echoes of Futurism can be found in a variety of artists and movements: Vorticism in London (in 1914 Marinetti and the English Vorticist C. R. W. Nevinson collaborated on a manifesto, Vital English Art), some forms of Expressionism in Germany, avantgarde painting and typography in Moscow around 1913–15, architecture of the twenties in Holland, Germany and France. Russia may be claimed as futurism's greatest immediate debtor. Mayakovsky's literary Futurism owed much to Marinetti's, even if their political views were largely opposite, and the revolutionary art of Russia, especially the architecture, in several respects is the fulfilment of what the Milanese men had attempted.

VORTICISM

Paul Overy

It is often forgotten amidst the uncritical cries of delight at the recent 'renaissance' of English painting and sculpture that English artists made an important contribution to the modern movement before the First World War, although that holocaust fairly quickly put a stop to it. Not all of these artists were formally associated with the vorticist movement although nearly all of them showed with the Vorticists at some time or were in contact with them.

In retrospect Vorticism seemed dominated by the personality of Wyndham Lewis, not because he was the best painter, but because as a skilful polemicist he was his own best publicist. In 1956 the Tate Gallery in London held an exhibition entitled Wyndham Lewis and Vorticism in which 'other Vorticists' were relegated to an inferior position. Another survivor, William Roberts, rightly protested in some virulent pamphlets.

Wyndham Lewis was not the most important of the abstract artists working in England around 1914, but the publication of the magazine BLAST that Lewis edited, was one of the most important events in English art of the time. There were only two issues. One in the summer of 1914, 'this enormous puce coloured periodical', as Lewis described it, which the protagonists can be seen holding, like children clutching their story books, in Roberts's comic re-creation of the scene fifty years later, The Vorticists at the Café de la Tour Eiffel, now in the Tate Gallery, London. The second and last issue, leaner and in a black and white cover, appeared in 1915.

Many of the works by Lewis, Roberts, Edward Wadsworth, Frederick Etchells and others, that were reproduced in BLAST, have disappeared and this is now the only record of them. BLAST was printed on spongy paper in very black ink and coarse type. In an essay on 'The Future of the Book' in 1926 the Russian artist and designer El Lissitzky wrote of BLAST as one of the precursors of the New Typography which revolutionized graphic design in the twenties and thirties and is still with us (often now debased and

meaningless). This and Edward Johnston's lettering for the Underground in 1917 were England's last important contribution to the modern movement in design and anticipated the typographical innovations of De Stijl, the Bauhaus and Russian designers like Rodchenko and Lissitzky himself.

Many of the works of these early English abstract artists, particularly those of Wadsworth and Lewis, look as if they were inspired by the then recently developed technique of aerial photography. Here they anticipated the works of Malevich, whose suprematist paintings and drawings are now thought to date from 1915. It is not certain that Malevich knew of their work – although if Lissitzky could see BLAST, so could Malevich, but this might possibly have been at a later date. The resemblances of vorticist and suprematist works are probably due to the fact they were both influenced by Cubism and Futurism, by photography, and by recent developments in engineering technology and architecture.

Ezra Pound, who was then a close associate of Lewis and who gave the movement its name, described in an article at the time how Vorticism differed from Futurism: 'Futurism is descended from Impressionism. It is, in so far as it is an art movement, a kind of accelerated Impressionism. It is a spreading, or surface art, as opposed to Vorticism, which is intensive.'

Futurism is essentially an acceleration of successive images, seen simultaneously, across a very shallow plain, as also was the 'cubofuturism' of Marcel Duchamp's *Nude Descending a Staircase*. What Vorticism did was to extend this acceleration into depth, creating an intense, inrushing perspective – a vortex. Pound wrote: 'The image is not an idea. It is a radiant node or cluster; it is what I can, and must perforce, call a VORTEX, from which, and through which, and into which ideas are constantly rushing. In decency one can only call it a VORTEX. And from this necessity came the name "vorticism".'

In order that BLAST should not go unnoticed, the publication of the first issue was celebrated by a Blast Dinner – the occasion recalled in Roberts's Tate painting and a Blast Party at the 'Cave of the Golden Calf' a night-club run by Madame Strindberg, the playwright's second wife, at which, according to Edgar Jepson, 'the

Turkey Trot and the Bunny Hug were performed'. This and items in BLAST like the lists of 'Blasts 'and 'Blesses'* – where individuals and institutions were damned or praised – were obviously designed to attract maximum publicity, but underneath the bombast and the self-propaganda, the blasting and bombardeering, the movement was a serious attempt to establish a viable modern style in England which would probably have succeeded but for the war.

BLAST contained (in Lewis's manifestos) some of the most intelligent criticism of Cubism and Futurism ever written. Wadsworth contributed a review, with extensive translated extracts, of Kandinsky's book Concerning the Spiritual in Art. Wadsworth's own paintings of the period are more rational, cooler than those of Lewis. They anticipate in some ways the style Kandinsky was to adopt after the war, at the Bauhaus, but which at this stage he had only formulated theoretically in his writings. Lewis's work is more dynamic, less tightly organized than Wadsworth's, very powerful and cerebral with the same kind of brutal, slightly inhuman energy that is found in his first novel, Tarr. Coming across reproductions of Lewis's paintings or drawings as one thumbs one's way through the thick, spongy pages of BLAST gives one a sudden feeling of vertigo, of plunging into an abyss of space. Pound, in coining the name Vorticism, had exactly caught the feeling of Lewis's work - in this sense alone was Lewis right in asserting, many years later, that he was the only Vorticist. (In his introduction to the Tate Gallery catalogue in 1956 Lewis wrote 'Vorticism, in fact, was what I, personally, did, and said, at a certain period.')

Some of the drawings and paintings of Frederick Etchells are very close to Charles Rennie Mackintosh's designs (of about the same time or slightly later) for the interior of the Bassett-Lowke house in Northampton (1915–16). Etchells himself turned to architecture after the war. He made the first English translation of Le Corbusier's *Towards a New Architecture* and designed the first modern office block in London for Crawfords, in High Holborn (still standing).

The same vigorous decorative mannerism (exploited much later,

^{*} This idea was taken from Apollinaire – and somewhat bowdlerized. Where the Vorticists had 'Blast', Apollinaire had 'Merde'.

in the twenties, by Art Deco designers) can be seen in some of Roberts's work of the period. One of these, a pencil drawing entitled St George and the Dragon was reproduced in the Evening News in April 1915 and caused something of a stir. Roberts was only nineteen at the time.

David Bomberg was in his early twenties. He was never formally a Vorticist, although associated with them. His early works like Mud Bath and In the Hold and the series of lithographs for the Russian Ballet (not published until 1919 but done before the war) are amongst the most accomplished of the abstract or near-abstract work produced in England at this time, and more of his best work seems to have survived than that of the other painters. He was only on the fringe of Vorticism and his work was freer, more lyrical (yet very strong) in colour. Although there is the strong diagonality characteristic of Vorticism in Bomberg's early work, he was more concerned with preserving the flatness of the plane surface of the picture. There is no vertiginous, inrushing of forms into space as in Lewis's work, and to a lesser extent that of Wadsworth, Roberts and Etchells.

Epstein's Rockdrill in which the machine-like figure was originally mounted on a real mechanical drill and the last works of Henri Gaudier-Brzeska, the young French sculptor who worked in London and who was killed at the front in 1915, show the strong influence of vorticist ideas, resulting in a brutal, dynamic energy. Brutality is not usually an admirable quality in art, any more than in life, and with it usually goes a corresponding sentimentality. (This is true of both Gaudier and Epstein's work, although not of Lewis's.)

This brutal energy was characteristic of Vorticism. At their best the Vorticists achieved a strong visualization of the headlong flight of Europe into mechanical barbarity, an awareness of the brutalization of man by his irresponsible control of his environment that is lacking in the idealized art of Cubism and the romanticized art of Futurism. This, and the acceleration of forms into depth, was the significant contribution of Vorticism to the art of the twentieth century.

DADA AND SURREALISM

Dawn Ades

Early in February 1916 Hugo Ball, a German poet and philosopher, a refugee in Switzerland from the war, founded the Cabaret Voltaire in a bar called the Meierei in a 'slightly disreputable quarter of the highly reputable town of Zurich'. The Cabaret Voltaire was a cross between a nightclub and an art society, planned as a 'centre for artistic entertainment' where young artists and poets were invited to bring along their ideas and contributions, read their poems aloud, hang their pictures, sing and dance, play music. By February, Ball wrote in his diary:

The place was full to bursting; many could not get in. About six in the evening, when we were still busy hammering and putting up futurist posters, there appeared an oriental-looking deputation of four little men with portfolios and pictures under their arms, bowing politely many times.

They introduced themselves: Marcel Janco the painter, Tristan Tzara, Georges Janco and a fourth, whose name I did not catch. Arp was also there, and we came to an understanding without many words...³

By the end of February the Cabaret was spinning with activity and it was clear that they needed a name to cover what had become a new movement. The name was apparently found by Ball and Huelsenbeck by accident as they were leafing through a German-French dictionary: 'Let's take the word dada,' I said. 'It's just made for our purpose. The child's first sound expresses the primitiveness, the beginning at zero, the new in our art.' The Cabaret lasted for six months; an entry from Tzara's Zurich Chronicle reads,

February 26 – HUELSENBECK ARRIVES – bang! bang! bangbangbang... Gala night – simultaneous poem 3 languages, protest noise Negro music ... invention dialogue!! DADA! latest novelty!!! bourgeois syncope, BRUITIST music, latest rage, song Tzara dance protests – the big drum – red light ... ⁵

The following year a new dada season was enlivened by the opening of the Galerie Dada, and the appearance of the periodical Dada energetically organized, edited and distributed by Tzara. In spite of the war, copies of this reached, among other people, Apollinaire in Paris. When the war ended the original Dadaists from Zurich scattered, and continued their activities in other places, notably in Cologne and Paris.

Dada was christened in Zurich, but the speed with which the name spread immediately after the war to other countries and other groups of people indicates that its attitudes and activities already existed. It was essentially an international movement: of the Zurich Dadaists, Tzara and Janco were Rumanian, Arp Alsatian, Ball, Richter and Huelsenbeck German. Nor was it limited to Europe. In New York the expatriate Frenchmen Duchamp and Picabia produced proto-dadaist reviews, '391' and Rongwrong, during the war, and gathered a group of disaffected young Americans round them, including Man Ray.

'Dada', as Breton said, 'is a state of mind.'6 This state of mind was already endemic in Europe before the war, but the war gave a new point and urgency to the dissatisfaction many young artists and poets already felt. Huelsenbeck wrote in 1920, 'We were agreed that the war had been contrived by the various governments for the most autocratic, sordid and materialist reasons.'7 The war was the death agony of a society based on greed and materialism. Ball saw Dada as a requiem for this society, and also the primitive beginnings of a new one. 'The Dadaist fights against the death-throes and death-drunkenness of his time . . . He knows that this world of systems has gone to pieces, and that the age which demanded cash has organised a bargain sale of godless philosophies.'8 Art itself was dependent on this society; the artist and poet were produced by the bourgeoisie and were then expected to be its 'paid wage-labourers', and art merely served to preserve and bolster it up. Art was as intricately bound up with bourgeois capitalism as the complex imagery of this passage by Tzara indicates: 'Is the aim of art to make money and cajole the nice nice bourgeois? Rhymes ring with the assonance of the currencies and the inflexion slips along the line of the belly in profile. All groups of artists have arrived at this trust

company after riding their steeds on various comets.'9 It had become a commercial transaction both literally and metaphorically, artists were mercenary in spirit, poets 'bankers of language'. It had also become a kind of moral safety valve, condoning a dubious patriotism: 'None of us had much appreciation for the kind of courage it takes to get shot for the idea of a nation which is at best a cartel of pelt merchants and profiteers in leather, at worst a cultural association of psychopaths who, like the Germans, marched off with a volume of Goethe in their knapsacks, to skewer Frenchmen and Russians on their bayonets.' ¹⁰ The Dadaists' revolt involved a complex kind of irony, because they were themselves dependent upon the doomed society and the destruction of it and its art would thus mean the destruction of themselves as artists. So in a sense Dada existed in order to destroy itself.

'ART' - parrot word - replaced by DADA, PLESIOSAURUS, or handkerchief

MUSICIANS SMASH YOUR INSTRUMENTS BLIND MEN take the stage

Art is a PRETENSION warmed by the TIMIDITY of the urinary basin, the *hysteria* born in *The Studio* ¹¹

Jacques Vaché, who died of an overdose of opium in 1918 without ever hearing of Dada, understood the irony of this state of mind perfectly: 'Besides, ART of course doesn't exist...yet: we make art – because it's thusly and not otherwise – Well – what do you want to do about it?

'So we neither like Art nor artists (down with Apollinaire)... All the same, since it's necessary to disgorge a little acid or old lyricism, let it be done abruptly, rapidly, for locomotives go fast.' ¹² For the Dadaists went on producing things, even if these were often like Trojan horses, anti-art objects.

The dada state of mind is well expressed if one juxtaposes Man Ray's Gift, an ordinary flat-iron with a row of tin tacks sticking from the bottom, with Duchamp's idea for a 'Reciprocal Ready-made – use a Rembrandt as an ironing board'. 13

Picabia said, 'The only really ugly things are Art and anti-art. Wherever art appears, life disappears.' With the discrediting of the work of art came the cultivation of the gesture. Dada was a way of life. Ball wrote, 'The bankruptcy of ideas having destroyed the concept of humanity to its very innermost strata, the instincts and hereditary backgrounds are now emerging pathologically. Since no art, politics or religious faith seems adequate to dam this torrent, there remain only the blaque and the bleeding pose.'14 Dada claimed as its heroes Vaché, who once interrupted a performance of Apollinaire's Les Mamelles de Tiresias by threatening to fire his pistol at the audience, and whose suicide was a final gesture, and Arthur Cravan, a hopelessly incompetent poet who became an enduring legend on the strength of such exploits as challenging the world heavyweight boxing champion Jack Johnson to a fight, or arriving to give a lecture on modern art to a glossy New York audience drunk and undressing on the platform. In 1918 he set out for Mexico from the USA in a rowing boat, and was never seen again. Dada gestures abound: for instance the scandal stage-managed by Duchamp when he entered a urinal that he called Fountain for the Independents Exhibition in New York under the pseudonym R. Mutt, and when they refused to exhibit it, resigned from the jury.

The effect of such gestures was quite out of proportion to the amount of energy the Dadaists spent on them. It was as though Dada had a life of its own – for there was no real unity among the Dadaists. Their exhibitions, for example, were remarkable for their total incoherence. There is no such thing as a dada style. Dadaists continued to produce art (or what has owing to a process of osmosis subsequently become art), but each following his own direction. Dada had a slightly different character, too, in its different locations. However, one can perhaps distinguish two distinct kinds of emphasis within Dada. On the one hand there were those like Ball and Arp who were looking for a new art to replace an outworn and irrelevant aestheticism, and on the other hand those like Tzara and Picabia who were intent on destruction by mockery, and were also prepared to exploit the irony of their position by fooling the public about their

social identity as artists. Picabia enjoyed an enormous success in Paris as the dada artist.

In Zurich, Dada more or less bore the aspect of a new art movement, pursuing experiments in the 'new medium', collage, and in a new language for poetry. Arp later wrote,

In Zurich in 1915, losing interest in the slaughterhouses of the world war, we turned to the Fine Arts. While the thunder of the batteries rumbled in the distance, we pasted, we recited, we versified, we sang with all our soul. We searched for an elementary art that would, we thought, save mankind from the madness of these times.¹⁵

While the evenings at the Cabaret Voltaire were becoming increasingly noisy and provocative, Arp, and other Dadaists like Hans Richter and Marcel Janco, were, in private, searching in their different ways for an elementary, abstract art. Arp wanted art to be anonymous and collective, and together with Sophie Taeuber, his future wife, made collages and embroideries based on simple geometrical shapes. The Dada reviews are full of his striking woodcuts. He also began his wood reliefs, such as *Portrait of Tzara*, whose more fluid, organic shapes prefigure his later reliefs and sculptures, but which were often roughly nailed together. He deliberately avoided oil painting which seemed to him weighed down with tradition and connected with man's exaltation of himself. Dada meant something very particular to Arp:

Dada aimed to destroy the reasonable deceptions of man and recover the natural and unreasonable order. Dada wanted to replace the logical nonsense of the men of today by the illogically senseless. That is why we pounded with all our might on the big drum of Dada and trumpeted the praises of unreason. Dada gave the Venus de Milo an enema and permitted Laöcoon and his sons to relieve themselves after thousands of years of struggle with the good sausage Python. Philosophies have less value for Dada then an old abandoned toothbrush, and Dada abandons them to the great world leaders. Dada denounced the infernal ruses of the official vocabulary of wisdom. Dada is for the senseless, which does not mean nonsense. Dada is senseless like nature. Dada is for nature and against art. Dada is direct like nature. Dada is for infinite sense and definite means. 16

It is not surprising that although he later moved in surrealist circles Arp's sympathy always remained with Dada.

Arp was a poet as well as an artist, and he joined in the attack on language that Dada started and Surrealism was, in its own way, to follow. Richter describes Arp one day tearing up a drawing and letting the pieces fall to form a new pattern; he was beginning to let chance enter his compositions (see note 26), and at the same time was producing spontaneous free-flowing ink drawings that have much in common with the Surrealists' automatic drawing [illustration 54]. He introduced chance in his poems, too, 'tearing up' sentences so that there is no logical coherence, although they are far from being meaningless: 'laughing animals froth by the iron pots the rolls of clouds bring out animals from their kernels',17 and sometimes introducing words or sentences picked at random from a newspaper: 'World wonder sends card immediately here is a part of a pig all 12 parts put together stuck on flat will give the clear side view of a stencil amazingly cheap all buy' (Weltwunder 1917). Tzara, whose Vingt-Cinq Poèmes keep up a torrential flow of wild images, went even further, recommending as the recipe for a dadaist poem the cutting up of sentences from a newspaper, these then to be shaken up in a bag and drawn out at random. 'The poem will resemble you', he said, referring to the idea that chance can be as personal as deliberate, conscious, action. I have discussed these experiments at some length because they have a direct bearing on the future of Surrealism. Automatism, so closely linked with chance, was a fundamental part of Surrealism; and in the first Surrealist Manifesto Breton discusses seriously the 'newspaper poem', as a surrealist activity. However, as we shall see, while Surrealism was to organize these ideas into a set of rules and principles, in Dada they were only part of a great outburst of activity all of which was aimed at provoking the public. destroying traditional notions of good taste, and liberation from the constrictions of rationality and materialism.

Hugo Ball went further than anyone in his search for a new language for poetry. He was a strange man, torn between the desire for direct political commitment and action, and a longing to withdraw from the world into a life of asceticism. His role in Dada has never been properly defined. His early links with German Expressionism,

the Blaue Reiter and Der Sturm, are evident in the Cabaret Voltaire programmes; they were links that he shared with Arp and Richter, who was still painting vividly expressionist pictures. But he began to turn against its lofty phrase-making, and felt that self-expression, although the idea lingered, had little in common with the mood of Dada. He explained his new language in Flucht aus der Zeit:

We have developed the plasticity of the word to a point which can hardly be surpassed. This result was achieved at the expense of the logically constructed, rational sentence . . . People may smile if they want to; language will thank us for our zeal, even if there should not be any directly visible results. We have charged the word with forces and energies which made it possible for us to rediscover the evangelical concept of the 'word' (logos) as a magical complex of images. 18

Early in 1917 a whole evening was devoted to Ball's reading of his phonetic poem at the Galerie Dada. Dressed in a kind of cylindrical pillar of shiny blue cardboard, so that he could not move, Ball had to be carried on to the platform, where he began to recite slowly and majestically 'gadji beri bimba glandridi laula lonni cadori . . .' The public laughed and applauded, thinking it was another joke at their expense, which they were willing to join in. He went on reciting, and as he reached the climax his voice took on the intonation of a priest. It was one of Ball's last appearances in Dada. Other Dadaists, like Raoul Hausmann in Berlin, 19 developed the phonetic poem into what Hausmann called a purely abstract form, which Schwitters used in his famous Ursonate. Other experiments included the 'simultaneous poem', which consisted of Tzara, Huelsenbeck and Janco simultaneously reading three banal poems in German, French and English at the tops of their voices. (Simultaneity was a legacy, as was 'Bruitism', from the Futurists.) But Ball's mysticism was increasingly out of place in Dada. He lacked the gentle but ironic humour which enabled Arp to keep his balance within Dada, and finally withdrew. 'I have examined myself carefully,' he said, 'and I could never bid chaos welcome.'

I write a manifesto and I want nothing, yet I say certain things, and in principle I am against manifestos, as I am also against principles. I

write this manifesto to show that people can perform contrary actions together while taking one fresh gulp of air; I am against action . . .

If I cry out: Ideal, ideal, ideal Knowledge, knowledge, knowledge Boomboom, boomboom, boomboom.

I have given a pretty faithful version of progress, law, morality, and all other fine qualities that various highly intelligent men have discussed in so many books, only to conclude that everyone dances to his own boomboom.

Tzara's Dada Manifesto of 1918, aggressive and nihilistic, really marks the beginning of a new phase for Dada. It was this manifesto which seduced Breton and won the adherence of the Littérature group in Paris, and it seems to have been inspired by the arrival in Zurich of Francis Picabia, whose itinerant review '391', which appeared from 1917 in Barcelona, New York, Zurich and Paris, contained the most virulent attacks on practically everything. Picabia's black pessimism, combined with his magnetic, energetic personality, dominated Dada for the rest of its existence.

Picabia perfected the presentation of the Dada object as a theatrical gesture. Dada 'works' were usually by their very nature transitory, and were often produced for the entertainment/ demonstrations that acted as baiting grounds for the public. These purpose-built works were often startlingly different from the art produced by the Dadaist in his studio. Janco's masks, for instance, bore no resemblance to his cool, cubist plaster reliefs. 'I haven't forgotten the masks you used to make for our Dada demonstrations. They were terrifying, most of them daubed with bloody red. Out of cardboard, paper, horsehair, wire and cloth, you made your languorous foetuses, your Lesbian sardines, your ecstatic mice.'20 By contrast, Richter describes the comic effect Arp achieved by reproducing his morphology on a huge scale, painting the sets for one of their soirées: 'We began from opposite ends of immensely long strips of paper about two yards wide, painting huge black abstracts. Arp's shapes looked like gigantic cucumbers. I followed his example, and we painted miles of cucumber plantations before we finally met in the

middle.'21 The distinction between their demonstrations and their exhibitions became increasingly slight, with manifestos and poems being read at exhibitions, and paintings presented at their entertainments. At the first dada 'matinée' in Paris in January 1921 Picabia stage-managed one of the high spots of the afternoon. After showing paintings by Gris, Léger and de Chirico, Breton brought on a painting by Picabia (who was never present in person at such moments), called Le Double Monde, which consisted only of a few black lines on the canvas with inscriptions like 'Haut' (top) at the bottom, and 'Bas' (bottom) at the top, 'fragile', and finally at the bottom in enormous red letters L.H.O.O.Q. (Elle a chaud au cul).²² When the public took in this obscene pun there was a tremendous outcry, and before they could draw breath another work of art was wheeled on to the stage, this time a blackboard with a few inscriptions and the title Riz au Nez, which were promptly wiped off by Breton.²³ The Dadaists used their works, in fact, as an actor uses props. Another of Picabia's paintings, L'ail Cacodylate epitomizes Dada's attitude to art. Given the value of a painting relies on the signature of the artist, Picabia invited all his literary and artistic friends, including the Dadaists, to cover his canvas with their signatures, and this is all the painting consists of.

The presentation of transitory, impermanent or clearly meaningless objects in an exhibition was even more provocative. A commonplace today, in 1920 it was enough to make the chief constable in Cologne try to prosecute the Dadaists with fraud for charging an entrance fee for an art exhibition which was in fact nothing of the sort. Ernst replied, 'We said quite plainly that it is a dada exhibition. Dada has never claimed to have anything to do with art. If the public confuses the two, that is no fault of ours.' This exhibition. master-minded by Ernst, Johannes Baargeld and Arp, who was fresh from Zurich, was held in a small courtyard reached by going through the lavatory of the Bräuhaus Winter. Visitors on the opening day were met by a small girl dressed in a white communion gown reciting obscene poems. The exhibition contained a large number of 'disposable' objects. A sculpture by Ernst had an axe attached with which the audience were invited to destroy it. Baargeld's Fluidoskeptrick der Rotzwitha van Gandersheim, a foretaste of many surrealist objects, consisted of a small glass tank filled with water coloured red (blood-stained?), with a fine head of hair floating on the surface, a human hand (wooden) protruding from the water and an alarm clock at the bottom of the tank. It was smashed in the course of the exhibition. Ironically, the exhibition was closed while the authorities investigated complaints of obscenity, but all they could find was a Dürer engraving of Adam and Eve, and the exhibition was re-opened.

In Jesus-Christ Rastaquouère Picabia wrote, 'You are always looking for an emotion that has already been felt, just as you like to get an old pair of trousers back from the cleaners, which seem new as long as you don't look too close. Artists are cleaners, don't be taken in by them. The real modern works of art are not made by artists, but quite simply by men.'23 The non-superiority of the artist as creator was one of the fundamental dada pre-occupations. Linked to this is a whole complex of ideas, interpreted in a different way by each Dadaist. Poetry and painting can be produced by anybody; there is no longer the need for a particular burst of emotion to produce anything; the umbilical cord between the object and its creator is broken; there is no fundamental difference between a man-made and a machine-made object, and the only personal intervention possible in a work is choice.

Duchamp more than anyone else explored these ideas. In 1914 he 'designated' the first of his ready-mades, a bottlerack [illustration 55]. Others followed over a period of several years, including a hatrack and a snow shovel (In advance of a broken arm). 'A point I very much want to establish is, that the choice of these ready-mades was never dictated by an aesthetic delectation. The choice was based on a reaction of visual indifference, with at the same time a total absence of good or bad taste, in fact a complete anaesthesia.' The effect of an exhibit with neither good nor bad taste is to disorient the viewer. Although these mass-produced manufactured objects have acquired a kind of baptism into art through being illustrated many times in exhibition catalogues and books on modern art, they still remain profoundly disconcerting. 'There is no rebus, there is no key. The work exists, its only raison d'être is to exist. It represents nothing but the wish of the brain that conceived it.'25

By trying to avoid taste, which he equated with habit, Duchamp produced works which are remarkably dissimilar from each other in appearance, although the same themes and pre-occupations occur; and he deliberately introduced chance into his works.²⁶ His last oil paintings, in 1912, The Bride and The Passage from the Virgin to the Bride, subtly suggest human organs transposed into machines, or diagrams for machines, and spawned hundreds of 'machine' drawings, notably those by Picabia [illustration 56]. The Large Glass, The Bride Stripped Bare by her Bachelors, Even, with its extremely complex iconography, is the culmination of his 'public' career as an artist. It represents a love machine, which, because it can never 'work', forever frustrates the desire of its protagonists. It illustrates perfectly the way in which his and other dada machine paintings are the exact opposite of the futurist machine aesthetic: they are entirely ironical in their attitude. After 1923 Duchamp took his own advice to young artists and went underground. By ostensibly renouncing all artistic activity, except for occasionally designing surrealist exhibitions, he appeared to have carried Dada to its logical conclusion.27

Dada in Berlin must be briefly discussed separately, because it belongs specifically to the political situation in Germany from 1917, when disillusionment with the war was growing, through the desperately harsh post-war years when their hopes of a communist state were blighted. In Berlin Dada took its most overtly political form.

When Huelsenbeck returned to Berlin from Zurich in January 1917, he exchanged a 'smug fat idyll' for a 'city of tightened stomachers, of mounting, thundering hunger'. He found the strange phenomenon of a harassed, worn-out people turning to art for comfort: 'Germany always becomes the land of poets and thinkers when it begins to be washed up as the land of judges and butchers.' It was naturally Expressionism that they turned to, because it offered the clearest escape from ugly reality, aiming at 'inwardness, abstraction, renunciation of all objectivity'. Dada at once identified this attitude as their immediate enemy. Everything Dada produced in Berlin is remarkable for its harsh, aggressive insistence on reality. 'The highest art will be that which in its conscious content presents

the thousandfold problems of the day, the art which has been visibly shattered by the explosions of last week, which is forever trying to collect its limbs after yesterday's crash' (from the first German Dada Manifesto). Their invention of photomontage, an adaptation of collage, made from newspaper cuttings and photographs, took a very different path from other dada collages such as those of Max Ernst which tended to a *poetic* disorganization of reality. Photomontage, using the visual material of the world around them, of familiar media, became in their hands a biting political weapon. George Grosz, Hannah Höch, Raoul Hausmann and John Heartfield all used it. Heartfield's later photomontages provide a crushing indictment of Hitler and capitalist militarism.

To ensure that no one could still mistake Dada for a 'progressivecultural idea' Hausmann and Huelsenbeck drew up a programme of action, 'What is Dadaism and what does it want in Germany?', which demanded 'the international revolutionary union of all creative and intellectual men and women on the basis of radical Communism', and 'the immediate expropriation of property (socialization) and the communal feeding of all . . .' Only Heartfield, however, was a member of the Communist Party, and such demands as the 'introduction of the simultaneist poem as a communist state prayer', and 'immediate regulation of all sexual relations according to the views of international Dadaism through establishment of a dadaist sexual centre' did nothing to reassure the Communists about their seriousness, while the law-abiding citizen regarded them as Bolshevik agitators. Several of them, however, were involved in the November Revolution, and when this failed, continued in their opposition, keeping their identity as Dadaists long after the movement had died elsewhere.

Surrealism

Surrealism was born out of a desire for positive action, to start to build again from the ruins of Dada. For Dada, in negating everything, had to end by negating itself ('the true Dadaist is against Dada'), and this led to a vicious circle that it was necessary to break out of. This was most acutely felt by the group of young Frenchmen

centred round André Breton. Breton's inclination to formulate theories had always clashed with the nihilism of Dadaists like Picabia, as one can see by comparing one of his dada manifestos, 'Dada is a state of mind... Free thought in religious matters does not resemble a church. Dada is artistic free thought,' ²⁹ with, for instance, Picabia's Cannibal Manifesto,

You are all accused, stand up . . .
What are you doing here, parked like serious oysters . . .
Dada feels nothing, it is nothing, nothing, nothing.
It is like your hopes, nothing.
Like your paradise, nothing.
Like your artists, nothing.
Like your religion, nothing.

It was Breton who finally put an end to Dada by organizing a series of demoralizing events like the mock trial, in 1921, of Maurice Barrès, the patriot and man of letters. The rift within the ranks of the Dadaists was clearly shown up when Tzara declined to cooperate and joyfully sabotaged the whole affair by refusing to answer seriously the questions gravely posed by Breton as 'President' of the court. Intended as part of a campaign of terrorism against leading members of French society, the trial was totally lacking in humour and really belongs to the pre-history of Surrealism. In 1922 Breton announced plans for an International Congress to determine 'the direction of the modern spirit', in which representatives of all modern movements, including Cubism, Futurism and Dada were to appear – and thus by inscribing Dada, as it were, into the history of art, Breton effectively killed it.

The relationship between Surrealism and Dada is complex, because in many ways they were so similar. Politically, Surrealism inherited the bourgeoisie as its enemy, and continued, at least in theory, its attack on traditional forms of art. Artists previously associated with Dada joined the Surrealists, but it is impossible to say that the work of Arp, Ernst, or Man Ray, for instance, became surrealist overnight. Surrealism was, as it were, a substitute for Dada; as Arp said, 'I exhibited with the Surrealists because their rebellious attitude to "art" and their direct attitude to life was

wise like Dada.'30 The radical difference between them lay in the erection of theories and principles in place of Dada's anarchism.

But it took two years before Surrealism was actually formed as a movement, and these years, from 1922 to 1924, became known as the 'période des sommeils'. The future Surrealists, including Breton, Eluard, Aragon, Robert Desnos, René Crevel, Max Ernst, were already exploring the possibilities of automatism and dreams, but the period was marked by the use of hypnotism and drugs. In an article entitled 'Entrée des médiums', in 1922, Breton describes the excitement they felt when they discovered that while in a hypnotic trance certain of them, notably Desnos, could produce startling monologues, written or spoken, filled with vivid images which, he claimed, they would be incapable of in a conscious state. But a series of disturbing incidents, such as the attempted mass suicide of a whole group of them while in a hypnotic trance, led to the abandonment of these experiments, and in the first Surrealist Manifesto Breton avoids any discussion of 'mechanical' aids such as drugs or hypnotism, stressing Surrealism as a natural, not induced, activity.

In 1924 the Bureau of Surrealist Research was established, Breton's Surrealist Manifesto was published, and the first issue of the surrealist review, La Révolution Surréaliste, appeared. An atmosphere of expectant exhilaration was generated, and many more young writers and artists were attracted to the new movement. Among these was Antonin Artaud, who later founded the revolutionary Théâtre Alfred Jarry. He was placed in charge of the Bureau of Surrealist Research, which Aragon described as 'A romantic inn for unclassifiable ideas and continuing revolts'. In his 'Letter to the Chancellors of the European Universities' Artaud expresses their all-encompassing wish for freedom, for escape from the chains of a banal existence, and also their overriding optimism.

Further away than science will ever reach, there where the arrows of reason break against the clouds, this labyrinth exists, a central point where all the forces of being and the ultimate nerves of the Spirit converge. In this maze of moving and always changing walls, outside all known forms of thought, our Spirit stirs, watching for its most secret and spontaneous movements – those with the character of revelation, an air of having come from elsewhere, of having fallen from the sky . . .

Europe crystallizes, slowly mummifies herself beneath the wrappings of her frontiers, her factories, her courts of justice, her universities. The fault lies with your mouldy systems, your logic of two plus two equals four; the fault lies with you, Chancellors... The least act of spontaneous creation is a more complex and revelatory world than any metaphysics.³²

By acknowledging the power of the 'act of spontaneous creation' Surrealism removed the veto Dada had placed on art and the necessity for the ironic Dada position; it gave the artist back his raison d'être without at the same time imposing a new set of aesthetic rules. But Artaud's appeal for the breaking down of frontiers was not met for a long time, for Surrealism did not really become international until 1936, remaining very much a French movement centred in Paris.

The Surrealist Manifesto announced Surrealism as a literary movement, mentioning painting only in a footnote. It claimed, however, to take in the whole spectrum of human activity, with the object of exploring and unifying the human psyche, embracing hitherto neglected areas of life like the dream and the unconscious. The Manifesto was as much the culmination of the two preceding years as the announcement of something totally new. It gave the following definition of Surrealism:

SURREALISM, n.m. Pure psychic automatism through which it is intended to express, either verbally or in writing, the true functioning of thought. Thought dictated in the absence of all control exerted by reason, and outside any aesthetic or moral pre-occupation.

ENCYCL. Philos. Surrealism rests on the belief in the superior reality of certain forms of association neglected until now, in the omnipotence of the dream, and in the disinterested play of thought. It aims at the definitive ruin of all other psychic mechanisms and at its substitution for them in the resolution of the principal problems of life. 33

Breton claims that the original source of his interest in automatism was Freud. He had trained as a medical student, worked at the Charcot Clinic under the neurologist Babinski, and spent some of the war in a hospital at Nantes (where he had met Vaché). Writing in the *Manifesto* of the years just after the war, he says, 'Completely occupied with Freud as I still was at that time, and familiar with his

methods of examination that I had had some occasion to practise on patients during the war, I decided to obtain from myself what one tries to obtain from them, a monologue delivered as fast as possible, on which the critical mind of the subject should not bear any judgement, which, consequently, is unhampered by any reticence, and which should be as exactly as possible spoken thought.'34 Together with Philippe Soupault he produced pages of writing in this way, which, when they came to read and compare them, astonished them by 'the considerable choice of images' it produced. 'of a quality such that we would not have been capable of producing a single one longhand'.35 The imagery, the vivacity and emotion in their writing was very similar - the differences in the texts stemming from the differences in their dispositions, 'Soupault's being less static than mine'. The Surrealists always stressed that automatism would reveal the true and individual nature of anyone who practised it, far more completely than could any of his conscious creations. For automatism was the most perfect means for reaching and tapping the unconscious. The texts that Breton and Soupault had written were published in Littérature, in 1919, under the title Les Champs Magnétiques (Magnetic Fields), and these, five years before the Manifesto, could be called the first surrealist work.

The first Manifesto is a patchwork of ideas - the definition of Surrealism stresses automatism, but a long section is devoted to dreams, which Freud had revealed to be a direct expression of the unconscious mind, while the conscious mind relaxed its control during sleep.³⁶ It would be a mistake, however, to think that because of its apparent origins in psychoanalytical theory, a spirit of scientific investigation presided over the early years of Surrealism. In spite of the homage given to Freud, it is clear that the use they made of his techniques of free association and dream interpretation was in many ways directly contrary to his intentions. 'It is up to man now to belong to himself completely, that is to say to maintain in an anarchic state the band, everyday more powerful, of his desires.'37 Wilfully to encourage man's unruly desires is to fly in the face of Freud's psychoanalysis, which aimed at curing man's mental and emotional disorders, in order to enable him to take his place in society and live, as Tzara said, in a state of bourgeois normality.

Nor were they interested primarily in the interpretation of dreams, being content to let them stand by themselves. Freud once refused to contribute to an anthology of dreams organized by Breton, saying that he could not see what a collection of dreams without the dreamer's associations and childhood memories could possibly tell anyone. What the Surrealists saw in them was the imagination in its primitive state, and a pure expression of 'the marvellous'.

Although he does not acknowledge it in the Manifesto, automatism also owed a good deal to the mediums and their 'automatic writing', and this is betrayed when Breton stresses the passivity of the subject: 'we become in our works the dumb receptacles of so many echoes, modest recording devices'.38 Both Ernst and Dali were to stress their passivity in front of their work, comparing themselves with mediums. However, when the Surrealists talk about the 'beyond' they do not mean to imply the supernatural, like the mediums' messages from the dead, but rather things which are beyond the bounds of immediate reality but which can be revealed to us by our unconscious or by our senses in a state of heightened sensibility.

A long passage in the Manifesto is devoted to the 'surrealist image'. Metaphor is natural to the human imagination, but this potential can only be realized by allowing the unconscious full play. Then, the most striking images occur spontaneously. 'Language was given to man to use in a surrealist way.' The surrealist image is born by the chance juxtaposition of two different realities, and it is on the spark struck by their meeting that the beauty of the image depends, the more different the two terms of the image are, the brighter the spark will be. This kind of image, Breton believed, could not be premeditated; the most perfect example, which they set out to rival, and which became their motto, was Lautréamont's 'As beautiful as the chance meeting on a dissecting table of a sewing machine and an umbrella.'39

Breton admitted that his own imagination was primarily verbal, but acknowledges the possibility of visual images of this kind. In fact they already existed in Ernst's collages, and as early as 1921 Breton wrote a preface to an exhibition of Ernst's in which he describes them in terms very similar to those he uses later to describe the poetic surrealist image. 40 These dada collages already promise the wild dépaysement of Ernst's later series of collages, La Femme 100 Têtes [illustration 57] and Une Semaine de Bonté, which properly belong to Surrealism.

The plastic arts are in a sense auxiliary to Surrealism, whose main interests were poetry, philosophy and politics, although it was really through them that Surrealism became known to a wide public. Within the visual arts Surrealism was one of the most voracious of all modern movements, drawing into its range the art of mediums, children, lunatics, the naïve painters, together with primitive art which reflected their belief in their own 'integral primitivism'. They played childrens' games, like the 'cadavre exquis' in which each player draws a head, body or legs, folding the paper after his turn so that his contribution cannot be seen. The strange creatures that resulted provided Miro with inspiration for his paintings.

Pierre Naville, one of the first editors of La Révolution Surréaliste, denied that such a thing as surrealist painting could exist: 'Everyone now knows there is no surrealist painting. Neither the lines of the pencil consigned to the randomness of gesture, nor the pictorial retracing of dream images, nor imaginative fantasies, of course, can be so described.

'But there are spectacles.

'Memory and the pleasure of the eyes: that is the whole aesthetic.'41 Breton answered this charge in a series of articles that appeared in La Révolution Surréaliste from 1925, discussing Picasso, Braque and de Chirico, as well as those painters who forged the strongest links between Surrealism and painting, Max Ernst, Man Ray and Masson. When the articles appeared as a book Le Surréalisme et la Peinture, in 1928, he added Arp, Miro and Tanguy. Breton does not attempt to define surrealist painting as such - he approaches the question in a different way, assessing the relationship of each painter individually to Surrealism. He avoids any real discussion of aesthetics, although he rather vaguely inscribes his argument into the context of the question of 'imitation' in art, saying that he was only interested in a painting in so far as it was a window which looked on to something, and that the painter's model should be 'purely interior'. Later, in Artistic Genesis and Perspective of Surrealism (1941),

he defines automatism and the recording of dreams as the two paths open to Surrealism.

The painters connected with the Surrealists, in fact, succeeded in maintaining a greater degree of independence from Breton's dominating personality than did surrealist writers, perhaps because painting was not Breton's own field. They could in a sense use surrealist ideas without being submerged by them, and certainly found the atmosphere generated by Surrealism very stimulating.

Ernst was perhaps the closest to the surrealist poets, particularly to Paul Eluard, and he followed Surrealism's theoretical developments with interest. In 1925 he discovered frottage, which he describes as 'the real equivalent of that which is already known by the term automatic writing'.

I was struck by the obsession that showed to my excited gaze the floor boards upon which a thousand scrubbings had deepened the grooves. I decided then to investigate the symbolism of this obsession, and in order to aid my meditative and hallucinatory faculties I made from the boards a series of drawings, by placing on them at random sheets of paper which I undertook to rub with black lead. In gazing attentively at the drawings thus obtained ... I was surprised by the sudden intensification of my visionary capacities and by the hallucinatory succession of contradictory images superimposed, one upon the other.42

This method, by which the author assists as 'spectator at the birth of his work', by-passes conscious control, and avoids questions of taste or skill. However, these pencil frottages, which use other textures as well as wood, are of an extraordinary beauty and subtlety, a combination of the passive 'seeing' activity described by Ernst and subsequent careful, delicate composition. They are filled with visual puns, as in the Habit of Leaves [illustration 59], where a wood grain rubbing becomes an enormous veined leaf, balanced between the trunks of two 'trees' which are also rubbings from planks of wood.

For Miro and Masson, automatism was to offer, in different ways, a completely new direction to their work. The two painters had adjoining studios in Paris, and one day in 1923 Miro asked Masson whether one should go to see Picabia or Breton. 'Picabia is already the past,' Masson replied, 'Breton is the future.' Masson adopted the principle of automatism wholeheartedly, and the pen and ink drawings that he started in the winter of 1923-4, just after he met Breton, are among the most remarkable products of Surrealism. The pen moves swiftly, with no conscious idea of a subject, tracing a web of nervous but unhesitating lines from which emerge images which are sometimes picked up and elaborated, sometimes left as suggestions. The most successful of these drawings have a completeness about them which comes from the unconscious working out of textural, sensual references as well as visual ones. They seem to have the organic quality that Breton had noticed in the phrases that came to him spontaneously, when half-awake, a quality he describes at greater length when discussing automatism in Artistic Genesis and Perspective of Surrealism:

In terms of modern psychological research, we know that we have been led to compare the construction of a bird's nest to the beginning of a melody which tends towards a certain characteristic conclusion. A melody imposes its own structure, in as much as we distinguish the sounds that belong to it and those that are foreign to it . . . I maintain that graphic as well as verbal automatism - without damage to the profound individual tensions which it is capable of manifesting and to some extent resolving - is the only mode of expression which fully satisfies the eye or ear by achieving rhythmic unity (just as recognizable in the automatic drawing or text as in the melody or the nest) . . . And I agree that automatism can enter into composition with certain premeditated intentions; but there is a great risk of departing from Surrealism if the automatism ceases to flow underground. A work cannot be considered surrealist unless the artist strains to reach the total psychological scope of which consciousness is only a small part. Freud has shown that there prevails at this 'unfathomable' depth a total absence of contradiction, a new mobility of the emotional blocks caused by repression, a timelessness and a substitution of psychic reality for external reality, all subject to the pleasure principle alone. Automatism leads straight to this region.43

The claims that Breton makes for automatism are exaggerated here because he was attempting to re-establish it at the expense of the 'other route offered to Surrealism, the so-called trompel'æil fixing of dream images',⁴⁴ which (he said) had been abused by Dali and was in danger of discrediting Surrealism. In fact there are, apart from Masson's drawings and certain of his 'sand' paintings, few purely automatic works – and how is one to assess anyway the degree of automatism in a drawing or painting? Various new methods of courting the unconscious were developed which involved a more mechanical kind of automatism and had the advantage of by-passing manual dexterity. These included Max Ernst's frottage, and 'decalcomania', which was invented by Oscar Dominguez. Black gouache was spread on a sheet of paper, and another sheet pressed down lightly on top, and then carefully lifted off just before the paint dried; the result should be 'unequalled in its power of suggestion' – it was 'da Vinci's old paranoiac wall carried to perfection'.⁴⁵

Masson found that too rigid an adherence to the principles of automatism led him nowhere, and by 1929 he abandoned it in favour of a return to a more ordered, cubist style. Miro, however, like Ernst, made triumphant use of automatism, to free his paintings from their earlier, tightly representational style, a legacy from Cubism which, as representing for him 'established art', Miro turned violently against ('I'll smash their guitar'). Breton said that by his 'pure psychic automatism' Miro might 'pass as the most surrealist of us all'.46 'I begin painting,' Miro said, 'and as I paint the picture begins to assert itself, or suggest itself, under my brush. The form becomes a sign for a woman or a bird as I work . . . The first stage is free, unconscious'. But, he added, 'the second stage is carefully calculated'.47 For the next few years Miro alternated between paintings in which automatism is dominant, like the Birth of the World, which he started by spreading wash 'in a random manner' with a sponge or with rags over lightly primed burlap and subsequently developed by improvising lines and flat patches of colour on it, and canvases like Personage Throwing a Stone with their biomorphic forms and sign language. These latter paintings derive from one of the first paintings he did after making contact with the Surrealists, in which fantasy is suddenly set free, The Tilled Field [illustration 61]. A landscape peopled with strange creatures is dominated on the left by a creature which is a fusion of man, bull and plough, on the right by a tree sprouting an ear and an eve. It was not just

greater technical freedom Surrealism offered Miro, through automatism, but the freedom to explore uninhibitedly his dreams, child-hood fantasies, and follow the rich vein of inspiration he found in Catalan folk art, children's art, and the paintings of Bosch.

The distinction between automatism and dreams, adhered to for instance in La Révolution Surréaliste, where separate sections are devoted to automatic texts and the recital of dreams, does not apply at all rigidly to surrealist painting. Arp, Miro, Ernst, for example, happily mix them, not only in their work as a whole, but within the same painting. Arp's paintings, reliefs and sculptures have affinities with both automatism and dreams: he talks about his 'dreamed plastic works'. His flexible morphology lends itself naturally to visual puns, relying on analogies, like the hand which is also a fork, the buds which are also breasts, which proliferated in his work during the twenties when he was in close contact with the Surrealists.

The category of surrealist works known as 'dream paintings' are really those in which an illusionistic technique predominates; they may not necessarily be records of dreams. Tanguy's paintings, for example, are dream-like, but not records of dreams, being rather explorations into an interior landscape [illustration 62]. Many surrealist paintings, however, have characteristics of what Freud calls 'dream work', for instance the existence of contrary elements side by side, the condensation of two or more objects or images, the use of objects which have a *symbolic* value (often masking a sexual meaning).

A small group of paintings by Max Ernst, dating from 1921–4, including the *Eléphant Célèbes*, *Oedipus Rex*, *Pietà or Revolution by Night*, do have the clarity and single-mindedness which might come from their being records of a vivid dream or dream image. Strongly influenced by de Chirico, they are enigmatic but irresistible images, imposing the painter's vision, or dream on the world, disrupting our sense of reality as effectively but not as violently as his collages. They are not offered us for interpretation, although indications as to their possible 'meaning' are given in the titles. Dali's paintings, on the other hand, are a deliberate dramatization of his own psychological state, so heavily abetted by his readings in

psychology that they sometimes look like illustrations to a case study by Freud or Krafft-Ebing.

Dali saw his minute, illusionistic realism as a kind of anti-art, free from 'plastic considerations and other "conneries". He joined the Surrealists in 1929, at a time when the movement was torn by personal and political conflicts. For the next few years he provided it with a new focus, not only in painting, but also through his other activities like the film *Le Chien Andalou* (1929) which he made with Buñuel. But by 1936 the cynical way in which he publicized himself, combined with his total political indifference at a time when the Surrealists were mobilizing themselves for positive action, proved too damaging and he was purged from the movement.

Dali's paintings parade his obsessive fear of sex, leading to onanism and the threat of castration. (He did a series of paintings of William Tell whose legend he interprets as a castration myth.) The work does not provide a key to his unconscious, for he has done all the work of interpretation himself, and we are presented with a conscious and possibly dubious description. If one compares de Chirico's paintings before 1917, which held a powerful attraction for all the Surrealists, with Dali's, one sees the difference between the unconscious sexual symbolism of the towers and arcades in de Chirico's work which reinforces their enigmatic, hallucinatory quality and Dali's heavily obvious symbolism, for instance the recurring image of the woman's head which is also a jug, a reference to the Freudian commonplace of the container symbolic of woman.

Dali said that the only difference between himself and a madman was that he was not mad. The paranoia which he claimed was responsible for his double images has little or nothing to do with medical paranoia. The paranoiac-critical activity was an adaptation of Ernst's frottage method, which had called the artist's visionary capabilities into play. It involved the ability to see two or more images in one configuration, for instance in Slave Market with the Disappearing Bust of Voltaire [illustration 63], the heads of people in black with white ruffs in the centre of the picture are also the eyes of the philosopher's bust. The method was based on the 'sudden power of systematic associations proper to paranoia', and was 'a spontaneous method of irrational knowledge'. 49 'I believe', Dali

said, 'that the moment is near when by a procedure of active paranoiac thought it will be possible to systematize confusion and contribute to the total discrediting of the world of reality.'

Dali's paintings are disturbing, but not as truly disruptive as those of Magritte. Magritte's paintings are argumentative; they question one's assumptions about the world, about the relationship between a painted and a real object, and they set up unforeseen analogies or juxtapose completely unrelated things in a deliberately deadpan style, which has the effect of a slow fuse. They do not have a meaning in the sense that an argument is resolvable. In The Human Condition 1 [illustration 64], for instance, an easel stands in front of a window holding what looks like a pane of glass, because on it is an exact continuation of the landscape seen through the window. However, the 'glass' juts over the side of the curtain, and it is shown to be solid, in fact a painting on canvas. Thus it is a painting within a painting and although the illusionism is really quite crude, a powerful tension is set up between our recognizing the fidelity of the landscape on the canvas to the 'real' landscape and the knowledge that they are both merely painted. Magritte plays many, and more complex variations on this kind of idea.

Surrealist activity in the realm 'beyond' painting is very diverse, but the most extensive and richest field for invention was the surrealist object which dominated the International Exhibition of Surrealism in Paris in 1938. This exhibition marked the apogee of Surrealism before the war. It aimed at the creation of a total environment, and the result was magnificently disorientating. The effect was that, to adapt Rimbaud's phrase, of a salon at the bottom of a mine.50 Duchamp, who organized the decor, hung twelve hundred sacks of coal from the ceiling; dead leaves and grass covered the floor around a pool fringed with reeds and ferns, a charcoal brazier burned in the centre, and in the corners were huge double beds. At the entrance to the exhibition stood Dali's Rainy Taxi, an abandoned vehicle with ivy growing over it, and the dummies of the driver and an hysterical woman passenger inside, showered with water and crawled over by live snails. A 'surrealist street' led to the main hall lined with female mannequins 'dressed' by Arp, Dali, Duchamp, Ernst, Masson, Man Ray and others. Inside

were assembled as well as many paintings such surrealist objects as Meret Oppenheim's breakfast cup and saucer lined and covered in fur, and Dominguez's *Jamais*, a huge gramophone with a pair of legs sticking out of the trumpet and a woman's hand replacing the pick-up head.

The war dispersed the Surrealists from Paris. Many of them, including Breton, Ernst and Masson, went to New York, where they continued surrealist activities, helping to sow the seeds of post-war American movements like Abstract Expressionism and Pop Art, and attracting into their orbit Roberto Matta and Arshile Gorky. They returned to France after the war, but Surrealism was no longer the most dominant movement in art, although it could not end as long as Breton was alive. Breton, the prime mover of Surrealism, died in 1966, but many of the ideas behind Surrealism still have a generative force. Because the term 'surrealism' is used so freely now, having passed into common currency rather as 'romantic' did, it might be useful to recall the aim of Surrealism: 'Everything suggests that there exists a certain point of the mind at which life and death, the real and the imaginary, the past and the future, the communicable and the incommunicable, the heights and the depths, cease to be perceived contradictorily. Now it is in vain that one would seek any other motive for surrealist activity than the hope of determining this point.'51 It aimed not at the opposition of the apparently contradictory states, for instance of dream and waking life, but at their resolution into a state of sur-reality (beyond reality), and this is what is achieved by the best of visual Surrealism.

Notes

- 1. Hans Richter, Dada, Art and Anti-Art, London, 1965, p. 13.
- 2. Press announcement 2 February 1916, ibid., p. 16.
- 3. Hugo Ball, Flucht aus der Zeit, Munich, 1927, (trans. in Transition, no. 25, Paris, 1936).
- 4. Richard Huelsenbeck, *Dada Lives!* 1936, (in Motherwell (Ed.) *Dada Painters and Poets*, New York, 1951, p. 280). This account is disputed by Tzara, who claims *he* found the word, as is the meaning, which is variously suggested to be French for hobbyhorse, or Rumanian (da, da) for yes.

- 5. In Motherwell, ibid, p. 235. First published in Berlin, *Dada Almanach*, 1920.
 - 6. André Breton, 'Dada Manifesto', Littérature May 1920, no. 13.
- 7. Richard Huelsenbeck En Avant Dada: A History of Dadaism, 1920, in Motherwell, ibid., p. 21.
 - 8. Hugo Ball, op. cit.
- 9. Tristan Tzara, *Dada Manifesto 1918*, first published in *Dada 3*, Zurich, December 1918.
 - 10. Richard Huelsenbeck, En Avant Dada.
- 11. Tristan Tzara, 'Proclamation without Pretension', Seven Dada Manifestos, Paris, 1924.
- 12. Jacques Vaché, *Lettres de Guerre*, Paris, 1919. This quotation is from a letter to Breton, 18 August 1917. He left no other works, and his myth was largely fostered by Breton.
- 13. Marcel Duchamp, The Bride Stripped Bare by her Bachelors, Even, typographic version of Duchamp's notes in the Green Box by Richard Hamilton, London, 1960. (The notes dated from 1912–23.)
 - 14. Hugo Ball, op. cit.
 - 15. Hans Arp, 'Dadaland ' $On\ My\ Way,$ New York, 1948, p. 39.
- 16. Hans Arp, 'I become more and more removed from aesthetics', ibid, p. 48.
 - 17. Hans Arp, Die Wolkenpumpe, Hanover, 1920.
 - 18. Hugo Ball, op. cit.
- 19. Hausmann avoided words altogether, using only letters to create what he called a rhythm of sounds, to make 'lettrist' poems.
 - 20. Hans Arp, 'Dadaland', op. cit.
 - 21. Hans Richter, op. cit., p. 77.
- 22. Picabia also wrote L.H.O.O.Q. on Duchamp's bearded Mona Lisa.
 - 23. Francis Picabia, Jesus-Christ Rastaquouère, Paris, 1920, p. 44.
- 24. Marcel Duchamp, statement at *The Art of Assemblage: A Symposium*, Museum of Modern Art, New York, 9 October 1961.
- 25. Gabrielle Buffet, quoted by Picabia in *Jesus-Christ Rastaquouère*, p. 44.
- 26. It is interesting to compare Duchamp's use of chance, where it is a means of avoiding logical order and personal taste, with Arp's, where as an aspect of automatism it takes on a more mystical significance, 'I... gave myself up to an automatic execution. I called it "working according to the law of chance", the law which contains all others, and is unfathomable, like the prime cause from which all life springs, and

which can only be experienced by total abandonment to the unconscious.' ('And so the circle closed', On My Way, p. 77.)

- 27. Only after Duchamp's death in 1968 was it revealed that he had been working for twenty years on a major work, Etant Donné: 1° La Chute d'Eau, 2° Le Gaz d'Eclairage, 1946–66, which consists of a room, which the spectator cannot enter, in which are a nude, (model), and a brilliantly illuminated landscape, the whole thing being a complex illusion, impossible to describe in such a short space.
 - 28. Richard Huelsenbeck, En Avant Dada.
 - 29. André Breton, Dada Manifesto, op. cit.
- 30. Hans Arp, letter to M. Brzekowski, 1927, in L'Art contemporain, no. 3 (1930?)
- 31. Louis Aragon, *Une Vague de Rêves*, privately printed, Paris, 1924.
- 32. Antonin Artaud, in *La Révolution Surréaliste*, no. 3, April 1925. Most of this issue was devoted to praise of Eastern values and ideas.
- 33. André Breton, Manifeste du Surréalisme, Paris, October, 1924 in Manifestes du Surréalisme, Paris, 1962, p. 40.
 - 34. ibid, p. 36.
 - 35. ibid, p. 37.
 - 36. Freud's Interpretation of Dreams was published in 1900.
 - 37. André Breton, Manifeste du Surréalisme, p. 31.
 - 38. ibid., p. 42.
- 39. Isidore Ducasse, Comte de Lautréamont, Chants de Maldoror (chant sixième), Paris, 1868-74.
- 40. 'It is the marvellous faculty of attaining two widely separate realities without departing from the realm of our experience, of bringing them together and drawing a spark from their contact; of gathering within reach of our senses abstract figures endowed with the same intensity, the same relief, as other figures; and of disorienting us in our own memory by depriving us of a frame of reference it is this faculty which for the present sustains Dada.' Reprinted in *Beyond Painting* (see n. 42).
 - 41. Pierre Naville in La Révolution Surréaliste, no. 3.
- 42. Max Ernst, Beyond Painting, (trans. Dorothea Tanning), New York, 1948, p. 7.
- 43. André Breton, Artistic Genesis and Perspective of Surrealism, 1941, Le Surréalisme et la Peinture, new edn., Paris, 1965, p. 68.
 - 44. ibid, p. 70.

- 45. Breton, 'D'une décalcomanie sans objet préconçu (Décalcomanie du desir),' 1936, in Le Surréalisme et la Peinture, op. cit., p. 127.
 - 46. André Breton, Le Surréalisme et la Peinture, op. cit, p. 37.
- 47. Quoted in James Sweeney, 'Joan Miro: Comment and Interview', Partisan Review, New York, February 1948, p. 212.
- 48. Salvador Dali 'L'Ane pourri', Le Surréalisme au service de la Révolution, Paris, 1930, vol. 1, no. 1, p. 12.
- 49. Salvador Dali, The Conquest of the Irrational reprinted in The Secret Life of Salvador Dali, 1942, p. 418.
- 50. 'I accustomed myself to simple hallucination: I saw quite deliberately a mosque in place of a factory, a drummers' school attended by angels, carriages on the highways of the sky, a salon at the bottom of a lake; Rimbaud, Une Saison en Enfer, quoted by Ernst in Beyond Painting, p. 12.
- 51. André Breton, Deuxième Manifeste du Surréalisme, Paris, 1930, in Manifestes du Surréalisme, op. cit., p. 154.

SUPREMATISM

Aaron Scharf

Suprematism is not so much a movement in art as it is an attitude of mind which seems to reflect the ambivalence of contemporary existence. It was almost a one-man performance. Kasimir Malevich (1878–1935) was its guiding spirit. It appeared about 1913 in Russia. To express 'the metallic culture of our time' was Malevich's intention; not by imitation, but by creation. Malevich disdained the traditional iconography of representational art. His elemental forms were designed both to break the artist's conditioned responses to his environment and to create new realities 'no less significant than the realities of nature herself'.

Malevich's geometry was founded on the straight line, the supremely elemental form which symbolized man's ascendancy over the chaos of nature. The square, never to be found in nature, was the basic suprematist element: the fecundater of all other suprematist forms. The square was a repudiation of the world of appearances, and of past art. In 1915, along with other such fundamentalist canvases, his painting of a black square on a white ground was first exhibited in Petrograd, then the capital of Russia. But it was not merely a square and Malevich was annoyed with the intransigence of critics who failed to grasp the true nature of that almighty form. Empty? It was not an empty square, he insisted. It was full of the absence of any object; it was pregnant with meaning.

Furthermore, it is not in the paintings but in the small drawings of suprematist elements, made by Malevich between 1913 and 1917, that reside the more subtle implications of Suprematism [illustration 65]. Not black, but grey, they were carefully and deliberately shaded in with a pencil. The square and its permutations: the cross, the rectangle, were meant to show the signs of the hand – an assertion of the human agency – and this is central to the philosophy of Suprematism. But although the geometric forms were intended to convey the supremacy of mind over matter, it was also essential that they demonstrate another quality. Why have I blackened my

square with a pencil? asked Malevich. 'Because that is the humblest act the human sensibility can perform.'

Of what significance, then, are the empty white fields in which suprematist forms hover? [illustration 66]. They represent the illimitable reaches of outer space; more so, of inner space. The blue of the sky, the blue of tradition, that coloured canopy blinding his view to infinity had, Malevich believed, to be torn apart. 'I have broken the blue boundary of colour limits,' he proclaimed. 'I have emerged into white. Beside me, comrade pilots, swim in this infinity. I have established the semaphore of Suprematism. Swim! The free white sea, infinity, lies before you.' This cosmic transcendentalism echoes the metaphysical lingo of Wassily Kandinsky and the theosophical speculations of the legendary Madame Blavatzky whose germinal spirits loom large behind Malevich.

Art. Malevich believed, was meant to be useless. It should never seek to satisfy material needs. The artist must maintain his spiritual independence in order to create. And though, like many of his fellow artists in Russia, Malevich welcomed the 1917 Revolution, he never subscribed to the belief that art should serve a utilitarian purpose, geared to the machine and to social and political ideologies. He opposed the artist's subservience to the State as much as he rejected the obedience to natural appearances. The artist must be free. The State, he protested, creates a structure of reality which becomes the consciousness of the masses. Thus, the consciousness of the individual is shaped by those who support the organism of the State. Rejecting any kind of propagandist art, he maintained that those who succumb to this regimenting power, are called loyal supporters of the State. Those who retain their individuality, their subjective consciousness, are looked upon with suspicion and treated as dangerous.

He repudiated any marriage of convenience between the artist and the engineer. That idea, which had taken root in Europe in the first two decades of this century, was greatly enhanced by the exigencies of the Russian Revolution. Artists and scientists, he insisted, create in totally different ways. And while truly creative works are timeless, the inventions of science and technology are transitory. If Socialism, he warned, relies on the infallibility of science and

technology, a great disappointment is in store for it. Works of art are manifestations of the subconscious mind (or superconscious as he called it) and that mind is more infallible than the conscious. Notwithstanding the explicit expression of these views, Malevich continued to work and teach in Russia, though with dwindling importance, until his death in 1935 when he was buried in a coffin which he had covered with suprematist forms.

In the light of Malevich's declarations it is evident that not only did Suprematism reflect the material essence of the man-made world, but it also communicated a yearning for the inexplicable mystery of the universe. Though reduced to simple geometric forms, Malevich's compositions sometimes appear to be almost literal references to real objects: aeroplanes in flight, architectural clusters as though seen from above. In works like Suprematist composition expressing the feeling of wireless telegraphy (1915) the dots and dashes of the international code are employed directly. On to the tabula rasa he places forms which communicate feelings about the universe and about space: impressions of sounds, Composition of combined suprematist elements expressing the sensation of metallic sounds (1915), of magnetic attraction, of mystic wills and mystic waves, Suprematist composition conveying the feeling of a mystic 'wave' from outer space (1917).

His most notorious painting, Suprematist Composition: White on White (c. 1918), a tilted white square on a white background, has been interpreted in many ways [illustration 67]. We do not really know what it was Malevich intended to represent. But in the context of his other work and considering his own statements, it is not too audacious to assume that it was meant to convey something like the final emancipation: a state of nirvana, the ultimate statement of suprematist consciousness. The square (man's will, man perhaps?) sheds its materiality and merges with infinity. A faint vestige of its presence (of his presence) is all that remains.

DE STIJL

The Evolution and Dissolution of Neoplasticism: 1917–31 Kenneth Frampton

'Art is only a substitute while the beauty of life is still deficient. It will disappear in proportion, as life gains in equilibrium.'

Piet Mondrian

The De Stijl or Neoplastic movement which lasted as an active force for barely fourteen years, from 1917 to 1931, may be essentially characterized in the work of three men, the painters Piet Mondrian and Theo van Doesburg and the architect Gerrit Rietveld. The other seven members of the original, rather nebulous group of nine formed under Van Doesburg's leadership in 1917 and 1918, that is the artists, Van der Leck, Vantongerloo and Huszar and the architects, Oud, Wils and Van't Hoff, and the poet Kok are all to be seen in retrospect as catalytic but relatively marginal figures, who although they played essential roles, did not in fact produce works, either actual or theoretical, which were eventually to become central to the mature style of the movement. It was, in any event, initially a loose union which was bonded together formally by the mutual appearance of most of these artists as signatories of the first De Stijl manifesto published under Van Doesburg's editorship, in the first issue (of the second year) of the De Stijl magazine that appeared in November 1918. This group was in a constant state of flux and at least one foundation member Bart van der Leck¹ was to disassociate himself from it within a year of its foundation and others such as Rietveld were recruited in the subsequent years as replacements.

The De Stijl movement came into being as the conflation of two related modes of thought. These were, firstly the Neo-Platonic philosophy of the mathematician Dr Schoenmaekers who published in Bussum, in 1915 and 1916 respectively, his influential works entitled The New Image of the World (Het neiuwe Wereldbeeld) and The Principles of Plastic Mathematics (Beeldende Wiskunde) and

secondly the 'received' architectural concepts of Hendrik Petrus Berlage 2 and Frank Lloyd Wright.

As the Dutch art historian H. L. C. Jaffé has stated, it must be acknowledged that it was Schoenmaekers who virtually formulated the plastic and philosophical principles of the De Stijl movement when, in his book *The New Image of the World*, he referred to the cosmic pre-eminence of the orthogonal as follows: 'the two fundamental complete contraries which shape our earth are: the horizontal line of power, that is the course of the earth around the sun and the vertical, profoundly spatial movement of rays that originates in the centre of the sun'...³ and again later in the same work he wrote of the De Stijl primary colour system: 'The three principal colours are essentially, yellow, blue and red. They are the only colours existing... Yellow is the movement of the ray... Blue is the contrasting colour to yellow... As a colour, blue is the firmament, it is line, horizontality. Red is the mating of yellow and blue ... Yellow radiates, blue "recedes", and red floats.'

This is very different from the Weltanschauung of Frank Lloyd Wright who pragmatically emphasized the horizontal as the 'line of domesticity', the contrasting line of the prairie against which 'inches in height gain tremendous force'. Nonetheless Wright also evoked a totally homogenous man-made world when in his introductory text to the first Wasmuth volume on his work he wrote: '...it is quite impossible to consider the building one thing and its furnishings another... Heating apparatus, lighting fixtures, the very chairs and tables, cabinets and musical instruments, where practical are of the building itself'; and later of the role of art in relation to architecture, 'to thus make of a dwelling place a complete work of art in itself, as expressive and beautiful and more intimately related to life than anything of sculpture or painting... this is the modern American opportunity.'4

Wright's idea of such an architecture had already been disseminated throughout Europe by the publication in German of the two famous Wasmuth volumes on his work in the years 1910 and 1911. Thus these two related but independent poles of thought, as epitomized in the writings of Schoenmaekers and Wright, were publicly available by 1915. The appearance of Mondrian's first strictly

post-cubist compositions, consisting almost exclusively of broken horizontal and vertical lines [illustration 70], virtually coincided with the artist's return from Paris to Holland in July 1914 and with a time that he subsequently spent in Laren in almost daily contact with Schoenmaekers. For the direct in-put of the other 'pole' we have the architect Robert Van't Hoff, who after a pre-war sojourn in the States, realized in his Huis-ter-Heide in 1916, a remarkable early reinforced concrete villa, built to his own designs in a derivative Wrightian style ⁵ [illustration 72]. Paradoxically neither Schoenmaekers nor Van't Hoff were to play significant roles in the movement after 1917. They had, by then, as it were, already served their purposes. The ideas that they had respectively engendered and demonstrated were promptly absorbed and transformed after the war by the central figures of the movement, that is by Mondrian, Van Doesburg and Rietveld.

Two other peripheral figures were to play catalytic but short-lived roles during this immediate post-war period. One was the Belgian artist, George Vantongerloo and the other was the irascible Dutch pioneer Abstractionist, Bart van der Leck. Their respective contributions now seem to have been crucial, for, without them, one seriously questions whether the main line De Stijl artists would have been able to develop their characteristic aesthetic with such immediate conviction; that is to pass from their early gropings of 1917 to their mature style of 1923 in a period of only six years. It is obvious for example that Van Doesburg's famous abstraction of a cow of 1916–17 owes much to Van der Leck, while Vantongerloo's sculpture, Interrelation of Masses of 1919 [illustration 69], clearly anticipates in general forms the aesthetic of mass which is to be utilized by Van Doesburg and Van Esteren in their Artist House and Rosenberg House projects of 1923.

The aesthetic and programmatic development of the De Stijl movement may be broken down into three phases. The first phase from 1916 to 1921 is formative and essentially centred upon Holland with some outside participation; the second phase from 1921 to 1925, is to be regarded as a period of maturity and of international dissemination; while the third phase from 1925 to 1931 must be seen as a period of transformation and of ultimate disintegration.

Mondrian's own position with regard to De Stijl's development is an important touchstone in determining the characters of each of these phases. As a consequence of his stoic and singularly serious attitude Mondrian was always able to maintain a certain detachment from the immediacy of the world around him. It was the already theosophically inclined Mondrian⁶ who forged in Laren, in 1914, the initial link between the 'movement to be' and the ideas of Schoenmaekers.⁷ Similarly it was again Mondrian who established the fruitful connection with Bart van der Leck in Leyden, in 1916; an artist by whom both he and Van Doesburg were immediately influenced. Once again it was Mondrian who finally broke both with De Stijl and Van Doesburg in 1925, over the latter's 'arbitrary' modification of the orthogonal format pre-ordained by Schoenmaekers.

1916 - 21

Apart from Robert Van't Hoff's villa Huis-ter-Heide completed in 1916, it is painting, sculpture and cultural polemic that largely determines and informs De Stijl activity during its first phase, that is up until 1921. In spite of his early collaboration 8 with Van Doesburg, J. J. P. Oud, who became Rotterdam's City Architect in 1918 at the precocious age of 28, was never, it must now be recognized, wholeheartedly affiliated with the movement - neither formally by virtue of his abstention from the first manifesto, nor intellectually, as an architect, in his own subsequent work. A strong predilection for symmetry or repeated symmetrical systems is evident in Oud's work certainly up until 1921, when he severs all public ties with the movement. The frequently cited exception to this is his Purmersand Factory project of 1919, where a plethora of asymmetrical elements are awkwardly placed against an otherwise symmetrical façade. Jan Wils, for his part, the third architect member of the 1917 group and a manifesto signatory, continued to work in an equally lugubrious Wrightian style, until he left the movement late in 1921. Thus there was no De Stijl architecture strictly speaking before 1920, when it made its first tentative appearance in the interior designs of Gerrit Rietveld. Indeed it was primarily Rietveld, under

the influence of Van Doesburg and (indirectly) Mondrian, who first developed the architectural aesthetic of the movement as a whole.

The years 1915 and 1916 saw Mondrian in Laren, in frequent contact with Schoenmaekers. During this period he produced virtually no painting at all but wrote instead his basic theoretical essay, entitled Neoplasticism in Painting, which first appeared as 'De Nieuwe Beelding in de Schilderkunst' in 1917-18 in the first twelve numbers of the De Stijl magazine and which was afterwards reworked twice, in both French and English. First as Le Néo-Plasticisme published in 1920 and then as Plastic Art and Pure Plastic Art published in 1937.9 By 1917 Mondrian is at an intellectually new point of departure in which his work comprises a series of compositions consisting of floating, rectangular coloured planes [illustration 73]. He has at this juncture abandoned for good, both the painterly palette and technique of his 1912 to 1913 post-cubist period and also the nervous staccato linearity and elliptical format of his 'plus-minus' or 'oceanic' style of 1913 to 1914 [illustration 70]. In 1917, both Mondrian and Bart van der Leck arrive at separate formulations of what they each consider to be a totally new and 'pure plastic'9 order, with Van Doesburg tentatively following in their wake. However, Mondrian at this date is still preoccupied with the generation of shallow spatial displacements, through the literal and phenomenal overlapping of his coloured planes 11 (blue, pink and black), whereas his two colleagues Van der Leck and Van Doesburg are more concerned with the structuring of the picture plane itself. This they achieve through a hidden geometrical ordering of narrow bars of colour (pink, yellow, blue and black) set within a dominant white field. Van Doesburg's 'cow' abstract dates from this period as does his Rhythm of a Russian Dance [illustration 75] of one year later, i.e. 1918; both works being influenced by Van der Leck. This is in contrast to Van der Leck's own Geometrical Composition No. 1 [illustration 74] and Mondrian's Composition in Blue, A [illustration 73] which are parallel definitive neoplastic works of the previous year.

Nineteen-seventeen is also the year of the famous red-blue chair ¹² designed by Gerrit Rietveld [illustration 76]. This simple piece of furniture, obviously derived, as a type, from the Victorian folding

bed-chair, provided the first opportunity for a projection of the barely formed Neoplastic aesthetic into 'actual' three dimensions. In its form, the bars and planes of Van der Leck's and Van Doesburg's compositions were realized for the first time as articulated and displaced elements in space. What is remarkable about this chair, apart from its open articulation, is the exclusive use made of primary colours in conjunction with a black linear frame; a combination which, with grey and white added, was to become the canonical colour scale of the De Stijl Movement.¹³ It is surprising that Rietveld, the 'outsider', should have been the first to establish this neoplastic colour scheme, as neither Van Doesburg nor Mondrian were restricting themselves to primary colours at this date. Bart van der Leek was apparently the only painter solely working in primaries at this time. With this chair Rietveld also demonstrated for the first time an open architectonic spatial organization which was not only appropriate to the broader cultural programme of the movement, but also an aesthetic manifestly free from the influence of Wright. It still predicated a Gesamtkunstwerk but one totally free from the biological 'form-forces' 14 of nineteenth-century Synthetic-Symbolism; that is from the gestural and textural expressiveness of the late Art Nouveau.

Surely few, if any, of Rietveld's immediate colleagues would have been able to foresee the full aesthetic potential of the modest pieces of 'elemental' furniture that he produced in the years between 1918 and 1920, the buffet, the baby-cart, the wheelbarrow, etc. Although all of these so-called elemental pieces were built up almost entirely out of pure un-morticed rectilinear elements (that is of articulated wooden spars and planes simply dowelled together) none of them even began to suggest the fully three-dimensional coordinate system which was to be at once apparent in Rietveld's design for Dr Hartog's study, realized at Maarssen in 1920 [illustration 78]. In this work each piece of furniture, including the suspended light fitting, was fully 'elementarized' 15 as it were, and the effect was at once to suggest an infinite series of planes in space, both horizontally and vertically. From this design to the acknowledged master work of the De Stijl Movement, the Schröder house built in Utrecht in 1924, was (with the encouragement of Van Doesburg) but one further step away. This step was Rietveld's so-called Berlin Chair [illustration 80] which, painted in tones of grey, was designed in 1923. This was Rietveld's first totally asymmetrical piece of furniture, and it ushered in a whole series of fully asymmetrical pieces during the next two years; an end table, a stacking cabinet, and a metal table light. As Theodore Brown has observed, Rietveld had 'literally sketched the model of the space construction of the Schröder house' in his Berlin Chair of 1923. In Rietveld's work the evolution of the neoplastic architectonic style is almost directly observable. There are four generic pieces and these, ranged in evolving sequence, are the red-blue chair of 1917, Dr Hartog's study of 1920, the Berlin Chair of 1923 and the Schröder House of 1924.

By the end of the year 1921, the original composition of the De Stijl group had radically altered. Van der Leck, Vantongerloo, Van't Hoff, Oud and Kok had by then all resigned. Immediately after the armistice, Mondrian had re-established himself in Paris. Rietveld had begun to build his practice in Utrecht, while for his part, Van Doesburg had started to proselytize the 'style' abroad in its as yet undeveloped state. The fresh blood brought into De Stijl in 1922 reflected Van Doesburg's post-war international orientation. Of the new members of that year only one was Dutch, the architect Cor van Esteren. The others were Russian and German respectively; the architect El Lissitzky and the film maker Hans Richter. It was at Richter's invitation that Van Doesburg first visited Germany in 1920 and from this visit followed an official invitation from Walter Gropius to come to the Bauhaus in the following year. This subsequent visit of 1921, engendered a local scandal, the repercussions of which have since become legendary.

On Van Doesburg's arrival in Weimar he immediately took up a line of attack against the individualistic, expressionist and mystical approach prevalent in the Bauhaus at that time; subject as it then was to the overwhelming didactic presence of Johannes Itten. Faced with a predictably hostile reception Van Doesburg opened his own atelier adjacent to the school, where he gave courses in painting, sculpture and architecture. The student response appears to have been immediate and enthusiastic and Gropius was compelled to take a stand and issue an edict forbidding all students to

attend Van Doesburg's courses. Van Doesburg wrote to the poet Anthony Kok,

I have radically turned everything upside down in Weimar. That is the most famous Academy, which now has the most modern teachers! Every evening I spoke to pupils there and everywhere I scattered the poison of the new spirit. The 'style' shortly will appear again, more radical. I have any amount of energy and I now know that our ideas will triumph: above all and everything.¹⁷

Despite Gropius's sanction the struggle continued unabated throughout 1922 and into 1923, when after staging a major exhibition at the Landes Museum in Weimar, Van Doesburg left with Cor van Esteren to establish a new work centre in Paris. In spite of this, the impact of Van Doesburg's ideas upon the Bauhaus, student body and faculty alike, was both immediate and very marked. One Bauhaus design after another, subsequent to Van Doesburg's visit, testifies to his influence and even Gropius who under the circumstances had cause to be apprehensive of such charisma, designed in 1923, a suspended light [illustration 77] for his own study, which has undeniable affinity with the Rietveld fitting designed for Dr Hartog [illustration 78]. More important, however, for the development of De Stijl was Van Doesburg's meeting (once again no doubt through Richter) with his Eastern European counterpart, the Russian graphist, painter, and architect, Eliezar Lissitzky.

1921-5

As a result of this meeting the second phase of De Stijl development from 1921 to 1925 is increasingly subject to the pervasive influence of Lissitzky's elementarist outlook. Although Jaffé is more inclined to attribute this change in orientation to Van Esteren's entry into De Stijl at this time, all the evidence suggests that both Van Doesburg and Van Esteren fell under Lissitzky's influence, for on his own Cor van Esteren appears at this date to have been a rather conservative designer. By 1920 Lissitzky had already developed, in Vitebsk, with his suprematist mentor, Malevich, his own notion of an elementarist 19 architecture. This conjunction of two

very similar but not identical, architectonic concepts suprematistelementarism and neoplastic-elementarism, each evolved independently of the other, is certainly a neglected incident of crucial import to the history of twentieth-century applied art. Van Doesburg's work, in any case, was never the same after his initial encounter with Lissitzky in 1921. No further evidence is needed than the drawings that he and Van Esteren began to produce in the following year - axonometrics or hypothetical architectural constructs in which major planar elements engender a shoal of secondary planes which nebulously appear to float in space about their respective centres of gravity [illustration 83]. These works can surely only be seen as a direct De Stijl response to the challenge of the spatially evocative Proun¹⁹ style invented by El Lissitzky in 1920. Van Doesburg was so captivated by this style that he sought at once to incorporate it into the De Stijl spectrum of thought. Thus Lissitzky became a member of De Stijl in 1922, and Van Doesburg republished on this occasion in De Stijl 6-7 Lissitzky's famous typographic children's tale of 1920 The Story of Two Squares. Furthermore Van Doesburg's 'constructivist' 20 cover design for the De Stijl magazine after 1920 [illustration 71] is in marked contrast to the Huszar covers of the period 1917 to 1920 [illustration 68]. This change represents a conscious shift from a black woodcut logotype and a classical layout to an 'elemental' aesthetic more suitable to over-printing and standard modern type-setting technique.

In 1923 Van Doesburg and his most recent collaborator, the Dutch architect Cor van Esteren, managed to publicly crystallize the architectural style of Neoplasticism through an exhibition of their joint work which was displayed at Léonce Rosenberg's Galerie de l'Effort Moderne in Paris. This show was an immediate success and in consequence was re-staged elsewhere in Paris and later in Nancy. It comprised, apart from the axonometric studies previously mentioned, their Rosenberg House project (model and plans) and, in addition, two other seminal works, their study for the interior of a university hall [illustration 84] and their project for an Artist's House.

At the same time in Holland, Huszar and Rietveld collaborated on the design for a small room to be built as part of the Grosse-Berliner Kunstausstellung of 1923 – Huszar designing the environment and Rietveld the furniture, including the important Berlin Chair. Simultaneously of course Rietveld was working with Madame Schröder on the design and detailing of the Schröder House [illustrations 79 and 81]. It must be emphasized that this house was a collaborative effort – the client Mrs Trus Schröder-Schräder afterwards becoming a member of De Stijl.

With this sudden output of work, almost exclusively architectural, the neoplastic-architectonic style became crystallized. Its broad principles were at once recognizable. A dynamic asymmetrical arrangement of articulated elements throughout; the spatial explosion of all internal corners as far as possible; the use of low relief coloured rectangular areas to structure and modulate internal spaces, and of course finally the adoption of primary colour for the purposes of effecting accentuation, articulation, recession, etc. The 1924 Schröder House, built on the end of a late nineteenth-century suburban terrace, was in most respects a direct building out of Van Doesburg's 16 Points of a Plastic (Beeldende) Architecture published at the time of its completion. ²¹

The top floor and the main living level of this two-storey house, with its 'open-transformable' plan [illustration 79], intrinsically exemplifies Van Doesburg's main points (nos. 7–16) where he declares the new architecture to be first and foremost a dynamic architecture of open skeletal construction – free from encumbering walls which carry loads and from oppressive openings in such walls which appear as unnecessarily constricted apertures. His prime point no. 11 reads as follows:

The new architecture is anti-cubic, that is to say, it does not try to freeze the different functional space cells in one closed cube. Rather it throws the functional space cells (as well as overhanging planes, balcony volumes, etc.) centrifugally from the core of the cube. And through this means, height, width, depth and time (i.e. an imaginary four dimensional entity) approaches a totally new plastic expression in open spaces. In this way architecture acquires a more or less floating aspect that, so to speak, works against the gravitational forces of nature.

In all evident respects the Schröder House fulfilled Van Doesburg's sixteen-point specification; it was in turn elementary,

economic, functional and without precedent. Equally it could be seen as unmonumental and dynamic; as anti-cubic in its form and anti-decorative in its colour. Yet however ingeniously it contrived to appear otherwise it was, in fact, both for technical and financial reasons, finally executed as a traditional brick and timber structure and not as the ideal technical-skeletal system postulated by Van Doesburg.

1925-31

The third phase of De Stijl activity from 1925 onwards is one of postneoplastic development accompanied by disintegration. At the outset there is the dramatic rift between Mondrian and Van Doesburg over the latter's introduction of the diagonal into his works of 1924. This conflict caused Mondrian's resignation from the group 22 and Van Doesburg's subsequent nomination of Brancusi to replace Mondrian, as the elder of the 'cause'. But clearly the initial unity of the group has now been totally vitiated; in spite of and perhaps even because of Van Doesburg's polemical activity. For it is Van Doesburg himself who has been affected by left wing anti-art constructivist concepts, in which social forces and the means of technical production are seen as spontaneously determining form, independent of any concern for the 'ideal' forms of a universal harmony, that is for the formal world of a Gesamtkunstwerk, to which all other secondary forms must subscribe. Van Doesburg was prescient enough, in any case, to realize that such a Gesamtkunstwerk ideal could only result in an arbitrary, artificially delimited culture - hermetically sealed off from the 'banal' production objects of everyday life. Such a culture would in any case eventually become inherently antipathetic to the programmatic De Stijl concerns (subscribed to even by Mondrian) for the unification of art and life.

Van Doesburg appears to have accepted in his own work at least, a Lissitzkian solution to this dilemma.²³ This was to separate out, one from the other, the various modes of operation and the consequent forms technically and artistically engendered at the various scales of the built environment. Thus furniture, fittings, instruments and utensils, 'spontaneously' engineered by the society at large

could be accepted as the ready-made type objects of the culture whereas at the macro level, the space containing such objects still required to be modulated and ordered by a conscious aesthetic act. This view Van Doesburg formulated, in extreme (and for him), somewhat inconsistent anti-art terms, in his essay (written with Van Esteren) entitled Towards a Collective Construction published in 1924, in which the authors speak of achieving a more objective, technical and industrial solution to the problem of architectural synthesis. Here one reads under the seventh point of the manifesto statement accompanying the text, the following: 'We have established the true place of colour in architecture and we declare that painting, without architectural construction (that is, easel painting) has no further reason for existence.' 24 This was the polemic that was to inform Van Doesburg's last major work, the powerful interior that he was to design and realize for the Café L'Aubette in Strasbourg in 1928.

Rietveld had little direct professional association with Van Doesburg after 1925. Nonetheless, his work developed in a very comparable direction, that is gradually away from the 'elementarism' of the Schröder house and of his ladder back chair sequence designed between 1917 and 1925, to more objective solutions arising out of new techniques. Whereas the cause for Van Doesburg's departure from the canons of Neoplasticism was intellectual, Rietveld's was primarily technical. Rietveld started in this direction by redesigning the seats and backs of his later ladder back chair models as curved planes, not only because such surfaces were more comfortable, but also because they possessed greater inherent structural strength. This departure led naturally to the technique of wood lamination and from there it was but a step, once the inhibiting neoplastic orthogonal aesthetic had been relinquished, to making a chair out of a single sheet of moulded plywood, and this he achieved in two versions in 1927, one with and one without a tubular metal sub-frame.

Rietveld's architecture after 1925 undergoes a parallel development. The Schröder House, with the exception of a totally misconceived attempt built at Wassenaar in 1927, was not to be repeated. In that year however, he also realized a small two-storey chauffeur's

house in Utrecht of about the same size [illustration 82]. This house is the product of the self-same technological determinism as his bent plywood chair. Certain points of Van Doesburg's plastic architecture may be counted as still being present, but most of them are absent. In spite of its pronounced asymmetry it is far from being anti-cubic. It is a definitive closed box. Its structure is indeed skeletal but none of its planes appear to float in space. It makes no use of primary colours. Its painted black surface is stencilled instead with a gridded pattern of small white squares. This finish imparts an homogenous neutral surface of 'technique' to the concrete planks from which the exterior skin is fabricated. Apart from the vertical and horizontal steel bands set at modular intervals to hold these concrete modules in position, there is no other differentiation to the simple cubic mass. However well proportioned, it is an architecture of objective technique, rather than a demonstration of neoplastic universal equilibrium.

The Strasbourg Café L'Aubette [illustration 87] (now destroyed) comprised a sequence of two large public rooms, plus ancillary spaces located within an existing eighteenth-century shell. These rooms were designed and realized by Theo van Doesburg in association with Hans Arp and Sophie Taeuber-Arp, during the years 1928 and 1929. Van Doesburg seems to have decided on the overall theme, of wall surfaces modulated by low relief, while each artist in turn designed a room. With the exception of Arp's two-dimensional mural in the 'caveau-dancing', low-relief panels were used in all instances to divide the given internal wall areas. In each room, colour, lighting and equipment were integrated into the total composition. Van Doesburg's scheme was in effect a reworking of his project for a university hall, which had been conceived as a suprematist anti-perspectival 'distribution' of the traditional De Stijl elements. Van Doesburg's Aubette room was similarly overwhelmed by the diverging lines of a diagonal relief, passing directly from the walls across the ceiling. Of crucial importance, however, was its furnishings, for in it, there were no 'elementarist' pieces at all. The chairs were à la Thonet bentwood products made to Van Doesburg's design. The detailing throughout was straightforward and simple. The metal tubular railing connections, for example, were not articulated, but simply welded in one plane while the main lighting consisted of bare bulbs mounted off a single metal tube suspended from the ceiling. Of this design Van Doesburg was to write: 'The track of man in space (from left to right, from front to back, from above to below) has become of fundamental importance for painting in architecture . . . In this painting the idea is not to lead man along a painted surface of a wall, in order to let him observe the pictorial development of the space from one wall to the other but the problem is to evoke the simultaneous effect of painting and architecture.' ²⁵ This was the Lissitzkian Proun-Raum ²² approach par excellence, in which the whole complex achieves integration through a differentiated aesthetic treatment being accorded to objects at different scales; one law applying to gross space and another to equipment.

Café L'Aubette, finished in 1928, is the last Neoplastic architectural work of true significance. Thereafter most artists who were still affiliated with the De Stijl idea, including even Van Doesburg, came increasingly under the influence of the anti-art 'new objectivity' which deriving ultimately from the preoccupations of international socialism, was primarily concerned with the technical achievement of a new social order. Hence Van Doesburg's own house built in Meudon [illustrations 85 and 86] during the years 1929 and 1930 barely fulfils any of his polemical sixteen points of a plastic architecture. It is primarily a utilitarian atelier-house, of rendered, reinforced concrete frame and block construction, superficially resembling the type of artisan dwelling that Le Corbusier projected in the early twenties. For windows Van Doesburg chose to use standard French industrial sash and for the interior to design his own purpose-made furniture in tubular steel [illustration 86].²⁶

By 1930 the neoplastic ideal of a world of universal harmony had been eroded, firstly by internal polemical inconsistency and controversy, and then later by the impact of external cultural pressure. As an ideal it was now once more reduced to its point of departure, to its origins in the domain of abstract painting, to its confinement as a realm, within the frames of Van Doesburg's own art concret, hung on the walls of his studio at Meudon. Yet Van Doesburg's conscious concern for a universal order remained unmodified for in

his last polemic entitled, Manifeste sur l'Art Concret of 1930 he wrote: 'If the means of expression are liberated from all particularity, they are in harmony with the ultimate end of art, which is to realise a universal language.' ²⁷ However, how such means of expression were to become liberated in the case of applied art, such as furniture, equipment, etc., was not made clear.

Theo van Doesburg died in a sanatorium in Davos, Switzerland in 1931 at the age of 48 and with him, died the moving spirit of Neo-plasticism.²⁸ From the original Dutch De Stijl group only Mondrian remained active, to go on and to demonstrate alone, in the domain of painting, the tense equilibrium of his singular, austere and yet rich vision.

1968

Notes

- 1. In spite of an initial concern with the architectonics of stained glass, Bart van der Leck was opposed to the premature union of architecture and painting and on this issue soon disassociated himself from the movement. In the first annual issue of the De Stijl magazine he wrote: 'To each art, separately and by itself, its own means of expression are sufficient. Only when these means of expression of each art have been reduced to purity . . . so that each art has found its essence as an independent entity, only then, a mutual comprehension, a relationship will be possible, in which the unity of the different arts will manifest itself.' See H. L. C. Jaffé. De Stijl 1917–1931, Amsterdam, 1956, p. 170.
- 2. Berlage had himself been under the influence of Wright since the publication of the second Wasmuth volume in 1911. According to Reyner Banham in *Theory and Design in the First Machine Age*, New York, 1960, p. 143, it was from Gottfried Semper, via de Groot and his pupil Berlage that the Neoplastic artists appropriated the term 'De Stijl', the Style. For their part the De Stijl artists were, as one would expect, very conscious of evoking 'style' as an almost metaphysical concept when they wrote in their magazine in 1919, 'The object of nature is man. The object of man is style . . . The style idea as abolition of all styles thus creating an elementary plasticity, is sensible, spiritual and ahead of its time.' For full text in English see *De Stijl Catalogue 81* Stedelijk Museum Amsterdam, 1951, pp. 7 and 8.

- 3. See H. L. C. Jaffé, op. cit., pp. 58 and 60.
- 4. See Frank Lloyd Wright on Architecture. Selected writings edited by Frederick Gutheim, New York, 1941, pp. 59–76. Texts taken from Ausgefuhrte Bauten und Entwurfe, Berlin, 1910.
- 5. Frank Lloyd Wright's Unity Temple of 1906 was obviously a formal model for the Huis-ter-Heide. Theodore M. Brown in his study, The Work of G. Rietveld Architect, Utrecht, 1958, quotes Rietveld as stating that in 1918 the owners of the Huis-ter-Heide asked him to make imitation 'Wrightian' furniture for its interior. On the other hand plastic studies by Van't Hoff of this date closely resemble Malevich's architectonic studies of the early 1920s.
- 6. Michel Seuphor, in his *Piet Mondrian Life and Work*, New York, 1956, quotes Albert van den Briel to the effect that Mondrian had been definitely attracted to the Dutch theosophical movement by 1905, when he returned from his stay in the Dutch Brabant to Amsterdam.
- 7. See Joost Baljeu's essay The Problem of Reality with Suprematism, Proun, Constructivism and Elementarism, The Lugano Review 1965/1, pp. 105–24. According to Baljeu, Schoenmaekers had in his turn been influenced by the mathematician L. E. J. Brouwer who wrote in 1905 a book entitled Life, Art and Mysticism.
- 8. This collaboration occurred on Oud's Noordwijkerhout Sanitorium realized in 1917. Van Doesburg was responsible for the floor tiling amongst other interior details.
- 9. The word Neoplasticism comes from the Dutch nieuwe beelding first coined by Schoenmaekers in his book The New Image of the World (Het nieuwe Wereldbeeld, Bussum, 1915). Beelding translates with somewhat wider connotations into German as Gestaltung. 'Le Néo-Plasticisme' was first published in 1920 by the Gallery Léonce Rosenberg, Paris. 'Plastic Art and Pure Plastic Art' was first published in 1937 in Circle (an international survey of constructive art), London, edited by J. L. Martin and N. Gabo. This essay was subtitled by Mondrian as 'Figurative Art and Non-Figurative Art'. What Mondrian intended by a new pure plastic art is best expressed in his own words:

Gradually art is purifying its plastic means and thus bringing out the relationships between them (i.e. between figurative and non-figurative). Thus in our day two main tendencies appear: the one maintains figuration, the other eliminates it. While the former employs more or less complicated and particular forms, the latter uses simple and neutral forms, or ultimately, the free line and pure colour ... Non-figurative art brings to an end the ancient culture of art ... the culture of particular

form is approaching its end. The culture of determined relations has begun.

- 10. The term 'oceanic style' seems doubly appropriate. Firstly because of the titles given to these works: 'The Sea', 'Pier and Ocean', etc., and secondly because of Mondrian's propensity for an 'oceanic feeling' in the Freudian sense. As Jaffé points out the inspiration for these oceanic works was 'the sea and the pier at Scheveningen'. op. cit., p. 43.
- 11. In the works of this period, some spatial displacement occurs through the colours advancing and receding in others this movement is reinforced through coloured planes literally overlapping.
- 12. H. L. C. Jaffé dates the chair unequivocally as 1917; T. M. Brown as 1918 give or take one year. It seems psychologically unlikely that Rietveld would have made the 'Wrightian' pieces after designing this work; in which case 1918 would be the more probable date.
- 13. This is the colour scale which Van Doesburg was eventually to classify into parallel contrary sets, into the 'positive' set, red, blue and yellow and into the 'negative' set, black, grey and white. For full text (dated 1 November 1930) see the last number of the De Stijl magazine, January 1932, dedicated to Theo van Doesburg, pp. 27 and 28.
- 14. Van de Velde was the main theoretician of a synthetic and symbolic Jugendstijl aesthetic, in which complex plastic forms were regarded as the expressive vehicles of inner forces. Hence his famous aphorism: 'A line is force . . . it derives its force from the energy of the man who drew it.' See 'Henry van de Velde: A Re-evaluation' by Libby Tannebaum, Art News Annual XXXIV The Avant-Garde, edited by T. B. Hess and J. Ashberry, New York, 1968, pp. 135–47.
- 15. Elementarism as an aesthetic of dematerialized forms in space gained currency as an idea in the early twenties due no doubt in part to the polemical and creative (Proun) activity of Lissitzky. The German manifesto Aufruf zur Elementaren Kunst which declared elementary art to be simply one, 'built out of its own proper elements alone' and free, unlike Suprematism of philosophical connotations, appeared in the October 1921 issue of De Stijl above the signatures of Hausmann, Arp, Puni and Moholy-Nagy. It was Frederick Kiesler who first demonstrated this aesthetic, in its most 'dematerialized' form, in his Cité dans L'Espace exhibit of 1925. Van Doesburg first discussed elementarism in the De Stijl VII issue of 1926, in an article entitled 'Painting and Plastic', in which he developed the notion of elementarism as an anti-statical system of counter composition; a system which he was to demonstrate in his designs for the Café L'Aubette.

- 16. See T. M. Brown, op. cit., p. 42.
- 17. De Stijl Catalogue 81. Stedelijk Museum Amsterdam, 1951, p. 45.
- 18. For one fairly complete account of this episode see *Poetica dell'architettura neoplastica* by Bruno Zevi, Milan, 1953, chapter 1.
- 19. Kasimir Malevich renamed the school that took over from Chagall in 1919, in Vitebsk UNOVIS an abbreviation of 'Affirmation of the New in Art'. This of course became under Malevich a suprematist school and from this Lissitzky derived the name PROUN for his synthetic suprematist-elementarist art work; thus PRO + UNOVIS i.e. for the New Art. He later characterized this synthetic work in the book Die Kunstismen, which he edited with Hans Arp in 1925, as the 'interchange station between painting and architecture'.
- 20. 'Constructivist' here refers to graphics of magazines such as the Russian periodical *LEF* designed by Rodchenko in 1923. See *The Great Experiment Russian Art 1863–1922*, London, 1962 by Camilla Gray; pp. 231–3.
- 21. See T. M. Brown, op. cit., pp. 66–9. Point no. 11 anticipates the aspirations which both Kiesler and Lissitzky were soon to publicly express, for an elementarist architecture free from the tyranny of gravity and the constrictions of foundations and massive masonry structure. See Frederick Kiesler's statement L'Architecture Elémentarisée in De Stijl VII 79/84, 1927, p. 101 and El Lissitzky's Russland. Die Rekonstruktion der Architektur in der Sowjetunion, Wien, 1930.
- 22. See H. L. C. Jaffé, op. cit., p. 27. Mondrian wrote to Van Doesburg on leaving: 'After your high handed improvement (?) of neo-plasticism any cooperation is quite impossible for me... For the rest sans rancune.'
- 23. See El Lissitzky (Life, Letters, Texts) by Sophie Lissitzky-Kuppers, Thames & Hudson, 1968, p. 361, for El Lissitzky's description of his own Proun-Raum designed for the 1923 Grosse-Berliner Kunstausstellung as first published in the magazine G. 'The new room neither needs nor desires pictures—it is not in fact a picture, it is transposed into flat surfaces... I hang a sheet of glass on the wall; it has no painting behind it, but a periscopic device which shows me what is actually happening at any given moment, in true colour and with real movement. The equilibrium which I seek to attain in the room must be elementary and capable of change, so that it cannot be disturbed by a telephone or a piece of standard office furniture.'
 - 24. For full text see De Stijl VI, 6 July 1924, pp. 89-92.
 - 25. See H. L. C. Jaffé, op. cit., p. 174.

- 26. See catalogue: *Theo Van Doesburg 1883–1931*. Stedelijk van Abbemuseum Eindhoven, December 1968, plate, B69.
 - 27. See H. L. C. Jaffé, op. cit., p. 175.
- 28. As T. M. Brown has written: 'A close study of the Dutch 1920s forces the question of whether in fact a "Stijl" point of view actually existed outside Van Doesburg's fertile imagination.' Nederlands Kunsthistorisch Jaarboek 19 (1968), p. 214.

CONSTRUCTIVISM

Aaron Scharf

To many critics in the 1920s modern art was anarchy, anarchy was Communism, and the mutilation of natural appearances – like the mutilation of the existing social structure – was anarchistic and communistic. The New York Times, for example, reprinted an article on the subject in their 3 April 1921 edition. The Reds in art, as in literature, the Cubists and Futurists and all their noxious offspring 'would subvert or destroy all the recognized standards of art and literature by their Bolshevist methods'. Modern French art was saturated with the Bolshevist influence, another writer complained. And yet another that the 'Red' art politicians of Paris, Berlin and Moscow were 'insanely bent on rooting out even the memory of the great of the past, for fear the vulgar proletariat might develop an aristocratic longing for . . . the majesty of the civilizations of the aristocratic past'.

Certainly, from David's time at least, artists, leftists, were in many cases motivated as much by social and political aspirations as by purely formal ones. But until the occurrence of Constructivism, no movement in the evolution of modern art had been so thoroughgoing an expression of Marxist ideology or so intimately connected with a revolutionary communist organism. Constructivism was indeed 'Red' – despite the disclaimers with which quite understandably the proponents of avant-garde art defended themselves against the fanaticism of critics who did not bother to elaborate on the more subtle distinctions, to separate out the finer strands making up the complex fabric of modern art.

Constructivism was neither meant to be an abstract style in art nor even an art, per se. At its core, it was first and foremost the expression of a deeply motivated conviction that the artist could contribute to enhance the physical and intellectual needs of the whole of society by entering directly into a rapport with machine production, with architectural engineering and with the graphic and photographic means of communication. To meet the material

needs, to express the aspirations, to organize and systematize the feelings of the revolutionary proletariat - that was their aim: not political art, but the socialization of art.

Often, Constructivism was overtly propagandist in nature: sometimes by the placement of simple geometric forms in the kind of literary context which turned such forms into representations, or near representations, of actual objects; sometimes, as in poster design or in photomontage or in book and magazine illustration, fragments of the camera image provided the necessary and very concrete references to reality.

In El Lissitzky's Beat the Whites with the Red Wedge, a street poster made about 1920, the simple shapes convey the collision of the two antagonistic forces in revolutionary Russia, not with the narrative descriptiveness of traditional art but with the stark legibility and incipient symbolism which is so appropriate to the poster's function. In his illustrations for a children's book published in 1922, a charming serial called The Story of Two Squares [illustration 88], the elemental forms are converted by the context into representational configurations. Two squares, one black and the other red, hurtle towards the earth (a red circle) in which an architectural cluster (cubes and rectangles) rests. They see only chaos below (geometric forms in disarray). Crash! The red square scatters the lot and on a black square order is established by the red which maintains its vigil over all while the black square, smaller now, moves off into space. How many children (and adults) in the newly born socialist state were intrigued by this naïve but lucid symbolism is hard to know. But the use of such forms, reflecting a great sympathy with the technological world, is absolutely consistent with Lissitzky's typographical principles of optical economy and the intrinsic expressiveness of the type forms and layouts and of course with the idea of Constructivism.

To the Constructivists, a new world had been born and they believed that the artist or, better, the creative designer should take his place alongside the scientist and engineer [illustration 89]. This was not a novel idea. Architects like Louis Sullivan and his student Frank Lloyd Wright, Henry van de Velde and the Futurist Antonio Sant' Elia among others in the nineteenth and early twentieth centuries had proposed, similarly, that it was not the artist, but the engineer who now stood at the frontiers of the new style. They eulogized simple shapes. They believed that buildings and objects should be freed from the ornamental excrescences and the accumulated barnacles of past art. They advocated the nude building, the purity inherent in elementary forms. New industrial materials and the machine, they said, contained within themselves a special beauty of their own. This architectonic primitivism was admirably reflected in the work of Alexander Rodchenko who from 1915 executed designs entirely with the rule and compass [illustration 90], later to throw himself wholeheartedly into the constructivist effort. To these artists, geometric forms, uniform areas of pure colours, had an aura of rational order about them and it was order that they wanted to impose on society.

We want 'not to make abstract projects, but to take concrete problems as the point of departure', wrote Alexei Gan, one of the theorists of the movement. Social expediency and utilitarian significance, production based on science and technique, instead of the speculative activities of earlier artists, were the first principles of Constructivism. A new social order necessarily brings to life new forms of expression, they believed; and Communism is based on organized work and the application of the intellect. Was Constructivism, then, entirely without art? Iconoclasts, they rejected the bourgeois preoccupation with the representation and interpretation of reality. They repudiated the idea of art for art's sake. The materialist direction of their work would, they believed, uncover new and logical formal structures, the innate qualities and expressiveness of the materials. And in the fabrication of socially useful things the very objectivity of the processes would further reveal new meanings and new forms.

What these artists proposed was consistent with Marx's contention that the mode of production of material life determines the social, political and intellectual processes of life. Constructivists believed that the essential conditions of the machine and the consciousness of man inevitably create an aesthetic which would reflect their time. Two potent words were sequestered by constructivist theoreticians to demonstrate their dialectical creative process: tectonic and

factura; their synthesis resulting in constructive reality. Tectonic: the whole idea, the fundamental conception based on social use and expedient materials - the merging of content and form; factura: the realization of the natural propensities of the materials themselves, their peculiar conditions during fabrication, their transformation. In all likelihood, the modern nostrums about the 'integrity of the material' gained impetus from the terminology of the constructivist dialecticians.

As they aspired towards the unification of art and society, the Constructivists expurgated from their minds and from their vocabularies the arbitrary classifications which traditionally had imposed on art a hierarchic scale giving the supremacy to painting, sculpture and architecture. The idea of 'Fine Art' being superior to the socalled 'practical arts' was to them no longer valid. Appropriately, then, Constructivists like Vladimir Tatlin (1885-1953), Alexander Rodchenko (1891-1956) and El Lissitzky (1890-1941) worked in many fields. Tatlin taught wood and metal fabrication and in the Institute of Silicates, ceramics. His industrial designs included functional workers' clothes. He was concerned also with the cinema, for many years designed for the theatre, and he experimented with gliders. Rodchenko worked during a long career in typography, poster and furniture design and magazine illustration. He also distinguished himself in the field of photography and film. Lissitzky too was engaged in many sectors, notably architecture and interior design. Furniture, magazine illustration and layout, occupied him during much of his life. Similarly, other artists associated with Constructivism dispensed their talents in a multiplicity of ways.

Painting and sculpture were not entirely discarded. They were not ends in themselves according to the tenets of constructivist realism, but were parts of processes through which architecture or industrial products were fully realized. Lissitzky's conception of the proun points this up. Proun is an abbreviation from the Russian phrase which means something like 'new art objects'. This paradigm of constructivist realism was in its essence meant to convey the idea of creative evolution, beginning with the flat plane and more or less illusionistic renderings (a kind of architect's or designer's plan), followed by the fabrication of three-dimensional models, then

finally the total realization in the construction of utilitarian objects. Proun, simply, was a method of working, entirely in harmony with modern technological means. Through this forming process, all the essential elements of form: mass, the flat plane, space, proportion, rhythm, the natural properties of particular materials used, plus the demands made by the ultimate function of the object, should come to fruition in the final object itself. No doubt, Lissitzky's earlier training as an engineer and architect was instrumental in the resolution of this idea. In fact, he explicitly associates the procedure with that followed by engineers and architects.

Because of the formal characteristics of his designs, and because of his sympathy with some of Malevich's attitudes, Lissitzky is sometimes classified as a Suprematist. This, I think, is fallacious. The propensity for diagonals in his graphic work no more makes him a Suprematist than Mondrian's assertive horizontals and verticals make him a Constructivist. It is not a question of style. It is one of intention. Lissitzky may have embraced certain suprematist ideas, but his principal purpose, his whole manner of working, was allied to Constructivism. This is also clearly indicated in his writings. His guiding principle for architecture was that space was made for people, not people for space: 'we no longer want a room to be a painted coffin for our living bodies.' His concern with the material problems of existence is reflected in his speculations about the future. To mitigate the growing problem of vast accumulations of printed books, for example, he envisaged electronic libraries.

With the success of the October Revolution in 1917 these artists, tremendously enthusiastic, plunged into the task of creating an art of the proletariat, an art participating as they said in the expediencies of that revolution. In 1918, to celebrate its first anniversary, a gigantic re-enactment of the storming of the Winter Palace in Petrograd (the capital till that year) was organized by Nathan Altman with a cast of thousands: not trained actors it should be noted but, reflecting the concrete reality favoured by Constructivism, with non-actors, the ordinary citizens of Petrograd who, by involvement with that historic event performed from direct experience. The huge square was decorated, not only with heroically-scaled representations of workers and peasants, with figurative eulogies to the

victorious Red Army, but also with massive triangles, segments of circles, rectangles and other such elementary forms.

Perhaps the most appropriate symbol of the unification of painting, sculpture and architecture with the information and propaganda organ of the State, was Tatlin's extravagant synthesis, designed between 1917 and 1920, called the Monument to the Third International [illustration 91]. This complex was to be constructed in the form of a massive spiral which efficaciously conveyed the dynamism of the space age - a sanguine thrust into an unknown but promising future. The Empire State building, completed by 1931, is 1250 feet high. The height intended for the Russian structure is sometimes said to be at least that. Inside would hang a cylinder, a cube and a sphere containing meeting halls, offices and, at the very top, an information centre - all revolving at different rates of speed: one of the earliest examples of kinetic sculpture; kinetic architecture more accurately. Utilizing almost every technical means of communication then known - including a special projection device for throwing images on to clouds - news bulletins, governmental proclamations and revolutionary slogans would be dispensed daily, hourly, to the people. Tatlin's tower was a stupendous declaration of faith in a communist society. But for a large wooden model, it was never built.

Following the Revolution, plans for new architectural structures based on constructivist principles far outnumbered the buildings actually erected. Carried away by utopian visions, Russian architects and designers wanted literally to give the new society a new shape. Not to construct, they said, but to reconstruct. Often, as symbolic statements, their designs flagrantly disregarded the elementary requirements of the physical function and now remain, on paper, inspired encomiums to the new world – nothing more [illustration 92]. Those relatively few which were realized: workers' clubs, communal housing, schools, factories and exhibition buildings, were not accomplished without a great deal of anguish and frustration. And it is perhaps a poetic irony that the best known constructivist building surviving today is Lenin's mausoleum in Moscow. For to add to the economic disabilities of the infant Soviet, industrially they were centuries, not decades, behind time. Incredible stories have

been told about the technological poverty which, well into the thirties, paralysed many of the new attempts in manufacture and architectural construction. Often, for these modern buildings, logs instead of planks were delivered to the sites and these were cut, not with circular saws and electric planers, but with adzes. The technologically primitive legacy from Tsarist Russia impeded for a long time the realization of such advanced ideas. Tatlin's tower could not have been built without the greatest of difficulties, if it could have been built at all. Thus, the high ideals and emblematic geometry of Constructivism did not so much reflect Russian science and technique as it did that of the West. Lissitzky, writing in Moscow in 1929, made this clear: 'the technical revolution in western Europe and America has established the foundation of the new architecture.' He points specifically to the large urban complexes of Paris, Chicago and Berlin.

It was largely because of this infirmity that an intensive programme for training the artist-designer was, in 1918, initiated. New schools, Higher Art and Technical Workshops called VKhutemas (from Vishe KhUdozhestvenny Teknicheskov Masterskov), appeared and the very utilization of such abbreviations, common enough in the new Russia, is to some extent an etymological demonstration of their sympathy with modern technocracy. Many of the Constructivists taught or had studios in the VKhutemas. Naum Gabo not long ago described the curriculum of the Moscow workshops and the intensity with which the students engaged in ideological discussion; a part of their training which, he maintains, was ultimately of more importance than the actual studio teaching there. The programme for these schools was organized at first by Wassily Kandinsky. Based mainly on an amalgam of the ideas put forth in his book Concerning the Spiritual in Art, on Suprematism and on the incipient concepts of Constructivism known as the 'culture of materials', it later became the prototype for parts of the German Bauhaus course. In Russia it was however soon discredited. Free painting and sculpture were proscribed, as was the teaching of Kandinsky's somewhat metaphysical analyses of colour and form, and the course was reorganized with the emphasis placed on production techniques rather than artistic design. Disillusioned, Kandinsky and Gabo soon left Russia to work in other countries where their ideas emphasizing the spiritual content of art were more readily accepted.

The ideological battles between those with suprematist inclinations and those who stood resolutely on constructivist principles were fought not with words alone but with the weapon of art itself. In 1916, Malevich fired a salvo of trapezoids with his Suprematism Destroyer of Constructivist Form. His White on White (c. 1918) was an affront to Rodchenko who counter-attacked that same year (the year the VKhutemas were initiated) with his Black on Black. This painting symbolized the death of all isms in art, especially Suprematism. Trotsky and Lunacharsky had supported Constructivism but with the NEP in 1921, Lenin's New Economic Policy, Constructivism's usefulness was seriously questioned. Yet those artists—and Malevich—continued to work in Russia, though ultimately their influence there waned.

The vacuum left in easel painting by the suppression of the Petrograd Academy (which had been patronized by the Tsarist régime), by the rejection of Suprematism and by the refusal of the Constructivists to have anything to do with picture-painting, was filled during the mid-twenties by illustrators and naturalistic painters organized as AKHR (The Association of Artists of the Revolution), later, as OST (The Society of Easel Painters) and still later, by others: artists, socialist realists who convinced the authorities that they too had an important part to play in the building of an egalitarian society.

Among the few survivors of that revolutionary group of Constructivists is Naum Gabo who still advocates the principles of 'constructive realism' as he calls it. But Gabo was never whole-heartedly in sympathy with the central ideas of Constructivism and though he has been critical of Malevich's dogmatism, he nevertheless is closer in essence to his ideas and to those of Kandinsky than to the utilitarian concepts of the Constructivists. Gabo defends the constructive artist's use of elementary forms and the tools and techniques of the engineer. But lines, shapes and colours, he believes, possess their own expressive meanings independent of nature. Their content is based, not directly on the external world, but springs from the psychological phenomena of human emotions – something the

168 Concepts of Modern Art

Constructivists could never accept. It is through enhancing one's spiritual life that the creative act, he says, contributes to material existence. The 'constructive idea' is not intended, he insists, to unite art and science, not to *explore* the conditions of the physical world, but to *sense* its truth. This, the Constructivists and their followers would say, was sheer romanticism and the sophism of abstract art. Constructivism, to give the term its original meaning, repudiates the concept of 'genius': intuition, inspiration, self-expression. Constructivism is didactic, it is physiologically rather than psychologically orientated, it is intimate with science and technology, it is concrete.

June 1966

ABSTRACT EXPRESSIONISM

Charles Harrison

'What about the reality of the everyday world and the reality of painting? They are not the same realities. What is this creative thing that you have struggled to get and where did it come from? What reference or value does it have, outside of the painting itself?' – Ad Reinhardt (in a group discussion at Studio 35, 1950).

As a label for the different works of a particular generation or community of artists, centred on New York from the forties for at least a decade, the term 'Abstract Expressionism' is misleading, embracing as it does at one extreme the work of Willem de Kooning, which is rarely 'abstract', and at the other the work of Barnett Newman, which is not characteristically expressionist. The term has gained currency, however, and can therefore be assumed to be relatively neutral in use.¹

One wants to establish a view of Abstract Expressionism which is broadly heuristic rather than dogmatic; a view which caters to a need for some reliable understanding of the painters' formal and technical concerns and of their relationships to previous art, without at the same time denying the possibility of insight into the painters' more general and 'metaphysical' notions of the significance of their actions and their assertions. One needs also to maintain some truth to a world which allowed the coexistence, and at certain levels the compatibility, of very different characters and characteristics: both Newman and De Kooning; both 'abstract' painting and figure painting; both deep seriousness and high vulgarity; both the deadpan and the sublime.

In so brief a survey of so wide a subject it is necessary to be selective and to find some bases from which to operate the selection. My approach to the subject is therefore predicated upon the conviction that the quality and originality of the art of Jackson Pollock, Willem de Kooning, Clyfford Still, Barnett Newman and Mark Rothko establishes their precedence above that of other artists now custom-

arily included in group surveys: William Baziotes, Bradley Walker Tomlin, Adolph Gottlieb, Robert Motherwell, Richard Pousette Dart, Franz Kline and Philip Guston.² I hope the text which follows will serve as some justification of that conviction. I have considered Arshile Gorky and Hans Hofmann as significant figures involved in but not central to the notion of 'First Generation' American painting.

I have also predicated my interpretation of Abstract Expressionism as a historical phenomenon upon the particular intensity of the art of the later forties, when each of the five artists I have singled out established distinct, individual and 'mature' styles.³ (In 1950 Rothko was aged 47, De Kooning and Still 46, Newman 45, Pollock only 38.) I offer this concentration upon the late forties, somewhat tentatively, as further justification for the scant attention paid to Robert Motherwell, whose series of Elegies to the Spanish Republic were developed into large scale during the early fifties from small works of 1948 and 1949, and of Franz Kline, whose first large-scale black-and-white paintings (Cardinal, Wotan, Chief) date from 1950. I feel more confident in the omission of Ad Reinhardt. For all the quality of his earlier work, his superb black paintings distinguish him as a painter of the sixties.

Space has not allowed any extended consideration of 'origins' or 'background'.

The major developments of twentieth-century European art, certainly in the eyes of the Americans, were Cubism and Surrealism. In conventional critical attitudes – largely dominated by a formalist tendency – these developments have been seen as antithetical if not mutually exclusive. Cubism and its derivatives have been seen as essentially 'visual', and concerned with 'picture space' – the relations which obtain between the real world of three dimensions and the essentially illusory, two-dimensional world of the canvas (the 'proper' concern of painting). Surrealism has been seen by its antagonists as an art movement vitiated by literariness and theatricality (i.e. as essentially non- or anti-'visual'), and by its protagonists as a means to the liberation of the spirit and to the 'revolution of consciousness' – a notion very easily related to a sense

of involvement in conditions of social/political/cultural oppression and of hopes for change.

Robert Motherwell, at least, saw his own work in terms of 'a dialectic between the conscious (straight lines, designed shapes, weighted colours, abstract language) and the unconscious (soft lines, obscured shapes, automatism) resolved into a synthesis which differs as a whole from either'. Motherwell's assertions often have an elegance untypical of the Abstract Expressionists, but the implicit suggestion here that formal and spontaneous procedures are not necessarily irreconcilable holds good for the Abstract Expressionists as a whole. Artists have often tended to confuse their critics by sustaining interests which are apparently ideologically incompatible. The artist has perhaps tended to work on a 'deeper' level, where involvement in the technology of painting provides him with an idiom which the critic cannot 'translate'. Certainly this was true in New York in the forties.

Between the 'extreme' concepts of Cubism and Surrealism there were important points at which various potential sources of influence in the works of individual admired painters became compatible as instances of a general 'deep' problem or possibility. Certain works, of a period well represented in American collections between the wars, by Picasso for example (The Studio, 1927-8, Museum of Modern Art, New York), Miro (Dutch Interior I, 1928, MOMA), Léger (La Ville, 1919, Philadelphia Museum; formerly Gallatin Collection, New York), Matisse (Bathers by the River, 1916-17, Art Institute of Chicago; formerly Valentine Gallery, New York) and, more locally, Stuart Davis, became compatible to the American painters as 'source material' in the context of their usage of the 'enlarged box' space of Synthetic Cubism. The chief characteristics of such paintings are an abandonment of 'naturalistic' illumination and of modulated relationships between formal elements in favour of flat forms, usually relatively hard-edged, deployed in spatial relationships, usually strongly conditioned by colour relationships, in the context of a composition which only allows reading of a 'consistent' space when that space is enclosed; the space is either entirely filled by forms and planes (as in the Léger), or it refers to an actual box-like space (as in the Picasso and Miro interiors) or it is identified

with the canvas surface itself – and is thus prevented from functioning in reference to a particular 'real' space – through the application of an all-over soft but opaque painted ground (as in the Matisse and in many Miros of the twenties and thirties).

Around 1942-4, several of the American painters, however distinct and dissimilar their subjects, disposed them in an essentially synthetic-cubist 'enclosed' space: Motherwell (Pancho Villa Dead and Alive, 1943), De Kooning (untitled painting, c. 1944, Eastman Collection), Pollock (Male and Female, 1942, Guardians of the Secret, 1943), Baziotes (The Parachutists, 1944), Tomlin (Burial, 1943). The significant variation is between a method of ordering dependent upon the push-and-pull of flat 'post-collage' forms (Tomlin at one extreme) and an intense disordering of this in the name of a 'postsurrealist' automatism (Pollock at the other). Some of Gottlieb's early 'pictographic' paintings of the later forties also recall latecubist space, though flattened by the influence of Torres-Garcia's compartmentalized paintings of the late twenties and early thirties and of Paul Klee's own pictographs. Clyfford Still's exceptional Self-portrait of 1945 also relates, though, as in Pollock's works of the same date, the power of the imagery asserts a priority for 'content' over 'spatial organization' which is ultimately - as it was for Pollock - decisively destructive of cubist means of composition.

Hans Hofmann and Arshile Gorky had of course worked with synthetic-cubist 'interior' space some ten years earlier, and their paintings of the mid thirties provide a key point of transition between the work of the Europeans and that of the Americans. Gorky had come to America in 1920 from Armenia, Hofmann in 1933 from Munich.

Gorky's conviction of the significance of the four great Europeans, Miro, Matisse, Picasso and Léger, certainly seems to have predated that of his contemporaries De Kooning, Gottlieb, Newman, Rothko and Still (they were all six born between 1903 and 1905) and of the younger men, Pollock, Motherwell and Kline (born between 1910 and 1915); but he served a long apprenticeship in styles of late Cubism and of Surrealism, whereas the development of the Americans through gamuts of twentieth-century European concerns was astonishingly rapid once it had been begun in the early forties. It

was not until 1947, the year before his suicide, the year that Pollock painted his first all-over drip paintings, and the year after Still's one-man show at 'Art of this Century', that Gorky achieved a truly independent style which reconciled, as, more absolutely and more radically did Pollock's, the previously irreconcilable: drawing as an image-generating activity, and painting as an activity which implied assertion of the flatness of the flat canvas (Agony, The Betrothal II, Year after Year, The Limit, The Orators, all of 1947). A new kind of painterliness, freed of a depicting function as drawing was not, was largely the means to this.

In his own work, and through the progress of his admirations, from Cézanne, via Picasso and the transitional Kandinsky, to Miro and even Duchamp, guided in the latter stages by Roberto Matta,5 Gorky exemplified the developing relationship between American and European painting. The argument as to whether he should be seen as 'the last Surrealist or as a pioneer of the New American painting' is best left unresolved. Rubin's characterization of him as a 'transitional painter's seems appropriate, so long as it is not employed to derogate the achievement and independence of his last paintings.

Hans Hofmann, a much older man than Gorky (he was born in 1880), was uniquely qualified to transmit to a younger generation the central concerns of early twentieth-century European art. He grew up in Munich at the time of the Secession's activity there. He was in Paris from 1904 to 1914, during the fauve and cubist episodes, and had been a close friend of Robert Delaunay. In 1915 he opened a school of fine arts in Munich, where the tenets of Kandinsky's abstract art had been formulated a few years earlier, and where, during the war, Hofmann stored many of Kandinsky's paintings of the crucial transitional period. The year he closed his Munich school, Hofmann taught at the Art Students' League in New York, where Pollock was then enrolled, and in 1934 he opened the Hans Hofmann School of Fine Arts in New York.

Hofmann was steeped in first-hand experience of Cubism, Fauvism and Expressionism and their various extensions. Clement Greenberg, who attended lectures given by Hofmann and was deeply affected by his teaching and conversation, has written 'You could learn more about Matisse's colour from Hofmann than from Matisse himself', and 'no one in this country, then or since, understood Cubism as thoroughly as Hofmann did'.

Hofmann's chief concern, which he transmitted forcefully and articulately to his students, was for a colour/form unity in which pictorial space was to become 'plastic' through the assumption, by processes of colouring, of the 'placing' function previously filled by processes of drawing. He thus synthesized aspects of cubist and fauvist theory and prepared to a very considerable extent a framework and an ideology for post-war 'colour painting' generally and for 'post-painterly Abstraction' specifically.⁸

Hofmann exhibited occasionally with the Abstract Expressionists during the forties, but in generation (he was, for instance, 32 years older than Pollock), in origin (he was 52 when he first visited America) and in his work, he evades complete integration with them. His painting, for all its quality at its best, and for all its immense variety, remained European in a specific sense. There is evidence of a consistent pursuit of 'substantiality' and of a pervasive attachment to composition as a process of evident relating of parts ⁹ which proclaims some strong European loyalties.

Among Hofmann's students in the late thirties was Lee Krasner, whom Pollock was to marry in 1945. She introduced him to Hofmann in 1942. Greenberg has attributed to Hofmann's example and influence the fact that 'the "new" American painting in general is distinguished by a new liveliness of surface', 10 but it is hard not to believe that this 'liveliness' of surface would not have been achieved without him. There were, after all, many forces working to that end.

The coincidence of late-cubist concerns in the most advanced European painters offered one crucial context of influence for the Americans. A necessary antinomic context was provided by that aspect of European Surrealism which involved the combination of 'automatic' techniques ¹¹ with an interest in primitive and 'archetypal' subject matter. The Americans' application of the notion of automatism was comparatively wide, so that in this context as many disparate sources of influence were rendered compatible as in the context of late-cubist versions of pictorial space. (And of course

in much of Picasso's and Miro's work the two were at least potentially coincident.) Also, since the American painters were by and large attracted to a Jungian rather than a Freudian view of 'unconscious', 'subconscious' or 'preconscious' imagery, 12 it was not impossible for them to reconcile an interest in techniques of spontaneity with an interest in 'heroic' or 'epic' subjects. They tended to see both as involving the production of 'archetypes'. In the case of Pollock, for instance, this involved a reconciliation of the self-exploratory imagery and techniques of Miro and Masson with the declarative imagery and techniques of the Mexican mural painters - notably Orozco - by whose work he had been impressed at an earlier stage. The Picasso of the thirties - the Picasso of Guernica - seemed around 1940 to epitomize the possibilities inherent in this conjunction, as the Picasso of the twenties - the Picasso of the Three Dancers - seemed to epitomize the possibility of the existence of 'strong' subject matter in late-cubist space. Pollock in particular seems to have been obsessed by Guernica. 13 Picasso was seen by many of the New York painters as more or less omnipotent. 'On the WPA...we used to practise a clandestine kind of automatic drawing . . . Stuart Davis and Léger were big influences in those days. But Picasso was God. Picasso influenced all of us.' (Peter Busa)¹⁴

In the forties – and especially around 1944–6 – there was an overlying compatibility between the consequences of the persistence of cubist influence and the consequences of involvement in surrealist strategies for 'freeing conscious control over procedures of composition'.

Robert Motherwell was to a considerable extent the spokesman for the theoretical aspects of European Surrealism in which he had received a thorough education, largely from Seligmann, Matta and Paalen. By his own account he 'explained' Surrealism to Pollock, to Gorky and to Rothko. He was well read in aesthetics and art history and had been introduced as early as 1941 into the circle of surrealist emigrés in New York which included Tanguy, Masson, Duchamp, Ernst and Breton. He became an early and close associate of Roberto Matta, a young South American painter then concerned to revive the strategies of spontaneity which the European Surrealists had largely abandoned in the thirties. Motherwell met

Baziotes and Pollock in 1942, and for a while at the close of that year they paid regular visits to Matta's studio, together with Kamrowski and Peter Busa, ¹⁶ where they discussed, among other things, the need to find 'new images of man' (Matta¹⁷) and the potentialities of automatic techniques.

Like Pollock, Motherwell was concerned to work his way through synthetic-cubist versions of picture space towards a larger painting with a more 'active' surface; but his means were less disruptive, more 'art-conscious' than Pollock's. From 1943 on he was for instance devoted to collage, not merely, one suspects, as an extension of his range of approaches to the surface of the painting, but as a means of suggesting a world of 'plastic' relationships, invested with particular associations, which could render compatible the legacy of cubist types of composition and the techniques of surrealist juxtaposition without real danger of loss of control. It was as if automatism was to him something essentially theoretical which he never very effectively put into practice. As compared, say, with Pollock's work, to which it must have seemed close in the early forties, Motherwell's lacks boldness and spontaneity. Where Pollock was changing the terms of reference of a tradition, Motherwell remained 'artistic' in relation to European models. In his work of the fifties, as the forms become simplified and the scale considerably enlarged, the tendency is towards rhetoric rather than grandeur.

Perhaps the notion of automatism – an essentially literary and strategic notion after all – was really less effective than the urgency of the needs which that notion, among others, was adopted to serve. Hans Hofmann was generally unsympathetic to Surrealism, at least until the mid-forties, when it seems he was prompted to reconsider by the work of younger painters; ¹⁸ and his concerns were generally formalist concerns, i.e. concern with composition as structure and with surface as tension-in-depth; yet in substantial works of the early forties, such as *Effervescence* of 1944, puddled and dripped paint serves to loosen up the surface beyond the point at which reminiscences of cubist formalities can survive to perpetuate associations with the particularizations of space in the material world. These works predate Pollock's all-over dripped paintings by several years and serve to emphasize that surrealist automatism, while it may

undoubtedly have served a necessary function in loosening the hold of cubist picture-space, was not necessarily the only mode in which this could be achieved. The negative motive – the need to 'evade' the cubist frame of reference to the world ¹⁹ – itself suggested ends which implied the same means. In Pollock's work, 'automatism' (the ideology of *graphism* as 'self-discovery') and extreme painterliness ('aformal' means of departure from oppressively formal ends) come to signify one and the same thing.

A survey of the archetypal, aggressive, animal, sexual, mythic imagery of Pollock's work of the early forties - roughly from, say, Male and Female of 1942, through the Guggenheim Mural of 1943, Night Ceremony of 1944, via gouaches and pen drawings of 1946 heavily reminiscent of Miro at one extreme and Masson at the other, to the Sounds in the Grass paintings of 1946 - reveals a gathering impetus away from the exploitation of specific (though 'disintegrating') single images (Pasiphäe and She Wolf of 1943) via the agglomeration of image-types (the Mural, and Gothic of 1944) towards a recognition of the priority of the procedures over the results of image-generation. It is in these terms that Pollock progresses from a considerable dependence upon compatible but secondhand imagery (Guernica, etc.) towards an original mode of selfexpression in which the notion of the possibility of significance in imagery is by no means betrayed; which itself can be seen as the achievement of a degree of 'self-realization'.

In 1945 Pollock moved from New York to East Hampton, Long Island. As Ellen Johnson has observed, after this date the 'mythic' titles of the early forties seem to give way to titles which evoke the natural world. It seems reasonable to suppose that this reflects at the very least a change of attitude on Pollock's part towards the possible range of subjects accessible to his painting. I would suggest that the procedures of integration with the painting of which Pollock spoke ²⁰ reflect, or are dependent upon, or are implied by a growing sense of integration in some wider contexts of his life during the years 1946–50. The nature of the accomplishment of the paintings of these years suggests it. (Pollock retitled the magnificent No. 31, 1950; he is said to have called it One, because he felt at one with it.)

In Pollock's 'all-over' paintings of 1946, for instance Sounds in the Grass; Shimmering Substance and Eyes in the Heat, the imagery, if not recognizable, is still recognizably there; but the activity upon the surface – that part of the painting, that is to say, which flatly asserts itself as occupying a literal place upon a surface literally viewed as flat – increasingly veils, or edges out or overpowers the imagery established as the result of the less spontaneous, earlier stages of the painting. As the 'pace' of the painting accelerated – as he got more fully 'into the painting' – Pollock seems to have found the actual procedure of paint application increasingly expressive; not a means of depicting, but the actual means to mimetic life, within the painting, of the significance which the depicted form was to have embodied.²¹

The result is very dense (though very rich) in both colour and texture; the Sounds in the Grass paintings are comparatively small, and it seems as if there simply was not enough room in them to allow full scope to the kind of expansion which was inevitably entailed in the 'evolutionary' process outlined above. It was not merely a matter of inadequate space between the four borders of the canvas; there was not enough room between the surface of the canvas and the source of the movement which the brush was to trace upon it, i.e. (by this date) the painter's shoulder. This sense of 'lack of room to paint in' may well have been in a very direct way a consequence of that quality of actual physical violence which Pollock brought to the activity of painting (according, specifically, to Motherwell – an eye-witness to Pollock's painting procedures whose testimony I am otherwise reluctant to call). ²²

Although Pollock's solution to the problem of reconciling his technique with his needs and concerns was highly individual, he was not alone in confronting the problem. It seems to have been a general problem in the mid-forties. Matta, at least, felt a shift in priorities from existential concerns to a recognition of the need for a new 'space' in which to make these concerns manifest: 'At one point the artists started discussing not any more who we are and what happens to us and how we are changed by our paintings, etc., but started talking with their hands, trying to describe space like a dancer does.' ²³

To abandon the canvas on the easel or wall and place a larger canvas on the floor was a development which may thus have served for Pollock a need also felt by others. But the change may well have seemed to him to be motivated by essentially practical and particular considerations – the need for 'more room' etc. – however radical the implications of the action and however dramatic its consequences within Pollock's art and beyond.

I suspect that Pollock may also have been motivated, in increasing both the size of the canvas and the area of travel of the paint, by a desire to open the painting up a bit; to avoid a situation in which a relatively prolonged and satisfactorily intense period of working on a painting was bound to result in a surface too worked-over and too dense to admit of mimesis of some kind.

The adoption of the drip-and-spatter technique and of dried-out brushes, sticks and trowels as tools, can also largely be accounted for in practical terms: Pollock was enabled by this means to maintain a relatively upright position, a distance away from the floor and the canvas. The painting-at-arm's-length stance cannot be sustained for a painting on the floor as it can before an easel or a wall. The point of balance for Pollock became the hips, not, as before, the shoulder; the natural rhythm - and Pollock was a 'rhythmical' painter from the start - became inevitably more expansive, involved longer, more sweeping movements of the hand controlling the application of paint. He gained more sway over the canvas. The dictates of gravity and the increased fluidity of the paint ensured that a painting produced in this manner would be more prone to those 'accidental' effects which, in the name of automatism, Pollock had been concerned to exploit since at least 1936 (the year of his participation in Siqueiros's experimental workshop) as a means of 'freeing' both procedure and imagery from self-conscious attitudes towards the technology of painting.

The solution of technical and physical problems – problems of 'approach' – thus entailed solutions to fundamental problems of expression. These were Pollock's own particular problems of self-expression, but the manner in which his concerns were expressed served to give his paintings status as instantiations of those concerns he felt in common with his contemporaries – with the other

Abstract Expressionists and, to a greater or lesser extent, with all those who shared or can share his intuitions to any degree. This was one of those remarkable conjunctions of technical with ideological radicalism which, when they occur, mark the moments of true revolution in the history of art.

In Hofmann's work from 1940 onwards (a small painting in oil on plywood, *Spring* of 1940, is perhaps the earliest), dripped and poured paint is often deployed in a manner and to ends not dissimilar to Pollock's. The particularization of relationships in illusioned depth – the 'push and pull' of Hofmann's surfaces – is what separates these works from the younger man's. The automatism of the Surrealists (particularly Masson), experiments with dripped paint by Ernst, and the experiments conducted in Siqueiros's workshop have all been mentioned more or less frequently as sources for Pollock's technique. In the end what is important is not how Pollock painted, but how it was for him to paint that way, i.e. what ends were being served in those moments and by that technique.²⁴

It was certainly no anarchism in the métier. (Busa: 'Pollock was a natural painter. He could swim in it and come out creating the most beautifully organized lyrical effects. Pollock had the most articulate understanding of his means . . . 'Matta: 'He was very concerned with paint.') 25 The point is that where for Hofmann the drip-and-spatter technique was essentially an aspect and a function of composition in the abstract, where for Masson it was a means to the invention and 'discovery' of form, where for Ernst it was perhaps significant as a 'departure', for Pollock this activity involved the very shaping of pictorial form. It was his means of synthesizing, of subsuming his powerful vocabulary of archetypes and myths and creatures and of giving that synthesis a mimetic life in paint - a life, that is to say, 'at the moment of painting'. 26 For all that we may see Pollock's interlaced all-over canvases of 1947 to 1950 as representing a new kind of pictorial space after Analytic Cubism,27 we cannot but be intuitively aware - if we are responding with sympathy and without bias ('Formalist' or 'Literalist' or whatever) - of the traces of the life of painting's content in general and of Pollock's painting's content in particular. In certain paintings (the earliest of the all-over paintings of 1947, such as Full Fathom Five and Cathedral, and certain other works of the early fifties) these traces are visible 'near the surface'; hints, like biomorphs in amber, of another life caught at another moment, carrying with them a powerful sense of the particular in experience which is no less specific for being impossible of translation into other terms than those which govern our means of perceiving them (i.e. for being highly idiomatic).

It is of course not adequate to describe Pollock's procedure as simply a matter of embodiment in these terms. The problem of enlivening the surface of the canvas was one which had to be solved in terms of the resources available in painting at the time. The comparative art-historical 'innocence' of his technique undoubtedly helped to free Pollock from certain inherited approaches to picturemaking (as outlined above), and empowered him to divest himself of the second-hand aspects of his vocabulary of motifs; but nothing could free him from the 'deeper' epistemological requirements of painting in the twentieth century; in particular he confronted - as did each of the major Abstract Expressionists in his own way the specific range of problems involved in the clash between, on the one hand, the complex legacy of painting's illusionistic function (a point of departure for all significant painting up to 1947), and on the other, the now incontrovertible facticity of the painting as an object and of its surface as a surface which could no longer sustain illusion of the narrative kind.

What made these problems so intense for the Abstract Expressionists was not so much an ambition to make abstract paintings and to 'flatten' the picture space still further, as a conviction that the making of great art involved the embodiment of significant content. The problem was not what their (abstract) paintings were to look like so much as how to find a vehicle and how to find space for very specific kinds of subject matter in face of the apparent exhaustion of the resources which had sustained painting's traditional representational functions. When a group of Abstract Expressionists founded a school in 1948, they called it, at Barnett Newman's suggestion, 'The Subjects of the Artist'. According to Motherwell, the name 'was meant to emphasize that our painting was not abstract, that it was full of subject matter'. In one is to

find a generally viable characterization of the shared concerns of the Abstract Expressionists during the forties, it can only be in terms of shared concerns with content. Pollock's 1947–50 paintings need to be seen in terms which allow for some acknowledgement of this.

In the most elegant of Pollock's works of 1950 - such as Autumn Rhythm (Number 30, 1950), One (Number 31, 1950) and Number 32, 1950 - the procedures of rhythmic composition in an increasingly selfsustaining technique do indeed seem to declare a holistic priority for the painting in its non-referential aspect; but even here individual 'incidents' detach themselves and assume particular function as one's concentration intensifies. One senses that the 'resolved' quality of these paintings represents a hard-won achievement in a wider context than that of the simple canvas surface; and it seems that that response can only be explained in terms of an intuition of the presence of some signifiers of 'states' capable of resolution. These 'states' are hard to characterize in other terms than those in which they are embodied, i.e. in 'visual' terms; but it is perhaps not unreasonable to expect that the 'emotional range' - the sense of unsparing, unreassuring involvement in existential problems - conveyed by the imagery of Pollock's pre-1947 work, should continue to characterize his means and motivation for self-expression after that date. In these great and unrelenting paintings the images themselves are 'characterized by absence'.

It is significant that the next major series of works – the black-enamel canvases of 1951–2 – recapitulate much of the specific imagery of the pre-1947 paintings (and, more evidently, of pen-and-ink drawings of the early forties). There is an analogy to be made here, I think, with the conditions under which Braque and Picasso used collage to reintroduce figuration in 1912–13, thus providing themselves with an alternative direction to that suggested to them (and to many later painters of real ability, Pollock among them) by the gathering abstractness of Analytical Cubism in 1910–11. I am inclined to think that the greatest painters of this century ('painters' specifically, not necessarily 'artists' in general) have been those who had reasons for being unwilling to see absolute abstractness as a necessary preserve for their art.³⁰ It is important to remember that in the early fifties both Pollock and De Kooning were

painting major, large-scale figure compositions; at the date of writing, De Kooning is still painting figures; Pollock died in 1956 when only 44.

It has been a tenet of extreme modernist/formalist criticism that Pollock's works after 1950 generally represent a decline after the high point of the preceding three years.³¹ Among the paintings which would be derogated under this programmatic critique are several which are surely among the highest, most intense achievements of twentieth-century art: Blue Poles of 1952, Portrait and a Dream and Ocean Greyness of 1953 and many others. These paintings do not seem to have opened up any radical new possibilities for figurative art (nor, in any short-term or evident way, did Rembrandt's late selfportraits) but this does not necessarily imply that they are arthistorically retrogressive. To see them as such implies a reading of Pollock which would see him essentially as an innovator of styles of abstraction. Such a view seems to contradict the known facts about Pollock's points of departure, and to depend upon a sadly selective view of the work. I suspect that the idea that there is a (strong) necessity for abstraction in painting, which this view implies, is in turn a result and a function of a too restricted - in the long term perhaps destructively restricted - purview of art.

Pollock remained a comparatively isolated figure. He belonged to none of the artists' groups, ideological, social or whatever, which began to form from around 1948 onwards as a sense of community developed. In 1945, the year of his second one-man show at 'Art of This Century', he had moved out of New York to East Hampton. In 1948, in his first one-man show at the Betty Parsons Gallery (his fifth one-man show in New York) Pollock showed his all-over drip paintings for the first time. In the same year Willem de Kooning had his first one-man show, exhibiting the series of black-and-white works which he had begun two to three years earlier.

De Kooning had in fact been known and admired among painters since the mid-thirties. In the later thirties he was one of a group of friends which included Gorky, Stuart Davis, the sculptor David Smith and the painter, writer and man of many other qualities, the influential John Graham. The association with Graham was

important to De Kooning, as it was to Pollock, whom Graham befriended in the late thirties. Graham's writings, which embraced both post-cubist technology and an involvement in myths, primitivism and the theory of the unconscious, instantiated at an early date the possibility of compatibility between formal abstraction and mythic imagery.

De Kooning's black-and-white paintings are his most 'abstractexpressionist' works, employing as they do automatist techniques of composition and a 'resonant' imagery compatible with the 'mythic' interests of the mid-forties (titles include Black Friday, Orestes and Dark Pond); but essentially De Kooning was concerned with problems more central to the cubist than to the surrealist traditions of twentieth-century painting. Of course by 1940 the two streams were not always easy to distinguish. Picasso in particular had been concerned to inject possibilities for high expressiveness into contexts suggesting that formal problems were there for solving. Paintings like the Three Dancers of 1925 suggest the possibility of 'strong' emotive subject matter in post-cubist space; but the price paid is the reinstatement of just those stage-set characteristics of perspectival painting which Cubism had supplanted - which, in fact, the Post-Impressionists had largely abandoned. And devoid of the narrative functions of earlier art, the tendency of such paintings is towards rhetoric. The figures become puppets; Picasso the puppeteer par excellence.

De Kooning's ambitions collided on this point: how to implant a fully sensuous particular volume within the conventional frame of the canvas without abandoning – as Picasso was forced to do (denying Cézanne in the name of self-exposure) – the evident resolution of painting and drawing upon the flat surface. In 1910–11, when Analytic Cubism was both at its most complex and its most hermetic, Braque and Picasso resorted to codifications – necks of violins, sound-holes of guitars, brand-names from bottles etc. – to conventionalize the 'fact' that a certain 'space' was 'occupied' by a specific volume. The Abstract Expressionists, with the exception of Gottlieb and Motherwell (an honorary European), were by the midforties as reluctant to employ such synoptic devices as they were to resort to 'deep' space.

De Kooning has been characterized by Thomas Hess, an early and

loyal champion, as reluctant to seek syntheses for apparently antithetical concerns.³² Certainly, much of the tension inherent in all De Kooning's work derives from the irresolute nature of the relationships between such antinomies as image and ground, painting and canvas, colouring and drawing, illusion and flatness, and between the autobiographical instantaneousness of perception – response, vision, glance, glimpse etc. – on the one hand, and the interminable complexity of fitting together and fitting in on the other. In his willingness to 'suspend' the painted subject in the procedures of its formulation, De Kooning is close to Pollock. Beside the mature works of these two even Kline's paintings look finished and composed.

In his figure paintings of around 1938 to 1945 (from Two Men Standing say, to Pink Angels) and even more forcefully in the great series of Women which began in 1950,33 De Kooning recapitulated a problem which had obsessed Cézanne and which the Cubists had not solved, but only camouflaged: how to allow, or create 'equivalence' for those objects or spaces or forms whose presence binocular vision and locomotor ability allow us to confirm in the real world, but which are hidden from view, squeezed out or desubstantiated in the inevitably selective process of transfer to a twodimensional surface. Cézanne could not paint the wall behind the Femme à la Cafetière, but he seems to have been passionately concerned to 'make room' for it, however shallow the space at his disposal and however substantial the figure it enclosed. De Kooning continually poses himself similar problems for the reconciliation of competing realities: 1) the world depicted; the figure in a given space; 2) the flatness of the canvas and the nature of the paint. In painting, illusion has conventionally served to mediate between the two; it is a condition of the latter which serves the former. De Kooning's nature is not to reconcile. He allows figure to be invaded by ground, ground to be absorbed by figure. The ontology of the painting remains provisional in a sense which implies something more than the equivocation we associate with the use of illusion.

It seems almost as if the very drying of the paint, the 'literal' congealing of the image, tipped the scales too far over for De Kooning's satisfaction. The De Kooning mythology is replete with stories of paintings delivered dripping wet to exhibitions, of devices

employed to delay the drying process, of continual cancellation, revision and readjustment of apparently 'finished' ('resolved') paintings.34

This 'suspension' is most readily apparent in the single-figure paintings, but it finds perhaps its most intense expression in those works of 1946-50 which are near-abstract conglomerations of suggestive shapes (from the first black-and-white paintings, Light in August, etc., through to Attic and Excavation). These remarkable, dense paintings seem mostly to have originated from quasi-automatist elements and procedures - freely painted letters and numerals, cut-and-pasted fragments of figures, collage juxtapositions, etc. - which are integrated and absorbed as the painting progresses, not only as formal motifs, but as aspects of an asymptote of some final position. As the end-product of this process of accumulation, absorption and even cancellation, the painting enshrines not only, like Pollock's works of 1946, the 'history' of its content, but the very tensions still instinct in the strivings of motifs from a world of motifs each to occupy a significant place in the restricted world of the canvas. Attic of 1949 and Excavation of 1950 stand comparison with any other twentieth-century painting.

In the drawing/painting dichotomy, the scale of cubist painting ultimately favoured drawing. (Perhaps its large scale was one reason why the Demoiselles d'Avignon could never be 'finished'.35) De Kooning's enlargement of the scale of the canvas, to a point at which a stroke with a house-painter's brush is read as the nearest thing to 'line', favoured painting procedures even in contexts where there appeared to be a delineating function. The result is to suspend the process of identification in a welter of modalities. In the absence of other clues - such as shading or the use of perspective - drawing (essentially a monochrome process) is a matter of plan and elevation. To establish coexistence of the two upon the same surface (as Juan Gris did, for instance, in works of 1912-16) is not to offer an equivalent for the space-generating function of painting. Painting is a process essentially concerned with the placing of tone and colour upon the canvas and thus involves the viewer in modalities of 'spaceperception' (gradations of 'modelling'). Even after the introduction of collage in 1912, the Cubist could not really cope with the spatial

modalities implied by colour without resorting to strong silhouettes and flat forms, essentially characteristic of 'drawing' functions. (Hence, largely, Synthetic Cubism. Delaunay's Orphism seemed to offer an alternative, but only by 'abandoning' substantiality altogether.)

There is an overwhelmingly warm-blooded aspect to De Kooning's subjects and devices - an aspect notably lacking in, for instance, Picasso's cubist portraits of 1910 and even in cubist paintings of the nude. (See the Picasso Nude Figure in the Albright Knox Gallery, Buffalo, New York, one of the greatest of all cubist paintings, and one which De Kooning must surely have known well; there is an almost total avoidance of flesh tones and tints in this painting; it is not convincingly 'human'.) Cubism could never cope adequately with spherical forms; the curve of a guitar or a glass, even a profiled buttock, these could be rendered by line; but shoulders, temples and breasts were always points of crisis in cubist paintings. Many of these crises were recapitulated in De Kooning's work of the early forties; the Glazier, for instance, of around 1940 is 'the result of hundreds of studies on how to paint a shoulder',36 and the painting remains unintegrated. But the women, the seated women of the early forties and more majesterially the great series of 1950-53, address themselves above such incidental problems. Their great globular breasts outface cubist structure and burst through the limits of cubist drawing, as if challenging us to see such palpable stuffs as they are made from as mere aspects of a continuum of forms and planes.

The absorption by painting of functions of drawing seems to have been what rendered this possible; in fact, though the women's breasts are painted, they are never modelled. They are characteristically laid on each with one grand loop of the brush. 'Modelling' in De Kooning's mature work becomes a generalized, matter-of-fact function of the paint, not a local, specific, depicting function. In face of his work after *Excavation*, it is no wonder that a declassification of De Kooning's status among the Abstract Expressionists should have become so crucial a priority for exponents of the post-fifties 'form without content' ideology.³⁷

For most of the forties De Kooning and Pollock seem to have been the figures among the Abstract Expressionists around whom the critics and younger artists mostly oriented themselves.³⁸ They have served to represent rival claims among their interpreters,³⁹ although De Kooning, at least, does not seem himself to have been governed by a sense of rivalry (vide his often quoted statement that it was Pollock who 'broke the ice' for the others). Significantly, Clyfford Still's first one-man show in New York, at 'Art of this Century' in 1946, was seen by at least one interested contemporary, Peter Busa, as representing a kind of possibility outside the alternatives offered by De Kooning and Pollock: 'In my book, Still's quiet hand created the critical distance we needed; from the anti-art gestures, from Surrealism, from French painting and from De Kooning's painting as well. Also his was an attitude markedly different from Pollock's.' ⁴⁰

By 1946 Still's work was already highly distinguished and in a manner which seemingly owed little to French painting. Certainly no other American painter in that year could have put together so consistent and so consistently individual a show. Greenberg has noted affinities to Turner and to Monet in the use of 'sheer or closevalued colour'.41 These particular affinities can also be expressed in terms of a common jaggedness and 'dryness' of outline, both of form and of actual brush- or knifestroke, though such characteristics are as easily found in Ryder's painting or even in certain early twentiethcentury American cubist-expressionist works as in the paintings of the Europeans. What is significant is that by as early as 1944 Still had identified his art - and himself as an artist - with a particular highly non-Mediterranean tradition of 'heroic' or 'sublime' Romanticism; a quality far more 'Germanic' than 'French' - Nietzsche rather than Valéry, Rilke rather than Mallarmé. Gottlieb and Rothko expressed a similar orientation in their writings of 1943-7, 42 but it was not until 1947 that Rothko's paintings showed a relevant distinctness, and later in the case of Gottlieb. Rothko and Newman were too individual and ultimately too self-sufficient to have been very dependent on Still's example, but undoubtedly Still's work impressed earlier than theirs, and his work may have appeared to add justification to their development of a strategy of myths.

By the mid forties, if not much earlier (Still has always been highly 'inaccessible' and very little has been published about his early

work and life), Still's work was about as free as must then have seemed possible from any sense of self-conscious confrontation with post-cubist problems. (It is significant that at least one literate American artist of a much younger generation, Don Judd, has made an implicit association between 'cubist fragmentation' and 'European rationalism'. Even during the forties Cubism was potentially suspect as a source for the 'rationalizations' of concrete or geometric art.) Still also seems to have committed himself earlier than any of the other painters to the notion of the particular significance of the wall-sized painting. The remarkable 1944-N No. 1 is 105 inches high and 92½ inches wide; apart from Pollock's Mural, painted for a particular space, there are few works of the mid forties which even approach this size, and certainly none by Rothko, Newman, or Gottlieb. Still's art was already uningratiating and uncompromising at the time of his first New York showing:

The anxious men find comfort in the confusion of those artists who would walk beside them. The values involved, however, permit no peace, and mutual resentment is deep when it is discovered that salvation cannot be bought. We are now committed to an unqualified act, not illustrating outworn myths or contemporary alibis. One must accept total responsibility for what he executes. And the measure of his greatness will be in the depth of his insight and his courage in realizing his own vision. Demands for communication are both presumptuous and irrelevant...⁴⁴

Still's paintings since 1945 have been remarkably consistent in basic characteristics: asymmetrically placed jagged 'planes' which are interwoven with 'grounds' in such a way that neither evidently overlies or stands out against the other; an all-over scaly paint surface usually applied with a palette knife; an avoidance of 'organic' or 'lush' colours: no pinks or soft reds, very few greens; a predominance of deep earth browns, resonant maroons, acid yellows, chalky whites, opaque dark blues, and a range of greys and blacks.

This is a very markedly non-Mediterranean chromatic range; the very antithesis of the Cubists' and a long way even from Matisse's; closest of anything to certain of Emil Nolde's landscapes – and that affinity does nothing more than suggest a common approach to

colour in terms of assertive and symbolic rather than descriptive and narrative potentialities. Newman's and Rothko's use of colour could be characterized as essentially non-referential in similar terms and to similar ends. In fact the developing anti-naturalism in the colour of these three painters was a significant means to freedom from the kinds and considerations of subject matter instinct and current in European painting and its traditions.⁴⁵ This involved a corollary freedom to embody subject matter of a different status in an essentially less circumstantial context. On the evidence of work from the mid forties, Still seems unarguably to have been the leader in this.

Until 1946 Still worked 'out West and alone'. In an introduction to Still's one-man show at 'Art of This Century' in New York in 1946, Rothko expressed his admiration for the other man's creation of 'new counterparts to replace the old mythological hybrids which have lost their pertinence in the intervening centuries'. Still's paintings are remarkable in avoiding on the one hand any evident association to specific contingencies of the material world, and on the other any underlying structure as witness to a rehearsed metaphysic. His stance as a painter involves an arrogant assertion of the freedom of his vision over the epistemology of the more factitious aspects of the art.

That pigment on canvas has a way of initiating conventional reactions for most people needs no reminder. Behind these reactions is a body of history matured into dogma, authority and tradition. The totalitarian hegemony of this tradition I despise, its presumptions I reject. Its security is an illusion, banal, and without courage. Its substance is but dust and filing cabinets. The homage paid to it is a celebration of death. We all bear the burden of this tradition on our backs but I cannot hold it a privilege to be a pallbearer of my spirit in its name.⁴⁶

The appearance of Still's paintings is consistent with his determination to refuse acquiescence to 'the collectivist rationale of our time', and to escape incorporation into the omnivorous 'totalitarian mind'. They remain definitely 'outside'. Their dense, opaque, slabbed surfaces defy our attempts to 'enter' (in the sense that we might imaginatively conceive of 'entering' the surface of a painting by

Rothko). In a context wholly devoid of pathos, his art reflects a condition of 'solitariness', 'non-associativeness' and 'otherness'. Rothko quotes him to the effect that his paintings were 'of the Earth, the Damned and the Recreated'.

Like Still, Barnett Newman seems to have felt ill at ease in the forties with the heritage of European art. The possibility of independence became real for him at the point when he seems to have sensed that a straight line need not evoke a Euclidean, a 'nonobjective' world; that an uncompromising division of the surface could in effect serve to embody uncompromisingly 'subjective' themes; that he was not bound, in fact, to choose between 'abstraction' and a world of subjects.

For five years in the early forties Newman had abstained from painting. During that time he appears to have attempted - often in writing - to understand the broad development of art in terms of its subjects and to account for the apparent present sterility of 'content'. He saw Post-Impressionism, with its emphasis upon problems of representation, as a 'school of still-life painters with a Nature Morte critique to all things'. 47 He concluded that the motive force for the making of art was terror (before the 'unknowable') and that the acknowledgement of terror was tragedy (the cognizance of the 'unknowable'; the awareness of the hopelessness of action in the face of ignorance and chaos). Like Rothko, Newman seems to have read both Aeschylus and Nietzsche, assimilating an educated concept of tragedy into a consciousness deeply affected by traditions of Jewish mysticism.⁴⁸ And in 1945, like Rothko and Gottlieb two years earlier, he explicitly related a general concern for the embodiment of significant subject matter to a specific response to the conditions and consequences of the war.

... In times of violence, personal predilections for niceties of color and form seem irrelevant. All primitive expression reveals the constant awareness of powerful forces, the immediate presence of terror and fear, a recognition of the brutality of the natural world as well as the eternal insecurities of life. That these feelings are being experienced by many people throughout the world today is an unfortunate fact and to us an art that glosses over or evades these feelings is superficial and meaning192

less. That is why we insist on subject matter, a subject matter that embraces these feelings and permits them to be expressed. (Gottlieb)⁴⁹ . . . The war, as the Surrealists predicted, has robbed us of our hidden

terror, as terror can only exist if the forces of tragedy are unknown. We now know the terror to expect. Hiroshima showed it to us. We are no longer then in the face of a mystery. After all, wasn't it an American boy who did it? The terror has indeed become as real as life. What we have now is a tragic rather than a terror situation. (Newman)⁵⁰

The notion of 'action in chaos' - 'a tragedy of action in the chaos that is society' (Newman) - pervades abstract-expressionist ideology.

When Newman recommenced painting in 1944 it was, initially, in terms of a spontaneous procedure for the generation of potent images. '... My idea was that with an automatic move, you could create a world'.51 The few surviving works from the years 1944-5 include vivid oil and pastel paintings with organic, broadly 'genetic' rather than specifically 'sexual' motifs. The first vertical stripe, 'reserved' by brushing ink over a masked line, thus establishing both 'surface' and 'void' at once, appears in a small monochrome work on paper of 1945. From this point on Newman's paintings became consistently more 'generalized', more 'archetypal' in form, more extreme in their non-figurativeness, and more expressive and individual in colour. His oil paintings of 1945-7 are based upon circular forms (with potential associations ranging from vulva and void to seed and sun (Pagan Void, 1946), or upon verticals ('break', 'path', 'shaft of light', 'man', etc.) (The Command, 1946), or upon combinations of the two (Genetic Moment, 1947). Until the end of 1947 the verticals, however sharply drawn and flatly painted, appear against or in context of textured and associative fields.

The terminus, post quem of Newman's mature style is marked by a small oil, Onement I of 1948, in which an impasto cadmium red light stripe, overlaid on masking tape, is all but centred vertically upon a more thinly painted, even, cadmium red dark field. The painting was the result of an 'accident'. Newman was testing the brighter red on the masking tape prior to its removal. The decision not to remove the tape and not to 'paint up' the unmodulated ground was undoubtedly not prefigured and seems moreover to have been made over a long period. It was not for some months that

Newman proceeded to a new painting.⁵² Thoughtfulness in the face of 'new' possibilities, new assertions, was a characteristic of the abstract-expressionist painters at their best, and a counter to both surrealist and neoplastic notions of the function of intuition. (This 'thoughtfulness' is parodied in those paintings by Kline in which a grand 'spontaneous' brushmark is touched up along the edges.) Newman's first vertical canvases of 'human' scale, such as *Abraham* and *Concord*, date from 1949. In the three years 1949–51 Newman painted some of this century's greatest paintings.

The vertical divisions of Newman's compositions provided him with a decisive solution to the limitations and equivocations of latecubist space without driving him into quasi-surrealist aformalities. The vertical stripes echo the framing edges and thus establish a relationship in which the literal, material limit of the painting its actual edge - is given identity as a compositional function rather than merely as a condition of composition. Besides reiterating the framing edges, Newman's verticals also reiterate the significance of explicit verticality in a context which admits the heritage of a tradition - a tradition in earlier stages of which such explicit relationships - such 'geometry' - had symbolic significance; or, at the very least, served to underline the metaphysical, non-anecdotal content in paintings with representational subject matter. (See, for instance, Duccio's Maesta Crucifixion. The three elongated crosses, each addressed in precise vertical alignment with the framing edge, with each crosspiece a precise horizontal, establish a relationship of identity between painted subject and painted surface in which the ideal function of the painting as object is implicit.) In painting with narrative/representational content such conventions of association were vital as signifiers of a transcending non-referential function. The interrelationship between subject and object thus established is an epistemologically more secure - better educated - means of instantiating 'transcendental' aspects of the painting as object than the more fanciful Hegelian concept of the illusionistic painted surface as a created 'something other' (something 'non-literal'). It is partly in terms of this interrelationship of significance that Newman's paintings lay claim to 'sublime' status. Now that the naturalizing impulses which had supplanted the earlier geometry were deprived of

their raison d'être – the world of things and beings to be 'naturally' delineated – Newman could resurrect the significance of the geometry – invoke that aspect of the tradition – in a context which was devoid of narrative and which discouraged association with any encapsulated metaphysic. (This was the antithesis of Mondrian's neoplastic, neo-Platonic geometry.) None of this is intended to demonstrate direct 'influence' nor to suggest that there is anything inherently mystical about the functions of Newman's verticals; merely that, given as wide a view over the history of art as Newman himself was evidently concerned to take, their functions can be seen in some respects as conventional.

In 1943, in a radio broadcast and in a letter to the *New York Times* (upon which Newman collaborated) ⁵³ Mark Rothko and Adolph Gottlieb proclaimed their involvement with 'eternal symbols', their 'kinship with primitive man', their conviction of the expressive power of myth and their insistence upon the primacy of subject matter.

In pictographic paintings (heavily influenced by the work of the Uruguayan Joaquim Torres-Garcia) dating from the early forties until about 1952, Gottlieb disposed individual motifs – abstract shapes, human features and forms largely derived from North American Indian cultures – in a more or less compartmentalized structure. Greys and dry earth colours serve to 'localize' the space of the painting without resort either to 'deep' space or to post-cubist planes. 'It's a primitive method', he wrote in 1945, ⁵⁴ 'and a primitive necessity of expressing, without learning how to do so by conventional ways . . . it puts us at the beginning of seeing.'

In the later of these pictographs, more 'neutral' and more 'painterly' elements – dry, scumbled areas, soft, thick brushmarks and symbols such as arrows and plus-signs – become interwoven as 'compartments' and 'contents' merge. There is a considerable affinity with the works of Klee's last years. The surfaces of the pictographs become increasingly painterly, comparatively less anecdotal, prefiguring the *Burst* series which Gottlieb began in 1957. But Gottlieb's works never altogether transcend the anecdotal as do Rothko's and Newman's by the late forties. There is always a strong,

somewhat 'French' reliance upon displayed characteristics of facture: one texture or colour or form or motif against another; never quite the 'sense of the whole thing' achieved so consistently by Rothko and Newman from 1948 onward.

Rothko had experimented with automatism in the early forties, like so many others, and like Pollock in the mid forties was drawn to Miro. In Rothko's works of 1945-6 there is a reminiscence of those of Miro's of the twenties in which schematic and calligraphic forms are simultaneously floated upon and embedded in a 'soft', 'deep', 'opaque' ground. The strictly horizontal divisions of Rothko's midforties watercolours, such as Geologic Reverie of c. 1946, function as do the horizons of Miro's mid-twenties landscapes, as a means of dividing the painting laterally into zones, thus evading, as did Newman by comparable means, the problem of recession relative to all four framing edges. (This problem had survived Cubism.) In Rothko's mature work close tonal relationships across horizontal divisions between large rectangular areas of colour serve similarly to prevent the centre of the painting from 'receding into depth' relative to the corners. In 'taking the whole painting' right out to the edges and into the corners, Rothko, Newman, Pollock and Still achieved a degree of integration of their images which had been beyond even Braque and Picasso at their best. Hess records that Newman once described his Euclidian Abyss of 1946-7 as 'my first painting where I got to the edge and didn't fall off'.55

The decisive point in Rothko's development came in oil paintings of 1947, when his choices of colour were finally freed from considerations of the vestiges of descriptive functions. The 'soft-space' hues of his pre-1947 watercolours swallowed up his biomorphs and assumed the organization of the surface.

At the moment of transition in his painting from 'biomorphic' to 'colour-field' abstraction, Rothko wrote of 'the shapes in the pictures' as 'performers... created from the need for a group of actors who are able to move dramatically without embarrassment and execute gestures without shame', and of the need for 'everyday acts' to belong to 'a ritual accepted as referring to a transcendent realm'. ⁵⁶

The (crudely) Jungian rather than Freudian interpretation of the

unconscious in the work of Pollock, Newman, Rothko and Gottlieb reflected certain aspects of the ambitions they had in common. When they wrote, they wrote of 'rituals' rather than 'relations'. They were not so much concerned to draw attention to the pathos of isolation and insecurity in man's relationships with man as to embody the priority of the 'aesthetic act' over the 'social'.57 Hence, in large part, their involvement - emphatic in the early forties, less self-conscious after about 1948 - in archaic mythology, in romantic anthropology and in primitive art;58 hence also their subsequent move away to a more 'absolute' position. Undoubtedly, for Newman and Rothko the proclaimed involvement with the primitive and with mythology was in part a strategy designed both to protect them from and to elevate the status of their paintings above the banal contingencies and the trivializations of social life. Still's misanthropy can be seen as having a similar function. 'With us the disguise must be complete. The familiar identity of things has to be pulverized in order to destroy the finite associations with which our society increasingly enshrines every aspect of our environment.' (Rothko, 1947) 59

They expected, in certain respects, to be solitary (as, in a very real sense, they were) 60 and they knew their work would reflect this. The transaction between painting and spectator was envisaged as essentially private and intimate; the 'man-sized' paintings which Rothko and Newman painted from 1949 onward were designed to be seen from close to 61 in a context which encouraged silence and absorption. '... I realize that historically the function of painting large pictures is painting something very grandiose and pompous. The reason I paint them however – I think it applies to other painters I know - is precisely because I want to be very intimate and human. To paint a small picture is to place yourself outside experience, to look upon an experience as a stereopticon view or with a reducing glass. However you paint the larger picture, you are in it. It isn't something you command.' (Rothko, 1951) 62 'I paint large pictures because I want to create a state of intimacy. A large picture is an immediate transaction: it takes you into it.' (Rothko, 1958) 63

This implied 'absorption' of the spectator by the painting, particularly in the case of Rothko, to whom the notion was absolutely

crucial, also suggested that the spectator was involved in a kind of surrender to the void - an abandonment of a contingent sense of himself; i.e. that the painting, as well as being itself a 'heroic' assertion, also served as a means of embodying to the viewer, even of imposing upon him, that state of solitariness which in the first place rendered the assertion necessary, difficult and 'heroic' for the painter. Many of Newman's titles substantiate this: The Name. The Way, The Gate, Outcry, Right Here, Here. Rothko and Newman both 'characterize' the spectator as a man standing alone before the painting.

'Original man, shouting his consonants, did so in yells of awe and anger at his tragic state, at his own self-awareness, and at his own helplessness before the void.' (Newman) 64 'For me the great achievements of the centuries in which the artist accepted the probable and familiar as his subjects were the pictures of the single human figure - alone in a moment of utter immobility.' (Rothko, 1947) 65

It is necessary to be able to see all this at more than one level: a 'heroic' and 'elevated' ambition in a context of desperate alienation, but also strategies of elevation, irony from behind the tragedian's mask, 66 sophistication in the context of 'extremeness'. Newman's Euclidian Abyss, with its invocation of the concept of the 'void', is also readable, at a less exalted level, as a means of derogatory reference to the emptiness and archaism of Mondrian's geometry - it is a very 'literate' painting. One series of Newman's paintings, the fourteen Stations of the Cross of 1958-66, has as generic subtitle Lema Sabachthani, the Hebrew version of Christ's cry from the cross: 'My God, My God, why hast Thou forsaken me?'67 This is consistent with Newman's preoccupation with heroic or tragic assertion in total solitude. Another, more recent series is titled Who's afraid of Red, Yellow and Blue? instantiating Newman's ironic critique of dogma and of the elevation of significance and problematics in the technology of painting.68

The notion of significance at the 'higher' level becomes more credible in the context of the ironies of the 'lower'. We are not required altogether to suspend scepticism. We can be sure that at whatever level Newman's notion of the sublime operated, it was certainly not at a level that would encourage pseudo-religiosity about the procedures of painting. As painters, the Abstract Expressionists, even Pollock, most emphatically Pollock, were supremely practical and down-to-earth. If anything secured them from pathos in the search for the 'tragic', it was surely this.

There are times when the metaphysics seem to have been used almost as if to keep the technologists of the cult of painting at bay – a common enough strategy among artists. A painting like Newman's magnificent *Vir Heroicus Sublimis* of 1950–51 sustains the high ambition of the artist without in any way masking the precision and blandness of the drawing and painting.

Newman's paintings signify their operations on 'elevated' levels in terms of evident formalities rather than evident metaphysics: scale – after 1949 there are few works less than six feet in height (there is an exceptional group of very narrow works of 1950); saturation and remarkable balance of colour – remarkable in terms of the unconventional stress laid upon extreme relationships between one area of colour and another; extremeness in drawing – straightness and roughness of edge, narrowness and width of areas, symmetricality and asymmetricality of placing. Newman's paintings are 'extreme' as a whole in the sense that he seems consistently concerned to play upon minima and maxima: how narrow an area can be and still 'hold' from the appropriate viewing distance; how great a tonal contrast or complementarity of colour can be sustained without disintegration of the whole; how 'simple' a painting can be in 'means' while sustaining great complexity of 'effect', etc.

The number of variables is astonishing within what might seem so reduced a morphology. In a large group of works painted between 1949 and 1952, no two paintings have anything approaching the same qualities of surface. At the highest level of Newman's output the range is immense; say, between *Cathedra* (a 'deep' mostly purplish-blue painting) and *Vir Heroicus Sublimis* (a 'flat', mostly red painting), both eight feet high and eighteen feet wide (two eightfoot squares plus two feet) and both completed in 1951. They are very distinct paintings.

Newman wrote in a 'Prologue for a New Esthetic' in c. 1949: 'What is all the clamor over space? . . . My paintings are concerned

neither with the manipulation of space nor with the image, but with the sensation of time . . . '

Rothko's paintings encourage a sense of perceived 'mysteriousness' rather more than do Newman's, largely because there is a greater illusion of transparency and translucence in the surface. It is conventional to respond to such surfaces in such kind; this is an aspect of the 'ritual accepted as referring to a transcendent realm'. It is important to remember that this illusory space has its origin - not in specific, but in general terms - in the 'liquid', 'metamorphic' contexts of Rothko's pre-1947 paintings; it is a 'world' of its own. or at least serves as reference to an 'other' world. Rothko's alternative to the 'tableau vivant of human incommunicability', 69 which was all evident-subject paintings seemed to offer in 1947, was no celebration of other joys - in his terms this would have been idealist. self-deceptive, irrelevant - but an alternative means of communion in a context which allowed for considerations of mortality (as the context, say, of Mondrian's art did not). 'A clear preoccupation with death. All art deals with intimations of mortality.' 70

If anything like an intimation of mortality can be derived from Rothko's paintings - as I believe it can, in a 'conventional' context - it is not in any 'religious' terms, but in terms of that sense of 'surrender to the void', of allowing oneself to be absorbed into the 'interior', the 'illusory space' of the painting, which is an actual condition of spectatorship established by the formal characteristics of the painting itself once we accept the conventional possibility of a 'mutual' relationship. In terms of our everyday and contingent realities, the appropriate orientation to a painting by Rothko - the kind and degree of concentration it demands - is equivalent to a state of 'not-being'. This is perhaps an asymptote of an 'ideal' orientation rather than an 'achieved state', but according to the conventions of response to painting our intuition can operate to 'bridge' the gap between the two.

'Veils' of colour are scumbled one over another-cool over warm, warm over cool, cooler over warmer, warmer over cooler etc., or dark over light etc. - to the point at which 'levels' of illusion become inseparable in a total 'soft', 'translucent' and essentially 'deep' surface. As the sum total of these modalities the 'identity' of the painting is impossible to encapsulate.

As Rothko's work developed up to the point of his death there was an overall tendency for his tonalities to become more tenebrous, his hues deeper and darker, and for the motifs – the often vestigial presences 'within' the canvas, areas which do not quite reach the edge at any one point – to become more inextricably integrated with, or more equivocally related to the 'field'. The conditions of spectatorship which Rothko's paintings imply seem, as his work develops, to involve a gathering silence and a progressive dimming of the light of the 'real' world by which we see them.

Early twentieth-century abstraction - that of Kandinsky, Malevich and Mondrian - had been sustained by idealism and by a belief in a 'coming era of great spirituality'. The years between the wars, alike in Europe and America, brought disillusion to many, put paid to many dreams for the future prospects of 'art' and of 'culture' and, in Europe at least, saw the rise of idealism of quite another kind. Or was it so different? At least one of the Abstract Expressionists made an explicit association between one kind of idealism and the other. In a symposium of 1951, under the title 'What Abstract Art Means to Me', De Kooning described an art of 'spiritual harmony' in terms which suggested that he saw its protagonists as in process of flight from painful realities of life: 'Their own sentiment of form instead was one of comfort. The beauty of comfort. The great curve of a bridge was beautiful because people could go across the river in comfort. To compose in curves like that, and angles, and make works of art with them could only make people happy, they maintained, for the only association was one of comfort. That millions of people have died in war since then, because of that idea of comfort, is something else.' 72

It is hard for us, even now, to see European abstract art in the disenchanted light by which some American artists viewed it (and still do). After all, many of our highest and dearest cultural and spiritual aspirations are invested in European notions of the meaning-fulness of abstract art. But to the American artists, concerned in the early forties, as the Europeans mostly were not, with major problems

of major art, Suprematism, Neoplasticism, Concrete Art, Absolute Art, Purism, etc., if they did not actually accord with totalitarianism, certainly did not answer to the circumstances in which they were concerned to embody their apprehensions and their affirmations. Even in Europe we may come to view the progenitors of our abstract art as primitives of a kind, men whose consciousness of the world was screened as a child's is, who were thus privileged to embody the aspirations of a dematerialized world, an unsophisticated awareness.

In 1948, Barnett Newman expressed a more evolved view of the problem of representativeness in non-figurative art: 'The question that now arises is how, if we are living in a time without a legend or mythos that can be called sublime, if we refuse to admit any exaltation in pure relations, if we refuse to live in the abstract, how can we be creating a sublime art?' In so far as it is appropriate to see aspects of Abstract Expressionism in terms of a recapitulation of and development of conditions implicit in 1911–12 Cubism (pace Greenberg), I would suggest that the Abstract Expressionists were concerned, among other things, with the need to trace Cubism back down through its extensions to the point at which art ceased to be able to call upon a world of whole objects, i.e. back beyond the obfuscating idealism of Malevich, Mondrian and Kandinsky.

The European abstract artists somehow managed to derive, from their inability to make sense of man's changed and fraught relationship to the material world, an optimistic belief in a future which would be characterized by the 'spirituality' of all relationships. The Abstract Expressionist, confronting a more developed condition of the same alienation of man from the world he had previously painted, saw nothing with which he felt a relationship he could embody, nothing he could affirm with the confidence with which he could affirm his own existence and his own mortality.

The argument that science is really abstract, and that painting could be, like music, and, for this reason, that you cannot paint a man leaning against a lamp-post, is utterly ridiculous. That space of science – the space of the physicist – I am truly bored with by now. Their lenses are so thick that seen through them, the space gets more and more melancholy. All that it contains is billions and billions of hunks of matter, hot

or cold, floating around in darkness according to a great design of aimlessness. The stars I think about, if I could fly, I could reach in a few old-fashioned days. But physicists' stars I use as buttons, buttoning up curtains of emptiness. If I stretch my arms next to the rest of myself and wonder where my fingers are – that is all the space I need as a painter.⁷⁴

Notes

1. More partisan positions within American criticism are represented by Harold Rosenberg's label 'Action Painting', and by Clement Greenberg's "American-Type" Painting (i.e. positively non-European painting). Rosenberg's essay 'The American Action Painters' (originally published in Art News in 1952 and reprinted in Rosenberg's first collection of essays, The Tradition of the New) offered, at best, a sense of intense and early sympathy with the enterprise and an assertion of compatibility between the poet and the painters for which the latter must generally have been grateful; but his theatrical prose as it gathers impetus tends to outstrip the requirements of sense. Greenberg's "American-Type" Painting' was originally published in the Partisan Review in Spring 1955 and was reprinted in his collected essays, Art and Culture. His writing maintains a consistently high level of responsibility to the actual formal appearance of the paintings, but his increasing devotion to a 'modernist logic' of historicity (particularly after the mid fifties, and perhaps partly in reaction against Rosenberg's rabid existentialism) leads him to straitjacket interpretation. (In an excellent article published in Artforum in September 1965, Philip Leider, then editor of that journal, outlines the nature of the argument between the two positions, partly in relation to the concerns of younger critics, notably Michael Fried.)

As the influence of Rosenberg's criticism waned, so the modernist position hardened, particularly in the work of those younger critics influenced by Greenberg. The formal elements of abstract-expressionist painting were emphasized retrospectively in the most hard-working American criticism of the sixties (i.e. modernist criticism, pejoratively characterized as 'formalist'), to the exclusion of much that was necessary to provide a well-rounded picture, largely in the interests of a subsequent generation of painters little concerned with 'content' or 'subject matter', whose paintings required to be seen in terms of essentially formal developments beyond Abstract Expressionism. The

'rival' school is pejoratively characterized as 'literalist' and is ideologically derived in part from aspects of the work of Jasper Johns and more substantially from the work and writings of the 'sculptor' Robert Morris. Such criticism is seen as taking its point of departure from a response to the 'literalness' and 'evidentness' of the procedures of paint application and of the painted surface in Abstract Expressionism and especially in the work of Jackson Pollock. (In 'Literalism and Abstraction', an article on Frank Stella published in Artforum, April 1970, Leider outlines the development of rival ideologies from the work of Pollock.) The important issues concerned in critical approaches to Abstract Expressionism have been in danger of sinking from view beneath a morass of accusations, from one camp of rampant avantgardism and debased and debasing materialism and from the other of elitist aesthetics and naïve ontology.

Despite overwhelming evidence from the extant writings and reported statements of the abstract-expressionist painters themselves, the priority they accorded in the forties to concerns with 'content' and 'subject' was not well respected by spectators of their work until comparatively recently. More recent studies, perhaps partly in response to the progressive publication of original documents from the forties and early fifties, have tended somewhat to redress the balance, or at least to provide material for alternative hypotheses. The catalogue for the important Los Angeles County Museum exhibition, 'New York School—The First Generation Painting of the 1940s and 1950s' in 1965, included excerpts from writings and statements by all the artists included and contained the first really detailed bibliography of the movement (compiled by Lucy Lippard). An updated version of this catalogue has been published by Thames and Hudson as The New York School. Irving Sandler's recently published study of Abstract Expressionism has done much to readjust the overall picture in terms of substantiated history and original documentation. (Abstract Expressionism; The Triumph of American Painting, New York and London, 1970.) Writers on the subject, especially those without regular access to original material, are bound for some time to come to be indebted to Sandler's researches. The present writer is no exception.

2. The Los Angeles County Museum show included Baziotes, De Kooning, Gorky, Gottlieb, Guston, Hofmann, Kline, Motherwell, Newman, Pollock, Pousette-Dart, Reinhardt, Rothko, Still and Tomlin. Sandler devotes individual chapters to Gorky, Baziotes, Pollock, De Kooning, Hofmann, Still, Rothko, Newman, Gottlieb, Motherwell and

Reinhardt, and discusses James Brooks, Bradley Walker Tomlin, Franz Kline and Philip Guston as 'Later Gesture Painters'.

- 3. "When the revolution became an institution", when avant-garde became official art, I guess they put down the date 1950 for it' - Ad Reinhardt (from a talk given at the ICA, London, 28 May 1964, published in Studio International, December 1967).
- 4. From a statement in Sidney Janis, Abstract and Surrealist Art in America, New York, 1944.
- 5. See Ethel Schwabacher, Arshile Gorky, New York, 1957: 'Gorky frequently looked at ... the work of one master through the eyes of another . . . he was to see Duchamp through the eyes of Matta.'
- 6. William Rubin, Arshile Gorky, Surrealism, and the New American Painting, in Art International, February 1963.
- 7. Clement Greenberg, 'The Late Thirties in New York' (1957), printed in Art and Culture, Boston, 1963.
- 8. The term 'Post-painterly Abstraction' was coined by Clement Greenberg as the title of a mixed exhibition selected by himself for the Los Angeles County Museum in 1964. It is generally applied to the work of Morris Louis, Jules Olitski, Kenneth Noland and Helen Frankenthaler, and sometimes generally to the 'Washington School' of the sixties.
- 9. 'One shape in relation to other shapes makes the "expression" -Hofmann, in a panel discussion, from 'Artists' Sessions at Studio 35, (1950) published in Modern Artists in America, New York, 1951.
 - 10. Clement Greenberg, Hofmann, Paris, 1961.
- 11. To the Surrealists, 'automatism' signified any procedure employed as a means of avoiding 'control' over composition; the term might be applied to Arp's techniques involved in dropping pieces of torn paper or of string, to Picabia's ink blots, to Ernst's frottages and decalcomanias, and to the Surrealists' game of 'heads, bodies and tails', Le Corps Exquis (in which Motherwell participated). For the Surrealists these techniques were essentially strategic; once an 'image' had been identified, or an interesting texture isolated, conscious and sophisticated controls were re-employed to exploit it. For Pollock 'automatism' was more a characteristic of a 'rhythm' maintained throughout the painting.
- 12. '... I've been a Jungian for a long time ... painting is a state of being ... Painting is self discovery.' Pollock, interviewed by Selden Rodman, June 1956, published in Conversations with Artists, New York, 1957. When Pollock entered analysis in 1939, it was with a Jungian analyst.

- 13. See Rosalind Krauss, 'Jackson Pollock's Drawings' in Artforum, January 1971: 'During the eighteen months of his analysis in 1939–40 Jackson Pollock produced for discussion between himself and his analyst ... 69 pages of drawings ... The imagery on almost half of these sheets relates directly to Picasso's Guernica. In conversation, Dr Henderson has said that these drawings were dream representations which Pollock produced specifically for his analytic sessions rather than drawings made independently of the therapy and brought into the sessions to facilitate the process of association. Are we to think, then, that in 1939–40 Pollock's dream life was taken up with the Guernica?' These drawings were exhibited at the Whitney Museum in New York in 1971.
- 14. From 'Concerning the Beginnings of the New York School 1939–43', Peter Busa and Matta interviewed by Sidney Simon; *Art International*, Summer 1967.
- 15. See 'Concerning the Beginnings of the New York School 1939–43', Robert Motherwell interviewed by Sidney Simon; Art International, January 1967.
- 16. See 'Concerning the Beginnings of the New York School'. Baziotes, an early friend of Matta, had met Pollock, De Kooning, Kamrowski and Busa on the 'Project' the scheme organized by the Works Progress Administration to employ artists during the period of the Depression. Painters worked either on public commissions or in an 'easel painting division'. Regular employment under the WPA encouraged many 'part-time' painters, De Kooning among them, to see themselves as professionals.
- 17. From 'An Interview with Matta', conducted by Max Kozloff, published in *Artforum*, September 1965.
- 18. In 1947 his painting $Fury\ II$ was included in an exhibition on the theme of the 'Ideographic Picture' which Barnett Newman organized for the Betty Parsons Gallery.
- 19. Greenberg quotes Hofmann to the effect that for fifteen years he 'drew obsessively' in order to 'sweat Cubism out' Greenberg, *Hofmann*.
- 20. 'When I am in my painting, I'm not aware of what I'm doing. It is only after a sort of "get acquainted" period that I see what I have been about. I have no fears about making changes, destroying the image etc., because the painting has a life of its own. I try to let it come through. It is only when I lose contact with the painting that the result is a mess. Otherwise there is pure harmony, an easy give and take,

and the painting comes out well' – Pollock, from a statement published in *Possibilities*, Winter 1947–8.

- 21. 'Jackson always knew it: that if you meant it enough when you did it, it will mean that much' Franz Kline, from an interview with Frank O'Hara; 'Franz Kline talking', Evergreen Review, Autumn 1958.
- 22. See, for instance, Motherwell's account of Pollock working on a collage for an exhibition at 'Art of this Century' in 1943, in H. H. Arnason, 'On Robert Motherwell and his Early Work', Art International, January 1966. Motherwell describes Pollock spitting, burning and tearing.
 - 23. Matta in 'Concerning the Beginnings of the New York School'.
- 24. 'My painting is direct . . . The method of painting is the natural growth out of a need. I want to express my feelings rather than illustrate them. Technique is just a means of arriving at a statement. When I am painting I have a general notion as to what I am about. I can control the flow of paint: there is no accident, just as there is no beginning and no end.' Pollock, from his own narration to the film Jackson Pollock, by Hans Namuth and Paul Falkenberg, 1951. (Printed in Bryan Robertson, Jackson Pollock.) Compare with note 20; the sense of growth in confidence is perhaps a measure of Pollock's increased facility in his chosen techniques.
 - 25. From 'Concerning the Beginnings of the New York School'.
 - 26. See note 20.
- 27. For a strong statement of this view see Clement Greenberg, "American-Type" Painting': 'I do not think it exaggerated to say that Pollock's 1946–50 manner really took up Analytical Cubism from the point at which Braque and Picasso had left it when, in their collages of 1912 and 1913, they drew back from the utter abstractness for which Analytical Cubism seemed headed.'
- 28. The 'Subjects of the Artist' School was founded by William Baziotes, David Hare, Motherwell and Rothko in the autumn of 1948. Still was involved in the initial planning, but did not teach. Newman joined the faculty at the beginning of the second term.
- 29. Robert Motherwell interviewed by Max Kozloff, Artforum, September 1965.
- 30. 'It was with the utmost reluctance that I found the figure could not serve my purposes . . . But a time came when none of us could use the figure without mutilating it' Rothko, quoted by Dore Ashton in an article in the *New York Times*, 31 October 1958.

- 31. '. . . from 1951 on his work shows the strong tendency . . . to revert to traditional drawing at the expense of opticality ... These ... works probably mark Pollock's decline as a major artist' - Michael Fried, from his introductory essay to the catalogue of the exhibition 'Three American Painters' (Noland, Olitski, Stella) at the Fogg Art Museum, Harvard University, 1965.
- 32. See Thomas Hess, Willem de Kooning, catalogue of the exhibition organized by the Museum of Modern Art, New York and shown at the Tate Gallery, London, 1968.
- 33. The series Woman I to Woman VI was exhibited in De Kooning's third one-man show, at the Sidney Janis Gallery in New York, in March 1953.
- 34. See Hess, op. cit. Hess quotes Nietzsche: '... This everlasting, baleful "too late" - The melancholy of all that is finished.
- 35. The painter Walter Darby Bannard has written some singleminded articles on relationships of surface and scale between cubist and abstract-expressionist painting; see, for instance, 'Cubism, Abstract Expressionism, David Smith', Artforum, April 1968; 'Willem de Kooning', Artforum, April 1969; 'Touch and Scale: Cubism, Pollock, Newman and Still', Artforum, November 1971.
 - 36. Hess, op. cit.
- 37. Hess, op. cit., charts the changes in Greenberg's judgement of De Kooning. See his note 11.
- 38. See Max Kozloff's interview with Friedel Dzubas in Artforum. September 1965.
- 39. Certainly Rosenberg's view of De Kooning is as central to his notion of 'Action Painting' as Greenberg's view of Pollock is to his notion of 'American-Type Painting'.
 - 40. From 'Concerning the Beginnings of the New York School'.
- 41. See Greenberg's "American-Type" Painting, and also his essay 'After Abstract Expressionism', originally published in Art International, October 1962.
- 42. See Gottlieb and Rothko, joint letter to the editor of the New York Times, 13 June 1943; Gottlieb and Rothko broadcast, 'The Portrait and the Modern Artist', WNYC, New York, 13 October 1943; Rothko, 'The Romantics were prompted', Possibilities, Winter 1947-8; Gottlieb, statement in Tiger's Eye, December 1947.
- 43. See 'Questions to Stella and Judd', interview by Bruce Glaser, Art News, September 1966; Don Judd, 'Complaints Part 1', Studio International, April 1969.

- 44. Still, statement from 15 Americans, edited by Dorothy C. Miller, Museum of Modern Art, New York, 1952.
- 45. In the context of the Abstract Expressionists' use of colour, one can find common ground in the anti-naturalism of Still, Newman and Rothko, in De Kooning's 'vulgarization' an import from the world of commercial reproduction in which he served a part of his apprenticeship and in Pollock's affirmation of the status of paint as matter first and foremost. Pollock's colour itself, as opposed to his means of application, is rarely considered as a major factor in reviews of his post-1946 work; yet such works as *Lucifer* (1947) and *Blue Poles* (1952) depend upon significant uses and functions of colour as much as do any abstract-expressionist works. Frank Stella's work seems to me to owe much to this aspect of Pollock's.
 - 46. Still, loc. cit.
- 47. Newman, 'The Problem of Subject Matter', c. 1944, previously unpublished essay quoted in the Introduction by Thomas Hess to the catalogue of the Barnett Newman exhibition, Tate Gallery, London, 1972.
- 48. In his introduction to the Tate Gallery catalogue, Hess provides considerable and mostly convincing information to substantiate cabbalist interpretations of many of Newman's themes and titles. It seems hard to over-estimate the importance to Newman of his Jewish culture. Mark Rothko was also Jewish, as is Adolph Gottlieb.
 - 49. Gottlieb, broadcast, 1943.
- 50. Newman, 'The New Sense of Fate', previously unpublished essay of 1945 quoted by Hess, loc. cit. In his paper of 1951, 'What Abstract Art Means to Me', De Kooning also referred to the bomb: 'Today, some people think that the light of the atom bomb will change the concept of painting once and for all. The eyes that actually saw the light melted out of sheer ecstasy. For one instant, everybody was the same color. It made angels out of everybody. A truly Christian light, painful but forgiving.'
 - 51. Quoted by Hess, loc. cit.
- 52. Onement I was painted on Newman's birthday, 29 January 1948. Onement II, Newman's next work, was painted between October and December 1948. According to Hess, Newman completed twenty paintings between October 1948 and December 1949.
 - 53. See note 42.
- 54. Gottlieb, *Untitled Edition MKR's Art Outlook*, No. 6, New York, December 1945.
 - 55. Quoted by Hess, loc. cit. The original source is an interview with

David Sylvester. In this interview Newman affirmed the importance to him of this particular painting, partly in terms of the non-associativeness of its painted ground.

- 56. Rothko, 'The Romantics were prompted'.
- 57. See Newman, 'The First Man was an Artist', in $Tiger's\ Eye$, October 1947:

'Undoubtedly the first man was an artist. A science of paleontology that sets forth this proposition can be written if it builds on the postulate that the aesthetic act always precedes the social one . . . It is important to keep in mind that the necessity for dream is stronger than any utilitarian need. In the language of science, the necessity for understanding the unknowable comes before any desire to discover the unknown.' See also Rothko, 'The Romantics were prompted': '... the solitary human figure could not raise its limbs in a single gesture that might indicate its concern with the fact of mortality and an insatiable appetite for ubiquitous experience in face of this fact. Nor could the solitude be overcome . . . '

- 58. These involvements are well substantiated and well documented; Gottlieb began early to collect primitive art, and he and Rothko made various references to the 'immediacy' of primitive, archaic and antique myths and images, notably in the 1943 broadcast; Newman published articles in 1946 on Northwest Coast Indian Painting (introduction to an exhibition at Betty Parsons Gallery, New York) and on the art of the South Seas (in Ambos Mundos; the essay was a review of an exhibition at the Museum of Modern Art, New York; first printed in English in Studio International, February 1970).
 - 59. Rothko, 'The Romantics were prompted'.
- 60. 'Most of the people I knew, they just laughed about his [Rothko's] painting. They just didn't take him seriously at all. He and Barney Newman were ridiculed' Friedel Dzubas, interviewed by Kozloff, loc. cit. Neither Rothko nor Newman were lionized as Pollock and De Kooning often were by 1950. Newman was omitted from the Museum of Modern Art's '15 Americans' show in 1952, and, more surprisingly, from the same museum's touring show, 'Modern Art in the United States', which came to the Tate Gallery in 1956. It was not until 1959, when works from before 1953 were shown at French and Co., that Newman became a well regarded painter in New York. He produced very few works during the later fifties.
- 61. According to Barbara Reise ('The Stance of Barnett Newman', Studio International, February 1970), Newman 'requested' a close

viewing distance 'in a note pinned to the wall of his first one-man exhibitions'.

- 62. From a statement in Interiors, May 1951.
- 63. From excerpts from a lecture given at the Pratt Institute in 1958, noted by Dore Ashton and published in *Cimaise*, December 1958.
 - 64. From 'The First Man was an Artist'.
 - 65. From Rothko, 'The Romantics were prompted'.
- 66. 'Irony: a modern ingredient. A form of self-effacement and self-examination in which a man can for a moment escape his fate' Rothko, in a list of 'ingredients' of a 'recipe' for art, Pratt Institute lecture (see note 63).
- 67. See Newman's statement accompanying the exhibition of these paintings at the Guggenheim Museum, New York, in 1966, and the account of a public 'conversation' with Thomas Hess on the same occasion, given in Hess, *Newman*, op. cit.
- 68. See statement by Newman to accompany a reproduction of Who's afraid of Red, Yellow and Blue I, in Art Now: New York, March 1969: 'Why give in to these purists and formalists who have put a mortgage on red, yellow and blue, transforming these colours into an idea that destroys them as colors?'
 - 69. See Rothko, 'The Romantics were prompted'.
- 70. Excerpts from the Pratt Institute lecture. See note 66. Two at least of Newman's paintings are concerned with death: the sombre *Abraham*, painted in 1949 after the death of his father, and the black-and-white *Shining Forth* (to George), painted in 1961 and dedicated to the artist's brother who died early in that year.
- 71. The phrase is Kandinsky's own, from 'Concerning the Spiritual in Art', 1911.
- 72. Willem de Kooning, from 'What Abstract Art Means to Me', one of three papers given at a symposium at the Museum of Modern Art, New York, February 1951; published in the *Bulletin of the Museum of Modern Art*, New York, Spring 1951.
- 73. From 'The Sublime is Now', Tiger's Eye, December 1948. The notion of the sublime was crucial for Newman, Rothko and Still, and the word itself was one they often employed. In 1963, Still wrote in a statement accompanying an exhibition of paintings at the University of Pennsylvania, 'The sublime? A paramount consideration in my studies and work from my earliest student days. In essence it is most elusive of capture or definition . . .' In a frequently quoted article on 'The Abstract Sublime' (Art News, February 1961), Robert Rosenblum wrote of 'How

some of the most heretical concepts of Modern American Abstract Painting relate to the Visionary Nature-painting of a Century ago'. See also Lawrence Alloway, 'The American Sublime', in *Living Arts* 2, I.C.A., London, 1963; Patrick McCaughey 'Clyfford Still and the Gothic Imagination' in *Artforum*, April 1970; Edward M. Levine, 'Abstract Expressionism: The Mystical Experience', in *Art Journal*, Autumn 1971. 74. De Kooning, 'What Abstract Art means to Me'.

KINETIC ART

Cyril Barrett

Kinetic Art means art which involves movement. (The word comes from the Greek, kinesis, movement, kinetikos, mobile.) But not all art which involves movement is 'kinetic' in the precise sense in which the term is used when we speak of Kinetic Art. From the earliest times artists have been concerned with depicting movement, the movement of men and animals: galloping horses, athletes running, lions leaping on their prey, birds in flight. In other words they have been concerned with the representation of movement, or, to be more accurate, of moving objects. But the kinetic artist is not concerned with representing movement: he is concerned with movement itself, with movement as an integral part of the work.

This distinction between represented and actual movement is not sufficient in itself to distinguish Kinetic Art from other forms of art which involve movement. Not all works which move are considered 'Kinetic' nor do all 'Kinetic' works move. In the precise sense in which the term is used, a work of Kinetic Art must have other specific qualities besides that of moving: the movement must produce a particular kind of effect which will be discussed in a moment. On the other hand, it is not essential that the work itself should move. The effects proper to Kinetic Art can be produced by the spectator moving in front of the work or by the spectator handling and manipulating the work. It may even be the case, as in Op Art, that neither the work nor the spectator moves and yet the effect may still be kinetic. But this is controversial, and I shall discuss it in its proper place. Suffice to say here that a work of Op Art, whether it should be considered as a branch of Kinetic Art or not, does not represent movement: it gives an impression of actually moving. Thus, in Kinetic Art some actual movement occurs; in Op Art the work itself appears to move; in representations of moving objects only the object represented appears to be moving.

These distinctions may be brought out more clearly by considering

the genesis of Kinetic Art. The Futurist Manifestos contained the germ of the idea of Kinetic Art:

We cannot forget . . . that the fury of a flywheel or the turbine of a propellor, are all plastic and pictorial elements of which a Futurist in sculpture must take account.

Boccioni, Technical Manifesto of Futurist Sculpture, 1912.

A roaring motor-car that looks as though running on shrapnel is more beautiful than the Victory of Samothrace . . . We declare that the splendour of the world has been enriched by a new beauty: the beauty of speed.

Futurist Manifesto, 1909.

Movement and light destroy the materiality of bodies.

Futurist Manifesto, 1910.1

But while they celebrated the beauty of movement in words, in their art the Futurists did little more than represent it pictorially. The only difference between, say, a sporting print and Balla's Dog on a Leash or Boccioni's Dynamism of a Cyclist is that the sporting print captures a momentary phase in the movement of a horse, whereas Balla and Boccioni present you with a number of phases as they might appear if superimposed on a single photographic plate.²

Some Futurist paintings, however, represented movement in another, more indirect, manner. Instead of representing a moving object they represented an object as it would appear to a moving observer: a street as seen from a low-flying aircraft or from a fast-moving car. In this the Futurists were merely developing an idea which was latent in the work of Cézanne and explicit in Cubism, namely, that of representing an object as it appears when viewed from the points of view of an observer who walks around it and not from the point of view of a fixed observer. But this is still only a representation of movement. Movement itself does not enter directly into the composition of the work. It is not Kinetic Art in a technical sense.

It was in Russia in the years immediately after the First World War that the idea of Kinetic Art was first realized.³ Though a number of artists – Tatlin, Rodchenko, Gabo and Pevsner – were working towards the idea simultaneously, its clearest and most forceful

expression is to be found in the Realistic Manifesto published by Gabo and Pevsner in August 1920. In the course of the manifesto they criticized Futurism (which had aroused considerable interest in Russia) for the shortcomings already mentioned: 'It is obvious to everyone that the simple graphic record of a series of momentary shots of an arrested movement does not re-create the movement itself.'4 Then, in language not unlike that of the futurist manifestos, they denounced the art of the past and proclaimed a new, dynamic art, the art of 'kinetic rhythms'. 'We renounce the thousand-yearold Egyptian error in art which considered static rhythms the only elements in pictorial art. We affirm a new element in pictorial art. kinetic rhythms, as the basic forms of our feeling for real time.'5 Gabo was to amplify this statement thirty years later when he wrote: 'Constructive sculpture is not only three-dimensional; it is fourdimensional, insofar as we are trying to bring the element of time into it. By time I mean movement, rhythm: the actual movement as well as the illusory one which is perceived through the flow of lines and shapes in the sculpture or the painting. In my opinion. rhythm in a work of art is as important as space and structure and image.'6

What Gabo and Pevsner envisaged was a form of sculpture in which movement would have an equal place with structure, space and image, but it was not to be a predominant place. They did not intend to substitute for traditional sculpture some sort of mechanical ballet. They did not renounce the essential and distinguishing feature of sculpture: construction in space.

What they renounced was mass. Engineering, they pointed out, had shown that the strength of bodies does not depend on mass: witness the T beam. But sculptors had not yet realized or taken advantage of this. 'You sculptors of all shades and tendencies still adhere to the age-old prejudice that volume cannot be separated from mass. But we can take, for example, four flat surfaces and from them construct exactly the same volume as out of four tons of mass.' Now, one way of constructing volume without mass is to outline it by means of flat surfaces or a wire grid, as Gabo and Pevsner did in their 'constructions'. The result, however, is static, although a suggestion of movement may be conveyed optically by

the torsion of the surfaces and the tension of the wires. George Rickey has aptly described these kinds of construction as 'static celebrations of kinetic events'. Another way of producing the same effect is by movement.

To see that this is so one has only to take a piece of string with a weight attached to the end of it and spin it rapidly. As it gathers speed, it begins to look solid, like a cone. The moving string outlines a certain area of space, creates a form or image in space, and thus takes on the essential features of sculpture. This is, as it were a paradigm, an archetype of Kinetic Art. A mobile work of Kinetic Art creates a form in space by movement. It is not essential that the form should appear solid: it is enough that the moving object outlines and defines a certain area of space and that some form or image should emerge as a result of movement.

The earliest work to fulfil these requirements was Gabo's *Kinetic Construction* of 1920.8 It consists of a vibrating metal rod powered by a motor. As the rod vibrates a simple wave is formed. It is slender and translucent like some frail, ethereal vase. Gabo hoped to progress from this humble beginning to more complex kinetic forms, but he was dissatisfied with the somewhat cumbersome electric motor as a source of power. In 1922 he made a drawing, *Design for a Kinetic Construction*, which was never realized. And, thereafter, for want of the technical means of executing his projects, turned instead to static constructions.

It was not until nearly a decade later that the next important work of Kinetic Art was produced. This was László Moholy-Nagy's Light Machine or Light-Space Modulator. Though Gabo does not seem to have adverted to the fact, light played an important part in producing the sculptural effect of his Kinetic Construction. It was the reflection of light from the metal surface which created the impression of solidity. Moholy-Nagy was fully aware of the importance of light in kinetic construction. Light not only plays on the metal parts of his machine; it also adds a new 'sculptural' element to it. Just as the moving parts outline and define certain areas of space, so the light sweeps out and embraces the space surrounding the machine: it encompasses the environment. This idea of the 'sculptural' use of light and of an 'environmental' art was one of the most fruitful in the

whole field of Kinetic Art and is the one which is being most vigorously exploited today.

On the theoretical side Moholy-Nagy also made an important contribution. In a manifesto issued jointly with Alfred Kemeny in 1922 he discusses the effect of Kinetic Art on the spectator. Before a work of Kinetic Art the spectator is no longer a passive or receptive observer: he becomes an active partner 'with forces which develop of their own accord'. In Kinetic Art the composition is not given all at once. The spectator has, as it were, to assemble and construct it for himself. But Moholy-Nagy regarded his works as merely experimental and demonstrative devices. He foresaw a time when the spectator would participate in the formation of the work itself. In this too Moholy-Nagy anticipated some of the more recent developments – spectator participation.

The Kinetic Art movement, as we know it today, may be said to date from Alexander Calder rather than from Gabo or Moholy-Nagy. Calder solved the problem of motive power in a way which was at once simple, elegant and obvious: he used the movement of the air. He thus had no need to hide his source of power or try to make it an integral part of the work. In the early thirties he began to make what he called 'mobiles'. These, in their fully developed form, consisted of flat metal plates, painted black and white or in the primary colours, red, yellow and blue. The plates were suspended from rods and articulated in such a way that they could move freely in any direction. When set in motion by a current of air they revolve gently at varying speeds and set up a sort of counterpoint of movement. But though Calder's 'mobiles' are in accordance with Gabo's conception of kinetic sculpture, Gabo's ideas do not seem to have had a direct influence on him. Calder came to Kinetic Art by way of toy-making. His use of primary colours may be traced to Mondrian and the forms which the metal plates take - and indeed the playful spirit of the 'mobiles' - to Miro.

For a long time Calder was the only artist of consequence working with kinetic sculpture. He was regarded as somewhat eccentric. Kinetic sculpture, after all, is neither painting nor sculpture as traditionally understood. It seems to lack seriousness; its proper place, some people would think, is the toyshop. But since the Second

World War, and particularly since the fifties, Kinetic Art has increasingly engaged the attention of serious artists. But it would be futile to attempt to summarize all that has been done in the last twenty years. I shall therefore consider only the main directions in which artists have worked, and, for convenience, group their works under four heads: 1. Works involving actual movement; 2. Static works which produce their 'kinetic' effect by the movement of the spectator; 3. Works involving the projection of light; 4. Works which require the participation of the spectator.

1. Works which move Works which actually move may be distinguished from one another by the motive power employed. Since the twenties technology has sufficiently advanced to make it possible for artists to use a wide variety of electrically powered machines. But some still rely on natural sources of power. Kenneth Martin and George Rickey, like Calder, use the movement of air: Martin, to achieve a continuous upward spiral motion of curving metal strips; Rickey to produce contrasted rhythmic movements with tall, slender blades which move to and fro like high grass swayed by a breeze. Other artists employ natural forces together with electrical power. Takis uses magneticism. His Magnetic Ballet consists of a large white metal ball which, alternately attracted and repelled by a magnetic coil, is compelled to perform an erratic dance around it.

Of those who use electric motor power, some, like Pol Bury, conceal the source of power. Others such as Schöffer, Krämer, and Tinguely make it a part of the work. The latter solution is aesthetically more satisfying to the extent that the element of mystification is removed. But so far these 'machines' have not been altogether satisfactory as works of Kinetic Art, that is, movement is made to serve some particular purpose and is not presented as something of interest in its own right or as a 'sculptural element' in the sense explained above. Krämer's works are really mechanical ballets. Tinguely is more in the dadaist tradition, poking fun at the machine age and at ART itself – he has constructed, not entirely successfully, some 'auto-destructive' machines – and, though he has made a number of very satisfying moving compositions, they move on a single plane rather than in space (as if an Arp were set in motion).

The chief interest of a work by Bury is the mysterious life with which he has endowed the unpredictable movements of a cluster of nails, wires, or small wooden pegs.

2. Works involving movement on the part of the spectator In 1920, Marcel Duchamp demonstrated, by means of his Rotative Plaque Verre, that if a flat disc painted with concentric circles is spun rapidly it will take on the appearance of a solid object. In other words a moving object may undergo so radical an optical transformation as to appear to be something quite different. Under certain conditions the same effect may be attained by the spectator moving in front of an object. The artistic possibilities of this optical phenomenon have been explored by a number of artists. Soto has done so, for instance, in his 'vibration-structures' and 'metamorphoses'. 'What has always interested me', he says, 'has been the transformation of elements, the dematerialization of solid matter. To some extent this has always interested artists, but I want to incorporate the process of transformation into the work itself. Thus, as you watch, the pure line is transformed, by optical illusion, into pure vibration, the material into energy.'9 Soto achieves this effect by placing some object – a wire structure for example – in front of a moiré background. As the spectator moves in front of the work, the moiré background breaks up the line of the wire structure so that it appears as a series of little dots floating in space.

What is most striking about Soto's work is that its elements are simple and ordinary and yet the effect they produce when combined is very mysterious and complex. 'Separately', as Soto says, 'these things are nothing, but together something very strange happens ... a whole world of new meaning and possibility is revealed by the combination of simple, neutral elements.' Like Turner and the Impressionists, Soto's aim is to dissolve form into colour and light, to realize, as he says, 'an abstract world of pure relations, which has a different existence from the world of things ... My aim is to free the material until it becomes as free as music – although here I mean music, not in the sense of melody, but in the sense of pure relations.' A piece of music is not a 'thing' or even a combination of things: it is the relationship between sounds. Likewise a work by Soto is not a thing, an object, but the relationship of optical elements which come

into being as a result of movement: 'it is purely optical, without physical substance.' Like music, it sings.

Though the effects which Soto aims at have as much in common with those of a painter as of a sculptor, his works are three-dimensional. The works of other artists such as Vasarely, Agam, Cruz-Diez or Asis are more pictorial. In each case the forms alter as the spectator passes in front of them, as though one were looking at an abstract movie. Sometimes, as in the case of Cruz-Diez's physichromies, the colours change as well as the forms; they can range from a deep red when viewed from one end to a deep blue at the other. Both Agam and Vasarely get their effects by designing on sheets of perspex or some such material placed one in front of the other. Asis, on the other hand, gets his effects - usually a sort of watered silk pattern - by optical illusion, in fact by placing a perfor ated sheet in front of a background of dots corresponding in size to the perforations. Though these works gain in interest by their changing pattern, they do not depend on movement in the way in which those of Soto and the other Kinetic artists we have considered do. It is possible at any moment to fix on a particular phase of the composition and contemplate it as one would a painted relief. However, the fact remains that, when one does move, the composition alters in a way quite unlike that of a 'static' relief.

At this point a word should be said about Op Art, which, as has already been noted, is sometimes classified as Kinetic Art. It is so classified because it gives a strong *impression* of movement. The work seems to expand and contract, advance and recede; parts appear to rotate, to leap about the canvas, to appear and disappear, etc. It does not, however, involve actual movement, either on the part of the work or of the spectator. Hence one essential feature of Kinetic Art, as conceived by Gabo and Pevsner – the construction of some form or image in space by movement – is lacking. The space in which the shapes appear to move is wholly illusory, unlike the space in which the works of Soto or Asis operate, which is partly illusory and partly actual. Hence there is a case for excluding it from the category of Kinetic Art. It might be argued that to draw a line between what Soto and Asis are doing and what the Op artists do is arbitrary; the two merge into one another. But this is not true.

Although both may produce their effects by means of illusion, the Op artists produce the impression of movement by means of illusion, whereas the Kinetic artists do exactly the opposite: they produce illusion by means of movement. The Op artists rely entirely on pictorial means: the interplay of colours and lines. The Kinetic artists, on the other hand, rely on movement as a transforming element. They differ both in method and intention. To call both 'kinetic' would obscure important differences between them.

3. Works involving light The use of light may be roughly divided into the *pictorial* and what I shall call the *sculptural*, that is, light projected into space.

The sculptural use of light in the strict sense is that in which it is used to define areas of space. Three things are usually involved here: the light-source, the beam of light, or the aura of light, if it is not focused, and the illuminated surfaces - these may include parts of the work or, if it is in an enclosed space, the surrounding walls. This use of light has the effect of drawing the spectator into the orbit of the work itself. It creates an artistic environment. But the focus of attention can vary. In the work of Nicholas Schöffer, for instance, attention is directed more to the illuminated surfaces of the polished metal parts of the work than to movement of the light around the walls. In certain works of von Graevnitz, Piene and le Parc it is the movement of the light which is the main focus of interest. Piene's ambition is to make monumental light projections out of doors. 'My greatest dream', he says, 'is to project light into the vast night sky, to probe the universe as it meets the light.'11 The use of neon, on the other hand, as it is employed by Morellet, for instance, enables the artist to map out areas of space by means of the light source itself, that is, without projection.

In some ways light is the most effective means of presenting rhythms and patterns of movement visually. It is the most 'dematerialized of all the elements at the artist's disposal. Neon is particularly suitable for this purpose. As the works of Garcia-Rossi and Don Mason demonstrate, it is possible to produce the most subtle changes of tempo and mood by the random illumination of neon rods. Waves of light ebb and flow in the very heart of each rod, as though it momentarily came to life and then quietly died.

But light is not only 'dematerialized' in itself; it also has a 'dematerializing' effect on objects with which it comes in contact. As a spectator moves in front of a Light Relief by Mack the light reflected from the polished metal strips begins to flicker and vibrate, and the object seems to dissolve into vibrating light. In some of Martha Boto's works light projected through revolving metal discs gives one the impression of looking at whirling galaxies or silver dust. In Liliane Lijn's Liquid Reflections light is captured by droplets of water which act as lens, magnifying, reflecting and projecting it. The simplest elements can be incredibly transformed by means of moving light.

All these works involve the movement of light in space and so fall within the concept of Kinetic Art already outlined. But there are other works such as those by Malina and Healey which are more difficult to classify in this way. The light moves but it does not move in space. It is projected on to a screen from behind. This is what I mean by the pictorial use of light: painting with light.¹² In principle this use of light is no different from that in the cinema. But if one wishes to extend the term Kinetic Art to include even films at least abstract films such as those made by Eggling in the twenties - one runs the risk of confusing two distinct concepts. It might be argued, however, that unlike film or television, one can, at least dimly, discern the moving parts which produce the images on the screen of a Malina or Healey. Hence they involve actual movement in space, and so accord with the definition. Similarly the video-rotors of Peter Sedgley, in which ultraviolet light is projected on to revolving discs covered with concentric circles of variously coloured florescent paint may likewise be considered kinetic objects.

4. Works involving the participation of the spectator In a manifesto published in 1963, the Groupe de Recherche d'Art Visuel, to which le Parc, Morellet and Garcia-Rossi belong, wrote: 'We wish to put the spectator in a situation which he initiates and transforms. We wish to develop in him an increased capacity for perception and action.' ¹³ And speaking of their Labyrinthe, they said: 'It is deliberately directed towards the elimination of the distance between the spectator and the work of art. As this distance disappears the greater becomes the interest of the work itself, and the lesser the importance

of the personality of the maker.'14 Traditionally the spectator has played a more or less, though not entirely, passive role. He has admired works of art as the product of another's imagination, as something over against, distinct from himself. Now, it is suggested, he can enter into a more intimate relationship with the work by becoming a partner in its production. Spectator participation can range from the limited activity of setting a work in motion and stopping it, to actually constructing it. In this respect Lygia Clark's Animals offer a particularly good example.

These works are made of articulated sheets of metal which can be manipulated so as to assume various forms. Each part of the work is functionally related to every other, as in an organism, and the movements of the parts follow a definite sequence. The work has a life of its own: it will not settle into any and every position which the manipulator desires. Thus in manipulating the work he is conscious of a certain purposiveness within it. As Lygia Clark says, a new relationship is set up between the spectator and the work. This new relationship is made possible by the independent movement of the work in response to the action of the manipulator. This changes the role of the artist also. He no longer offers a completed work but rather a set of possibilities, a programme, a situation from which a work can develop.

The use of light offers even greater possibilities for spectator participation. As has already been said, the spectator enters into the work itself: it surrounds him. His attention is wholly concentrated by the surrounding darkness and the light makes an assault on his senses. One gets this concentration of the faculties in the cinema and the theatre. But in an environment of kinetic light objects such as the Groupe de Recherche's Labyrinthe the spectator's perceptions are still further heightened by the fact that he can not only activate the works but also move about within them.

There is one other feature of Kinetic Art which should be mentioned: the element of chance. Exact repetition of movement, however complex, becomes monotonous. But completely random movement has also to be avoided, for it would be without point or form: it would be chaotic. Some control must be exercised. This is generally achieved by finding some relationship between the elements in the work which remains constant through every variation of movement. The number of ways in which this relationship is realized may be indefinite. It may be a matter of chance which realization occurs at a particular moment. But because there is a constant underlying relationship, the movements have a pattern.

I have tried in this chapter to give some definition to the term 'Kinetic Art', but, like so many artistic terms, such as Futurism, Expressionism, Abstract and Pop Art, no firm definition can be given. It is inevitable that it should be used in all sorts of different ways. This may be bewildering to the uninitiated, but it need not lead to utter confusion provided certain distinctions are made. I have tried to indicate what these distinctions are. There are works which involve movement in space, either on the part of the work itself or of the spectator, whether he manipulates the work or not, and this ideally should involve some optical transformation of the elements of which the work consists. This is Kinetic in what I call the strict sense, that is, the sense in which it was understood by the early theorists. Then there are works which give an impression of movement without involving actual movement (Op Art); works which involve actual, though two dimensional movement - moving reliefs and films - with or without an illusion of movement in space; and finally static representations of movement, as in futurist paintings. If one cares to call any or all of these Kinetic Art, well and good, but at least the distinctions should be preserved. 15

The Kinetic Art movement, which came to the fore in the late fifties and early sixties and reached its climax about the time of the 'Lumière et Mouvement' exhibition in Paris in 1967, began to decline as a movement of central interest about the time of the Tate exhibition in 1970, and, though it continues as a movement, it has, like Cubism, become absorbed into the artistic system; many of its practitioners have passed on to other things such as environmental art and manifestations of various kinds.

Notes

- 1. Joshua C. Taylor, Futurism, New York, 1961, p. 134.
- 2. Cf. Muybridge, The Human Figure in Motion, 1880.
- 3. Duchamp's *Mobile* of 1913 an inverted bicycle placed on a stool was not Kinetic in the technical sense, although it could be moved. It was not even meant to be regarded as a work of art, and certainly, at the time, not meant to present movement as an object of aesthetic contemplation. Two Futurists, Balla and Depero, in 1915 made moving objects, *Complessi Plastici Mobili* and *Complessi Motorumoristi* respectively, the latter involving perhaps the first use of a motor are at least forerunners of Kinetic Art if not Kinetic artists in the more precise sense. But so much research has yet to be done that it is impossible to make categorical statements about the prehistory of Kinetic Art.
- 4. The Realistic Manifesto, printed in Russian in Gabo, London, 1957, p. 151. Translated by Camilla Gray.
 - 5. ibid.
 - 6. 'Russia and Constructivism' in Gabo, p. 160.
 - 7. The Realistic Manifesto, op. cit.
- 8. I do not regard Tatlin's model for a Kinetic Monument to the Third International of 1919–20 as a work of Kinetic Art. Although the parts move their movement is indiscernible since they require a year, a month or a day to complete their revolutions.
 - 9. Signals, I, 10 November–December 1965, p. 13.
 - 10. ibid.
 - 11. Zero One.
- 12. The pictorial use of light has a long history. In the eighteenth century Castel constructed an 'ocular harpsicord' which was to provide the visual equivalent of music. Many experiments along this line have been made since. Scriabin scored a piece of music for colour accompaniment. The most successful colour organ was that made by Thomas Wilfred in 1919.
- 13. Quoted in Image, Winter 1966, p. 21 in a translation by Reg Gadney and Stephen Bann.
 - 14. ibid.
- 15. Since this article was written in 1967 I have modified my views. For a fuller discussion of this point see my *Op Art*, London, 1970, pp. 123–4 and 145.

POP ART

Edward Lucie-Smith

On the longest view, Pop Art is ten to a dozen years old. The term itself was first used by the British critic Lawrence Alloway, in 1954, as a convenient label for the 'popular art' being created by admass culture. Alloway extended the term in 1962 to include the activity of artists who were trying to use the popular image in a context of 'fine art'. There have since been a number of competing labels, but this is the one that has stuck, despite (on occasion) the protests of the artists themselves.

The first truly Pop Art work made in Britain is generally accepted to have been Richard Hamilton's collage Just What is it that Makes Today's Homes so Different, so Appealing? This was made for an exhibition called 'This is Tomorrow', held at the Whitechapel Art Gallery in 1956. The first big impact made by Pop Art on the British public was at the Young Contemporaries Exhibition of 1961, which included work by David Hockney, Derek Boshier, Allen Jones, Peter Phillips, and R. B. Kitaj, and established a whole generation of young artists. In the same year, Peter Blake held his first exhibition at the Institute of Contemporary Arts.

The development of Pop Art in America is less easy to chart. It grew by surprisingly slow stages out of the prevailing Abstract Expressionist style, and many of the American Pop painters continue to name Willem de Kooning, one of the giants of Abstract Expressionism, as a major influence on their work. The important year seems to have been 1955, which was marked by the emergence of Robert Rauschenberg and Jasper Johns on the New York art scene. In 1958, Johns had his first one-man show, and the New York critic, Leo Steinberg, thus describes his reaction to what he saw: 'The pictures of De Kooning and Kline, it seemed to me, were suddenly tossed into one pot with Rembrandt and Giotto. All alike suddenly became painters of illusion.' Despite this, the New York art scene as a whole did not feel the full impact of Pop Art until the beginning of 1961.

It is necessary to state the facts thus baldly because Pop Art has had such a curious history - its reception was something quite unlike that which had greeted the modernist styles which preceded it. There was, it is true, a brief period of incubation. For the first five years or so, Pop was more or less 'underground'. And when it emerged there was a moment of recoil, even of resistance. This happened particularly in New York, for historical reasons. Abstract Expressionism had established itself in America as the first locally evolved style to achieve an international pre-eminence. Now, as Mario Amaya put it, in his book on Pop Art, the new painters 'appeared to be kicking the whole of the American achievement out of the window'. Harold Rosenberg, one of the most powerful and intelligent of American critics, tried to dismiss the new movement almost out of hand. 'A good part of the impact', he said, 'was attributable to the fact that illusionistic art is easy to talk about, in contrast to abstraction, whose rhetoric had been reused until it was all but exhausted.' For him, Pop Art was simply 'a contribution to art criticism'. Despite these doubts and these protests, Pop Art succeeded on the material level. It got through to the public. It was taken up by collectors. The leading Pop artists became established, and even rich, within an astonishingly short space of time.

Despite the initial hesitancy which I have just described, Pop Art has so far had a greater impact, and has taken firmer root, in America than elsewhere. The basic cause can perhaps be inferred from a statement contributed by a student at the Royal College of Art in London to a collective document entitled 'A Composite Model of the Critical Process'. 'Pop art', he said, 'depicts the consumer environment and its mentality: ugliness becomes beauty.' To this one may perhaps add another sentence from the same document: 'Subject is raised to the status of content by the artist's attitude to it.' American painting of the post-war years has been consistently nationalist in its attitudes. Leaders of the American art world have frequently expressed feelings of impatience towards what was going on in Europe; leading American painters are fiercely competitive, and often show open contempt for the work of their European rivals. Pop Art, as it emerged from the experiments of the fifties, was the ideal instrument for coming to grips with the American urban environment. The element of aggression, which Pop carried over from hard-selling commercial design, was especially attractive to American painters. These painters, indeed, found it easy to convince themselves that the style they now practised had a specifically American parentage, and that the cigar-store Indians, the folksy weathervanes, the 'American primitives' already so much admired and collected in the United States, supplied a kind of official fiat or imprimatur for what they were trying to achieve. An important exhibition called 'Pop Art and the American Tradition' put on at the Milwaukee Art Centre in April 1965 supplied eloquent confirmation for this view.

This is not to deny, however, that Pop also had a European ancestry. Its roots are to be found in Dada, and old Dadaists have not been slow to recognize the resemblance, though without any great enthusiasm for the fact. In his authoritative book on the Dada movement, Hans Richter quotes from a letter written to him by Marcel Duchamp: 'This Neo-Dada, which they call New Realism, Pop Art, Assemblage, etc., is an easy way out, and lives on what Dada did. When I discovered ready-mades I thought to discourage aesthetics. In Neo-Dada they have taken my ready-mades and found aesthetic beauty in them. I threw the bottlerack and the urinal into their faces as a challenge and now they admire them for their aesthetic beauty.'

Duchamp, in his dismay, has hit upon the difference as well as the resemblance. It seems to me that one of the puzzling aspects of Pop Art, and the one most urgently in need of explanation, is its apparent coolness, its absence of commitment to the subject matter it depicts. At first sight, there is a revival of dada techniques, dada gimmicks, but with none of the dada philosophy behind them. Dada it must be remembered, was specifically anti-art, a thing which had sprung up in opposition to a situation which already existed. It was therefore moulded by that situation. What the Pop artists did – at least in their early and exploratory phase – was to find something positive in these gestures of opposition, something which could be built upon. The apparent brashness of Pop must not lead us into thinking it unscholarly, nor its apparent detachment into finding it uncommitted. Pop is, among other things, a learned

and highly self-conscious movement. Jasia Reichardt, in her account of how Pop evolved in London, partly through a series of meetings held at the I.C.A., describes the impassioned discussions that took place, the learned investigations of Westerns, old comic books, and pulp Science Fiction. Those who attended these discussions were perfectly seriously and legitimately concerned with what we may call the archaeology of mass-produced myths, and of popular design. The concerns of leading Pop artists working in Britain have often extended well beyond the standard concerns attributed to them. Richard Hamilton, already mentioned here as one of the originators of the style, made a painstaking reconstruction of Duchamp's Large Glass for the retrospective exhibition of Duchamp's work held at the Tate Gallery in 1966. Hamilton is everywhere recognized as one of the leading experts on the history of the Dada movement. R. B. Kitaj, an American painter domiciled in Britain, is famous for the elaboration of his catalogue notes. On one occasion these notes referred the spectator to such things as the Journal of the Warburg Institute, a learned journal which is not in any respect to be equated with a Batman comic.

In fact, when one comes to describe a typical Pop painting, one soon discovers that there is no such thing. The idea of 'style' dissolves - Pop Art is generically styleless, hostile to categories. Let me cite a few examples to prove my case. In America, for instance, the leading Pop artists include not only Johns and Rauschenberg (who stand a little apart, and are perhaps better classified as forerunners, rather than as participants), but Andy Warhol, Jim Dine, Robert Indiana, Roy Lichtenstein, Tom Wesselmann, Claes Oldenburg, and James Rosenquist. Each of these differs fairly considerably from the others. Warhol, for instance, would like to eliminate the idea of the hand-made work of art altogether. Many of his pictures are based on photographic images transferred directly to the canvas by means of stencils. Harold Rosenberg speaks contemptuously of 'columns of Campbell's Soup labels in narcotic reiteration, like a joke without humour told over and over again'. A friendlier critic, in the preface to the catalogue of the Warhol retrospective held at the Philadelphia Museum of Art in 1965, says that 'his pictorial language consists of stereotypes'. The preface goes on to claim that 'Warhol's work

makes us aware again of objects which have lost their visual recognition through constant exposure. We take a fresh look at things familiar to us, yet uprooted from their ordinary contexts, and reflect upon the meanings of contemporary existence.' Lichtenstein, Jim Dine, and Oldenburg are all related to Warhol by their imagery and stylistic preoccupations, yet set about the task of creating awareness of 'the meanings of contemporary existence' in totally different ways. Lichtenstein paints blown-up enlargements of things in a style borrowed from the crudest comic strips - even the dots due to the printing process are meticulously reproduced. Dine is best known for his combinations of real objects and freely painted surfaces - a lawn-mower, a wash-basin, a shower-fitment, set against a background of painterly textures. Oldenburg is a maker of objects, rather than a painter, and these objects always have something surprising about them, in size, material or texture. Oldenburg creates giant hamburgers, for instance, in cloth and plaster, and bathroom fittings in vinyl stuffed with kapok. Indiana and Rosenquist are different again. Indiana is a painter of gigantic, menacing badges. 'EAT', they admonish us, 'DIE'. Rosenquist uses enormous images, but in fragments. The various parts are reassembled to make a pattern which is almost abstract. In many ways what Rosenquist does is not so far from what had already been done in the twenties by the pioneer American modernist, Stuart Davis. Davis, who was chiefly influenced by Synthetic Cubism, is, in fact, one of the direct ancestors of American Pop Art. Some of his best pictures are based on banal packaging designs, and the way he treates this material has often been cited by American critics as a kind of post hoc validation for what the Pop painters were trying to do.

Different as the leading American Pop artists are from one another, there is, nevertheless, a definable difference between them and their British colleagues – though it is undoubtedly true that British Pop Art owes a great deal to America itself. The early work of such painters as Peter Phillips and Derek Boshier was an uninhibited romantic hymn to a civilization half-real and half-imagined, a wonderland of pin-ups and pin-ball machines. David Hockney, too, mythologizes the United States – he has paid prolonged visits to Los Angeles, sending back astonished and excited pictorial reports

of the things he finds there. Within itself, however, British Pop is even harder to classify than American, in terms of style. Richard Hamilton, for example, has a rigour, a lack of effervescence and a sardonic wit which sets him apart from the rest. His productions tend to differ radically from one another because each is the embodiment of an idea, and the idea itself has been allowed to dominate the material form. If we placed, say, Hamilton's Hugh Gaitskell as a famous Monster of Filmland beside his altered photograph of figures on a beach (which looks like an enlargement of a drawing by Henri Michaux), there is nothing in handling, texture, or structure to tell us that these are works by the same hand. It is only the continuity of the intellectual process which links them together. Eduardo Paolozzi, clearly one of the pioneers of British Pop (and recently a collaborator of Jim Dine's in making a series of collages) somehow escapes classification as a 'Pop artist' in the usually accepted sense. His most recent sculptures, made of brightly chromiumplated metal, have a pop surface, but not pop content. R. B. Kitaj. whom I have mentioned earlier, is, like Richard Hamilton, a deliberately 'learned' artist. He, like Hamilton, is a painfully slow worker. The three artists whom I've just mentioned seem to me to represent a hermetic, almost a rabbinic, aspect of Pop, which is far removed from its usual image in the public mind.

Another artist who varies somewhat from the accepted image is Allen Jones. Jones is an eclectic – one who tries to create a compromise between Pop imagery and the main tradition of modern art. In his colour schemes, and in his handling of paint, for instance, Jones shows that he has learned the lesson of Matisse. He is interested in the metamorphosis of images in a way which reminds me of the more academic Surrealists – a 'Female Medal' will turn out to be a shaped canvas, in the form of a medal and its ribbon, made up of legs emerging from silky briefs. The results have a thin charm which has made Jones one of the most successful of British Pop painters so far as the public is concerned.

Other mavericks from Pop are Joe Tilson, Patrick Caulfield and Anthony Donaldson. In fact, to name the mavericks is almost to define the Pop Art movement in Britain. Tilson has been much influenced by Kitaj and by Paolozzi. His most original creations are his reliefs in vacuum-formed plastic. Here, the units were created in series, but the ways in which they were assembled could vary – the result was a kind of art where each object combined the qualities of the 'series made' and the unique – qualities which Pop Art by its very nature is always trying to combine. Caulfield's impassive hard-edge still-lives and landscapes have much greater personality than most of Tilson's work, but also far less variety. They seem to be a commentary on vulgar ways of seeing, rather than on vulgar ways of representing. Donaldson represents yet another tendency – the desire to cross-breed Pop Art and hard-edge abstraction. Donaldson's pictures use, for instance, the silhouettes of strip-tease dancers as repeating abstract units in the design. And the colours are the sickly shades of cheap plastics. Nevertheless the overall impact is that of an abstract painting.

The one thing which all of these artists have in common is certainly not a stylistic language, fully developed and ready for every possible sort of communication – the kind of stylistic language which the painters of the High Renaissance possessed. Instead, we find an almost too sensitive response to the prevailing atmosphere. What the painters I have been discussing reflect, what they share, is the tone and imagery of the modern megalopolis, of 'majority living', of men penned in cities and cut off from nature.

When one talks about Pop Art, one is therefore not discussing an art movement, as Cubism was an art movement, but an event which sprawls outside the conventional bounds of an essay of this kind, and which, for that matter, is only very marginally to do with the notion of 'art'. It is no accident that it has flourished chiefly in England and in America, and most conspicuously of all in New York and in London. True enough, there have been Pop painters elsewhere – Alain Jacquet in France, Alberto Moretti in Italy, Fahlstrom in Sweden. But the English or American observer, looking at the Pop Art created elsewhere is inclined to find something *voulu* about it. It does not seem to spring with such simple directness from the surrounding environment.

In fact, the requisite context for the creation of Pop Art is the Pop life-style, or, rather, Pop Art is itself an accidental by-product of that life-style, a crystallization which came about almost by chance. It is only in this one sense that one can use the word 'style' about Pop. In all other respects, it is, as I have said, styleless. What I am suggesting is this: that the main activity of the Pop artist, his justification, is not so much to produce works of art, as to make sense of the environment, to accept the logic of what surrounds him in everything that he himself does. The discovery of this logic, its form and direction, becomes the artist's major task. Warhol, in many ways the most puzzling and the most enigmatic of all the Pop painters, is an extreme example. Warhol once said: 'The reason I'm painting this way is because I want to be a machine. Whatever I do, and do machine like, is because it's what I want to do. I think it would be terrific if everybody was alike.' Cool detachment has become an identification which is equally cool. Warhol's earlier 'underground movies' were another affirmation of these attitudes - a minute examination of the banal leads finally to identification with what is shown. Yet Warhol is, in many respects, a kind of modern shaman. A Campbell's soup-can is signed, and becomes a Warhol, a work of art. A polarization has taken place; the artist has managed to align himself with complete accuracy with the forces which govern the world he lives in. By becoming like everyone else, he has become unique. And this enables him (more or less) to give up the business of art altogether.

Before making up one's mind about Pop Art, it is essential to try and explore some of the conditions that brought it into being, and this means asking some radical questions. What, for example, is the 'pop culture' which is supposed to supply Pop Art with its source material? Like practically everything else in our society, pop culture is the product of the Industrial Revolution, and of the series of technological revolutions which succeeded it. Bring together fashion, democracy, and the machine, and pop culture is a part of what results. In the days when everything was made by hand, fashion served a variety of purposes. One of these, more important, so it seems to me, than that of satisfying the desire for novelty, or of enhancing sexual attraction, was that of acting as a social demarcator. Fashion began at the top of a fairly rigid social structure, and gradually percolated downwards, becoming less elaborate and less stylish as it did so. Elaboration and style were, indeed, almost the

same thing, and many people had neither time nor money to think about being fashionable at all. The machine changed this. It brought more money and more leisure, and at the same time it imposed a logic of its own. If men wanted machine-made things, it was economically essential that these should be made in quantity. It was discovered that fashion supplied a powerful impetus where the machine was concerned. Things went out of fashion far more quickly than they wore out. Fashion accelerated the process of replacement, and helped to keep industry at work. At the same time the process of political democratization led to the feeling that everyone had a right to be fashionable if he or she wanted to be.

Pop culture is therefore part of an economic process which is likely to go on developing. Fashion is made instantly available to the widest possible market. It uses up visual ideas with alarming appetite. The hallmark of fashion is no longer elaboration, but novelty and impact. Richard Hamilton, in defining the qualities he thought desirable in art, wanted it to be transient, popular, low-cost, mass-produced, young, witty, sexy, gimmicky, glamorous, and Big Business – all the things which popular fashion already is.

Pop culture involves a shift in attitudes towards the object. Objects are no longer unique. We know that most of the things we use are made in identical thousands, each indistinguishable from the rest. We tend to value things, not for their own sake, but in terms of the jobs they perform. Many objects – a typewriter, a telephone, a vacuum cleaner, a television set – are things we think of in a way which is almost entirely abstract, in terms of the services they provide. Works of art are feeling the effects of this attitude as well: they are becoming performances or functions, rather than things. Pop Art shares this characteristic with other contemporary styles: Op Art and Kinetic Art, for instance. A Pop picture is often a frozen event – it comes across to us instantly, and then has made its point. We need never look at it again; it is disposable.

One startling example of the tendency towards the 'disposable' art is the Happening. A Happening is a work of art involving the interaction of people and things in a given setting or situation. I once heard Marshall McLuhan define it as 'an all-at-once situation without a story-line'. The Pop painters of New York were the

originators of the Happening – Dine and Oldenburg were especially active in staging them. The aim was to produce an emotional context, and when this catharsis was over, the work of art was over. It had fulfilled its purpose and disappeared.

There is one particular characteristic of Happenings which has been little commented upon – the fact that, though they involve people and objects, they are essentially abstract events, bearing about the same relationship to a conventional stage performance as a modern abstract painting does to a Rubens or a Teniers. I would venture to put forward the view that the great majority of Pop paintings are also essentially abstract.

But to return to Pop Art itself – in the early sixties, many people welcomed it as the reversal of a trend, a sudden, unexpected, lastminute victory scored by figuration over abstract painting. Perhaps they would not have done so, had they studied its origins more closely, and, in particular, the beginnings of Pop Art in America. I have already mentioned the influence which De Kooning exercised. De Kooning's is an art where images emerge from an abstract flux of paint; and these images, especially the famous series of 'Women', often have a pop flavour. The paintings of Johns and Rauschenberg are also significant here. Johns's best-known paintings are the 'Targets' and the 'Flags'. In each case, we are presented with something which is at one and the same time abstract and recognizable. As Mario Amaya says, 'the spectator is faced with a problem of viewing something exactly as it is in reality, only in terms of sensitively worked brushstrokes.' In Johns's work, as in De Kooning's, the paint is allowed to become something, rather than forced to depict something; the image is, so to speak, inherent in the paint, but it is on the paint that we chiefly concentrate our attention - we look at a Johns in much the same way that we look at the kind of late Pollock where there is no image at all.

Rauschenberg is rather different. His images, many and various as they are, strike the spectator as being quotations, illustrations inserted in the midst of an abstract discourse. The things – real objects or stencilled images – which turn up in Rauschenberg's work are not images we are invited to look at directly, but things the eye glides over, punctuations in the flow of paint. Rauschenberg, by

this characteristic, points forward to what Pop Art was to do, without being completely committed to its ethos.

For instance, one of the first discoveries we make, when we start to look at Pop paintings carefully, is that very little in them comes to us first hand, as the product of the artist's own direct observation. He does not re-create, he chooses. His choices are made from among images which have already been, so to speak, processed – not a living girl, but a pin-up in a magazine, not a real tin, a real package, but a tin or package seen in a coloured advertisement or on a poster. Those objects which we do get first hand in Pop pictures are usually present in their own persons: the wash-basin, the lawnmower, the various articles of clothing which we meet with in Jim Dine's pictures; the plaster-casts of people surrounded by real furniture that we find in the environments created by the American artist George Segal. What often seems to interest the Pop painter is the fact that the object is depersonalized, typical rather than individual - the device of the monotonously repeated identical image, so often met with in Pop Art, is one of the proofs of this. With rare exceptions - such as Peter Blake and Larry Rivers - Pop Art avoids the particular. And this, indeed, is what an abstract painter like Mondrian does. If we choose to accept the paradox of its abstraction, Pop Art becomes a good deal easier to interpret satisfactorily.

There are three artists, in particular, who tend to prove my point. Two are the exceptions whom I've just mentioned – Peter Blake and Larry Rivers. The third is the British born but for a long period American domiciled painter Richard Smith. Both Blake and Rivers seem to me to be emphatically figurative, but caught up within the Pop Art context. The quality they have in common, besides this, is nostalgia. Blake's nostalgia is something which has been pretty generally recognized and discussed. It supplies the basis for the comparison which my fellow-critic David Sylvester once made between Pop Art and the Pre-Raphaelites. When Blake paints a picture of a wrestler, and surrounds the image with a collection of badges and symbolic objects, he's paying tribute, not to present reality, but to something in the past, perhaps even to a past self. A fantasy which might seem too raw and crude, placed in the present, is carefully distanced. There is irony in the caressing tenderness of the paint; this tender-

ness is inappropriate to the subject, but not to the painter's mood. Larry Rivers, an American, often gets left out of discussions of Pop Art. He is regarded as a kind of maverick of the art scene, a brilliantly gifted but somehow basically frivolous painter. Of his gifts there is no doubt - Rivers handles paint more beautifully than anyone since Manet. And here, I think, is where the nostalgia comes in. Rivers turns, not towards objects which conjure up the past, but towards a whole past way of seeing. He tries to take the vision of a Manet, and to transport it entire into the twentieth century. He interprets completely 'contemporary' objects, like a Camel cigarette packet, with the dissolving touch which Manet kept for painting portraits of young girls. One must remember, when speaking of Rivers's nostalgia, that for an American painter, a great Impressionist like Manet is the past; he has the authority of history, and has it in a way which Europeans do not necessarily see. It is significant, too, that Rivers is always questioning his own bravura technique. There is a series of pictures by him, called 'Parts of the Body'. In one of these, which shows a splendid nude, all the anatomical features are carefully labelled, in French and in heavy block capitals. The words and the black lines that lead to them seem like an attempt to pin down something damnably elusive, something which, at any moment, would vanish like a ghost. The strenuous act of re-creation required by truly figurative painting seems not to interest any of the Pop painters but these two, and it is no coincidence that these also seem to be the only members of the school equipped with a specifically historical imagination (Kitaj uses historical events, but in a strictly contemporary way).

Richard Smith's work goes to the opposite extreme. Here is something recognizably Pop, which is yet almost entirely abstract. Smith's 1966 retrospective at the Whitechapel Gallery illustrated his development up to that point. In his early work, pictures painted in 1960 to 1962, Smith was an abstract painter who found his inspiration in modern packaging. He took the shapes and the colours (the synthetic pinks and greens) and made a picture out of them where the specific figurative reference had almost vanished. After this there came a phase in which he was using canvas over a shaped stretcher, so that the painting projected from the wall. The references

to packaging still remained, but the painting, so to speak, became the package. Finally, these shaped canvases became entirely abstract – the colour-areas became more defined, less painterly, and the Pop element seemed to disappear. Smith's work is now almost assimilated to that of the 'Primary Structures' group in America. Yet these later works, so pleasing to purists, would, I think, have been impossible without the initial experience of Pop Art, and behind that, of pop culture.

Smith denies that his recent work is sculpture, but so much of it is so nearly three-dimensional that it provides a convenient bridge to another topic – the question of the influence of Pop Art on sculpture. Interestingly enough, different things seemed to have happened in England and in America. In America, a certain amount of sculpture was assimilated into the Pop Art movement. It was a moot point whether Oldenburg's objects counted as sculpture or not, and the same question could be asked about Segal's environments, or the more violent, less literal tableaux constructed by Kienholz. Marisol, a talented and witty sculptor in wood, made a series of self-portraits which went back on the one hand to the cigar-store Indian, and on the other to the work of the late Elie Nadelman. As a tradition, Nadelman's work represents the very opposite extreme to that, say, of Henry Moore. Light, graceful, eclectic, it provided something to build on, but not much to react against.

In Britain, Pop seems to have provided a kind of escape route for a whole new generation of sculptors. These artists – Philip King, for example, and William Tucker and Tim Scott – are not Pop sculptors in any real sense of the term. But their brightly coloured work, often made in plastics, shows many traces of the Pop sensibility. In addition, it often seems to bear the same kind of relationship to commercial exhibition design that Pop paintings have to comic books and advertisements. As Richard Hamilton originally specified, this sculpture is young, witty, sexy, glamorous and the rest. It bears the marks of a specifically urban sensibility, at war, almost, with nature.

Pop was not the only influence to be seen at work in the new British sculpture. Equally important was a current which came from America; the influence of the late David Smith. It was Smith's powerful personality as a sculptor, looming so much nearer at hand, which seems to have checked the development towards any real school of Pop sculpture in the United States, and to have directed sculptors towards more austere ideals. The result is that, active as the Americans are today in the field of sculpture, it is difficult to find any precise equivalent of the British artists whom I've just mentioned. In America there is, on the one hand, what one may call the 'Pop object' - often made by a man who is primarily a painter, like Roy Lichtenstein. On the other hand there is austere, deliberately unforthcoming work of sculptors like Don Judd and Robert Morris, who are makers of what has now been labelled 'Primary Structures'. These seem to reflect a puritan refusal to participate, to ride on the merry-go-round of pop culture. Indeed, they amount to a rebuke, delivered to those artists who have been seduced by the trivialities of Pop. Despite this, there is a kinship between the new American puritans and the work of their far more exuberant British contemporaries. The acceptance of Pop and its rejection both seem to produce more or less the same result - a kind of sculpture which eschews references to nature.

The reaction against Pop Art has long since begun, but it is taking place in the context which Pop itself provided, or, rather, which it was the first to explore. For it is one of the points made by Pop Art that we do not invent new sets of conditions, we merely recognize them. If Pop Art was (as it seems to have been) the first art which was deliberately not made to last, the implication is clear. The passion for obsolescence wasn't an eccentricity – it amounted to a statement that no art, henceforth, would be any more durable. Everything about Pop Art was, and is, transient and provisional. By embracing these qualities, the Pop artists held a mirror to society itself.

OP ART

Jasia Reichardt

The term optical or retinal is generally applied to those two- and-three dimensional works which both explore and exploit the fallibility of the eye. The only other generalizations which are pertinent here are that all Op Art is abstract, essentially formal and exact, and that it could be seen as a development out of Constructivism and the essence of Malevich's aim to achieve 'the supremacy of pure sensibility in art'. Furthermore, it could be seen as a trend that has been influenced by ideas developed in the Bauhaus, and those of Moholy-Nagy and Josef Albers. The organizer of the Responsive Eye exhibition (the first international exhibition with a predominance of optical paintings, held at the Museum of Modern Art in New York in February 1965), William Seitz, who has documented Op and other closely allied idioms since 1962, has referred to Op Art as a generator of perceptual responses. It essentially possesses the dynamic quality which provokes illusory images and sensations in the spectator, whether this happens in the actual physical structure of the eye or in the brain itself. Thus one can deduce that Op Art deals in a very fundamental and significant way with illusion.

Here, however, one has to be more specific since all art is involved with illusion to some extent. Illusion exploits the spectator's capacity to complete images in the mind's eye on the basis of previous experience. It is, moreover, the process by which the imagination is stimulated to defeat the logic of two-dimensional canvas. This is the case, for instance, with *trompe l'oeil*. The term Op Art, however, is applied to that type of illusion where the normal processes of seeing are brought into doubt, mainly through the optical phenomena of the work.

As a name Op Art has been in general use since the autumn of 1964. It came about during a particularly prolific period for newly named movements, was applied loosely to works exploring chromatic or ambiguous relationships, and in fact any paintings dealing with what Albers described as 'the discrepancy between physical fact

and psychic effect'. Coined in America, Op Art was first referred to in print in *Time* magazine (October 1964), and two months later was featured in *Life*. By 1965 Op Art was a household phrase referring both in England and America to black and white boldly patterned fabrics, window displays, and generally utilitarian objects. A unique aspect of the movement was its nearly simultaneous arrival on both fronts – the esoteric and the popular.

The ancestors of Op Art as a perceptual art idiom, carrying it to the possible limits within the field of representation, are the Impressionists and Post-Impressionists (Seurat being the most obvious example), who employed as a mode of expression the optical mixture of tones and colours, rejecting the method of palette mixing and allowing the eye to mix the pure dots of colour at a distance. The indeterminate forms in their paintings resolve themselves chromatically as well as figuratively when the spectator steps back into a suitable position. Whereas the pointilliste technique was merely a creative approach for painters like Seurat, Signac, Pissarro, and Cross in the 1880s, the technical aspects of Op Art are committed to a now familiar concept in modern painting, where this technique has in fact become the subject matter, and virtually the sole content of the painting. Thus, these qualities, the technique and the subject matter are totally indivisible.

The most direct influences on the development of the Op Art movement, which roughly dates back to 1960 in the form of numerous individual lines of inquiry particularly in France and Italy, are to be found in the works and theories of Josef Albers and Victor Vasarely. Albers who taught at the Bauhaus, Black Mountain College and Yale, where he held his famous classes on colour, has always stressed the fact that any work which involves the use of colour is an empirical study in relationships. The statement in itself is in no way revolutionary – Ruskin too referred to colour as wholly relative according to what is placed next to it, while considering form as absolute. Albers, however, has explored this field probably more thoroughly than any other living artist and has demonstrated all the nuances of relativity and instability of colour and tone through the various interactions in his series of paintings called 'Homage to the Square'. He has shown how deceptive colour can be, how different colours can

be made to look identical and three colours can be read as two or conversely as four. The art of Albers is the art of pure sensation, and although it is neither as startling, nor as disturbing visually as, say, the black and white paintings of Bridget Riley, or illustrations given as examples in the manuals on the psychology and physiology of perception, the essential characteristics of what is now referred to as optical or retinal art, are very much part of his work.

Vasarely has been creating what might be described as black and white eye stimuli since 1935. Among these were his chequer-board compositions with chess pieces, and paintings of subjects like tigers and zebras which acted as vehicles for striped patterns. In all paintings since, he has employed optical ambiguity and disorientation through the use of syncopated rhythms and geometric patterns. The black and white, coloured, and more recently three-dimensional constructions are the expression of Vasarely's idea of what should be the relationship between the work and the spectator. He believes that 'to experience the presence of a work of art is more important than to understand it'. The intellectual concept of understanding becomes irrelevant in a realm of art which is involved with sensation to such a degree that it creates a virtually physical effect on the viewer. Vasarely is committed to the depersonalization of the artist's act – he feels that works of art should become available to all and discard their uniqueness. To his own field of activity he has applied the term cinetic art - an art form which is based on multi-dimensional illusion. Whereas kinetic art implies, in the strict sense, the use of mechanical movement, cinetic art is involved with illusionistic or virtual movement. The term cinetic could also be considered relevant to the work of Yaacov Agam, particularly his polymorphic paintings on corrugated surfaces with patterns that fuse and change as one walks in front of them, as well as to the works of Cruz-Diez and J. R. Soto, where any illusion of movement takes place as the spectator is in motion and the work remains stationary.

As a label Op Art is an uncomfortable one for the artists to whose work it is applied. It is not a programmatic art form in so far that its crucial aspect involves a technique rather than an ideology. Few of the underlying theories are supplied by the artists themselves, and furthermore it is impossible to make any exact delineation as to

where precisely the movement begins and ends. Some kinetic works, for instance, where use is made of light effects and a certain spatial ambiguity, often touch on the borderline of Op Art. The Groupe de Recherche d'Art Visuel from Paris work not only with mechanical movement, but with the illusion of movement as well. The classical example of the use of both types of movement is Duchamp's rotoreliefs of 1935 - discs with circular patterns which produce the illusion of motion in perspective when placed on a gramophone turntable. At the other end of the scale, also on the borderline of Op Art, are paintings which are so ambiguous formally that one switches from one reading to another, e.g. the interchangeable figure/ground compositions of Ellsworth Kelly. Here the simplicity of forms and specific use of colour, allows the viewer to see them alternately as figure and background. Kelly's paintings, like those of Peter Sedgley and the pattern pictures of Larry Poons and Richard Anuszkiewicz exploit the false impression engendered by use of complementary colours and produce a powerful after image. Although these paintings seem to belong so naturally to the Op Art movement, one must remember that Kelly, for instance, painted his chromatic figure ground compositions already in the fifties, at a time when different aspects of his work, rather than optical ones were discussed. This is also, of course, true of artists like Vasarely, Max Bill, Soto and Karl Gerstner among many others, whose individual pursuits suddenly in 1964 came into line with a newly named trend.

The number of artists working in the Op Art idiom is very limited, and among those who would come into this very tight category are those who explore such effects as the moiré patterns (like the wavy shimmering forms on watered silk). These result from the inexact superimposition of two or more sets of parallel lines, or other repetitive structures. The almost magical effects of undulating lines with illusion of depth and movement have been utilized by J. R. Soto, Gerald Oster, John Goodyear, Ludwig Wilding and Mon Levinson.

The most optically dynamic works, apart from three dimensional constructions like Karl Gerstner's lens pictures and illusionist glass boxes by Leroy Lamis and Robert Stevenson, are those black and white paintings which seem to produce a completely unstable surface. The most inventive painter in this field is Bridget Riley, whose

undulating stripes and various formal progressions are based on intuitively conceived patterns which are developed systematically in the finished painting. Among other artists whose paintings produce strange optical disturbances and ambiguities are the Japanese painter Tadasky who makes compositions of concentric circles which he paints on a turntable, and the American Julian Stanczak who creates abstract organic images with horizontal or vertical black and white stripes of varying thicknesses. Their works operate on what Gombrich has called the etcetera principle. A state when the mind is tricked into seeing something which does not exist because of the physical conditions which are created. Op paintings do not lend themselves to intellectual exploration – their forte is the provocation of an intense sensual and often sensational impact, which ultimately can be nothing less and nothing more than a unique experience.

1966

MINIMALISM Suzi Gablik

When, in 1913, Malevich placed a black square on a white ground, claiming that 'art no longer cares to serve the state and religion; it no longer wishes to illustrate the history of manners, it wants to have nothing further to do with the object as such, and believes that it can exist, in and for itself, without things',1 he laid the foundations for a secular art that was detached from utilitarian purposes and removed from the ideological function of representation. According to Malevich, 1914 was the year when the square appeared. It was the basic Suprematist element, never to be found in nature. Suprematism brought into being, during the second decade of this century in Russia, an art which was rigorously and single-mindedly abstract. Like Constructivism, it celebrated rationalism and a mathematical way of thinking, while sustaining 'an aesthetic position in which the construction of an object would point toward an immediate, legible geometry'.2 Sculpture was produced that had the clarity of mathematical models, and the developments of modern technology were brought to bear on artistic consciousness. Indeed, Tatlin's directive to cultivate 'real space and real materials' was to become, during the 1960s in America, the source, or point of departure, for a new kind of sculpture which would have the specificity and power of actual materials, actual colours and actual space, and which would aestheticize technology to a degree that even Tatlin himself could not have quite imagined. '. . . Symbolizing is dwindling - becoming slight', wrote Dan Flavin about Minimalism in 1967. 'We are pressing downward toward no art - a mutual sense of psychologically indifferent decoration - a neutral pleasure of seeing known to everyone.'3 In 1964, Flavin produced a neon sculpture that was entitled Monument for V. Tatlin [illustration 109]. It was simply an assembly of neon tubes that had been neither carved nor constructed in any way by the artist, and it did not appear to signify anything. It merely existed - an object resplendent in its own right.

The Minimalists shared with Mondrian the belief that a work of art should be completely conceived by the mind before its execution. Art was a force by which the mind could impose its rational order on things, but the one thing that art definitely was not, according to Minimalism, was self-expression. All those priorities that Abstract Expressionism, with its excesses of deep subjectivity and allusive emotionalism, had infused into American art during the 1950s, were now rejected as being too 'sloshy'. Traditional modes of composition had been jettisoned in favour of improvisation, spontaneity and automatism, and style had become, for the Abstract Expressionist painters, a matter of walking hieroglyphs and vertiginous gestures, with every brushstroke brought into being streaming with metaphysical and existential innuendo. The gesture itself was meaning, and what it expressed was the primordial, subjective freedom of the artist.

Into this Heraclitean flux of gestural painting, and standing, as it were, for the ultimate minimum which would suffice for a universe, the Minimalists introduced an epistemological cube; it stood as a commitment to clarity, conceptual rigour, literalness and simplicity. They wished to deflect art towards an alternative course of more precise, measured and systematic methodologies. Conjugating the cube to infinity, they conveyed an impression of perfect equilibrium, and produced a visual symmetry that never deviates from its own rigidly plotted field - the monotony of modular-determined units being, in a sense, the very opposite of freedom, like stars keeping their course.

In many ways, Minimalism received its initial impetus from painting, in that it was a conspicuous inversion of the values which had been exalted by the previous generation of Abstract Expressionists, but it soon evolved the aim of replacing sculpture with a new set of visual criteria - for the one thing Abstract Expressionism had distinctly failed to do was to evolve any sculptural style; all its triumphs were in the realm of painting. Those who became the leading practitioners of 'ABC' or Minimal art - Don Judd, Dan Flavin, Carl Andre, Robert Morris and Frank Stella - were all concerned (with the possible exception of Stella), ultimately, in constructing threedimensional objects, even though many of them began their careers

as painters - in the Abstract Expressionist mode. Their mature work, however, presents common stylistic features: predominantly rectangular and cubic forms that are purged of all metaphor and meaning, equality of parts, repetition and neutral surfaces. The ambition they shared was to create works of maximum immediacy, where the whole is more important than the parts, and where relational composition is suppressed in favour of an arrangement of simple ordering (progressive, permuted or symmetrical). Nor would any account of the period be complete without mention, in this context, of Tony Smith's enormous black monoliths, Larry Bell's mirrored glass boxes, John McCracken's brilliantly coloured leaning planks, and Sol LeWitt's grid constructions (although LeWitt prefers to refer to himself as a Conceptual artist). All these artists went in for industrial materials – used as neutrally as possible with their specific identity unimpaired - such as galvanized iron, cold rolled steel, fluorescent tubes, firebricks, styrofoam cubes, copper plates, industrial paint; and all of them preferred simple, unitary geometrical shapes, used either on their own as a simple gestalt, or as a series of repeated identical units. 'I object to the whole reduction idea,' Judd told Bruce Glaser in an early historic interview. 'If my work is reductionist, it's because it doesn't have the elements that people thought should be there. But it has other elements that I like.'4

The new aesthetics of exclusion first emerged significantly on the scene when the twenty-three-year-old Stella exhibited a haunting quartet of paintings, consisting of nothing but symmetrical pinstripes, as part of the 'Sixteen Americans' show, along with works by Louise Nevelson, Ellsworth Kelly, Jasper Johns and Robert Rauschenberg, at the Museum of Modern Art in 1959. There had, of course, been signposts all along the way, even during the most vibrant phase of Abstract Expressionism: Barnett Newman's painting Abraham, for instance, made in 1949 after the death of his father, which contained nothing but a single black stripe on a black field; Ad Reinhardt's symmetrical, one-colour paintings, culminating in 1960 in the series of cruciform black squares; Yves Klein's all-blue monochromes; Robert Rauschenberg's bare white canvases of 1952; Agnes Martin's uninflected grid paintings, which were exhibited at Betty Parsons' Gallery in 1961. All the same, and more

than anything else at the time, Stella's 'black' paintings, as they came to be known, seemed to test the limits of art, contracting it to an irreducible essence and stripping away the technical virtuosity of gestural painting. Arranged in rectilinear or cruciform patterns, Stella's stripes were painted with black enamel straight from the can. There were two problems, he claimed, which had to be faced before the assumptions of Abstract Expressionism could be satisfactorily contravened: one was spatial and the other was methodological. 'I had to do something about relational painting, i.e. the balancing of the various parts of the painting with and against each other,' he stated. 'The obvious answer was symetry [sic] – make it the same all over. The remaining problem was . . . to find a method of paint application which followed and complemented the design solution. This was done using the house painter's technique and tools.'5

Die Fahne hoch!, for instance (or The Banner High!, so-called for its reference to Jasper Johns's flags), contains four quadrants of stripes in mirror reversals of each other [illustration 110]. The paintings are about nothing but relations, orderly relations, embodied in an impersonal and inflexible composition of stripes. Like numbers, they are morally and metaphysically neutral. Carl Andre, who was sharing Stella's studio during this period, wrote about his friend's painting in the catalogue preface: '... Frank Stella has found it necessary to paint stripes. There is nothing else in his painting. Symbols are counters passed among people. Frank Stella's painting is not symbolic. His stripes are the paths of brush on canvas. These paths lead only into painting.'6 It was only a few months later that Ad Reinhardt declared, '... Everything is prescribed and proscribed. Only in this way is there no grasping or clinging to anything. Only a standard form can be imageless, only a stereotyped image can be formless, only a formulaized art can be formulaless.'7

The neutral emptiness of the black paintings appeared, to many people, as such a total retreat from humanistic concerns that they could only be an aberration, synonymous with all the anti-subjective, materialist, determinist, anti-life in our culture - aspiring to nothing more elevated than boredom and futility. Their baffling aloofness inspired a good deal of hostility from the critics. Brian

O'Doherty described Stella as 'the Oblomov of art, the Cézanne of nihilism, the master of ennui'.8 Irving Sandler found Minimalism in general to be 'mechanistic' and uninformed by any creative struggle or search,9 and more recently, Donald Kuspit has attacked it for being circular and pedantic, mechanically self-referential and 'authoritarian', its fixed forms being, in his view, a repressive denial of the life-world.¹¹¹ There is no doubt, even now, that Minimalism remains perhaps the most difficult, embattled and controversial art ever made.

One of the reasons people cannot bring themselves to appreciate Minimal art is that they do not consider that a row of styrofoam cubes, or firebricks, can be art at all. They see no evidence of the artist having done any 'work', and consequently, they quite sincerely believe that they are dealing with a gigantic fraud which has been allowed to spread its ramifications over the whole of Europe and America. Writing in 1965 on the newart, Barbara Rose had linked Minimalism not only with the renunciations of Malevich but also with those of Duchamp, whose ideas were, indeed, critical to the development of the Minimalist ethic.¹¹ The importance of Duchamp in this regard had to do with how readymades challenged the prestige in our aesthetic thinking of the notion of work as an essential ingredient in art. By proposing a urinal and a bottle rack as examples of 'readymade' art, Duchamp had minimized the role of the artist's hand as well as the value of artistic craftsmanship. He assigned aesthetic value to purely functional objects by a simple mental choice rather than through any exercise of manual skill. What he wanted to demonstrate was that art-making could be based on other terms than the arbitrary, tasteful arrangement of forms. The Minimalists, for their part, enlisted the module, with its serial potential as an extendable grid, towards the same end. The module is not a matter of taste; it precludes any arbitrary formal arrangement of parts by tasteful manipulation. By 1970, Robert Morris was ready to claim that 'the notion that work is an irreversible process ending in a static icon-object no longer has much relevance . . .'. What matters is 'the detachment of art's energy from the craft of tedious art production'. 12 Moholy-Nagy was perhaps the first artist ever to execute a series of paintings by telephoning instructions to a factory, but for Judd, it is the normal course of affairs to have his boxes fabricated outside the studio, just as Flavin chooses standard fluorescent tubes because of their neutrality and their availability, and leaves the work itself to be carried out by electricians and engineers.

At the time that he was sharing Stella's studio, Andre was making vertical sculptures from building timbers that entailed some carving and modelling of the wood. He has credited Stella's influence for his realization at a certain point that 'the wood was better before I cut it than after'. 13 Working the wood, he felt, did not improve it in any way. 'Up to a certain time I was cutting into things. Then I realized that the thing I was cutting was the cut. Rather than cut into the material, I now use the material as the cut in space.'14 At this stage, he eliminated, as part of the sculpture-making process, any activity that involved carving (or taking away) and constructing (or adding on). He began stacking and piling beams in 1961, but it was a bit later that he was to introduce the new element that became his special preoccupation and even a hallmark: horizontality. He wished to make his sculptures hug the ground. His earlier work had begun to seem 'too architectural, too structural', and one day, while he was canoeing on a lake in New Hampshire, it came to him that his sculpture should be as level as water. The fact that, during the early sixties, Andre had been employed as a brakeman and conductor for the Pennsylvania Railroad, has been pointed to by many critics as another important element in the development of Andre's vision the long lines of freight cars, the endless tracks extending to infinity, which also must have had an effect. Horizontality appeared, like a cold wind, in Andre's first major piece entitled Lever [illustration 111], which was specifically designed for the 'Primary Structures' exhibition at the Jewish Museum in 1966, one of the first museum shows to present Minimalism as an accomplished body of work. Andre's piece consisted of 137 unjoined commercial firebricks that extended along the floor for $34\frac{1}{2}$ feet. The vertical element, he claimed, had been the hardest thing of all to get away from. Once he had achieved it, he was able to say: 'All I am doing is putting Brancusi's Endless Column on the ground instead of in the air. . . . The engaged position is to run along the earth.'15

Lever was still partly engaged with the wall, but the metal-plate pieces, begun in 1967, simply occupy the floor. By far the most complex of these is one called 37 Pieces of Work, which was made to occupy 36 square feet of the Guggenheim Museum's ground floor. It is composed of 1,296 units: 216 each of aluminium, copper, steel, magnesium, lead and zinc. Andre once claimed that his ideal sculpture is a road, and in these – what could be termed 'classic' – Andres, of unjoined metal plates placed along the ground, you can walk, or even drive a Mack truck, across them.

One of the things that Minimalism hoped to achieve was a new interpretation of the goals of sculpture. Judd and Morris were its main polemicists, and (together with Barbara Rose), they published numerous articles anatomizing the new aesthetic and dictating the terms on which they wished their work to be apprehended. Judd, especially, saw his activity as an alternative to the conventions of painting and sculpture. All painting, he felt, was illusionistic, which made it seem 'not credible'. It seemed important to get rid of spatial illusionism, and the only way to do that was to eliminate figureground relationships: 'The only paintings that didn't have that kind of problem were Yves Klein's - the blue paintings,' he stated. 'But for some reason I just didn't want to do monochrome paintings.'16 Judd's early works are a combination of sculptural and painterly concerns - low reliefs, made of such materials as wood, asphalt pipe, and liquitex and sand on canvas; these, eventually, in his more mature phase, give way to fully three-dimensional floor and wall-pieces - always untitled, and therefore difficult to identify. By making his work occupy three dimensions, Judd felt he had successfully dealt with the problem of illusionism, actual space being more powerful and specific, he felt, than depicted space. And because they were no longer a 'stand-in' for reality - but were an actuality rather than a mere reflection – he called his new works by a new name: specific objects.

The prototypes for Judd's specific objects were a group of painted wood sculptures that were shown at the Green Gallery in New York in 1963. The first plexiglass boxes with metal sides were fabricated slightly later, from these prototypes, and were a significant feature of the 'Primary Structures' show at the Jewish Museum in 1966.

Stacked boxes may appear deceptively rude and simple, but they successfully achieved Judd's ambition to redefine the terms for making sculpture. Critical to that redefinition is the fact that the forms are assembled rather than being modelled or carved or welded. There are no adhesives or joints, no base or pedestal, so the work can be dismantled, stacked and stored. Each sculpture is composed by a simple arrangement of identical and interchangeable units, laid out in a repetitive manner, like a limitless chain. Sometimes the boxes are cantilevered from the wall, so that the wall, floor and ceiling become a part of the sculptural experience. Classic Judds offer an extraordinary vocabulary of surfaces and contrasting materials that range from the opaque to the translucent and reflective [illustration 112]. But always, the module serves as ordering principle, which does away with the need for relational composition (in Judd's work, all the parts are equal), eliminating, at the same time, the kind of moment-to-moment decision-making and rearranging that depends on arbitrary whim. Composition depends instead on the more predictable factors of repetition and continuity. Describing the specific look of this kind of contemporary abstract art, Leo Steinberg wrote in 1972 that 'its object quality, its blankness and secrecy, its impersonal or industrial look, its simplicity and tendency to project a stark minimum of decisions, its radiance and power and scale these become recognizable as a kind of content - expressive, communicative, and eloquent in their own way'.17

Morris, too, had been equally interested in this 'state of non-depiction' and in doing away with the figure-ground duality of representation. But whereas Judd wanted the kind of wholeness that can be achieved through the repetition of identical units, Morris addressed himself to the notion of self-sufficient wholes, unitary shapes on their own. He wished to construct objects without separate parts, to avoid divisiveness. In 1961 Morris fabricated his first unitary piece, an eight-foot high grey plywood column. (Morris painted all his plywood sculptures grey, since he believes that colour has no place in sculpture.) In 1965 he exhibited nine L-beams which, although they were all identical, were perceived as different shapes when laid on their side, up-ended, tilted, etc. [illustration 113]. With Judd's regular and identical blocks, set apart by equal spaces,

we are made to concentrate on visual likeness, but with Morris's L-beams, we have many different perceptions of what is actually a single shape. Placement, of course, becomes critical: a beam on its end is not the same as the same beam on its side. All of which would seem to prove the point of Judd's remark that 'it isn't necessary for a work to have a lot of things to look at, to compare, to analyze one by one, to contemplate. The thing as a whole, its qualities as a whole, is what is interesting.'18

Both Judd and Morris were concerned that the work should present itself as 'one thing', a simple gestalt that can be perceived as a whole, effective as an all-at-once experience rather than the kind of sequential, relational, reading-in-the-round that Cubism had generated. What they actually succeeded in doing, according to Barbara Rose, was to turn the central premise of Cubism inside out - by replacing Cubist simultaneity (or the superimposition of successive views of the same object from different angles) with gestalt-based instantaneity.19 Judd's wall-pieces, for instance, can only be looked at frontally, whereas the floor sculptures, even though you can walk around them, have no fixed sense of front, back or sides. As with all Minimalist works, composition is a less important factor than scale, light, colour, surface or shape, or relation to the environment. In a Minimalist work, the environment frequently becomes, as it were, the pictorial field; this is particularly apparent in the way that Flavin's neon sculptures diffuse an elusive iridescence upon the surrounding walls.

It did not take long for Minimalism to become one of the most uncompromising and pervasive aesthetics for our time, bringing about decisive changes not only in painting and sculpture, but also in music and dance. Both Philip Glass and Steve Reich have been composing, for quite some years now, music that has a modular structure - music based on repetition, stacked parts and grids, which, in the case of Glass, sometimes means playing only one line of music over and over. In the early days of the Judson Dance Theater in New York, Yvonne Rainer had revised her choreographic procedures to incorporate 'found' movement (standing, walking, running matter-of-fact, concrete, and even banal movements), performed so neutrally and non-expressively that they left no need for the

dancer's technical virtuosity. In Carriage Discreteness, for instance, a work for twelve performers, the dancers become neutral 'doers', performing tasklike activities such as transporting odd materials across the stage: 100 wood slats, 100 cardboard slats, 100 foam rubber slats, 5 mattresses, 2 styrene cubes, 2 plywood sheets, 1 brick and so on. (Morris was himself a collaborator of Rainer's for a short time during the mid-sixties.) Emptied of all ambiguity, of any traditional dramatic content or climax, Rainer's work leaves movement itself, as it were, walking on its own two feet. More recently, Lucinda Childs has evolved a mode of dance that is even more drastically Minimal, in which implacably repetitious movements enacted on an empty stage seem more like the miming of a symmetry than like performing.

The self-sufficient language of the grid – with its indifference to moral, social and philosophical values, its preoccupation with worlds comparable to those the mathematician calls forth when he plays with axioms, its mechanical habits developed in the very place where freedom existed, its meaning hemmed in by a network of set forms – remains as nothing less than a kind of Rosetta stone for our age, the significance of whose code has not really been broken. Not all the Minimalists, however, have held to a steady course, retaining the rarefied forms of Minimalism like a ritual language of priests. Even during the time that he was, properly speaking, Minimalism's most eloquent and germinative force, Morris, for instance, was simultaneously making sculptures of the human brain wrapped in dollar bills and piling up felt in heaps, and he continues, even now, to thread his way in and out of various genres; Stella's career, too, is riddled with stylistic discontinuities. The chromatic patterns of Stella's 'protractor' series, with their complex reference to Islamic architectural decoration, deliberately brought illusionistic devices back in play, and his recent, very rambunctious, relief-collages have long since left Minimalist austerities behind. In the case of Judd, Flavin and Andre, Minimalism has remained an instrument perhaps a little changed in outward appearance, but not at all in the manner of its employment. These artists (so far) have not compromised the stylistic integrity of their original statement, and have found it possible to renew their art without, like Orpheus looking back,

losing the stable meaning of their enterprise. As Andre says, 'I've produced a body of work that tends to generate its own future. This is the definition of having a style, when work you've done becomes an objective condition of work you will do.'20 For Andre, Flavin and Judd, the future gradually reveals in suspension a whole past of increasing density, like a cryptogram.

1980

Notes

- 1. Quoted in Exhibition Catalogue, Conceptual Art and Conceptual Aspects, New York Cultural Center, 1970, p. 56.
 - 2. Rosalind Krauss, Passages, New York, 1977, p. 57
- 3. Quoted in Exhibition Catalogue, A New Aesthetic, Washington Gallery of Modern Art, 1967, p. 35.
- 4. 'Questions to Stella and Judd', Interview with Bruce Glaser. Reprinted in Gregory Battcock (ed.), *Minimal Art: A Critical Anthology*, New York, 1968, p. 159.
- 5. The Pratt Lecture, 1960. Reprinted in *Frank Stella: The Black Paintings*, The Baltimore Museum of Art, 23 November 1976–23 January 1977, p. 78.
- 6. Sixteen Americans, The Museum of Modern Art, New York, 1959, p. 76.
- 7. 'Timeless in Asia', Art News, January 1960. Reprinted in Battcock (ed.), op. cit., p. 285.
- 8. 'Frank Stella and a Crisis of Nothingness', New York Times, 19 January 1964, Section II, p. 21.
- 9. Quoted by Lawrence Alloway, 'Systemic Painting'. Reprinted in Battcock (ed.), op. cit., p. 59.
- 10. 'Authoritarian Abstraction'. In The Journal of Aesthetics and Art Criticism, XXXVI/1, Fall 1977, p. 25.
 - 11. 'ABC Art'. Reprinted in Battcock (ed.), op. cit., pp. 275-7.
- 12. Statement in Exhibition Catalogue, Conceptual Art and Conceptual Aspects, The New York Cultural Center, 1970.
- 13. Enno Develing, essay in *Carl Andre*, Exhibition Catalogue, Haags Gemeentemuseum, 23 August-5 October 1969, p. 39.

- 14. David Bourdon, 'The Razed Sites of Carl Andre: A Sculptor Laid Low by the Brancusi Syndrome', Artforum, Vol. 2, October 1966, p. 15.
- 15. Diane Waldman, essay in *Carl Andre*, Exhibition Catalogue, The Solomon R. Guggenheim Museum, New York, 1970, p. 19.
- 16. 'Don Judd: An Interview with John Coplans', Pasadena Art Museum, Exhibition Catalogue, 1971, p. 21.
- 17. 'Reflections on the State of Criticism', Artforum, March 1972, pp. 42-3.
- 18. 'Specific Objects', Reprinted in Gerd de Vries (ed.), On Art: Artists' Writings on the Changed Notion of Art After 1965, Cologne, 1974, p. 128.
 - 19. American Art Since 1900, New York, 1975, p. 206.
 - 20. 'Carl Andre', Interview in Avalanche, Fall 1970, p. 23.

CONCEPTUAL ART

Roberta Smith

'And then there is that one-man art movement, Marcel Duchamp – for me a truly modern movement because it implies that each artist can do what he thinks he ought to – a movement for each person and open for everybody.'

Willem de Kooning, 1951¹

Starting in the mid-sixties, an extended free-for-all began in art which lasted for almost a decade. This free-for-all, a broad and extremely diverse range of activities known as Conceptual, or Idea. or Information Art - along with a number of related tendencies variously labelled Body Art, Performance Art and Narrative Art was part of a widespread abandonment of that unique, permanent yet portable (and thus infinitely saleable) luxury item, the traditional art object. In its place there arose an unprecedented emphasis on ideas: ideas in, around and about art and everything else, a vast and unruly range of information, subjects and concerns not easily contained within a single object, but more appropriately conveyed by written proposals, photographs, documents, charts, maps, film and video, by the artists' use of their own bodies, and, above all, by language itself. The result was a kind of art which had, regardless of the form it took (or did not take), its fullest and most complex existence in the minds of the artists and their audience, which demanded a new kind of attention and mental participation from the viewer and which, in spurning embodiment in the unique art object. sought alternatives to both the circumscribed space of the art gallery and the art world's market system.

This phenomenon represented a coming to full bloom of ideas which were for the most part introduced by a single artist, Marcel Duchamp, as early as 1917. That year, Duchamp, a young French artist who claimed to be 'more interested in the ideas than in the final product', took an ordinary urinal, signed it 'R. Mutt' and entered it as a piece of sculpture titled *Fountain* in an exhibition he was helping organize

in New York. His colleagues rejected this work and in doing so helped make Duchamp's 'Readymade' (as he called it), perhaps the quintessential 'proto-Conceptual' art work, one of the first to question self-consciously and irreverently both its own status as art and the multi-faceted context of exhibitions, critical criteria and audience expectations, which had traditionally conferred that status.

After Duchamp's Readymade, art was never the same again. With it, he reduced the creative act to a stunningly rudimentary level: to the single, intellectual, largely random decision to name this or that object or activity 'art'. Duchamp implied that art could exist outside the conventional 'hand-made' media of painting and sculpture and beyond the considerations of taste; his point was that art related more to the artist's intentions than to anything he did with his hands or felt about beauty. Conception and meaning took precedence over plastic form, as did thought over sensuous experience and, in an instant, the 'alternative' tradition of twentiethcentury avant-garde art was launched. In opposition to the increasingly abstract, 'formalist' tradition which his contemporaries -Picasso, Matisse, Mondrian and Malevich - were solidifying (art for art's sake), Duchamp posited his Readymades (art as idea), or what one writer has called 'his infinitely stimulating conviction that art can be made out of anything'.2

Duchamp became one of this century's most influential and lastingly controversial artists. He used language and all manner of verbal and visual punning, randomness as well as deliberately plotted chance, trivial and ephemeral substances, his own person, provocative gestures directed at his own or other art, as the means and subjects of his work. (In all, the many aspects of his career offer a virtual outline of the different tangents of Conceptual activity.) Duchamp was heralded by the Dadaists, who gave ideas similar to his an anarchistic, political bite, and he participated in certain phases of Surrealism. In the 1950s, as more impure, non-formalist approaches to art gained force in the 'Neo-Dada' work of Jasper Johns, Robert Rauschenberg, Yves Klein, Piero Manzoni and others, Duchamp's thought received more and more consideration.

The art of the late 1950s and early sixties, both in America and Europe, was peppered with context-conscious, non-object, postDuchampian, proto-Conceptual efforts, but these remain for the most part peripheral to 'mainstream' modernism and usually on the outskirts of careers devoted primarily to painting and sculpture. One thinks here of Robert Rauschenberg's Erased de Kooning Drawing (exactly that) of 1953, or his telegram portrait of Iris Clert - 'This is a portrait of Iris Clert if I say so'; of Yves Klein's attempts to fly: photographs of the artist swan-diving off high walls which represent some of the first instances of the kind of private documented Performance or Body Art that characterized much Conceptual work; of Arman's 1960 exhibition: a Paris gallery filled with two truckloads of rubbish; and of the Dutch artist Stanley Brouwn's announcement, also in 1960, that all the shoe shops in Amsterdam constituted an exhibition of his work; of Piero Manzoni's shiny chrome cylinders labelled with the information that they contain the artist's excrement. There were also the multi-media performances of the Fluxus group and its American counterparts. the free-form Happenings organized by Claes Oldenburg, Jim Dine, Allan Kaprow and others in New York. But it was not until the midsixties, and a younger generation, that Duchamp's revolutionary contribution sparked the imagination of so many artists that his 'one-man movement' grew into a throng. Achieving its purest and most widespread expression, his 'art as idea' was broken down and expanded into art as philosophy, as information, as linguistics, as mathematics, as autobiography, as social criticism, as life-risking, as joke, as story-telling.

After 1966, the interest in 'context' and in the dispensability of the unique art object became epidemic, and moved from the periphery towards the centre. The motivations were variously political, aesthetic, ecological, theatrical, structuralist, philosophical, journalistic, psychological. Young artists with vanguard ambitions were confronted with the finality of the Minimalist box which did not leave much to do in the way of form-making and which seemed to offer incontrovertible proof that conventional painting and sculpture were exhausted. In some cases the political unrest and growing social consciousness which characterized the sixties also encouraged a desire to avoid the traditionally elitist position of art and artist. Many artists found themselves uninterested in or morally opposed to

the traditional object's connotations of style, value and aura; others also wanted to circumvent, and some to ridicule, the market system it engendered; still others felt confined by the gallery space itself.

Conceptual Art, as it came to be known, was one of several interrelated, overlapping alternatives to traditional forms and exhibition practices. Some artists, whose work soon came under the rubric of Process Art or Anti-form, held on to materials but jettisoned the object, divesting their work of structure, permanence and boundaries via random, temporary distributions, 'scatter pieces' both indoors and out, of non-rigid, ephemeral substances – sawdust, cutup bits of felt, loose pigment, flour, latex, snow, even cornflakes. Others held on to permanence but jettisoned mobility and normal access, proposing and executing huge Earthworks in far-off parts of the landscape. (That both Process Art and Earthworks were usually known through photographs is only one indication of the kind of overlapping which occurred, for they too assumed an immaterial, conceptual existence.)

But if Process Art and Earthworks often ended up existing for the most part in the mind, Conceptual Art aimed at the mind from the beginning. As Conceptualist Mel Bochner explained in the mid-1970s during an interview about Malevich:

A doctrinaire Conceptualist viewpoint would say that the two relevant features of the 'ideal Conceptual work' would be that it have an exact linguistic correlative, that is, it could be described and experienced in its description, and that it be infinitely repeatable. It must have absolutely no 'aura', no uniqueness to it whatsoever.³

Ultimately, few Conceptual works achieved this ideal state, but some came close, and in doing so achieved an unsettling blend of aesthetic purity and political idealism.

'Art that imposes conditions – human or otherwise – on the receiver for its appreciation in my eyes constitutes aesthetic fascism', said Lawrence Weiner, towards the end of the sixties. Weiner did not care if his 'Statements', succinctly phrased Process-type proposals ('A square cut from a rug in use', 'One standard dye marker thrown into the sea'), were executed by himself, by someone else or not at all; that was the decision of the 'receiver' of the work. Some

works, which Weiner declared to be in the 'freehold' (his term for public domain) could be 'received', that is, possessed, by anyone: 'Once you know about a work of mine,' said Weiner, 'you own it. There's no way I can climb into somebody's head and remove it.' And Douglas Huebler, who was one of the first artists specifically called Conceptual, along with Weiner, Joseph Kosuth and Robert Barry, wrote in 1968, 'The world is full of objects, more or less interesting; I do not wish to add any more. I prefer, simply, to state the existence of things in terms of time and or space.' One of Huebler's early works, the New York – Boston Shape Exchange, used maps and instructions to propose the creation of identical hexagons (one in each city) 3,000 feet on a side, whose points would be marked by white stickers 1 inch in diameter. Even if executed, the work would have been impossible to experience as a whole, except in the viewer's mind.

Of all the tendencies which populated the art scene of the late sixties and early seventies, Conceptual Art took the most extreme stance, and it in fact remains most vivid, in memory and influence, today. For the Conceptual artists combined their objections to conventional media with a clear, radical alternative and a genuinely polemical position which they defined both in their art and their statements. Despite its extreme diversity, most Conceptual activity was united by an almost unanimous emphasis on language or on linguistically analogous sytems, and by a conviction - self-righteous and puritanical in some quarters - that language and ideas were the true essence of art, that visual experience and sensory delectation were secondary and inessential, if not downright mindless and immoral. 'Art's "art condition" is a conceptual state', wrote Joseph Kosuth.⁷ 'Without language there is no art', echoed Lawrence Weiner.8 Language gave the Conceptualists their distinct radical character and it also gave them a lot to work with. Not only were some, like Weiner and Huebler, freed from the humdrum of material constraints; the very apparatus of the printed and spoken word offered a whole new spectrum of media to replace painting and sculpture. Newspapers, magazines, advertising, the mail, telegrams, books, catalogues, photocopying, all became new means, and occasionally new subjects, of expression, offering myriad ways for Conceptual

artists to communicate their art to the world and, as often, to include that world in their art. Conceptual Art also made an entirely new use of photography in art as well as of film and of video, which became widely available in the 1960s for the first time, with the result that, throughout the movement, the non-unique visual image is almost as pervasive as language.

Another factor which made Conceptual Art perhaps the most radical of all 'post-Minimal' efforts, was that it made the most cogent, thoroughgoing use of Minimalism, dismantling its strategies, arguments, militancy and methods for its own purposes. The very term Conceptual Art, although originally coined by the Californian artist Edward Kienholz in the early 1960s, actually received its first theoretical exegesis from Sol LeWitt, whose Minimalist white cube structures were, by his own definition, Conceptualist. LeWitt was an important influence on both European and American artists interested in working beyond the object and in his 1967 Artforum article, 'Paragraphs on Conceptual Art', he stated:

In Conceptual art the idea or concept is the most important aspect of the work . . . all planning and decisions are made beforehand and the execution is a perfunctory affair. The idea becomes the machine that makes the art. . . . 9

'If someone says it's art, it's art', said Donald Judd, reiterating Duchamp. Judd also observed 'that advances in art are not necessarily formal ones'. Both quotes appeared in Joseph Kosuth's important, if belligerent 1969 article 'Art after Philosophy', 10 in which he distinguished art before from art after Duchamp, largely dismissing the former, and argued for art as a kind of logic, and for art works as analytic propositions concerned with the definition of art.

Minimalism itself had aspired to be completely logical. Yet it was also the first art movement to be 'formalist' and Duchampian in equal parts. It achieved pure, abstract, often classically beautiful form via a preconceived intellectual approach which made extensive use of various 'readymades': mathematical systems (used to determine composition), geometric forms, unmanipulated industrial materials and factory fabrication (which removed the artist from the

actual construction of the object). Minimalism reinforced an idea of progress in art which verged on the scientific and, likewise, of an art which moved forward by appropriating methods and ideas from other disciplines and areas of knowledge. Also, Minimalism's severe reduction did not leave younger artists, instilled with this idea of progress, much to do in the formal arena; this too helped push them towards what seemed to be the next logical step – the elimination, or at least de-emphasis, of the object, and the use of language, knowledge, mathematics and the facts of the world in and of themselves. It was ironic that a style which had so completely eliminated subject-matter should encourage an art which was all subject-matter.

The Conceptualists adopted the spare, clean, straightforward look of Minimal Art and also took its predetermined approach and its penchant for repetition to new extremes. For example, in an early body work by Vito Acconci, he documents, through photograph and text, his daily exercise of stepping on and off a chair for as long as possible over several month-long periods and compares his performances. In another instance, Douglas Huebler takes a photograph every two minutes for twenty-four minutes while driving along a road, and exhibits the resulting dozen blurry images over a caption explaining the system. These artists came close to relinquishing control of their work, letting the given facts of the road, on the one hand, or simple physical stamina, on the other, determine the form that it took. The Minimalist ideal of unmanipulated materials -Frank Stella wanting to keep the paint 'as good as it was in the can' - was applied to a much greater, less predictable set of variables. For better or for worse, art was opened up. To quote Robert Barry, whose early work consisted of releasing small amounts of inert gases into the atmosphere and photographing their completely unrecordable dispersal: 'I try not to manipulate reality.... What will happen, will happen. Let things be themselves.'11

Conceptual Art probably was the largest, quickest-growing and most genuinely international of all twentieth-century art movements. It would be impossible to list, categorize or even to know about all the acts committed in its name. Unlike Cubism, Abstract Expressionism or Minimalism, Conceptualism really cannot be narrowed down to a

handful of 'seminal artists' in one country or another. It is very difficult to pinpoint its originator or inventor, the way one can point to Braque and Picasso for Cubism or Stella and Judd for Minimalism. However, the artists most often referred to are Kosuth, Barry, Weiner and Huebler. They all exhibited together in 1968 and 1969 in a series of innovative exhibitions (at least one of which existed only as a catalogue) organized by curator—entrepreneur Seth Siegelaub.

Still, as one reviews the period, there is a sense of an art movement proceeding almost by spontaneous combustion. One reason for this, of course, lies within the nature of Conceptual Art itself, for, due to its reliance on language, the reproducible image and the media, it was easily and quickly communicated. The following are only a few of countless examples. In 1966, Bruce Nauman, a young Californian, made a series of punning colour photographs, one of which, in direct reference to Duchamp, was titled Portrait of the Artist as a Fountain and showed the artist spurting water from his mouth. In Vancouver, Iain and Ingrid Baxter formed the N.E. Thing Co. and exhibited the contents of a four-room apartment wrapped in plastic bags. A Japanese artist living in New York, called On Kawara, started a small black painting each day which simply stated that day's date in white block letters. This open series of identical units continues today. In France, Daniel Buren reduced his painting to a series of stripes printed on canvas or paper [illustration 123] and by the end of the year he and three other artists, who had arrived at similarly basic configurations, agreed that each would use his chosen configuration again and again in every situation. In early 1968, the English artists Terry Atkinson, David Bainbridge, Michael Baldwin and Harold Hurrell founded the Art & Language Press and proposed their 'Air Show' - a column of air of unspecified location, area and height. By 1969, they would be publishing their own highly esoteric magazine Art-Language, which presented art theory as Conceptual Art. Almost every country in Europe, North and South America boasted some sort of serious Conceptual activity during this period, as can be seen by a look through the catalogues of the large survey exhibitions which, by 1969 and 1970, were already documenting both it and other related modes.

Despite the vast number of works produced, Conceptual Art, not surprisingly, resulted in fewer museum masterpieces than any twentieth-century art movement. Nonetheless, its influence has been pervasive, as if its very immateriality allowed it to seep in everywhere, affecting tendencies contemporary with it and even exerting an influence on the more formally conservative art tendencies of the late 1970s. In this, Conceptualism was like Surrealism, which also lacked a coherent visual style and which had an overriding concern with meaning and subject-matter; both movements offered ideas which were infinitely adaptable because they could be used without the danger of appearing stylistically derivative.

One can divide and re-divide the vast expanse of Conceptual activities and manifestations into various groups and categories according to the use of language, the use of photography, subjectmatter, the degree and kind of physicality. Its most frequent and characteristic manifestation, however, was the printed word, occurring almost anywhere from books to billboards and quite often in combination with photographs. Nonetheless, the actual physical nature varied tremendously from work to work and was a hotly argued issue. Conceptual Art ranged from pure thought, as in Robert Barry's 1969 Telepathic Piece - a statement that 'during the exhibition I will try to communicate telepathically a work of art, the nature of which is a series of thoughts that are not applicable to language or image' - to the perversely hidden physicality of Walter de Maria's 1977 Vertical Earth Kilometer in Kassel, Germany. Basically a 'conceptual earthwork', this consists of a one-kilometer brass rod sunk into the ground with nothing visible except its top end, a small brass disc 2 inches in diameter. Despite its material and size, the work exists largely in the viewer's mind, although this existence is considerably intensified by the knowledge that such a grandiose conception has actually been carried out.

For some artists, particularly Kosuth, Weiner, Barry and the members of the Art & Language group, language achieved a quasiformal status, existing as both material and subject, and the work of these artists focussed almost exclusively on the question of defining art. Here, words and phrases were isolated, savoured, and discursively analysed. Barry projected single words on gallery walls

[illustration 114], Kosuth made white-on-black blow-ups of the dictionary definitions of art-related words, and Art & Language offered often impenetrable discussions of the nature, practice and perception of art, functioning as the movement's conscience (often outraged) and radical fringe. Kosuth in particular could present tautologies as self-contained as any Minimalist box. His One and Three Chairs [illustration 115], a common folding chair, an actualsize photograph of it and the dictionary definition of the word itself, is a progression from the real to the ideal which covers the basic possibilities of 'chairness'.

Mel Bochner's use of language was not as pure as Kosuth's, since Bochner was interested in the viewer's spatial as well as intellectual experience, but his work was almost as self-contained and relied similarly on philosophical approaches. For the most part, Bochner employed modest, ordinary materials, like pebbles, pennies, maskingtape and chalk in combination with writing or numbering (by hand) in order to illustrate, distil and confound various counting systems of philosophical propositions. His 1973 Axiom of Indifference [illustration 116], for example, considers the location of pennies with regard to masking-tape squares on the floor ('some are in', 'all are in', 'all are not in', etc.); it consists of two different arrangements of squares on opposite sides of the same wall, so that the viewer is challenged to decipher one arrangement while struggling to remember the other.

For almost all other Conceptual artists, language functioned more or less as a tool, a means by which they brought some aspect of life, rather than art, into focus in the viewer's mind or psyche. Huebler and Hans Haacke used language to convey or gather information, to broach complex non-visual issues, often political or social in nature, or simply to depict the teeming matrix of human existence. Theirs was a kind of Conceptual Social Realism - Huebler's anecdotal, Haacke's critical. Huebler asked museum visitors to write down 'one authentic secret' and the resulting 1,800 documents went into a book which makes fascinating, if at times repetitive reading as most secrets are quite similar to each other; since 1971, Huebler has been working on a series which aims to photograph 'everyone alive'. Haacke was, and remains, preoccupied with exposing systems of power and influence. His Real Time Social System of 1971 featured photographs of a large group of New York slum buildings, all owned by one firm, while captions revealed an array of holding companies, mortgage data, assessed values and property taxes. When the Guggenheim Museum cancelled his exhibition there rather than show this work, Haacke did one which traced the various family and business ties between the Guggenheim trustees.

For other artists, like Vito Acconci, Chris Burden and the English team of Gilbert and George, language, used in tandem with their bodies or lives, is communicated on a much more personal, one-toone level, in ways variously discomfiting, shocking or amusing. In his most notorious work, Seedbed [illustration 117], Acconci established a mutually voyeuristic relationship with his audience: the artist masturbated out of sight beneath a gallery-wide ramp, while visitors walking above were subjected to the sounds (via loudspeaker) of his fantasizing, often about their footsteps. Throughout his work, be it performance, videotape or lengthily-captioned photograph, the sense of forced and uneasy intimacy with the artist, his body and private thoughts, is intensified by his obsessive and repetitive use of words. Burden achieved international fame with a 1971 performance in Los Angeles which consisted of his having himself shot in the arm. Most of his performance pieces - he has been crucified on the back of a Volkswagen, crawled semi-nude across broken glass, briefly held hostage the hostess of a television talk show, and used commercial television spots to make ominous statements - reduce to rather harrowing, emblematic acts of will. Few people have actually witnessed Burden's performances, but the extraordinary, iconic photographs and stark factual captions, straightforward as any Weiner 'Statement', which document them, have given these events a permanent, reverberating existence in both the mind and the media [illustration 118]. Starting in the late sixties, the inseparable pair of Gilbert and George brought a nostalgic, but rigorously formalized gentility to Performance and Body Art: they simply designated themselves and every aspect of their proper English lives a 'Living Sculpture', and then proceeded to segment their existence into highly artificial, exhibitable form. They presented mannequin-like performances and also mailed cards and announcements, used large captioned drawings and finally photographs, to isolate various events and pastimes as Singing Sculpture [illustration 119], Relaxing Sculpture, Drinking Sculpture – narrating the entire undertaking in language which is the height of cheerful, old-fashioned impersonality, as summed up by their repeated refrain, 'To Be With Art is All We Ask'.

In many instances, as On Kawara's date paintings indicate, the passage of time itself is the all-important subject. The Dutch artist Jan Dibbets became known for photographs which captured the transition from morning to night, from natural to artificial light, in front of a given window [illustration 120]. Since 1965, the Polish artist Roman Opalka has been at work on his 1 to Infinity painting [illustration 121], filling canvas after canvas with endless numbers, reciting each number into a tape recorder as it is painted, so that each painting, considered a 'detail' of a single work, comes complete with a real time cassette of its own making. This last aspect of Opalka's undertaking is reminiscent of a proto-Conceptual work by Robert Morris, Box with Sound of Its Own Making of 1961, a small wood cube containing a tape recorder playing a loop of the sawing and hammering involved in the box's construction. Contemporary with Opalka's is the work of the German artist Hanne Darboven, who fills page after page with a combination of abstract handwriting and mysterious numerical systems, sometimes derived from the calendar itself, always explained in an accompanying index. In exhibition, Darboven covers entire walls with these pages of rhythmic, incessant scrawl and the effect is of a cumulative, mesmerizing marking of time [illustration 122].

Although Conceptual manifestos often declared Conceptual work to be 'beyond style', the movement could be said to run the gamut, almost chronologically, of many styles. It follows a definable stylistic progression familiar in the art of the past. The early, pure-language Conceptualists are classically detached and didactic; the various Body artists often seem Expressionist, even Baroque. Other work, for example the large photographs with which the English artists Hamish Fulton and Richard Long document their respective hikes through uninhabited terrain, are imbued with a pastoral, pre-industrial Romanticism. Finally, the most recent phases of Concep-

tual activity, which in the early 1970s earned the separate designation of Narrative or Story Art, seem deliberately light, amusing, almost decorative. In fact, the work of such artists as William Wegman, Bill Beckley, James Collins, Alexis Smith, composer-performer Laurie Anderson (not to mention a spate of other Performance artists), appropriates from popular culture and aspires to entertainment in a way that the original 'classical' Conceptualists would no doubt condemn.

Looking back from the beginning of the 1980s, the Conceptual 'moment' seems to have ended somewhere around 1974 or 1975. Today, although some interesting Conceptual activity continues among many of the artists mentioned here, and others, it does not dominate; rather, it coexists in a terrain densely populated with painting and sculpture, much of it representational, which it has, surprising as it may seem at first, helped fertilize. Nor is much of the Conceptual Art produced today as purist in terms of its media: one suspects that some artists got tired of having so little to show for their efforts. Art & Language closed its activities in New York in 1976, although its exhibitions and publications in England and Europe have increased since then and they have continued to publish the journal Art-Language. Although Kosuth, Weiner, Barry, Dibbets, Huebler and Haacke continue fairly close to their original concerns, all but Kosuth are gradually allowing occasional bursts of colour, luxurious imagery or ostentatious material to creep into their work. Acconci and Burden, as if exhausted by the strain of using their physical and psychic selves as material – it seems difficult to sustain any kind of Expressionist career - have turned to more tangible pursuits: Acconci to elaborate installation works using tape recordings of his characteristic mumblings, and swings and ladders which often imply the use of the viewer's own body; Burden to recreate some of society's most emblematic machines, such as the car and the television set, objects most people take for granted. Gilbert and George's large photographic arrangements, which focus on increasingly Expressionist themes such as drinking and dereliction, look handsomer every year. Daniel Buren's ubiquitous stripes, which sometimes highlight gallery or museum architecture with dazzling

complexity, have lost their anonymity and are instantly recognizable as 'Burens'. Bochner's counting systems led him to geometric form as a symbol for numbers (three-, four-, and five-sided shapes) and gradually into wall paintings of colourful, fanned out geometric arrangements. Opalka remains on course and his 1 to Infinity has recently passed the number 3,000,000.

Conceptualism neither democratized art nor eliminated the unique art object, nor did it circumvent the art market, or revolutionize art ownership. In fact, once they had adjusted to this activity, collectors eagerly accumulated photographs, statements and other Conceptual by-products. The art market was merely expanded in its infinite flexibility. For one thing, since so many Conceptual efforts exist only in printed form, a whole new category of art work - artists' books - was spawned. And, as the American Carter Ratcliff pointed out, Conceptualism also contributed to the official annexation of photography (old, contemporary, fashion) and of architectural drawings and musical scores into the category of art gallery art.

In many ways, de Kooning was right. What Duchamp had set in motion culminated, at least for a while, in a movement 'open for everyone', a time of tremendous liberation, experiment and even licence, which seems to have left little in the way of conventionally 'great' art, despite its extreme positions, its manifestos, its idealism and the challenging thinking it generated about art and its possibilities. Much like a phase of adolescence, Conceptualism was variously indulgent, polemical, hilarious, narcissistic, brilliant, but only occasionally moving or wise.

Ultimately, however, the role of Conceptual Art seems more important for the sense of liberation it generated as a side effect. By the end of the 1970s, Conceptualism, along with Minimalism, became the bête noire in a period, particularly in American art, which saw a rejuvenation of painting, a renewed emphasis on handworked materials and thick, rough 'personal' surface in both painting and sculpture, the widespread use of intimate scale and small size, and a prevailing attraction to subject-matter. In this respect, Conceptual Art was the first crack in the façade of abstract infallibility: the most recent self-proclaimed avant-garde art movement, the last about which one could argue its status as art, it nonetheless signalled the

modern', a period in which young artists in every medium seem preoccupied with the image and its meaning. Along with a renewed influence of Pop Art, Conceptual Art, perhaps unwittingly, helped revitalize the use in art of humour and irony, photographic imagery, the human figure, autobiographical subjects, and language – all elements which have been subsequently, and energetically, appropriated by younger painters and sculptors. Starting out in the vicinity of Conceptualism, a new and stylistically diverse generation of artists has gradually emerged: these artists are working out fresh ways of giving form to their ideas in extravagantly complex and colourful visual terms, without losing their train of thought.

1980

Notes

- 1. 'What Abstract Art Means to Me', a statement made in a symposium held at the Museum of Modern Art, 5 February 1951; reprinted in Thomas B. Hess, *Willem de Kooning*, New York, 1968, p. 143.
- 2. Anne d'Harnoncourt in *Marcel Duchamp*, ed. d'Harnoncourt and Kynaston McShine, New York, 1973, p. 37.
- 3. 'Mel Bochner on Malevich, An Interview' (with John Coplans), Artforum, June 1974, p. 62.
- 4. Interview with the artist in *Conceptual Art*, ed. Ursula Meyer, New York, 1972, p. 217.
 - 5. Interview with the artist, Avalanche, Spring 1972, p. 67.
 - 6. Statement in Six Years, ed. Lucy Lippard, New York, 1973, p. 74.
- 7. 'Art after Philosophy, I', Studio International, October 1969, pp. 134–7.
 - 8. Interview with the artist, Avalanche, Spring 1972, p. 72.
- 9. 'Paragraphs on Conceptual Art', *Artforum*, Summer 1967, pp. 79–83.
- 10. 'Art after Philosophy, I', Studio International, October 1969, pp. 134–7.
- 11. Interview with the artist in *Conceptual Art*, ed. Ursula Meyer, New York, 1972, p. 35.

POSTMODERNISM AND THE ART OF IDENTITY

Christopher Reed

'Postmodernism'. Definitions seem to vary with every citation, yet the use of the term to describe recent developments in the arts (and in other forms of social life from urban planning to theology) suggests a widespread belief that a coherent change in sensibility marks our era and distinguishes it from the 'modernism' that came before. One analysis of this apparent paradox of a coherent diversity is provided by the sociologist Norman K. Denzin, who defines postmodernism as 'both a form of theorizing . . . and a period in social thought'.¹ Thus phenomena (including art) arrive in the category of postmodernism in two ways: first, by occurring in the postmodern era; and second, by demonstrating particular forms associated with postmodern thought.

In art textbooks, the postmodern period is often said to begin in 1977, with the publication of Charles Jencks's The Language of Post-Modern Architecture, which sought to supplant the minimalism of International Style design with more eclectic approaches.2 In fact, the end of modernism has been announced since modernism began - Jencks dates the term's earliest use to the Victorian era.3 But the term postmodernism gained currency only in the mid-1970s, and then was applied retroactively to the previous decade in an attempt to categorize developments in art from Pop to Conceptual that seemed to challenge formalist aesthetics and reverse the modernist evolution toward increasingly pure abstraction. The broadest definition of postmodernism, then, would be: the non-abstract art of the sixties, seventies and eighties. From this point of view, the lineage of Conceptual Art - from Duchamp through Dada and Surrealism to Rauschenberg - as it is traced in this volume's essay on Conceptual Art in contrast to 'mainstream modernism' - is the story of postmodernism as well. Indeed, some critics, those looking at Duchamp especially, have derided 'postmodernism' as a misnomer, arguing that there has always been a postmodernist subcurrent within modernism. Even the term's claim to supplant modernism (the 'post' in

'postmodernism') might be seen as itself quintessentially modern according to the definition of modern art advanced in the preface to this book: a 'questioning and rejection of the past'.

Used broadly, as it often is, the term 'postmodernism' is quite susceptible to critique as illogical and over-ambitious. In the highly influential body of theory that has come from artists and critics who identify with postmodernism, however, the term has acquired a more specific set of meanings, revolving around terms like signification, originality, appropriation, authorship, deconstruction, discourse and ideology. Put as simply as possible, postmodernism challenges the modernist certainty about the autonomy of art - the kind of certainty evidenced, for instance, in Ad Reinhardt's epigraph for the essay on Abstract Expressionism in this book. Postmodernists see representation and reality as overlapping, because conventions of representation or language ('signification') are learned and internalized so that we experience them as real. Especially in an age when television and the other mass media play such a significant role in creating human consciousness, what we perceive as real is revealed to be always present in and filtered through representation. The term 'simulacrum' - drawn from the writings of the French philosopher Jean Baudrillard – is often used to signify this idea of representation as reality.4 For the postmodernist, then, nothing we can do or say is truly 'original', for our thoughts are constructed from our experience of a lifetime of representation, so it is naive to imagine a work's author inventing its forms or controlling its meaning. Instead of pretending to an authoritative originality, postmodernism concentrates on the way images and symbols ('signifiers') shift or lose their meaning when put in different contexts ('appropriated'), revealing ('deconstructing') the processes by which meaning is constructed. And because no set of signifiers, from art to advertising, is original, all are implicated in the ideologies (themselves patterns of language or representation, hence, 'discourses') of the cultures that produce and/or interpret them.

These postmodernist principles are exemplified by some of the artists who achieved celebrity around 1980 with work that recycles conflicting images and systems of representation. Julian Schnabel's successful career is often cited to describe the soaring art market of the early eighties. His huge panels combine images quoted from films, photographs and religious

iconography on surfaces patched together from posters, ponyskin, rugs, driftwood and – most famously – broken crockery. With titles like Giacomo Expelled from the Temple (1976–78), Painting Without Mercy (1981) and The Patients and the Doctors (1978) [illustration 124], Schnabel's works engage conventional forms of authoritative ideology (religion, art history, medicine), yet their ultimate effect denies the viewer any certainty about their meaning. Overwhelming in scale, simultaneously rough and fragile, messy, yet obviously laboured over, Schnabel's works seem desperate to communicate something, but that something is never clear; their mismatched signifiers force the viewer to confront the process of meaning-making itself.

Like Schnabel, David Salle combines images from various sources, juxtaposing and overlapping cartoons, news photographs, technical drafting, famous paintings, movie stills and pornography. Characterized as 'the ultimate Baudrillardian, reveling in the non-narrative play of detached signifiers', 5 Salle became famous for works like Savagery and Misrepresentation (1981) [illustration 127], which superimposes line drawings of a cartoonish horse-man and recumbent nudes over a waterfront scene drawn from Reginald Marsh, a Depression-era painter of working-class life. The relationship between the two images is left unclear. Does one erase or cancel another? Do they comment on each other? Do they replicate the effect of vision in the world today, where (as, for instance, on televisions that allow you to watch two channels at once) things seen together may have no relationship to each other at all? Perhaps the most telling example of this kind of postmodernist destabilization is the 'collaboration' between Salle and Schnabel (a collaboration where one participant was not consulted) in which Schnabel acquired a diptych by Salle, reversed the two panels, superimposed a portrait of Salle over one image and retitled it Jump [illustration 125]. The image's meaning, along with the very idea of authorship, is here left dramatically unresolved.6

In the early eighties, both Schnabel and Salle were celebrated for their sophistication in disrupting previously authoritative assumptions about the function and nature of art. At the same time, however, both artists were the objects of vehement criticism. Predictably, conservative critics, hostile to postmodernism, derided their departure from modernist convention. Under such headlines as 'A Painter's Pratfall' and 'Expressionist Bric-a-Brac',⁷ both major American mass-circulation newsweeklies attacked Schnabel by contrasting his paintings to the modernist paradigm set by Jackson Pollock, while David Salle was awarded 'the title of Most Overrated Young American Artist' in a review that interpreted his fame as a symptom of the overall triviality of postmodernism in comparison to 'serious painting'.⁸ Disparaged in this way by the defenders of modernism, both Schnabel and Salle also came in for criticism by avowed postmodernists. These challenges demonstrate important divisions within postmodernism, divisions over questions of identity.

Issues of identity are crucial to postmodernism, so much so that some theorists propose a new awareness of certain identities to be the defining characteristic of the postmodern age. In an influential essay, Andreas Huyssen maps four identities (which he calls 'phenomena') that 'are and will remain constitutive of post-modern culture for some time to come': national identities, especially those formed in response to imperialism; sexual identities; an environmentalist identity; and ethnic identities, especially non-western.9 Huyssen's analysis reaches beyond art to characterize postmodern culture in general, yet it is easy to see his observations exemplified in the rise of environmental $\mathrm{art^{10}}$ and feminist art, or in the expression of sexual, ethnic and racial identities in individual artworks or thematic exhibitions. Such emphasis on specific identities challenges formalist beliefs in a transcendent or universal art (that just happens to have been created overwhelmingly by and for a specific demographic group: white, Western, apparently heterosexual men of the upper middle class).

These art world developments, of course, reflect broader social critiques of hierarchies based on race, class, nationality, gender, sexuality and other forms of identity. But the specific social position of the arts—as they are closely tied to economic and academic privilege—has focused particular attention on sexual and gendered identities, which were always present, though previously repressed, in the art world. Art's commodity status as a luxury for the most privileged, reinforced by the unequal educational opportunities that mark all the academic disciplines, contributes to the near-invisibility of non-dominant racial, ethnic and class identities in the art world, which remains far less diverse than the broader culture. Despite occasional exhibitions and essays in art

journals, artists and commentators dealing with artefacts that engage these issues generally work outside or in uneasy relation to art institutions, where their projects are often labelled 'craft', 'popular culture', or as some other category of imagery outside the realm of 'art'. Although these same categories have been invoked to dismiss art associated with women and gav men, such work also found defenders already in the relatively privileged, mainly white constituency of the art world. 12 Identities rooted in gender and sexuality became central forces in the development of postmodernism.

Since the Renaissance, which began the systematic recording of artists' biographies, these chronicles have recorded stories of ambitious women and of same-sex eroticism. 13 Yet it is only in the last century that these characteristics have become identities - even the words 'feminist' and 'homosexual' are barely a hundred years old. And the art world, until very recently, precluded the articulation of these identities, sometimes by overt discrimination against women and homosexuals.14 but more often by subtly ruling their expression incompatible with artistic quality or accomplishment, or even with the definition of art itself. This process of exclusion is reflected, for example, in the other essays in this anthology where twenty times as many men as women are mentioned, while the effects of gender are nowhere discussed. Similarly, when gay artists like Robert Rauschenberg, Jasper Johns, Andy Warhol, David Hockney or Gilbert and George are cited, their sexual identity is ignored as irrelevant to their artistic production. While the conventions of modernism (still championed by many) ruled such concerns 'ideological', and hence outside the realm of art and aesthetics, parallel expressions of heterosexual masculinity - like the Futurists' machismo and 'contempt for women' [p. 98], Pollock's aesthetic of 'physical violence' [p. 178], or Rothko and Newman's determination to be 'human' by producing 'mansized' paintings [p. 196] - were perceived as easily compatible with artistic achievement.

If the biases of earlier writings now seem obvious, it is because of the feminist and gay movements, which, beginning around 1970, challenged conventional assumptions about sexuality and gender. Although these movements did not originate in the art world, from their inception artists and critics were involved. Explicitly feminist and gay perspectives began to affect the arts, therefore, at precisely the same moment as the rise of postmodernism. Looking at the definition of postmodernism advanced in the introduction to this essay, it is easy to see how these artistic and social movements might connect. From the outset, postmodernism dislodged the wedge that mainstream modernism had driven between art and life. Frankly engaging in social issues, postmodernists, like feminist and gay activists, deal with ideology, the mass media and the dynamics of authority. This common ground is often emphasized by conservative critics in order to dismiss postmodernism as a simple manifestation of 'radical feminism' or 'camp' gay culture. ¹⁵ Although gay and feminist critics often advocate postmodernist positions, however, their critiques of artists like Schnabel and Salle reveal serious differences with the postmodernism represented by these artists. Such debates within postmodernism centre on two issues: authority and activism.

Feminists, in particular, questioned the way the anti-authoritarian rhetoric of postmodernism seemed to become itself a form of cultural authority, a litany of proper names (mainly French and male) and complicated jargon that enabled artists and academics (again, mainly male) associated with postmodernism to sweep into the most conventionally prestigious positions in established galleries, museums and universities. Griselda Pollock, a prominent British feminist, argues that modernism must be understood as more than just a visual style (abstraction) and its supporting critical theory (formalism). Abstraction and formalist theory, she says, are merely the products of a 'system of interpretation' that emphasizes 'stylistic innovations and reactions embodied in the masterpieces of great individual geniuses'. The fashionable heroicization of individual theorists and artists during the eighties suggests to her that postmodernism is just one more style in the sequence of styles determined by 'modernist structures of production and consumption'. 16 Her theoretical point is exemplified by specific episodes throughout the eighties. When Schnabel, for instance, published black and white photos of himself at work on his huge canvases outside a Long Island beach house, he invoked the famous ARTNews and Life Magazine photospreads on Jackson Pollock that made him the 1950s paradigm of the inspired genius. 17 Here Schnabel, though his art looks different, seems to assert a claim on the most traditional kind of modernist fame.

An early – and perhaps definitively clear – critique of postmodernism comes from the pioneering American feminist, Lucy Lippard, who in $1980\,$

reviewed the feminist contributions to the previous decade's art, which was already heralded for breaking with modernist traditions. Lippard cited as feminist influences the emphasis on 'central imagery and pattern painting' as well as 'layering, fragmentation, and collage', the introduction 'of real emotion and autobiographical content to performance, body art, video, and artists' books', and the appropriation of 'traditional art forms such as embroidery, sewing, and china painting'. Anticipating Griselda Pollock, however, Lippard insists that feminist art is more than just another style, like 'postmodernism, post-Minimalism, and postbeyond-postness'. The difference, Lippard asserts, is that feminists know 'that it is impossible to discuss [art] without referring to the social structures that support and often inspire it'. Undermining the authority lodged in clichés of unique artistic genius, she says, 'We take for granted that making art is not simply "expressing oneself" but is a far broader and more important task: expressing oneself as a member of a larger unity, or comm/unity'. 18 For Lippard, it is this enunciation of a collective identity that separates feminism from postmodernism, distinguishing feminist practice as something more challenging to modernist convention: an art of identity. For her, the massive all-women, collaborative installations of an artist like Judy Chicago exemplify the potential of feminist art. Chicago's 1972 Womanhouse (co-organized with Miriam Schapiro), 1974 Dinner Party [illustration 128] and 1978 Birth Project assembled women using various 'craft' techniques to explore the specificity of their experience. Like Salle's quotations from pornography and Schnabel's gluedon crockery, Chicago's work challenges the modernist conventions that separate art from the rest of life, but her use of sexual imagery and 'crafts' - including ceramic plates - has a different aim: rather than simply deconstructing conventional ideologies, her work constructs an alternative narrative, in this case a story of women's history. 19 While David Salle insists, 'I never felt that my work located itself within any specific subculture', 20 Chicago's work asserts a feminist identity.

An emphasis on constructive 'comm/unity' over deconstructive authority led feminists to a second major conflict with postmodernism over issues of activism. Postmodernist efforts to reveal all reality as a series of shifting simulacra can foster a kind of nihilism, feminists argued; what basis for principled action remains once everything is equalized as just representation? Looking specifically at works by Salle, they challenged

the way his apparently random mixing of imagery exploits the shock value associated with pornography as a deconstructive device. When the counter-image that is undermined is one associated with political struggle (such as the Reginald Marsh quotation in Savagery and Misrepresentation), the porn shot's dynamic of masculine mastery is preserved, while 'Salle turns familiar symbols of cultural hope and activism to signs of cynicism and impotence'. Again, the artist's own statements bear out the feminist critique. In interviews, Salle describes the 'enormous identification' that prompts him to follow physically handicapped little girls on the New York subway. Apparently uninterested in the social implications of his actions, Salle does not address whether his presence disturbed or frightened the girls, but concludes with a kind of aestheticized nihilism: 'I don't know what it was I wanted, because you can't go home with them. Just the fact that that moment of recognition to me is one of excruciating beauty.'

For critics with an ideal of 'comm/unity', Salle's personal aesthetic thrill is not enough. Indeed, it is the same old pleasure that modernism has always promised to viewers privileged enough to distance themselves from 'life' in the name of 'art'. If 'postmodernism' is really meaningful, it cannot merely label a new modernist style, but must mark a shift away from such conventional notions of art's purpose and function. An example of this difference is revealed in a comparison of works by the French artist Sophie Calle and the American Bette Gordon, both of whom use their art to address the kind of voyeuristic pleasures Salle describes. Calle's photographs document practices in the tradition of Conceptual Art, including her 1979 The Sleepers (a.k.a. The Big Sleep), in which she invited individuals from the neighbourhood to sleep in her bed while she took pictures, and the 1980 Suite vénitienne, which was published as a book with an enthusiastic commentary by Baudrillard. Here she documented two weeks of her life in which she surreptitiously followed a casual acquaintance as he visited Venice. Though highly susceptible to gendered analysis, neither Calle nor Baudrillard engages these issues. Indeed, in detailing the implications of Calle's project, Baudrillard's text echoes Salle's stance of nihilistic aestheticism:

In comparison with our ideas of liberation, of individual autonomy \dots how much more subtle, more amazing, more discreet and arrogant all at once is the idea \dots

that someone else looks after your life. Someone else anticipates it, accomplishes it, fulfills it. . . . [I]t is certainly no more absurd to envision things this way than to rely on the decisions of a State, of a lottery . . . or of one's own will.

And Baudrillard concludes, discussing Calle's The Sleepers by invoking a traditional figure of aesthetic pleasure: 'Imagine a swooning woman: nothing is more beautiful. . . . '23

Calle's work, including its presentation as a book, is eminently postmodern in the way it challenges modernist beliefs in originality and in the separation of artistic representation from lived reality. Yet, as artist and critic Anne Rochette has observed, Calle is like other contemporary French artists influenced by postmodern theory - and unlike 'similarly influenced art made in Great Britain and the United States' - in that she does not explicitly engage the 'political implications' of postmodernism as they relate to issues of identity.²⁴ In contrast, Bette Gordon's 1984 film, Variety, is rooted in feminist concerns with pornography and the dynamics that gender the very act of looking. Gordon explains:

From a feminist perspective, the pleasure of looking in the cinema has been connected with the centrality of the image of the female figure. This has involved an exploration of the way in which sexual difference is constructed in cinema, the way in which the gaze is split (men look, women are looked at), and the representation of female pleasure.²⁵

Gordon's film creates a narrative in which the female ticket seller at a New York porn theatre begins following a man from the audience, fantasizing about him. The film foregrounds the relations between the porn 'industry' and other capitalist structures that channel our desires, the way our erotic fantasies are structured through the media, and thus the fallacy of claiming a unique personal voice. Finally, the woman contacts the man, explains that she has been following him, and they arrange to meet on a dark, rainy corner that is the film's final scene. When neither of them shows up, the film seems to be suggesting the ultimate impossibility of representing an authentic personal experience. Gordon's denial of the aesthetic satisfaction of conventional narrative closure flies in the face of art that would fuse modernist pleasures with postmodernist stylistic techniques. At the same time, her focus on feminist issues prevents viewers from overlooking these concerns and reminds them that she

speaks from her identity as a woman in a community of feminists, and that she sees her audience in similar terms. Though it resembles Calle's – or even Salle's – work in its engagement of postmodernist ideas about representation and reality, therefore, Gordon's film is very different in its emphasis on identity, both the author's and the viewers'. Gordon's engagement of postmodern and feminist ideas is indicative of developments in postmodern art through the eighties.

It is, of course, dangerous to generalize about a decade that is barely over; a century from now, we will have a much stronger consensus about what became of postmodernism . . . and a century later, a different consensus may prevail. Whatever the eventual consensus(es), however, it is important to recognize that history always reflects the purposes of the recorder - we select stories from the past to make sense of who we are (or aspire to be) today. Writings on recent history make this process especially clear, for they impose a narrative on events that continue to unfold in all their daily complexity, and these acts of narration become themselves documents of the history they seek to chronicle. The story this essay proposes is one of a reconciliation, during the decade of the eighties, between postmodernism and the art of identity that Lippard called for in 1980. As feminist pressure opened greater opportunities for women to exhibit and publish, feminists moved into the postmodernist art world. At the same time, because of the AIDS crisis, gay critics already associated with postmodernism gravitated toward the identity-based activism of the feminist movement. The result was a convergence of postmodernist theory with identity-based art and activism.

Among artists, the merging of feminism and postmodernism is often cited in the works of the New Yorkers, Cindy Sherman and Jenny Holzer, or of the London-based artist Mary Kelly, all of whom rose to prominence in the eighties. The potential as well as the possible pitfalls of this conjunction of forces, however, may be nowhere better exemplified than in the career of another of the decade's best-known artists, Barbara Kruger. At the beginning of the decade, Kruger gained recognition with a series of untitled works that combined generic-looking black and white photographs with provocative texts, accentuated by a trademark red frame. Kruger's professional background as chief graphic designer at Mademoiselle animates the visual dynamic of these images, but their sustained popularity in the art world derived more fundamentally from

their ability to reach two distinct audiences: feminists who identified with their activist tone and the new generation of mainly male postmodernists who were rising to positions of power at journals such as Art in America and October. Both groups claimed Kruger as their own, using strategies of explication and appreciation that ranged from the contradictory to the downright confrontational.

When Art in America ran its first feature on Kruger, its editor, Hal Foster, said her goal was to 'call language into crisis' (the phrase is quoted from an essay by the French theorist, Roland Barthes) by having the image address the viewer as 'you', so that the meaning shifts with each spectator according to a grammatical process analysed by Baudrillard. Foster praised Kruger for refusing old modernist ideas about the purity of aesthetics by blending 'languages of the self, of art, and of social life', but he sought to distance her from viewers who might read the 'we' or 'us' as the authentic voice of the artist or believe 'that power can be named [or] located'. Denouncing such essentialism (a belief that there are essences beyond or apart from their representation), Foster insisted:

power and desire are not fixed things 'out there': they exist, they hide, in representations. This is why Kruger reworks her images - to see who works through them, and to reverse the order of the speaker 'I,' the subject 'you.'

Foster's conclusion, 'the address of each work implicates us all', denies the claims of identity politics by returning to the modernist rhetoric of universality.26 The contradiction between feminist identity and a postmodernism associated with theories of representation, which is implicit in Foster's argument, becomes explicit in the introduction to a 1986 museum catalogue of Kruger's work:

[T]o peg Kruger as a feminist is not to give her work its due. For while many of her images support a narrowly feminist reading, the cumulative effect of her work is to draw our attention to a key social fact of life in media-ridden culture . . .: the showers of semiotic sparks touched off in our consciousness every day by constant exposure to fabricated images.27

Feminists, while they also admired Kruger, rejected an analysis that subordinated their concerns as 'narrow' in comparison to the rather ejaculatory image of semiotic spark showers. Reviewing a London exhibition of Kruger's work, the Woman's Art Journal asserted:

Kruger's address is always gender-defined: the 'I/we' is a woman's voice and the 'you' is directed toward a man who is on the side of power within a patriarchal culture.²⁸

The review quotes from interviews with Kruger about her aim 'to make for a more active spectator in some way', a goal she said was important 'for me, as a woman first and then as an artist'. Citing Hal Foster by name, the *Woman's Art Journal* went on to complain that Kruger's point 'has escaped the consciousness of some (male) viewers. . . . If Foster had understood the gender-address, he would have known that Kruger's address is not ambiguous, but unquestionably feminist.' And again Kruger is quoted:

I'm not interested in any of this complicit subversion trip – an implicit critique – that people talk about. The critique in my work is fairly explicit, you don't have to read three essays by [October editor] Doug Crimp to understand what my work is saying.

Of course, a postmodernist might rejoin that, in spite of such protestations, the catalogues for Kruger's one-woman shows seem invariably to carry the type of essay she here dismisses. Her 1983 London exhibition, for instance, was introduced with an essay by Craig Owens, reprinted in Art in America, which (while taking time to debate Foster's understanding of Baudrillard with concepts from other Continental theories of linguistics) endorsed Foster's view that her work was not gender specific: 'Kruger appears to address me, this body, at this particular point in space'. Writing about the two works illustrated at the end of this book [illustrations 129 and 130], Owens rejects certain interpretations as too literal. 'Can we be entirely certain that this woman is the victim of a male gaze?' he asks about Untitled ('Your gaze hits the side of my face'), while Untitled ('You construct intricate rituals . . .'), he insists, does not allude 'to repressed homosexuality, but rather to the fact that physical contact has itself become a social ceremony'. He concludes, 'Kruger's work, then, engages in neither social commentary nor ideological critique (traditional activities of the politically motivated artist's consciousness-raising). Her art has no moralistic or didactic ambition.'29

If Kruger could appeal simultaneously to two strongly antagonistic audiences, her accomplishment belies the often bitter arguments that separated feminism and postmodernism in the early eighties. Yet by the end of the decade, partisans on both sides of the debate were looking for a middle ground. Lucy Lippard in 1989 explained, 'I fear the 100% sensuous, sentimental anti-intellectualism that is the worst of essentialism, and I fear the 100% academicized intellectualism that is the worst of postmodernism'. Shortly thereafter she called for more interaction between art-world postmodernists and the 'activist art' coming from communities defined by race, ethnicity, class, gender and sexuality: 'We need a body of "criticism" produced by writers, scholars, artists, and activists who "read" each other. For without models and praxis, the loftiest theory hasn't a chance of effectiveness, and vice versa.'31

Exploring potential intersections between the art world and activism, Lippard cited several instances, among them, 'There is no reason . . . why some artists can't be protesting in Saint Patrick's Cathedral while others act up about AIDS in museums'. These examples were drawn from events in the gay community, in particular the massive public demonstrations organized by the AIDS Coalition To Unleash Power, ACT UP. Founded in New York in 1987, ACT UP quickly gained notoriety for its public confrontations with individuals and institutions obstructing the prevention and treatment of AIDS. The Archbishop of New York, who campaigned against preventative AIDS education, became a target of protests, which culminated when ACT UP (in coalition with the feminist Women's Health Action and Mobilization, WHAM!) disrupted his celebration of mass at Saint Patrick's Cathedral in 1989. As with all ACT UP demonstrations, the visual impact of the event was crucial. Posters announcing the action blanketed the city for weeks before and floated above the crowds at the rally. Inside the cathedral, activists held a 'die-in' (where they fell to the floor) and threw condoms into the air. The process of planning and executing the event was documented by ACT UP as a film, Stop the Church, so that it entered the realm of representation in a way that was closely controlled by its creators.

This emphasis on 'visuals' is typical of ACT UP, which drew many members from the New York art world that was being decimated by AIDS. Along with postmodernism, the legacy of Performance Art informed ACT UP's productions, which were reviewed as they occurred by established critics like Douglas Crimp. In 1987, Crimp devoted an issue of *October* to AIDS, forging a high-profile link between this postmodern

journal and political activism. Here and in his subsequent writings, Crimp publicized ACT UP's installations and demonstrations, linking them explicitly to the way 'questions of identity, authorship, and audience – and the ways in which all three are constructed through representation – have been central to post-modernist art, theory, and criticism'. About ACT UP's posters, Crimp writes, 'Assaults on authorship have led to the practice of anonymous and collective production. Assaults on originality have given rise to dictums like "If it works use it" or "If it's not yours steal it".'32

A postmodernist sensibility is very evident in ACT UP's posters, which, like Kruger's work, combine blocky text with scavenged images. Indeed, a well-known ACT UP graphic, I am out therefore I am [illustration 131], appropriates one of Kruger's own appropriated images. This comparison, however, exemplifies the change from the earlier postmodernist fixation on shifting signifiers and linguistic theory. ACT UP's images are a long way from interchangeability of 'I' and 'you', and even further from Craig Owens's proscriptions against the direct enunciation of homosexuality. Whatever ambivalence there may have been in the reference of Kruger's 'I shop therefore I am' [illustration 132] is cancelled in ACT UP's I am out therefore I am, which demands to be read as a forthright articulation of identity, asserted first by the individual carrying the placard or wearing the shirt, but ultimately by what Lippard would call a comm/unity.

Like feminist identity, gay identity was forged as much in anger and despair as in affirmation and aspiration. During the eighties, especially in North America, it was AIDS – or more specifically, society's indifference to an epidemic that first struck gay men – that catalysed gay identity as a newly powerful influence in the art world and in the broader culture. The beginning of the decade saw no gay equivalent to the community of feminist artists and critics like Chicago and Lippard. In 1982, Extended Sensibilities: Homosexual Presence in Contemporary Art, the first major New York exhibition of its kind, found that its rationale met with scepticism, even among some of the featured artists. Keith Haring, whose celebrated graffiti style was to become a staple of AIDS-activist graphics, was quoted in one review as typical in his attitudes: 'Haring accepts his homosexuality but does not see it as his only artistic concern'. Like earlier statements by artists such as Bridget Riley and Helen Frankenthaler, who rejected the label 'woman artist', 4this comment only makes

sense in context as a rejection of an identity that - because of the way stereotyping sustains social hierarchies – is made undesirable because it is seen as totalizing (precluding any other 'artistic concern') in a way that dominant identities, like 'male' or 'American', are not. The AIDS crisis created a climate in which there was more anger, less to lose. By the end of the decade, both Haring and the interviewer who questioned the importance of his gay identity had died, along with tens of thousands of others, mostly gay men and mainly in the cities in which the art world is centred. Especially in England and the United States, official indifference to an emergency in the gay community called forth responses that framed AIDS in the context of gay identity. 35 Today, a wide variety of artists one estimate is five hundred in the United States alone 36 – make AIDS a central issue in their work, but it was the artists' collectives of ACT UP that created the earliest and most visible response to the crisis, and this work, on posters, T-shirts and in art magazines, provided the most visible images of gay identity.

Looking at the decade of the eighties, many commentators have been struck by the way art dealing with AIDS drew from 'feminist-based analysis that considers representations of sexuality within culture' for strategies to effect social change.37 The use of feminist strategies is evident, not only in the forthright address of ACT UP imagery, but also in its emphasis on identity. Just as Judy Chicago, recognizing that identity is rooted in a notion of shared history, used her Dinner Party to embody women's history, so too ACT UP imagery asserts and celebrates a gay history at the same time that it addresses issues about AIDS. The pictures for ACT UP's Read My Lips campaign [illustration 133], for instance, were drawn from archival photos documenting lesbian characters on Broadway in the twenties and gay bars for servicemen during World War II. More subtly, the iconography of targets, flags and faded cityscapes in ACT UP posters recalls the art of Jasper Johns and Robert Rauschenberg to assert the legacy of gay art history. Similarly, Andy Warhol's colourful photo-portraits echo strongly behind ACT UP's acid-green Ronald Reagan with pink eyes in the 'AIDSGATE' poster. In a direct quotation of a gay artist's most famous work, ACT UP turned Robert Indiana's Pop invocation LOVE into another call: 'RIOT' [illustration 136].38 Eventually, well-known gay artists like Keith Haring began to create directly for ACT UP and other anti-AIDS campaigns, while ACT UP artists like Adam Rolston marketed their related work through established galleries. At the same time, artists' collectives like Group Material and General Idea put AIDS-related installations in museums and galleries around Europe and America, often drawing on the techniques of Dada and Pop art, which brought non-art objects into uneasy juxtaposition with each other and their art context, but now with a much clearer didactic intent. Where, at the opening of the eighties, the art world espoused a postmodernism defined in opposition to the identity-based practices associated with feminism, by the end of the decade, the development and articulation of identity was central to this kind of postmodern artistic practice.

The re-orientation of postmodernism could not have happened without a critique of postmodern theory. As critic James Meyer explained, '[T]he epidemic has caused us to question the post-modernist leitmotiv of an unknowable spectacle. . . . AIDS (an epidemic, a movement, a friend's death) does not sustain one's belief in an account of the social-as-text, a free-for-all of floating simulacra.'³⁹ Indeed, the eighties saw postmodernism reassessed by the critics associated with the theory of its early phase. By 1985, Hal Foster, recognizing the nihilistic danger in Baudrillard's ideas, suggested that deconstructive art had itself become 'a convention in need of critique', and began advocating for the art of 'counterhegemonic (feminist, third world, gay . . .) social movements' and minority cultures. When he revised and republished his 1982 essay on Kruger, its title was all that remained the same: a lengthy preface on political artists and the acknowledgment of the feminist implications of her work marked the critic's new interest in the art of identity.⁴⁰

Where Foster's shifting emphasis went unacknowledged in his text, articles by Craig Owens and Douglas Crimp drew attention to their changing priorities over the course of the eighties. Owens began his 1983 'The Discourse of Others' by upbraiding himself for what he called 'gross critical negligence' in his blindness to feminism, an oversight, he argued, that 'indicate[s] a blind spot in our discussions of postmodernism in general: our failure to address the issue of sexual difference – not only in the objects we discuss, but in our own enunciation as well'. In both its message and its reception, this essay is paradigmatic of the philosophical shifts taking place in the eighties. Today it is among the most often anthologized essays for college textbooks.⁴¹ At its 1983 publication in an

anthology on postmodernism, however, feminists privately noted Owens's position as a spokes man for feminism as symptomatic of the new avant-garde's perpetuation of masculine authority. Indeed, despite Owens's argument for attention to 'sexual difference' in 'our own enunciation', his position as a man – and as a gay man, in particular – remains unaddressed and is, indeed, undermined by the conclusion of the essay, which accepts that 'the address of Kruger's work is always genderspecific' but argues that her texts 'demonstrate that masculine and feminine themselves are not stable identities, but subject to ex-change'.

By 1987, Owens had taken the step he himself called for in 1983. In 'Outlaws: Gay Men in Feminism', which he acknowledges was provoked by feminist criticism of his earlier piece, Owens is explicit about his own gay identity, and he praises feminists who see the link between homophobia and misogyny as twin forms of social control. In addition to its frankly gay voice, 'Outlaws' evidences a second shift in Owens's writing, for he draws upon a new theoretical foundation. Semiotics and the delicious slipperiness of signifiers have given way to history and anthropology (in citations of Michel Foucault and Claude Lévi-Strauss) along with frankly political analyses of Nazi Germany and the American Supreme Court. Far from concluding, as he did about Barbara Kruger in 1983, in praise of an art that 'engages in neither social commentary nor ideological critique', Owens ends his 1987 piece with a call for gay men and feminists to band together to make resistance to homophobia 'a central concern of any Left political coalition'.

Nowhere is the importance of this issue for society at large more apparent than in the government's and media's scapegoating of homosexual men for the AIDS pandemic - a homophobic tactic which is as threatening as the disease itself to the welfare of the entire population. 42

Within two years, Owens himself had succumbed to AIDS.

Like Owens, by the end of the eighties Douglas Crimp had also publicly reassessed his own criticism, and with it what he calls 'postmodernist theory'. Looking at his earlier treatment of two artists who deal with gender, Crimp recounted how in 1983 he had celebrated Sherrie Levine's postmodernist appropriation of canonic modernist images. Levine simply rephotographed one of Edward Weston's celebrated photographic studies of his son, presenting it as Untitled (After Edward Weston), in a

challenge to modernist conventions of authorship, originality and indeed art itself. In contrast, Crimp had considered Robert Mapplethorpe whose 'old fashioned modernist appropriation', he believed, simply borrowed modernist conventions of art photography to make highly marketable objects. Looking back at the eighties from a 1990 perspective, however, Crimp found that controversies over AIDS-related imagery and public funding for the arts cast his comparison of Levine and Mapplethorpe in a new light. What he missed, he suggests, was the way both types of images were the same: both present the male body as sexual, raising the possibility of a homoerotic gaze. Measured by the recent actions of the academic and political establishment, Crimp says, even this suggestion of gay identity is more challenging than the 'parochial' issues of authenticity and appropriation are ever likely to be. What we have had to learn recently, not from but in spite of postmodernism, he says, is 'the dangerous, even murderous, ways in which homophobia . . . structures every aspect of our culture'. He concludes: 'What must be done now - if only as a way to begin rectifying our oversight - is to name homophobia'.43

This urge to name - to name an identity and the mechanism of oppression that structures it - may be what is most characteristic of postmodernism at the end of the eighties. No longer the modernism that sublimated social concerns in a rhetoric of spiritual abstraction, neither is it the equally abstract play of social signifiers that was celebrated by the postmodernists ten years earlier. One logical outcome of the move away from abstraction and toward specificity is autobiography, which became an important vehicle for artists dealing with issues of identity as the eighties gave way to the nineties. Jack Pierson, Lyle Ashton Harris and best known - David Wojnarowicz combined personal and mass-media imagery in their autobiographical paintings and gallery installations. Their work accepts the postmodern supposition that individual subjectivity is created through social signs and symbols, but, far from defaulting to an impersonal universality, it emphasizes the specificity of the artist's position at the intersection of gay identity with identities based on race and class. Like the feminist autobiographical art Lippard cited as characterizing the seventies, this work, although it is personal, is not solipsistic. The focus on identity renders the individual exemplary of a community. Wojnarowicz's bleak images, often including furious political commentary, were cemented in the American public consciousness as expressions of gay identity when they were made the focus of highly publicized attacks by right-wing religious and political spokesmen, who objected to the exhibition of his work in tax-supported settings. ⁴⁴ Similar attacks on Robert Mapplethorpe altered the perception of this photographer from, as Crimp's comments indicate, a master of formal technique to an emblem of gay identity.

While AIDS - which ultimately claimed the lives of both Mapplethorpe and Wojnarowicz - brought a new urgency to issues of gay identity in the art world, the late eighties also saw a resurgence of explicitly feminist work, now inflected with postmodernist principles. Postmodernist language play is evident in the name of the Guerrilla Girls - a collective whose acerbic posters documenting racism and sexism in the art world began appearing on New York streets in 1985 and soon spread to other American cities - the women involved preserve their anonymity by wearing gorilla masks at public appearances. 45 Perhaps the best example of art at the intersection of feminist community, sexual identity, postmodernist deconstruction of meaning and the censorship controversies that together characterize the art world at the turn of the nineties is the work of another collective: Kiss & Tell, from Vancouver. Their installation, Drawing the Line [illustration 138], which toured Canada. the United States and Australia, presents, in their words, '100 photographs of lesbian sexuality, arranged from less to more controversial'.46 Visitors are given pens and asked to record their comments (images or words) - women on the walls around the photographs, and men in a book at a central gallery space. The meanings of the images, then, evolve through the course of each exhibition, especially as the scrawls winding around the pictures multiply, with women often developing or refuting each other's comments.

Neither a throwback to the feminist art of the seventies nor the deconstructive spectacle of early postmodernism, works like these exemplify the convergence of these two trends over the course of the eighties. Lucy Lippard's word, 'comm/unity', might be the verbal emblem of this art, for it combines the kind of deconstructive linguistics that dismantle a term to reveal its meaning with an assertion of collective identity. In this development of an art of identity, both feminism and AIDS activism have been profoundly influential, grounding postmodern

theory in social practice and inspiring a new generation to participate in and care about art.

1993

Notes and Sources

- Norman K. Denzin, 'Post-modern Social Theory', Sociological Theory, Vol. 4, No. 2, Fall 1986, pp. 194–204.
- 2. Charles Jencks, *The Language of Post-Modern Architecture*, London, 1977, cited in Bruce D. Kurtz, *Contemporary Art 1965–1990*, Englewood Cliffs, 1992, p. 190; Corinne Robins, *The Pluralist Era: American Art, 1968–1981*, New York, 1984, p. 1.
 - 3. Charles Jencks, letter, Times Literary Supplement, 12 March 1993.
- 4. Jean Baudrillard, *Simulations*, trans. Paul Foss, Paul Patton and Philip Beitchman, New York, 1983.
- 5. Eleanor Heartney, 'David Salle: Impersonal Effects', Art in America, June 1988, p. 121.
- 6. Thomas Lawson, 'Last Exit: Painting', *Artforum*, Vol. 20, No. 2, October 1981, pp. 40–7.
- 7. Mark Stevens, 'A Painter's Pratfall', *Newsweek*, 16 November 1987, p. 119; Robert Hughes, 'Expressionist Bric-a-Brac', *Time*, 1 November 1982, p. 71.
- 8. Robert Hughes, 'Random Bits from the Image Haze', *Time*, 9 February 1987, pp. 68-9.
- 9. Andreas Huyssen, 'Mapping the Post-Modern', New German Critique, No. 33, Fall 1984, reprinted in After the Great Divide: Modernism, Mass Culture, Post-Modernism, Bloomington, 1986, pp. 178–221.
- 10. Jackie Brookner (ed.), Art and Ecology, special issue of Art Journal, Summer 1992.
- 11. Howardena Pindell, 'Art World Racism: A Documentation', New Art Examiner, March 1989, pp. 32–4; Patricia Failing, 'Black Artists Today: A Case of Exclusion', ART News, March 1989, pp. 124–31.
- 12. I would argue that the artists of colour who achieve the most art world recognition Betye Saar, Faith Ringgold, Jaune Quick-to-See Smith, for example, or film-makers Marlon Riggs and Isaac Julien gain access to magazines, galleries, grants and audiences through their overlapping identity as feminist or gay. Prominent examples of feminist and gay 'sponsorship' of artists of colour into visibility by the art world include Harmony Hammond's co-curatorship with Jaune Quick-to-See Smith of Women of Sweetgrass, Cedar and Sage, Gallery of the American Indian Community House, New York, 1985; Lucy

- Lippard's Mixed Blessings: New Art in a Multicultural America, New York, 1990; and Thomas Sokolowski's initiation of Interrogating Identity, Grey Art Gallery and Study Center, New York, 1991.
- 13. Surveys of women's artistic production through history include Griselda Pollock and Rozsika Parker, Old Mistresses: Women, Art and Ideology, London, 1981; and Whitney Chadwick, Women, Art and Society, London, 1990. For surveys of homosexuality in the arts, see James Saslow, 'Closets in the Museum: Homophobia and Art History', in Karla Jay and Allen Young (eds), Lavender Culture, New York, 1978, pp. 215-27; and Emmanuel Cooper, The Sexual Perspective: Homosexuality and Art in the Last One Hundred Years in the West, London, 1986. An excellent in-depth study of homosexuality in Renaissance art is Saslow's Ganymede in the Renaissance: Homosexuality in Art and Society, New Haven, 1986.
- 14. A concrete example is seen in the rules of the Abstract Expressionists' 'Artists Club', the founding constitution of which excluded dealers, critics, women and homosexuals from participation. See Ann Eden Gibson, $Abstract\ Expression$ ism, Race, and Gender, New Haven, 1994.
- 15. Hilton Kramer, Revenge of the Philistines: Art and Culture, 1972–1984, New York, 1985.
- 16. Griselda Pollock, 'Feminism and Modernism', in Rozsika Parker and Griselda Pollock (eds), Framing Feminism: Art and the Women's Movement, 1970-1985, London, 1987, pp. 79-122. For a recent critique ranging beyond the art world, see Somer Brodribb, Nothing Mat(t)ers: A Feminist Critique of Post-Modernism, North Melbourne (Australia), 1992.
- 17. Julian Schnabel, 'The Patients and the Doctors', Artforum, February 1984, pp. 54-8. See also Mary Lee Corlett, 'Jackson Pollock: American Culture, the Media and the Myth', Rutgers Art Review, 8, 1987, pp. 71-106.
- 18. Lucy Lippard, 'Sweeping Exchanges: The Contribution of Feminism to the Art of the 1970s', Art Journal, Fall/Winter 1980, reprinted in Get the Message: A Decade of Art for Social Change, New York, 1984, pp. 149-58. Although Pollock's essay is phrased as a critique of Lippard, it follows substantially from Lippard's points, suggesting that feminists are themselves sometimes susceptible to the claims for authoritative originality that they attribute to modernism.
- 19. Judy Chicago, Through the Flower: My Struggle as a Woman Artist, Garden City, N.Y., 1977; The Dinner Party: A Symbol of Our Heritage, Garden City, 1979; Embroidering Our Heritage: The Dinner Party Needlework, Garden City, 1980; The Birth Project, Garden City, 1985.
- 20. David Salle, 1981, interview by Peter Schjeldahl, in Jeanne Siegel (ed.), Art Words 2: Discourse on the Early 80s, Ann Arbor, 1988, reprinted as Art Talk: The Early 80s, New York, p. 171.

- 21. Carol Zemel, 'Postmodern Pictures of Erotic Fantasy and Social Space', Genders, 4, Spring 1989, pp. 27 and 31–2. For a similar critique, see Robert Storr, 'Salle's Gender Machine', Art in America, June 1988, pp. 24–5.
 - 22. Salle, interviewed by Schjeldahl, p. 172.
- 23. Sophie Calle, *Suite vénitienne*, and Jean Baudrillard, 'Please Follow Me' (published as one volume), Seattle, 1988, pp. 82 and 86 [final ellipsis of block quote in original].
- 24. Anne Rochette, 'The Post-Beaubourg Generation', Art in America, June 1987, pp. 41–9.
- 25. Bette Gordon, 'Variety: The Pleasure in Looking', in Carole S. Vance (ed.), Pleasure and Danger: Exploring Female Sexuality, London, 1984, pp. 189–203. For the theoretical background for these ideas, see Laura Mulvey, 'Visual Pleasure and Narrative Cinema', 1975, in Visual and Other Pleasures, Bloomington, Indiana, 1989, pp. 14–26.
 - 26. Hal Foster, 'Subversive Signs', Art in America, November 1982, pp. 88-92.
- 27. Kenneth Baker, 'The Art of Barbara Kruger', in *Slices of Life: The Art of Barbara Kruger*, Krannert Art Museum, University of Illinois at Urbana-Champaign, 1986, pp. 3–5.
- 28. Masako Kamimura, 'Barbara Kruger: Art of Representation', Woman's Art Journal, Spring/Summer 1987, pp. 40–3. Kamimura here acknowledges as an 'exception' the Kruger piece 'You are not yourself'.
- 29. Craig Owens, catalogue essay in Barbara Kruger: "We Won't Play Nature to Your Culture", Institute of Contemporary Arts, London, 1983, revised as "The Medusa Effect or, The Specular Ruse", Art in America, January 1984, pp. 97–105. This is also reprinted in Beyond Recognition Representation, Power, and Culture, Berkeley, Los Angeles, Oxford, 1992, pp. 191–200.
- 30. Lucy Lippard, 'Both Sides Now [A Reprise]', *Heresies*, 24, Fall 1989, pp. 29–34.
- 31. Lucy Lippard, 'Hanging Onto Baby, Heating Up the Bathwater', 1988, revised and reprinted in Craig Little and Mark O'Brian (eds), *Reimaging America:* The Arts of Social Change, Philadelphia, 1990, pp. 227–34.
- 32. Douglas Crimp and Adam Rolston, AIDS Demo Graphics, Seattle, 1990, p. 18. Douglas Crimp, 'The Boys in My Bedroom', Art in America, February 1990, pp. 47–9. See also 'AIDS: Cultural Analysis, Cultural Activism', October, 43, Winter 1987.
- 33. Nicolas Moufarrege, 'Lavender: On Homosexuality and Art', Arts, October 1982, p. 84. See also Daniel J. Cameron, Extended Sensibilities: Homosexual Presence in Contemporary Art, New Museum, New York, 1982; Gladys Ostermann, 'Panel Reviews Recent Issues and Perspectives: Homosexual Sensibilities', Women Artists News, Vol. 8, No. 3, Spring 1983, pp. 6–9.

- 34. Cindy Nemser, Art Talk: Conversations with Twelve Women Artists, New York, 1975, p. 4.
- 35. Simon Watney, Policing Desire: Pornography, AIDS and the Media, London, 1987.
- 36. Robert Atkins in conversation with Thomas Sokolowski, From Media to Metaphor: Art About AIDS, Independent Curators Inc., New York, 1992, p. 18. An earlier important exhibition of AIDS related work is Witnesses: Against Our Vanishing, Artists Space, New York, 1989.
- 37. Joyce Fernandes. 'Sex into Sexuality: A Feminist Agenda for the '90s'. Art Journal, Summer 1991, pp. 35-8.
- 38. Illustrations of ACT UP graphics may be found in Crimp and Rolston. AIDS Demo Graphics, cited above (note 32).
 - 39. James Meyer, 'AIDS and Post-Modernism', Arts, April 1992, pp. 62-8.
- 40. Hal Foster, Recodings: Art, Spectacle, Cultural Politics, Port Townsend, Washington, 1985, pp. 99-115, 146, 154-5, 170, 176-7, ellipses in original.
- 41. Craig Owens, 'The Discourse of Others: Feminists and Postmodernism', in Hal Foster (ed.), The Anti-Aesthetic: Essays in Post-Modern Culture, Port Townsend, Washington, 1983, pp. 57-82; reprinted in Norma Broude and Mary Garrard (eds), The Expanding Discourse: Feminism and Art History, New York, 1992, pp. 487-502; Howard Risatti (ed.), Postmodern Perspectives: Issues in Contemporary Art, Englewood Cliffs, 1990, pp. 186-207; Stephen David Ross (ed.), Art and its Significance, 2nd ed., Albany, 1987, pp. 584-91; as well as in Beyond Recognition, cited above (note 29), pp. 166-90.
- 42. Craig Owens, 'Outlaws: Gay Men in Feminism', in Alice Jardine and Paul Smith (eds), Men in Feminism, New York, 1987, pp. 219-32; reprinted in Beyond Recognition, cited above (note 29), pp. 218–35.
- 43. Crimp, 'Boys', cited above (note 32). Compare his 'Appropriating Appropriation', catalogue essay for Image Scavengers: Photography, Institute of Contemporary Art, Philadelphia, 1983.
- 44. Steven C. Dubin, Arresting Images: Impolitic Art and Uncivil Actions, New York, 1992, pp. 208-19. For an overview of David Wojnarowicz's work, see Larry Blinderman (ed.), Tongues of Flame, University Galleries, Illinois State University, 1990.
 - 45. Amy Harrison, Guerrillas in our Midst, documentary film, 1992.
- 46. Kiss & Tell (Susan Stewart, Persimmon Blackbridge and Lizard Jones), Drawing the Line: Lesbian Sexual Politics on the Wall, Vancouver, 1991, n.p.

The Plates

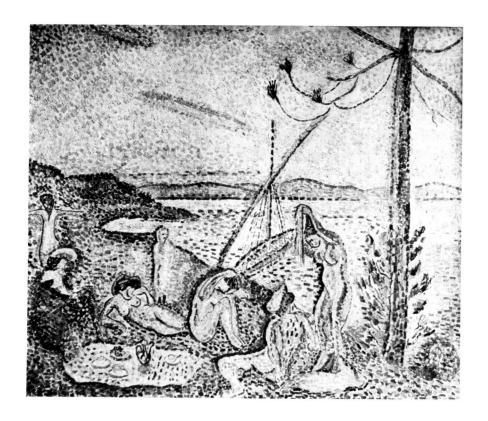

TE CALON D'AUTOMNE

On nous a dit ; « Pourquoi L'Illustration, qui consucre chaque année aux traditionnels Salons du printemps tout un numéro, affecta-elle d'ignore le jeune Salon d'autonne! Vos lecteurs de province el de l'itemper, exilés loin du Grand Palais, servient heureux d'avoir au moins une siéte de cos ourres de maîtres peu commus, que les journaux les plus errieux contres de maîtres peu commus, que les journaux les plus errieux.

Nous resistant a cer visuoni, such consumera è una propergraphici da la compania de la compania de la compositione de la compania de la compania de la composicione 2 mais en pourre da moise juger le dossia de su conspoiente de la compania de la compania de la compositione de la compania de la compania de la compositione de la compania de la compania de la compania de porte mobiles, el moss mosa estruccione dervirie sete unabrell, de la remunique consensada que el compania del del la compania del compania del compania del compania del la compania del compania

CHARLES CUERIN. — Balgneuses.

Date le clan des leunes, Guérin est un des premiers qui se accient frayé un otre receve. Les transcriptions de la forme étraines qui constituent premiers principal cinc cel de tiete particulier qu'elles sons à la fois familières, extrémement réalistes, es pourant afte vilgarité. Elles se relivent d'un insensate de seriment puis dans une tée forme meure, les stylian.

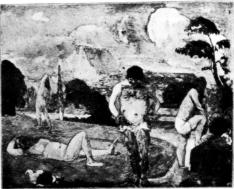

DALIS CETANNIE Les Baimeurs

Plus Cézame donne une sensation d'harmonie, de gravisé. La nature est, chez Cézame, solennelle et éternelle... Je ne puis n'empétibre de voir en singulier et et simple artaite une des plus beiles incurnations de l'art de pelodre... l'ai devant ces quyres sa pures la sensation de me trouves est de l'art de pelodre... l'ai devant ces quyres est pures la sensation de me trouves est pelodre...

Cétanne : le public va-t-il comprendre enfin ce language rude et havi qu'on ne parle guère à ses orellies ?... Il est temps que s'impose l'àpre grandeur de cette œuvre inequie, mois toujount écouvante... Les Buigneurs michelangeapes, sons un ciel obscur d'été craiques...

HENRI ROUSSEAU.— Le lion, ayant faim, se jette sur l'antilope.

Ancies deussier en estralte, M. Henri Roussea, asquet les Salons des Intérectants frest site autreurs
pour sa indient méralielle et la quicheir non appriur, a thé actuellé avec un pieux respet su Salon d'autreurs
us lutile reproduite les accupe une place d'Annesse.

C'est une miniature persane agrandie, transformée en un énorme décor, tou dépourvu d'ailleurs de méri-Tiennauxy-Sission, le Temps.

M. Rouseau a la mentalité réglée des monaistes hyranties, des tapissiers de Bayeux : S'est démonair non sa technique ne soit pais égale à sa candeux. Sa fresque n'est pas du sour indifférente : se conside que l'autriloge du penier plas visonne à tort d'un muieau de brochet ; mais le solell rouse es l'inverse un serson cartini les festilages démolgancs d'une rare ingéniciers décorative.

Louis Varionne Ba, Gil Stat.

ALCIDE LE BEAU. -- Le long du lac (Bois de Boulogne)

Il est tout un groupe qui continue le mouvement impressionniste avec talent, mais sons asses charger : forme générale et l'aspect particulier des choses délà vus par des pentres stel que Monet et Sister. Ainzi MM. Mainta...... Ainde Le Beau iqui, foi, résiène, cette fois, avec Van Coght. Ils savent pendre et ils exposent debelles toties : on peur que leur demander de décourdr le nature pour leur constit.

Il a stargi puissamment sa manière, rejette les détails superfils; sa vision du Bris de Boultgee, les lois inupuest les cycnet cutes sont d'une cruleur qui sécule inferieure l'especie de M. Le Beau est un des plus formants de Soles.

I.E., VUILLARD. - Panneau décoratif.

Un des plus beaux peintres que ces dernières années nous ajent révéles; ses harmonies sont une perpénoile lets pour le regard.

Austès Annessena, le Figure.

Ger pa vauges sont reposants ces intérieurs silencieux et quiets, propions infinitions à l'échée, aux doors réverses. Person Entoines copient et suffié net reverse les montements alons de ses fauturel, et transverférence. Person duite de la monte de la confidence de la confidence de la monte del monte de la monte de la monte del monte de la monte de la monte de la monte de la monte

HENRI MANGUIN. - La Sieste

M. Manguin : progrès énorme : fotépendant sorts des pochades et qui marche résolument vers le grand tableau. Trop de relents de Géranne enouve, mais la grifte d'une possante personnalité, toutéfois. De quelle homière est baignée cette femore à demine sui somentille sur un canadi forier?

Large Managers and William

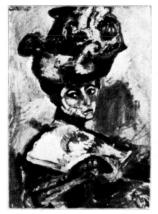

HENRI MATISSE - Femme au chapeau

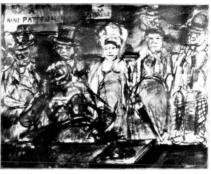

RGES ROUAULT. - Forams, Cabonins, Prires.

If let représent les par use sers élevaire le revise des l'interpe l'accert et à rélutiere le destinant amméres. Ri usur l' l'estific s'un eattre et le sersin sobre de voir la le serside d'une peticle d'éthantissement par de stablisse, avoir les de sersions définite maissement. L'interprése de carbon de la recherche de filles, finalité, austiton, par les M. Roualit éclare, mieux que l'un paste, sa lontere de carbon tribe à la recherche de filles, finalité, austiton, parties et

M. Rouault. âme de réveur catholique et misogyne

ANDRÉ DERAIN. -- Le séghage des voiles.

M. Devain effactorithera... Je le crois plus attritiste que petinte. Le cartil pris de son insegerfe virsientes, la juxtapo action facile des complémentaires sembléront à certain d'us act velocities puero. Recontamiens orgendant que se hatesiax decorresiont heurossement le mus d'une chamtire d'enfant. Louis Vauxonias. (d' Blus.

LOUIS VALTAT. - Marine

A note econe: ... Valtat et ses puissants bierón de eses sus akrupites fallases. ... Trassant réference, le Zourr. M. Louis Valtat montre une visie dicissance pous es questies noches propies ou visiantes, estin. Les brunes, et la menblese rélaire en sasonables.

GUSTAVE DEFFROY, & Joy

.....

M. Mitisse est Fan des plus rebustement doute de reincres d'au-soud bui. Il aussit pu obteur de Saclies braves il préfére s'enfoncer, errer en des recherches pussionnes dérondes au pointillaise plus de vibrations, de luminopre Mus le sousei de ja forme acuffe.

M. Henri Matriue, vi bien douë, s'est egaré comme d'autors

de contra mativa», se bien dové, s'est égair comme d'autres n'immittactes exponers, dont à reviendre de Bouwerse, value exclusifiés te

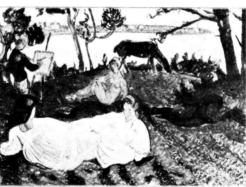

JEAN PUY - Flänerie sous les pins

M. Part de qui se ca an bard se la monercipie estado estado de Secreta de derebente que describo de polo que sa como de como de polo que sa como de como de polo que se se como de como de polo que se como de como de como de polo que se como de como de como de polo que se como de como de

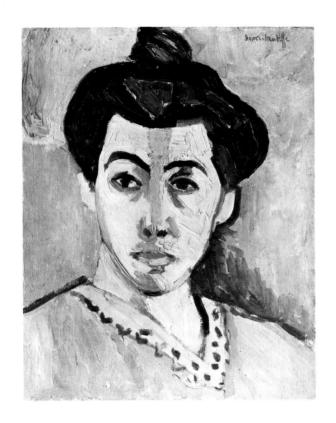

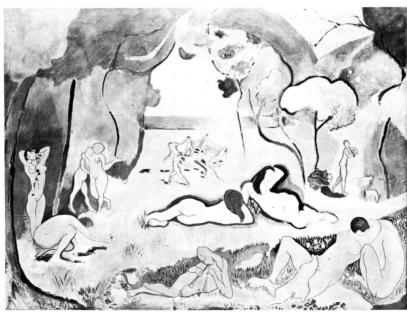

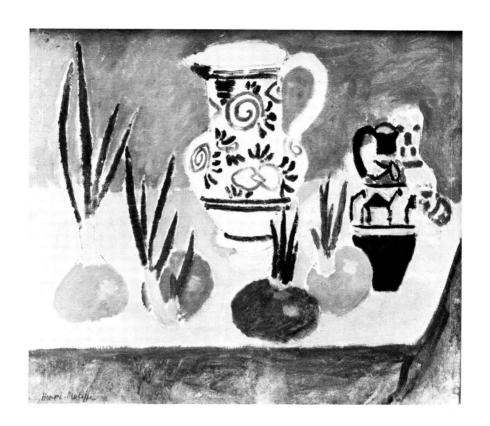

- 3. (above left) Matisse, Henri Portrait of Madame Matisse, 1906
- 4. (left) Matisse, Henri Joie de Vivre, 1906
- 5. (above) Matisse, Henri Still Life with Pink Onions, 1906

- 6. (below) Derain, André, Women in front of Fireplace, c. 1905
- 7. (right) Derain, André The Dance, c. 1905–6
- 8. (below right) Vlaminck, Maurice Landscape with Red Trees, 1906

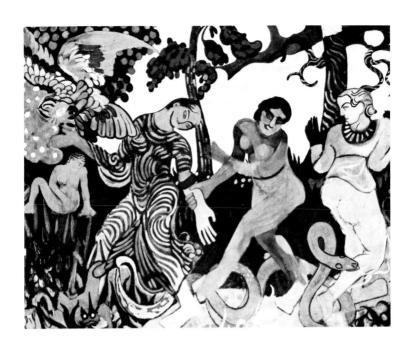

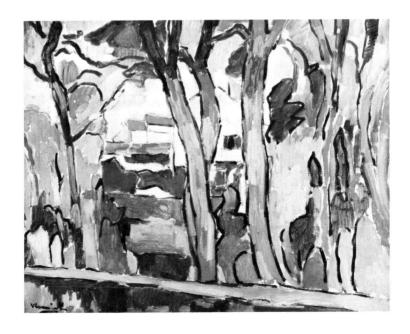

EXPRESSIONISM

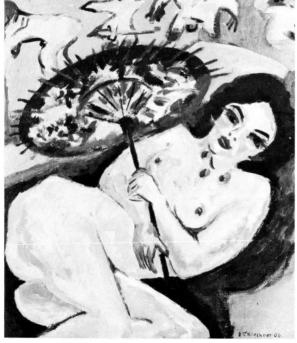

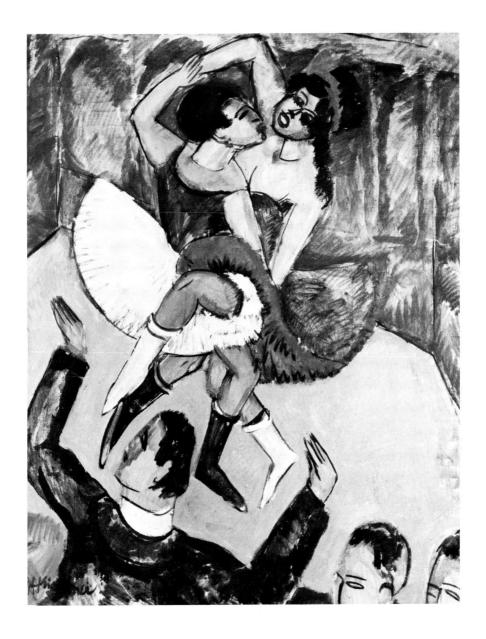

9. (above left) Kandinsky, Wassily Improvisation No. 23, 1911

10. (left) Kirchner, Ernst Ludwig Girl under Japanese Umbrella, c. 1909

11. (above) Kirchner, Ernst Ludwig Negro Dance (Negertanz), c. 1911

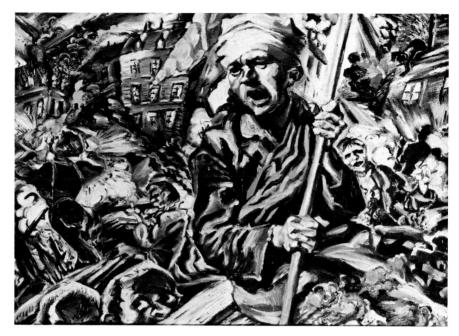

12. Meidner, Ludwig Revolution, c. 1913

13. Beckmann, Max Family Picture, 1920

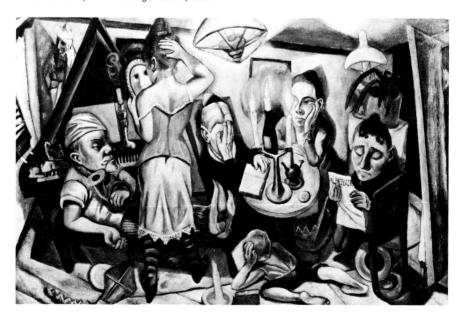

14. (right) Mendelsohn, Erich Sketch for Einstein Tower, 1920–21

15. (centre) Nolde, Emil Jestri, 1917

16. (below) Lehmbruck, Wilhelm $Fallen\ Man,\ 1915–16$

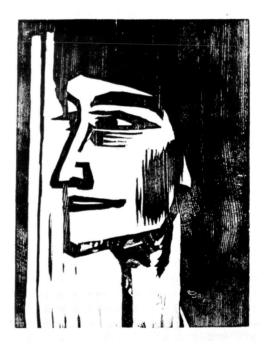

CUBISM

17. Picasso, Pablo Les Demoiselles d'Avignon, 1907

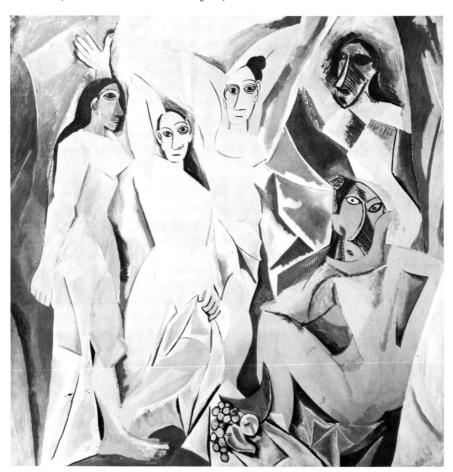

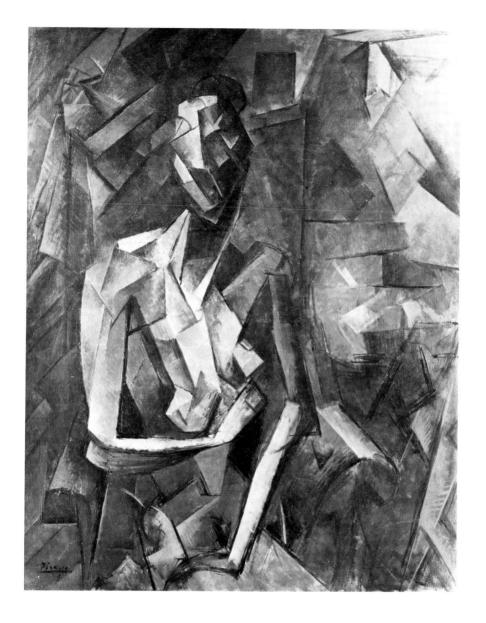

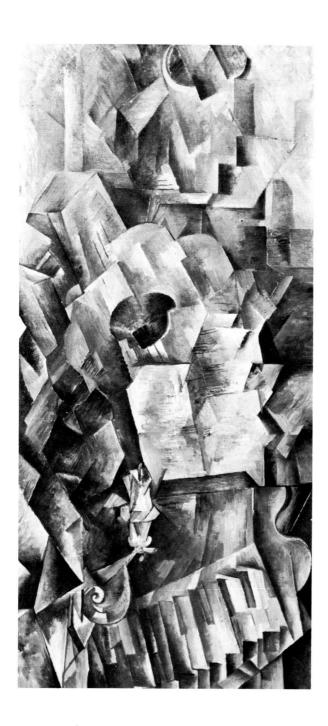

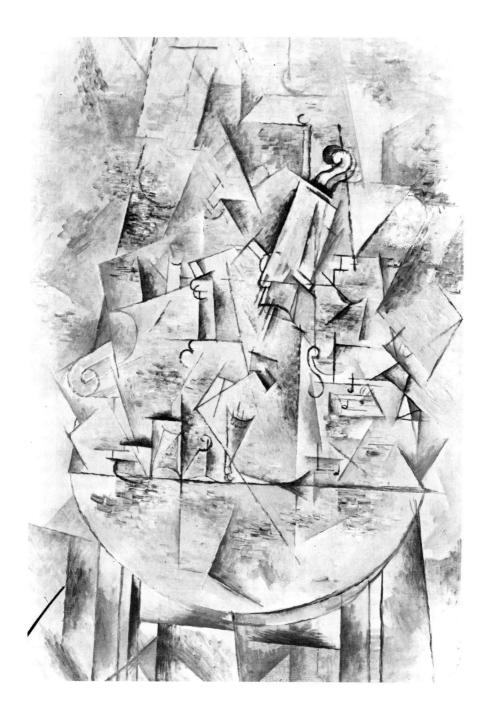

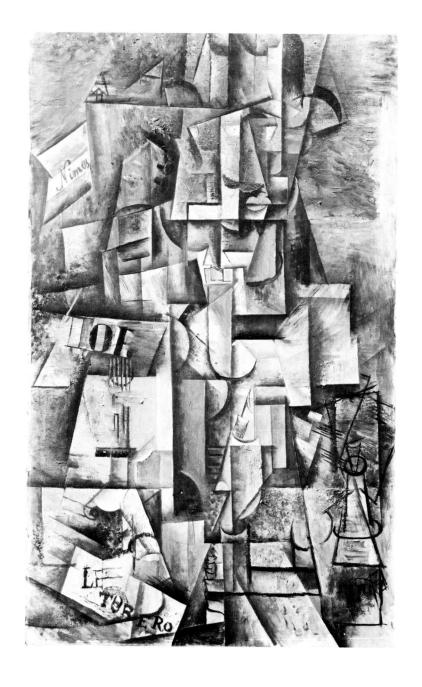

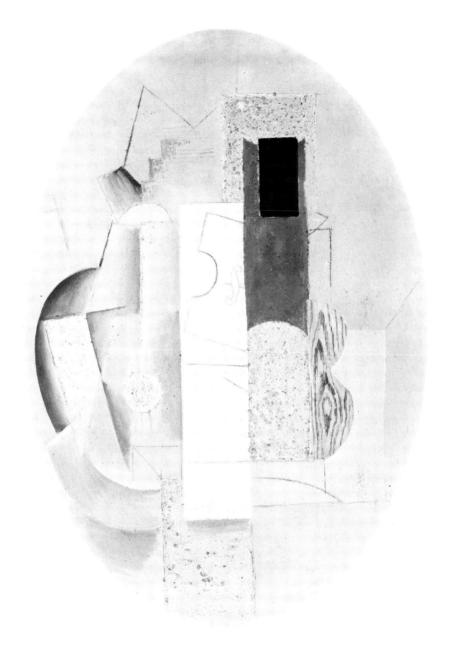

22. Picasso, Pablo Violin and Guitar, 1913

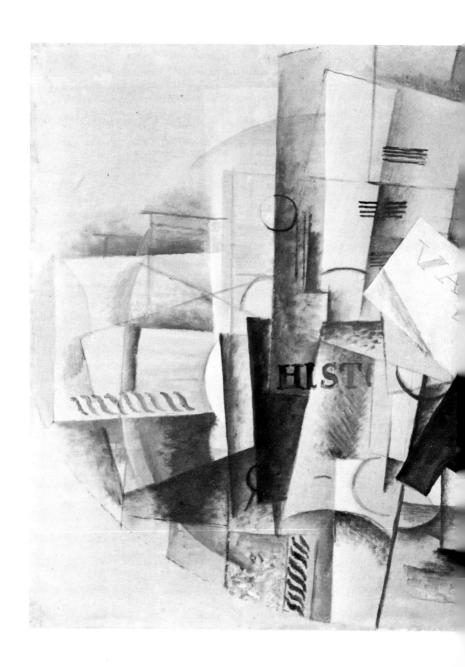

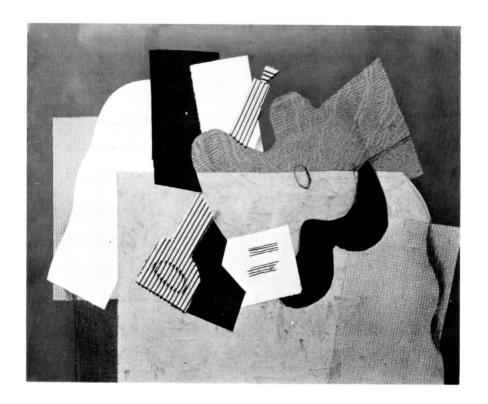

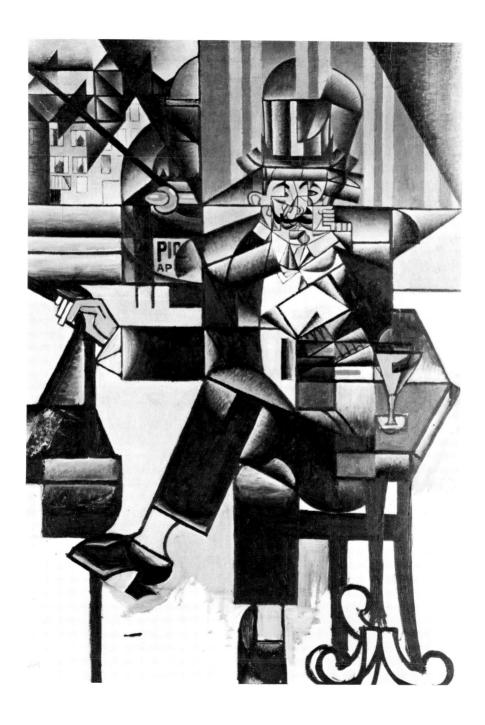

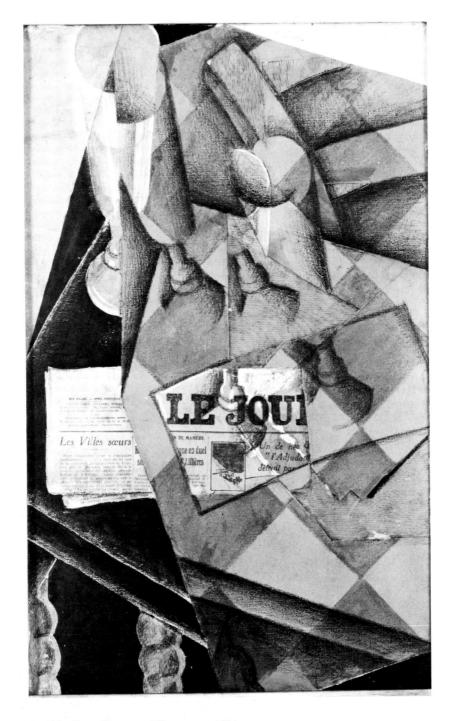

27. Gris, Juan Glasses and Newspaper, 1914

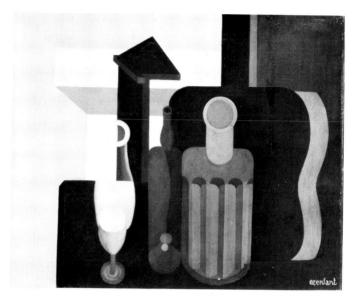

28. Ozenfant, Amedée ${\it Flacon, guitare, verre et bouteilles, 1920}$

ORPHISM

- 30. Delaunay, Robert The City of Paris, 1912
- 31. Delaunay, Robert Simultaneous Windows, 1912
- 32. Delaunay, Robert Sun, Moon. Simultaneous No. 2, 1913

33. Kupka, Frank Discs of Newton, 1911–12

34. Kupka, Frank Amorpha, Fugue in Two Colours, 1912

35. Picabia, Francis Dances at the Spring II, 1912

36. Picabia, Francis Udnie, American Girl (Dance), 1913

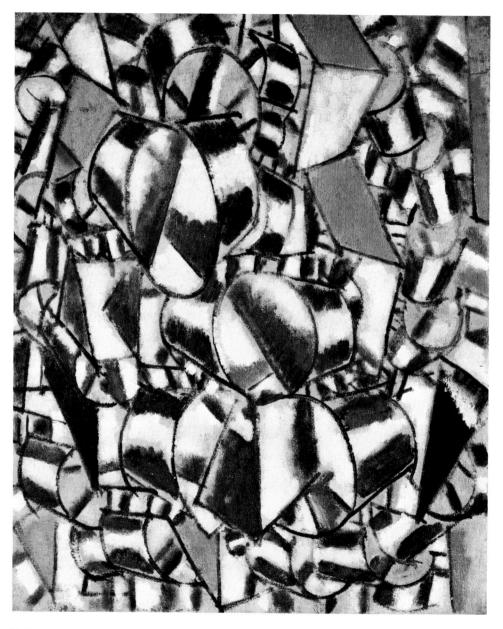

37. Léger, Fernand ${\it Contrast}$ of ${\it Forms},\,1913$

FUTURISM

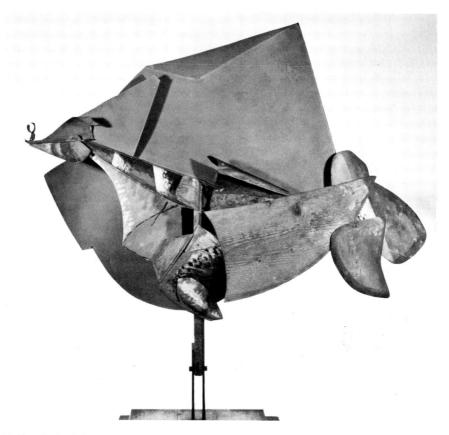

38. Boccioni, Umberto Dynamic Construction of a Gallop Horse and House, 1914

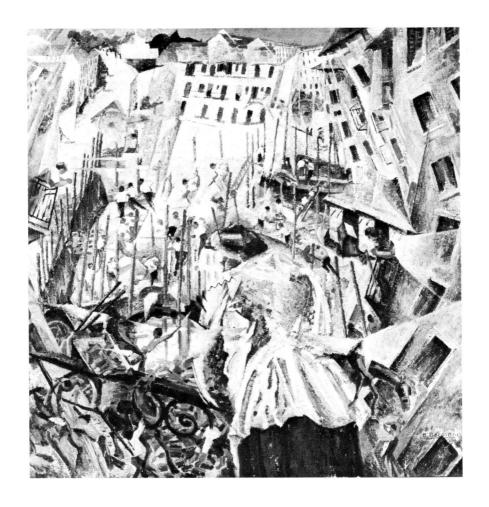

39. (above) Boccioni, Umberto $\it The\ Street\ Enters\ the\ House,\ 1911$

40. (above right) Carra, Carlo Funeral of the Anarchist Galli, 1911

41. (right) Severini, Gino Dancer-Helix-Sea, 1915

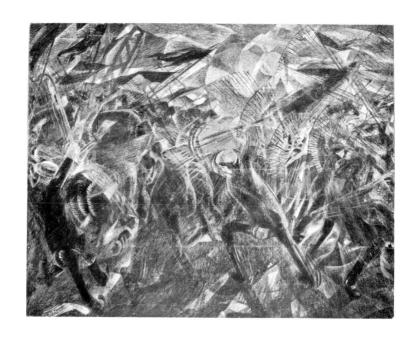

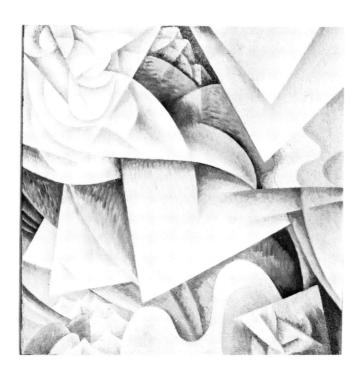

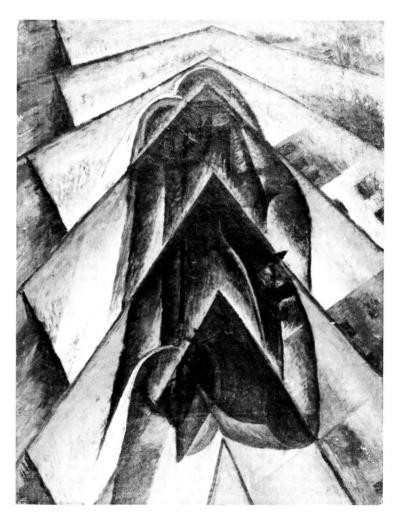

 ${\bf 43.} \ {\bf Russolo, \ Luigi} \ {\it Dynamism \ of \ an \ Automobile, \ 1911}$

- 44. (below) Boccioni, Umberto States of Mind No. 1: The Farewells, 1911
- 45. (right) Balla, Giacomo The Street Light, 1909

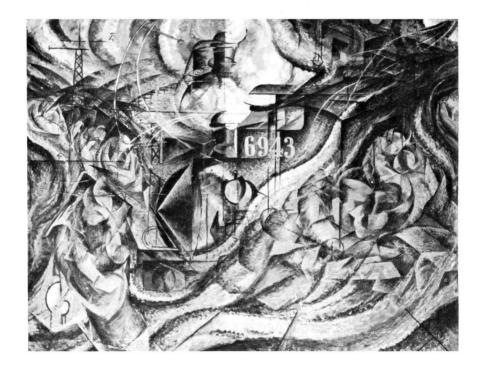

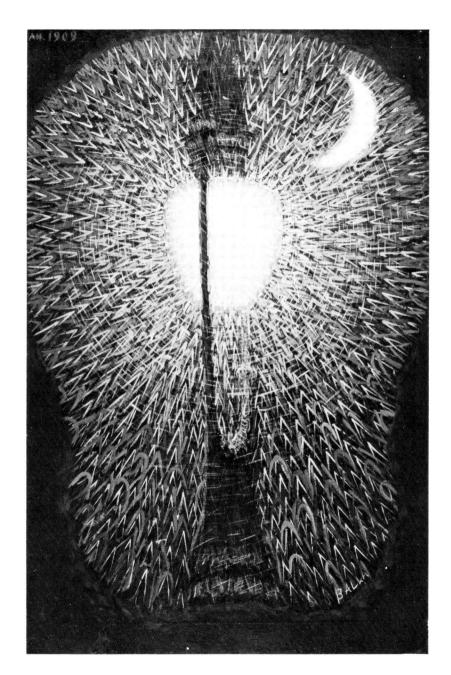

VORTICISM

46. (below) Lewis, Wyndham Abstract drawing (The Courtesan), 1912

47. (right) Roberts, William St George and the Dragon, 1915

48. (below right) Etchells, Frederick Progression. Reproduced in BLAST No.2, July 1915.

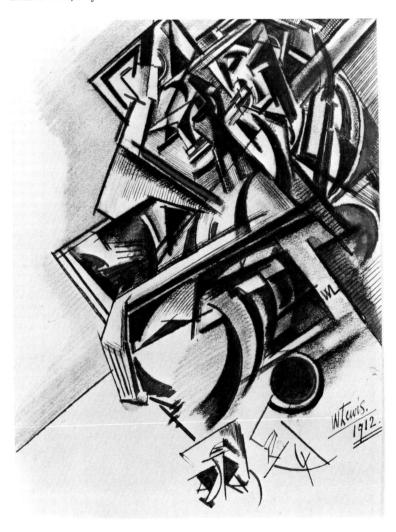

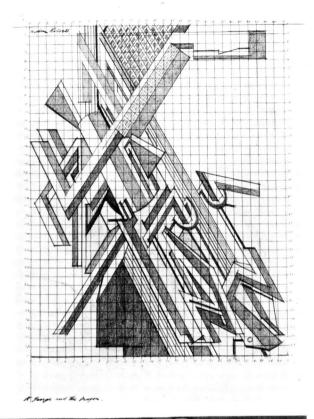

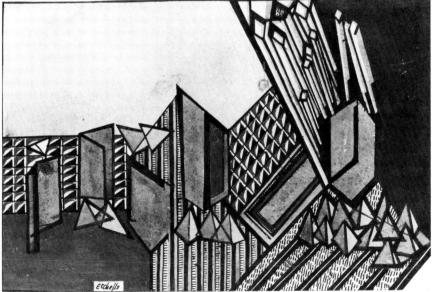

6

BLAST

years 1837 to 1900

Curse abysmal inexcusable middle-class (also Aristocracy and Proletariat).

BLAST

pasty shadow cast by gigantic Boehm (imagined at introduction of BOURGEOIS VICTORIAN VISTAS).

WRING THE NECK OF all sick inventions born in that progressive white wake.

BLAST their weeping whiskers—hirsute RHETORIC of EUNUCH and STYLIST— SENTIMENTAL HYGIENICS

SENTIMENTAL HYGIENICS
ROUSSEAUISMS (wild Nature cranks)
FRATERNIZING WITH MONKEYS
DIABOLICS—raptures and roses

of the erotic bookshelves culminating in PURGATORY OF PUTNEY.

1

BLESS ENGLAND!

BLESS ENGLAND

FOR ITS SHIPS

which switchback on Blue, Green and Red SEAS all around the PINK EARTH-BALL,

BIG BETS ON EACH.

BLESS ALL SEAFARERS.

THEY exchange not one LAND for another, but one ELEMENT for ANOTHER. The MORE against the LESS ABSTRACT.

BLESS the vast planetary abstraction of the OCEAN.

BLESS THE ARABS OF THE ATLANTIC.
THIS ISLAND MUST BE CONTRASTED WITH THE BLEAK WAVES.

- 51. (above) Bomberg, David $Mud\ Bath,\ c.\ 1913–14$
- 52 (above right) Bomberg, David In the Hold, c. 1913-14
- 53. (right) Roberts, William The Vorticists at the Café de la Tour Eiffel: Spring 1915

DADA AND SURREALISM

54. Arp, Hans Le Passager du Transatlantique, 1921

57. Ernst, Max Tantôt nus, tantôt vêtus de minces jets de feu, ils font gicler les geysers avec la probabilité d'une pluie de sang et avec la vanité des morts, 1929

58. (above, top to bottom) Valentine Hugo, André Breton, Tristan Tzara, Greta Knuston $Cadavre\ Exquis\ Landscape,\ 1933$

59. (below) Ernst, Max $Habit\ of\ Leaves,\ 1925$

60. (above) Masson, André $Automatic\ drawing,\ 1925$

61. (below) Miro, Joan $The\ Tilled\ Field,\ 1923-24$

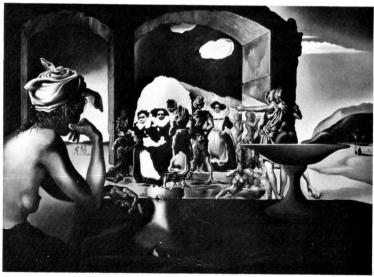

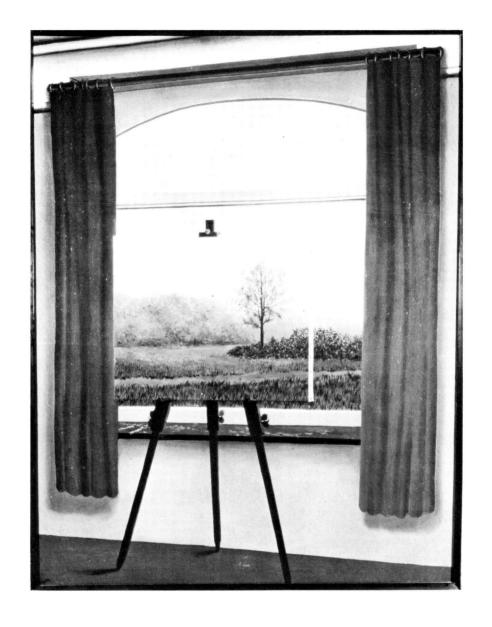

62. (above left) Tanguy, Yves Extinction of Useless Lights, 1927
63 (left) Dali, Salvador Slave Market with the Disappearing Bust of Voltaire, 1940
64. (above) Magritte, René The Human Condition 1, 1933

SUPREMATISM

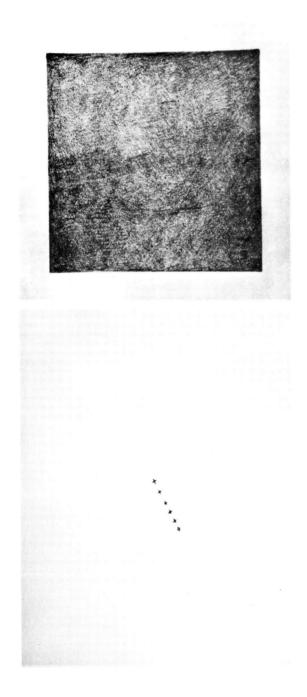

- 65. (left) Malevich, Kasimir The basic suprematist element: the square, 1913
- 66. (below left) Malevich, Kasimir Suprematist composition conveying a feeling of universal space, 1916
- 67. (below) Malevich, Kasimir Suprematist composition: White on White, 1918?

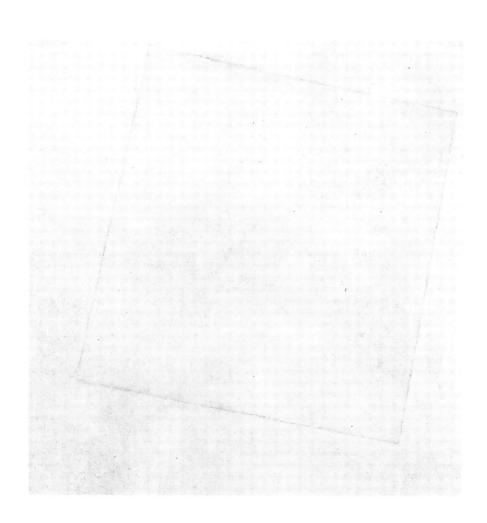

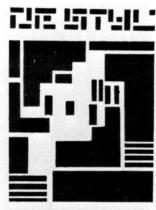

MAANDBLAD VOOR DE MO-DERNE BEELDENDE VAKKEN REDACTIE THEO VAN DOES-BURG MET MEDEWERKING VAN VOORNAME BINNEN- EN NAARS. UITGAVE X. HARMS TIEPEN TE DELFT IN 1917.

68

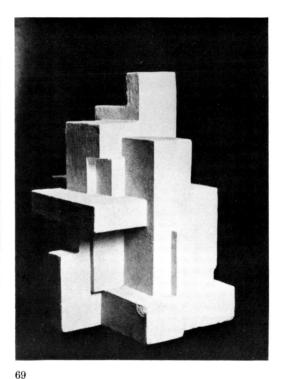

70

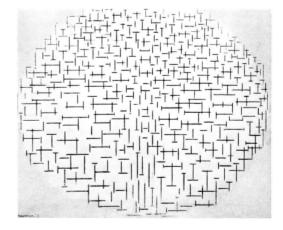

68. Huszar, Vilmos De Stijl logotype, 1917

69. Vantongerloo, Georges Interrelation of Masses, 1919

70. Mondrian, Piet Pier and Ocean, 1915

71. De Stijl logotype

72. van t'Hoff, Robert, Huis-ter-Heide, 1916

73. Mondrian, Piet Composition in Blue, A, 1917

ZESDE JAARGANG 1924

ELEIDEN ANTWERPEN PARIJS ROME

71

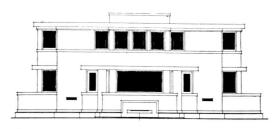

72

74. van der Leck, Bart Geometric Composition No. 1, 1917

75. van Doesburg, Theo Rhythm of a Russian Dance, 1918

76. Rietveld, Gerrit Thomas, Red-blue chair, module and mechanical diagram, 1917

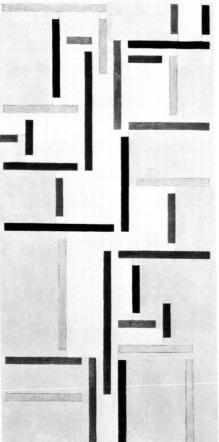

74 75

77. Gropius, Walter, Hanging lamp, for his own office in the Bauhaus, 1923

78. Rietveld, Gerrit Thomas, Dr Hartog's study with hanging lamp upon which Gropius's later design was modelled, 1920

77

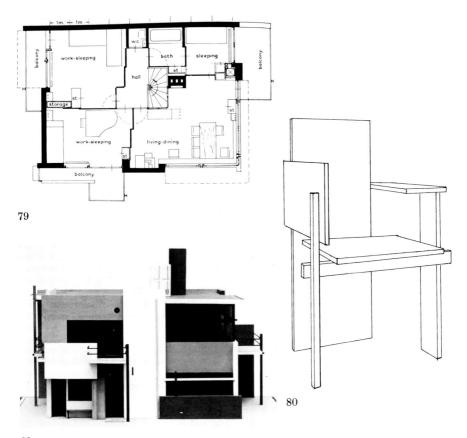

- 79. Rietveld, Gerrit Thomas, Schröder House. Upper floor plan with sliding and folding partitions in the closed position, 1923–4
- 80. Rietveld, Gerrit Thomas, Berlin Chair, asymmetrical assembly of planes in space, painted grey, 1923
- 81. Rietveld, Gerrit Thomas, House, elevation, 1923–4
- 82. Rietveld, Gerrit Thomas, Chauffeur's House, elevation, compounded out of 'standardized' modular concrete planks and metal stanchions, 1927

84

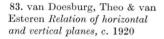

84. van Doesburg, Theo & van Esteren, Project for the interior decoration and modulation of a university hall, 1923

85. van Doesburg, Theo, Meudon House/elevation employing standard industrial glazing, Paris 1929

86. van Doesburg, Theo, Meudon House, interior with paintings, fittings and tubular steel furniture all by Theo van Doesburg, Paris 1929

87. van Doesburg, Theo, Café L'Aubette, Strasbourg, interior showing original bare light bulbs and bentwood furniture, the latter being specially built to the design of Theo van Doesburg

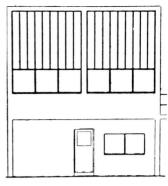

85

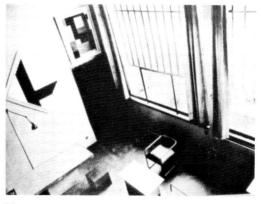

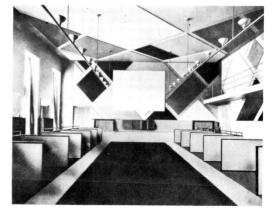

CONSTRUCTIVISM

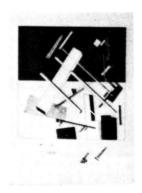

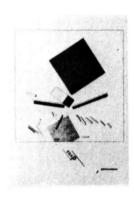

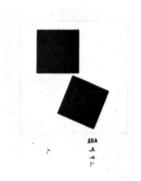

sорись за ренонструнцию транспорта

90. Rodchenko, Alexander, Compass and ruler drawing, 1915-16

91. (above) Tatlin, Vladimir Monument to the Third International (drawing), c. 1919

92. (left) Lissitzky, Eliezer Markowitsch Rendering for architectural structure, 1924

93. (above) Lissitzky, Eliezer Markowitsch 'Proun - The Town', 1921

94. (right) Lissitzky's studio. The Lenin Podium, 1924

ABSTRACT EXPRESSIONISM

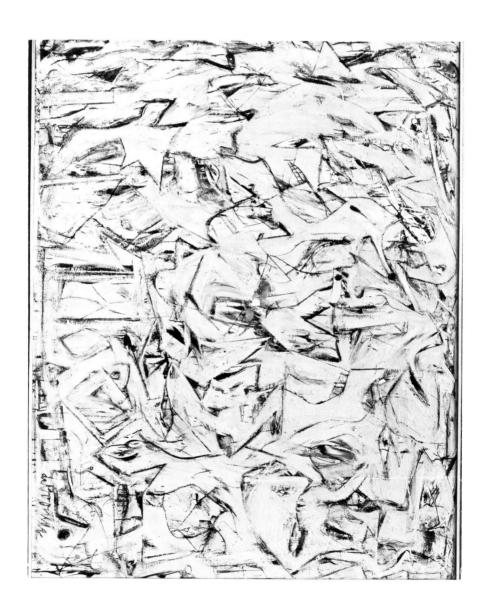

95. (above) de Kooning, Willem Excavation, 1950

96. (below) Newman, Barnett Vir Heroicus Sublimis, 1950-51

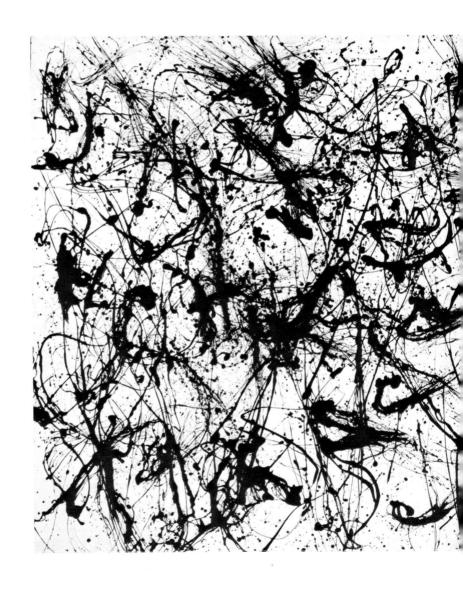

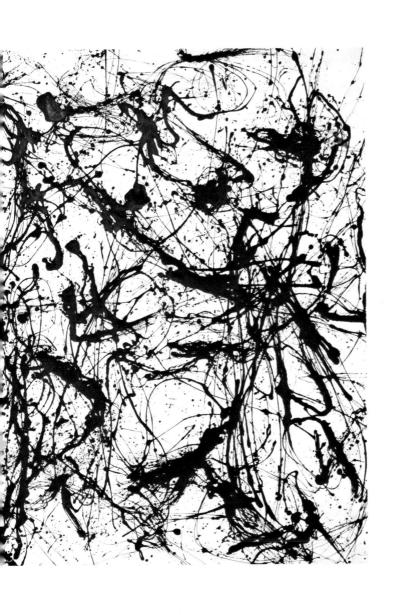

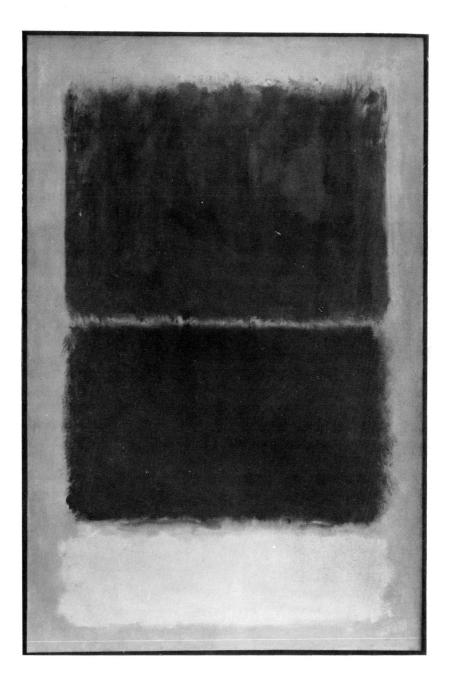

98. (left) Rothko, Mark Light Red over Black, 1957

99. (below) Still, Clyfford Painting - 1951

KINETIC ART

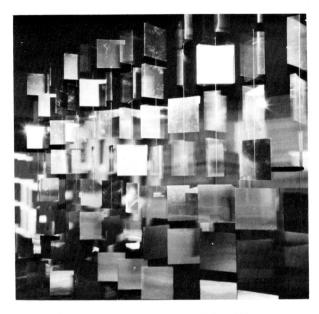

100. Le Parc, Julio Continual Light, mobile, 1960101. Soto, R. J. Vibration, 1965

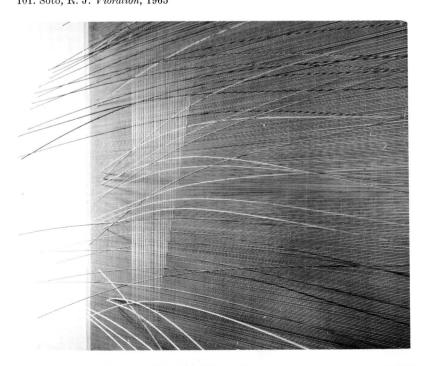

POP ART

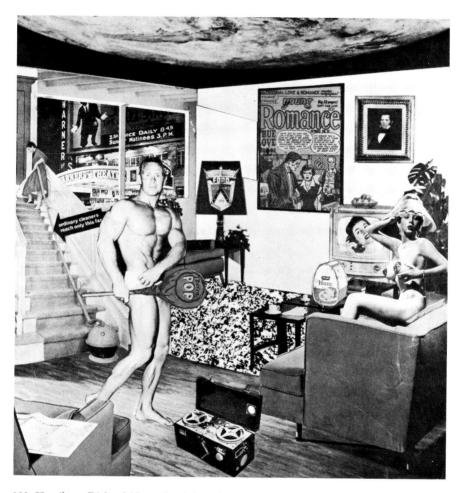

102. Hamilton, Richard 'Just what is it . . .', 1956

103. (below) Oldenburg, Claes Soft Engine, Airflow 6, 1966

104. (right) Warhol, Andy 'Saturday Disaster', 1964

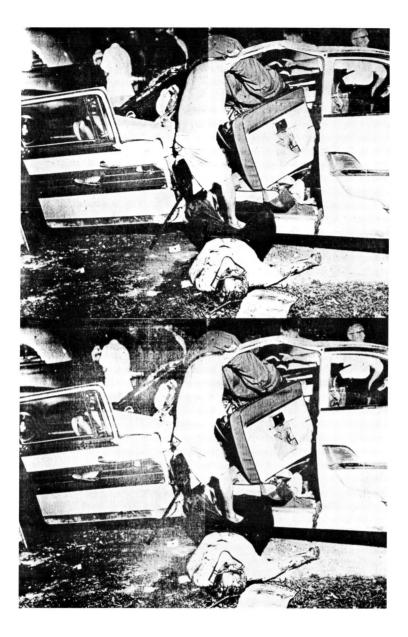

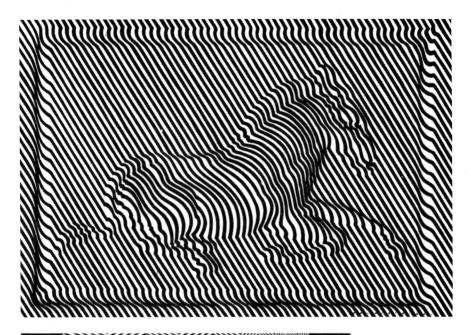

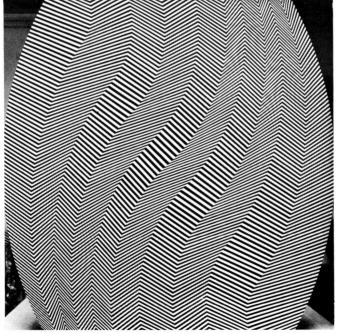

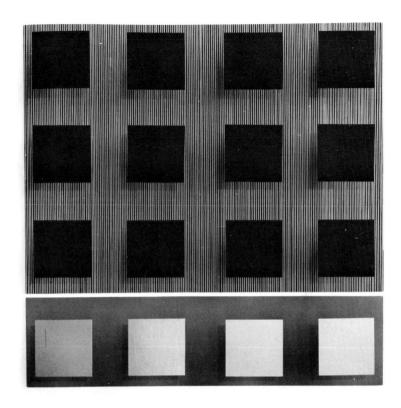

105. (above left) Vasarely, Victor Zebra, 1938
106. (left) Riley, Bridget Shuttle I, 1964
107. (above) Soto, R. J. Un quart de bleu, 1968
108. (below) Soto, R. J. Cinq grandes tiges, 1964

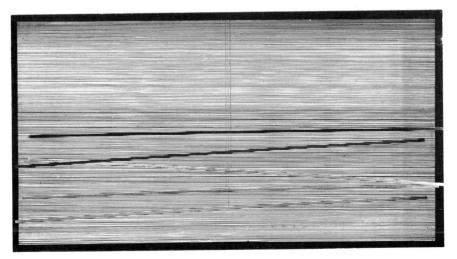

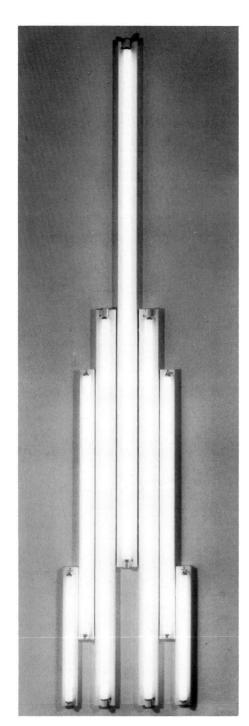

MINIMALISM

109. Flavin, Dan Monument for V. Tatlin, 1966

110. Stella, Frank Die Fahne hoch!. 1959

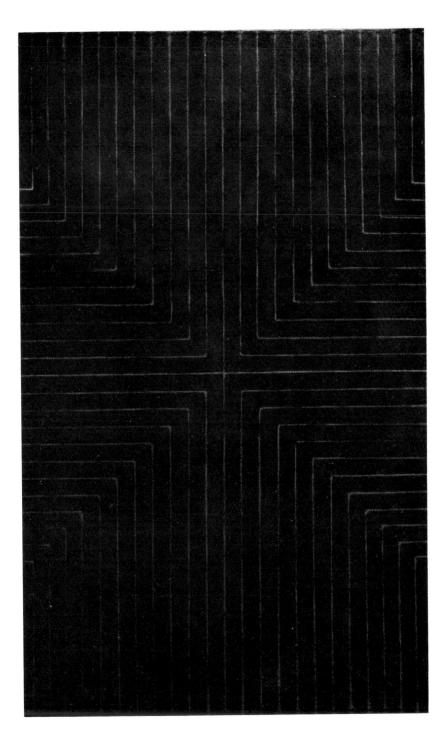

112. Judd, Don Untitled, 1970

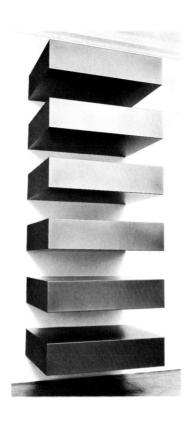

113. Morris, Robert Untitled, 1965

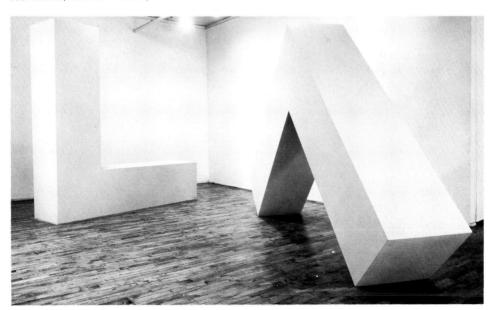

114. Barry, Robert Somehow, 1976

115. Kosuth, Joseph One and Three Chairs, 1965

ROOM A: SEEDGED

THE ROOM IS RCTIVATED BY MY
PRESENCE UNDERGROUND, UNDERGOUT - BY MY MOVEMENT FROM
POINT TO POINT UNDER THE
RAMP.

2) THE GOAL OF MY ACTIVITY
IS THE PRODUCTION OF
SEED - THE SCATTERING
OF SEED THROUGHOUT THE
UNDERGROUND AREA. (MY
AIM IS TO CONCENTRATE
ON MY GOAL, TO BE TOTALLY
ENCLOSED WITHIN MY GOAL)

3 THE MEANS TO THIS GOAL PRIVATE SEXUAL ACTIVITY 15 CMY ATTEMPT IS TO MAINTAIN THE ACTIVITY THROUGHOUT DAY, SO THAT A THE IMUM OF SEED IS PRO-DUCED; MY AIM IS TO HAVE CONSTANT CONTACT WITH MY SO THAT AN EFFECT FROM MY BODY IS CARRIED OUTSIDE.)

MY AIDS ARE THE VISITORS TO THE GALLERY - IN MY SECLUSION, I CAN HAVE PRIVATE IMAGES OF THEM, TALK TO MYSELF ABOUT THEM: MY FANTASIES ABOUT THEM CAN EXCITE ME, INDUCE ME TO SUSTAIN - TO RESUME - MY PRIVATE SEXUAL ACTIVITY. (THE SEED 'PLANTED' ON THE FLOOR, THEN, IS A JOINT RESULT OF MY PRESENCE AND THEIRS.)

118. Burden, Chris Doorway to Heaven, 1973

119. Gilbert and George The Singing Sculpture, 1971

121. Opalka, Roman

1 to Infinity
(detail from series),
1965>

122. Darboven, Hanne Untitled, 1972-3>

120. Dibbets, Jan Daylight/Flashlight Outside Light/Inside Light, 1971

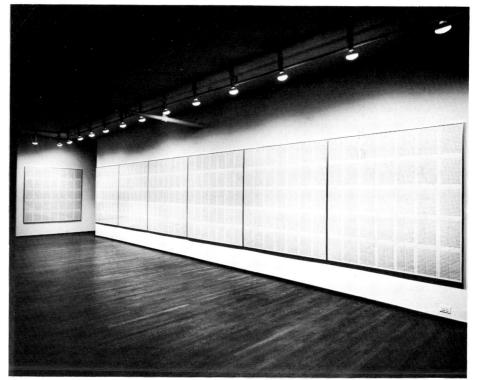

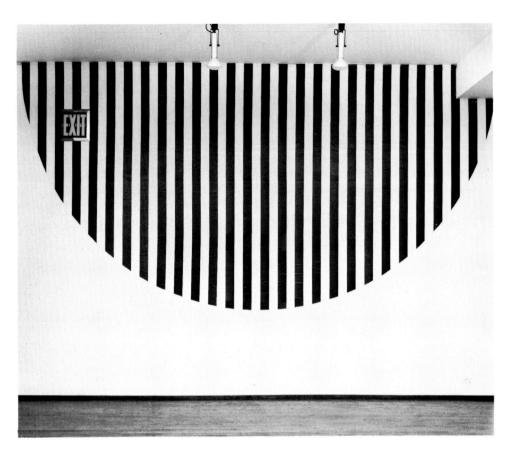

123. Buren, Daniel Piece No. 3 from exhibition 'To Transgress', 1976

POSTMODERNISM

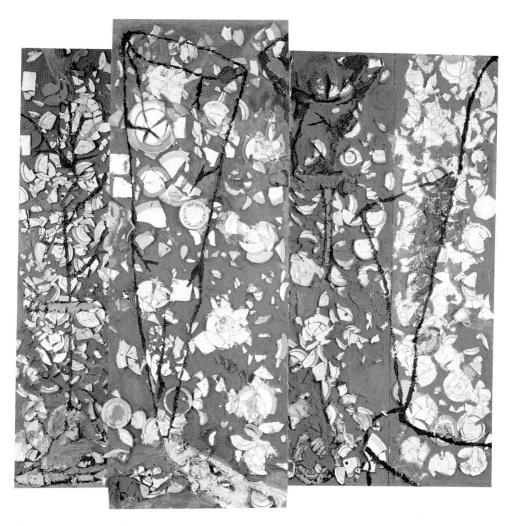

124. Schnabel, Julian The Patients and the Doctors, 1978

125. Schnabel, Julian Jump, 1980

126. Salle, David Daemonization, 1980

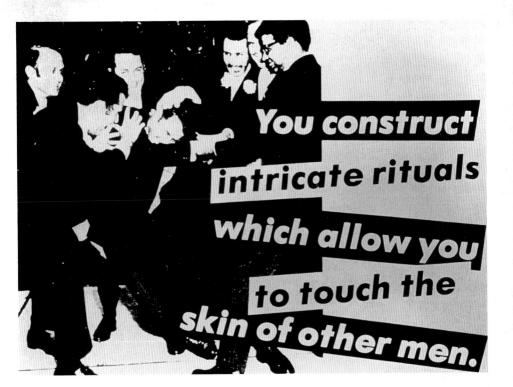

128. Chicago, Judy The Dinner Party, 1979

129. Kruger, Barbara Untitled ('You construct intricate rituals which allow you to touch the skin of other men'), 1980

130. Kruger, Barbara Untitled ('Your gaze hits the side of my face'), 1981

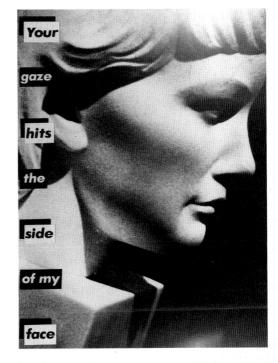

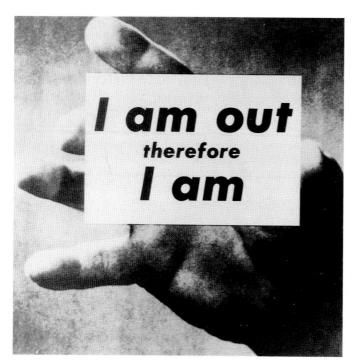

131. Rolston, Adam I am out therefore I am, 1989

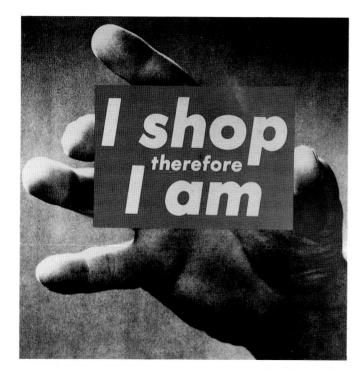

132. Kruger, Barbara Untitled ('I shop therefore I am'), 1987

133. Gran Fury Read My Lips (boys), 1988

READ MY LIPS

Gran Tury

134. Levine, Sherrie $After\ Edward\ Weston\ I,\ 1990$ 135. Mapplethorpe, Robert $Charles,\ 1985$

STONEWALL '69

MDS CRISIS 889

IGNORANCE = FEAR SILENCE = DEATH A FIGHT AIPS

137. Haring, Keith *Ignorance = Fear*, 1989

138. Kiss & Tell Drawing the Line, 1990

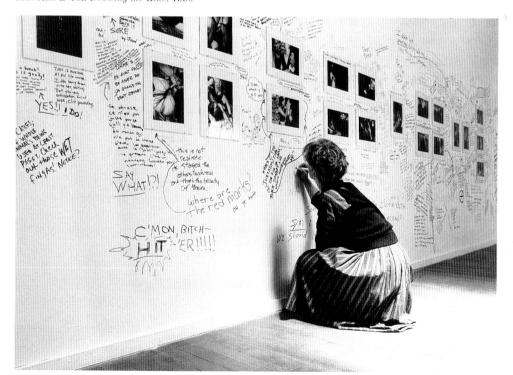

there are between five and ten thousand homeless people with Alds living on city streets or in shelters where they are susceptible to the more than 300 opportunistic infections people with Alds can get. T.B. and pneumonia is rampant in the shelter sytem. Shelter doctors are likely to purposefully not diagnose homeless people with Alds because hospitals are overcrowded and the beds are saved for people with linsurance or money. Intravenous drug users have to be completely clean of drugs for a period of seven years before they are elegible for drug trials. The welking period for most addiction treatment centers is one to two years; so this means a drug-addict whe has Alds has to kick his or her habit and then stay alive some how for acven years before being considered for the drug trials. It has taken eight years for the city dovernment to begin information cammanighs simed at infravenous drug users and only recently have some small ads on the subway begun to use the spanish language even though an enormous amount of heterosexual people with Alds are from minority communities. They also say the homosexual community is so well informed that there need be no ad campaigns aimed at homosexuality and safe as once again this is nonsense; there are large percentages of men who endage homosexual activity but because they simple fick some guy or get blown by a question of the subway and though the gay baths in love fanhatian were closed down the baths in harles have been allowed to remain ope and city health officials still won't acknowledge that Lesbians can get Alds.

139. Wojnarowicz, David 'Sex Series', 1990

List of Illustrations
Selected Bibliographies
Index

List of Illustrations

Fauvism

Foundation)

- 1. Matisse, Henri Luxe, Calme et Volupté, 1904. Collection Ginette Signac, Paris (photo J. Chambrin)
- 2. Pages from L'Illustration of 4 November 1905.
- 3. Matisse, Henri Portrait of Madame Matisse, 1906. 16×13 in.; 40.5×32.5 cm. Statens Museum, J. Rump Collection (photo Museum)
- 4. Matisse, Henri Joie de Vivre, 1906. $68\frac{1}{2} \times 93\frac{3}{4}$ in.; 174×238 cm. The Barnes Foundation, Philadelphia (photo copyright The Barnes
- 5. Matisse, Henri Still Life with Pink Onions, 1906. $18 \times 21_{2}$ in.; 46×55 cm. Statens Museum, J. Rump Collection (photo Museum)
- 6. Derain, André Women in front of Fireplace, c. 1905. Watercolour, $19\frac{1}{2} \times 23\frac{1}{2}$ in.; 49.5×59.5 cm. Collection Mr and Mrs Leigh B. Block, Chicago (photo National Gallery of Art,
- Washington) 7. Derain, André $\begin{array}{lll} 7. & \text{Derain, André} \\ The & Dance, & c. & 1905-6. & 73\times90 & \text{in.;} \\ 185\times228 & \text{cm.} \\ & \text{Fridart Foundation, Geneva (photo} \\ & \text{Fridart Foundation)} \end{array}$

Expressionism

Düsseldorf)

15. Nolde, Emil

- 10. Kirchner, Ernst Ludwig Girl under Japanese Umbrella, c. 1909. Oil on canvas, $36\frac{1}{2} \times 31\frac{1}{2} \text{in.}$; 92.5×80.5 cm.
- $\begin{array}{lll} Kunstsammlung & Nordrhein-Westfalen, \\ D\"{u}sseldorf & (photo & Walter & Klein, \\ D\"{u}sseldorf) & \end{array}$
- 11. Kirchner, Ernst Ludwig Negro Dance (Negertanz), c. 1911. Distemper on canvas, $56\frac{1}{2}\times45$ in.; 151.5×120 cm. Kunstsammlung Nordrhein-Westfalen, Düsseldorf (photo Walter Klein,
- 12. Meidner, Ludwig Revolution, c. 1913. Oil on canvas, $31\frac{1}{2} \times 45\frac{1}{2}$ in.; 80×116 cm. Nationalgalerie, W. Berlin (photo Museum)
- 13. Beckmann, Max Family Picture, 1920. Oil on canvas, $25_5^8 \times 39_4^8$ in.; 65×101 cm. Collection The Museum of Modern Art, New York. Gift of Abby Aldrich Rockefeller (photo Museum)
- 14. Mendelsohn, Erich Sketch for Einstein Tower, 1920–21. Inkand-brush drawing
- Jestri, 1917. Woodcut, $12\frac{1}{16} \times 9^3_8$ in.; 31×24 cm. Philadelphia Museum of Art, Academy Collection (photo A. J. Wyatt, Museum Staff Photographer)

16. Lehmbruck, Wilhelm Fallen Man, 1915-16. Synthetic stone, $30 \times 96 \times 32$ in.; $76 \times 244 \times 81$ cm. Collection Guido Lehmbruck, Stuttgart (photo W. Moegle, Stuttgart)

Cubism.

17. Picasso, Pablo

Les Demoiselles d'Avignon, 1907. Oil on canvas, 96×92 in.; 244×234 cm. Collection, The Museum of Modern Art. New York. Acquired through the Lillie P. Bliss Bequest (photo Museum)

18. Picasso, Pablo

Seated Woman (Seated Nude), 1909. Oil on canvas, $36\frac{1}{2} \times 24\frac{1}{4}$ in.; 92.5×61.5 cm. The Tate Gallery, London

(© SPADEM, Paris, 1973)

19. Braque, Georges

Piano and Lute, 1910. Oil on canvas, $36 \times 16^{5}_{8}$ in.; 91.5×42 cm.

The Solomon R. Guggenheim Museum. New York (photo Museum)

20. Braque, Georges

Le Guéridon, 1911. Oil on canvas, $45\frac{5}{8} \times 31\frac{7}{8}$ in.; 116×81 cm. Musée National d'Art Moderne, Paris

(photo Giraudon, Paris)

21. Picasso, Pablo

Le Toréro, 1912. Oil on canvas, $84\frac{3}{4} \times$ $50\frac{1}{4}$ in.: 215×128 cm.

Oeffentliche Kunstsammlung, Basel (photo Museum)

22. Picasso, Pablo

Violin and Guitar, 1913. Oil, pasted cloth, pencil and plaster on canvas. $36 \times 25 \text{ in.}; 91.5 \times 63.5 \text{ cm.}$

Philadelphia Museum of Art, Louise and Walter Arensberg Collection (photo A. J. Wyatt, Museum Staff Photographer)

23. Braque, Georges

La Table du Musicien, 1913. Oil and charcoal on canvas, $25\frac{1}{2} \times 36$ in.; 65×92 cm. Oeffentliche Kunstsammlung, Basel. Gift of Raoul La Roche (photo Museum)

24. Picasso, Pablo

Verre, Bouteille de Vin, Journal sur une Table, 1914. Pasted paper and pencil on

paper, $30\frac{1}{9} \times 40$ in.; 77.5×102 cm. Private collection, Paris (photo Hélène Adant, Paris)

25. Braque, Georges

Musical Forms (Guitar and Clarinet), 1918. Pasted paper, corrugated cardboard, charcoal and gouache on cardboard, $30\frac{3}{8} \times 37\frac{3}{8}$ in.; 77×95 cm. Philadelphia Museum of Art, Louise and Walter Arensberg Collection (photo A. J. Wyatt, Museum Staff Photographer)

26. Gris, Juan

L'Homme au Café, 1912. Oil on canvas. $50\frac{1}{9} \times 34\frac{5}{9}$ in.: 128×88 cm.

Philadelphia Museum of Art, Louise and Walter Arensberg Collection (photo A. J. Wyatt, Museum Staff Photographer)

27. Gris. Juan

Glasses and Newspaper, 1914. Pasted paper, gouache, oil and crayon on canvas, 24×15 in.; 61×38 cm. Smith College Museum of Art. Given by Joseph Brummer (photo Museum)

Purism

28. Ozenfant, Amédée

Flacon, quitare, verre et bouteilles, 1920. Oil on canvas, $32 \times 39^{\frac{1}{9}}$ in.: $81 \times$ 100.5 cm.

Oeffentliche Kunstsammlung, Basel (photo Museum)

29. Jeanneret, Charles-Edouard Nature morte à la pile d'assiettes, 1920. Oil on canvas, $32 \times 39\frac{1}{2}$ in.; 81×100 cm. Oeffentliche Kunstsammlung, Basel (photo Museum)

Orphism

30. Delaunay, Robert

The City of Paris, 1912. Oil on canvas, $105 \times 160 \text{ in.}$; $267 \times 406 \text{ cm.}$

Musée National d'Art Moderne, Paris (photo Musées Nationaux)

31. Delaunay, Robert

Simultaneous Windows, 1912. Oil on canvas, $18 \times 15^{\frac{3}{4}}$ in.; 46×40 cm.

Kunsthalle, Hamburg (photo Ralph Kleinhempel)

32. Delaunay, Robert

Sun, Moon. Simultaneous No. 2, 1913. Oil on canvas, 53 in. diameter; 133 cm. diameter.

The Museum of Modern Art, New York, Mrs Simon Guggenheim Fund

33. Kupka, Frank

Discs of Newton, 1911–12. Oil on canvas, $19\frac{3}{4} \times 25\frac{1}{9}$ in.; 50×65 cm.

Musée National d'Art Moderne, Paris (AM 3635 P) (photo Musées Nationaux)

34. Kupka, Frank

Amorpha, Fugue in Two Colours, 1912. Oil on canvas, 83×87 in.; 211×220 cm. Národní Galerie, Prague

35. Picabia, Francis

Dances at the Spring II, 1912. Oil on canvas, 97×99 in.; 246×251 cm.

The Museum of Modern Art, New York. Gift of the children of Eugene and Agnes E. Mayer: Elizabeth Lorentz, Eugene Meyer III, Katharine Graham and Ruth M. Epstein

36. Picabia. Francis

Udnie, American Girl (Dance), 1913. Oil on canvas, 118 × 118 in.; 300 × 300 cm. Musée National d'Art Moderne, Paris (AM 2874) (photo Musées Nationaux)

37. Léger, Fernand

Contrast of Forms, 1913. Oil on canvas, $39\frac{1}{2} \times 32$ in.; 100×81 cm.

The Museum of Modern Art, New York, The Philip L. Goodwin Collection

Futurism

38. Boccioni, Umberto

Dynamic Construction of a Gallop: Horse and House, 1914. Wood, cardboard and metal, $26 \times 47_4^3$ in.; 66×121 cm. Peggy Guggenheim Foundation, Venice (photo Fotoattualità, Venice)

39. Boccioni. Umberto

The Street Enters the House, 1911. Oil on canvas, $39\frac{1}{2} \times 39\frac{1}{2}$ in.; 100×100.6 cm. Niedersächsische Landesgalerie, Hanover (photo Museum)

40. Carrà, Carlo

Funeral of the Anarchist Galli, 1911. Oil

on canvas, $78\frac{1}{4} \times 102$ in.; 199×259 cm. Collection, The Museum of Modern Art, New York, Acquired through the Lillie P. Bliss Bequest (photo Museum)

41. Severini, Gino

Dancer-Helix-Sea, 1915. Oil on canvas, $29\frac{5}{5} \times 30\frac{3}{7}$ in.: 75×78 cm.

The Metropolitan Museum of Art, New York. The Alfred Stieglitz Collection, 1949 (photo Museum)

42. Balla, Giacomo

 $\label{eq:continuous} Interpenetration~No.~I,~1912.$ Oilon canvas, $39\frac{s}{8}\times23\frac{s}{8}$ in.; 100×59.5 cm. Mrs Barnett Malbin (The Lydia and Harry Lewis Winston Collection), Birmingham, Michigan

43. Russolo, Luigi

Dynamism of an Automobile, 1911. Oil on canvas, 41 × 55 in.; 104 × 140 cm. Musée National d'Art Moderne, Paris (photo Museum)

44. Boccioni, Umberto

States of Mind No. 1: The Farewells, 1911. Oil on canvas, $27\frac{3}{4} \times 37\frac{7}{6}$ in.; 70.5×96 cm. Private collection, New York (photo Charles Uht. New York)

45. Balla, Giacomo

The Street Light, 1909. Oil on canvas, $68\frac{3}{4} \times 45\frac{1}{4}$ in.; 175×115 cm.

Collection, The Museum of Modern Art, New York, Hillman Periodicals Fund (photo Museum)

Vorticism

46. Lewis, Wyndham

Abstract drawing (The Courtesan), 1912. Pencil drawing, 9\frac{9}{8} \times 7\frac{1}{4}\times in.; 24 \times 18.5 cm. Victoria & Albert Museum, London (photo Museum)

47. Roberts, William

St George and the Dragon, 1915. Pencil drawing, $9\frac{1}{2} \times 7\frac{1}{2}$ in.; 24×19 cm. Anthony d'Offay (photo R. Todd-White)

48. Etchells, Frederick

Progression. Reproduction in BLAST No. 2, July 1915. Pen, ink and water-colour, $5_4^3 \times 9$ in.; 14.5×23 cm.

Cecil Higgins Museum, Castle Close, Bedford (photo Hawkley Studio Associates Ltd)

49. Wadsworth, Edward Abstract Composition, 1915. Gouache, $16\frac{1}{5} \times 13\frac{1}{5}$ in.; 42×34 cm. Tate Gallery, London (photo Museum)

50a & 50b. Pages from the first issue of BLAST (Blasts and Blesses) Anthony d'Offay (photo R. Todd-White)

51. Bomberg, David Mud Bath, c. 1913-14. Oil on canvas, $60 \times 88^{1}_{4}$ in.; 152×224 cm. Tate Gallery, London (photo Museum)

52. Bomberg, David In the Hold, c. 1913-14. Oil on canvas, $78 \times 101 \text{ in.; } 198 \times 256 \text{ cm.}$ Tate Gallery, London (photo Museum)

53. Roberts. William The Vorticists at the Café de la Tour Eiffel: Spring 1915. Oil on canvas, $72 \times 84 \text{ in.}$; $183 \times 213 \text{ cm.}$

Tate Gallery, London (photo Museum)

Dada and Surrealism

54. Arp. Hans

Le Passager du Transatlantique, 1921. China ink, $8\frac{1}{2} \times 5\frac{1}{2}$ in.; 21.2×13.9 cm. Galleria Schwarz, Milan (photo Bacci, Milan)

55. Duchamp, Marcel Bottlerack, 1914. Galvanized metal, $23\frac{1}{9} \times 14\frac{1}{9}$ in.; 59×37 cm. diameter. Galleria Schwarz, Milan (photo Gallery)

56. Picabia, Francis Machine Tournez Vite, 1916. Tempera on paper, $13 \times 19\frac{1}{2}$ in.; 32.5×49 cm. Galleria Schwarz, Milan (photo Gallery)

57. Ernst, Max

Tantôt nus, tantôt vêtus de minces jets de feu, ils font gicler les geysers avec la probabilité d'une pluie de sang et avec la vanité des morts, 1929. Engraving. From Max Ernst: La Femme 100 Têtes, 1929

58. (top to bottom) Valentine Hugo, André Breton, Tristan Tzara, Greta Knutson

Cadavre Exquis Landscape, 1933. Coloured chalk on black paper, $9\frac{1}{2} \times 12\frac{1}{2}$ in.; 24 × 32 cm. Collection, The Museum of Modern Art, New York (photo Museum)

59. Ernst, Max Habit of Leaves, 1925. Frottage. From Max Ernst: Histoire Naturelle, 1926

60. Masson, André Automatic drawing, 1925. Ink on paper. From Waldberg: Surrealism, London, 1966

61. Miro, Joan The Tilled Field, 1923-4. Collection of Mr and Mrs Henry Clifford, Radnor, Pa. (photo Philadelphia Museum of Art)

62. Tanguy, Yves Extinction of Useless Lights, 1927. Oil on canvas, $36\frac{1}{4} \times 25\frac{3}{4}$ in.; 92×68 cm. Collection. The Museum of Modern Art. New York (photo Museum)

63. Dali. Salvador

Slave Market with the Disappearing Bust of Voltaire, 1940. Oil on canvas, $18\frac{1}{4}$ × 25^{3}_{4} in.; 46.5×65.5 cm.

The Reynolds Morse Foundation (The Salvador Dali Museum Collection) (photo Museum)

64. Magritte. René The Human Condition I, 1933. Oil on canvas, $39\frac{1}{2} \times 32$ in.; 100×81 cm. Collection Claude Spaak, Choisel

Suprematism

65. Malevich, Kasimir

The basic suprematist element: the square, 1913. Pencil on paper, $4\frac{1}{2} \times 7$ in.; 11.5×18 cm.

From K. Malevich: 'The Non-Objective World', 1927 Bauhausbuch 11, Munich (photo A. Scharf)

66. Malevich, Kasimir

Suprematist composition conveying a feeling of universal space, 1916. Pencil on paper, $4\frac{1}{2} \times 7$ in.; 11.5×18 cm.

From K. Malevich: 'The Non-Objective World', 1927 Bauhausbuch 11, Munich (photo A. Scharf)

67. Malevich, Kasimir

Suprematist composition: White on White, 1918? Oil on canvas, $31\frac{1}{4} \times 31\frac{1}{4}$ in.; 79×79 cm. Collection, The Museum of Modern Art, New York (photo Museum)

De Stijl

68. Huszar, Vilmos

De Stijl logotype, 1917. Cover for the 'De Stijl' journal edited by Theo van Doesburg, Delft, 1917

69. Vantongerloo, Georges Interrelation of Masses, 1919

70. Mondrian. Piet

Pier and Ocean, 1915. (Composition No. 10.) Oil on canvas, $10 \times 42\frac{1}{2}$ in.; 25×108 cm. Rijksmuseum Kröller-Müller, Otterlo (photo Museum)

71. Van Doesburg, Theo De Stijl logotype. New cover design initiated January 1921

72. Van't Hoff, Robert

Huis-ter-Heide, 1916. Early reinforced concrete house with a symmetrical plan; modelled after the work of Frank Lloyd Wright

73. Mondrian, Piet Composition in Blue, A, 1917. Oil on canvas, $19\frac{1}{2} \times 17\frac{1}{2}$ in.; 50×44 cm. Rijksmuseum Kröller-Müller, Otterlo (photo Museum)

74. Van der Leck, Bart Geometric Composition No. 1, 1917. Oil on canvas. Rijksmuseum Kröller-Müller, Otterlo (photo Museum)

75. Van Doesburg, Theo Rhythm of a Russian Dance, 1918. Oil on canvas, $53\frac{1}{2} \times 24\frac{1}{4}$ in.; 136×61.5 cm. Collection, The Museum of Modern Art, New York. Acquired through the Lillie P. Bliss Bequest (photo Museum)

 Rietveld, Gerrit Thomas
 Red-blue chair, module and mechanical diagram, 1917

77. Gropius, Walter Hanging lamp, for his own office in the Bauhaus, 1923 78. Rietveld, Gerrit Thomas

closed position, 1923-4

Dr Hartog's study with hanging lamp upon which Gropius's later design was modelled, 1920

79. Reitveld, Gerrit Thomas Schröder House. Upper floor plan with sliding and folding partitions in the

80. Reitveld, Gerrit Thomas Berlin Chair, asymmetrical assembly of planes in space, painted grey, 1923

81. Reitveld, Gerrit Thomas House, elevation, 1923–4 Municipal Museum, Amsterdam (photo Museum)

82. Reitveld, Gerrit Thomas Chauffeur's House, elevation, compounded out of 'standardized' modular concrete planks and metal stanchions, 1927

83. Van Doesburg, Theo and Van Esteren, Cor Relation of horizontal and vertical planes, c. 1920

84. Van Doesburg, Theo and Van Esteren, Cor Project for the interior decoration and

modulation of a university hall, 1923 85. Van Doesburg, Theo Meudon House. Elevation employing standard industrial glazing, Paris, 1929

86. Van Doesburg, Theo Meudon House, interior with paintings, fittings and tubular steel furniture all by Theo van Doesburg, Paris, 1929

87. Van Doesburg, Theo Café L'Aubette, Strasbourg, interior showing original bare light bulbs and bentwood furniture, the latter being specially built to the design of Theo van Doesburg

Constructivism

88. Lissitzky, Eliezer Markowitsch

The Story of Two Squares, a book
designed by Lissitzky and printed in
Berlin, 1922. Copy in Victoria & Albert

Museum. Cover plus 16 pp., $8\frac{1}{2} \times 10\frac{7}{2}$ in.; $21.5 \times 27.5 \text{ cm}$. (photo A. Scharf)

89. Russian poster, c. 1930 (photo A. Scharf)

90. Rodchenko, Alexander Compass and ruler drawing, 1915-16. Pen, ink and watercolour on paper. (photo courtesy of Alfred H. Barr Jr.)

91. Tatlin, Vladimir Monument to the Third International (drawing), c. 1919. (photo A. Scharf)

92. Lissitzky, Eliezer Markowitsch Rendering for architectural structure.

See E. Lissitzky, Russia, an Architecture for World Revolution. English edition Lund Humphries, 1970. (photo A. Scharf)

93. Lissitzky, Eliezer Markowitsch 'Proun - The Town'. From The Proun collection published in Moscow in 1921 in 50 copies. Lithograph, 9×11 in.; 22.7×27.5 cm.

Tretyakov Gallery, Moscow

94. Lissitzky's studio. The Lenin Podium, 1924. Drawing with photomontage

Abstract Expressionism

95. De Kooning, Willem

Excavation, 1950. Oil on canvas, 6 ft 8_{8}^{1} in. × 8 ft 4_{8}^{1} in.; 204×257 cm. The Art Institute of Chicago (photo Courtesy of The Art Institute of Chicago)

96. Newman, Barnett

Vir Heroicus Sublimis, 1950-1. Oil on canvas, 7 ft $11\frac{3}{8}$ in. \times 17 ft $9\frac{1}{4}$ in.: $242 \times 540 \text{ cm}$.

Collection, The Museum of Modern Art, New York. Gift of Mr and Mrs Ben Heller (photo Museum)

97. Pollock, Jackson

No. 32, 1950. Duco on canvas, $106 \times$ 180 in.; 269 × 457 cm.

Kunstsammlung Nordrhein Westfalen. Düsseldorf (photo Walter Klein)

98. Rothko, Mark

Light Red over Black, 1957, Oil on canvas, $91\frac{5}{8} \times 60\frac{1}{8}$ in.; 233×153 cm. Tate Gallery, London (photo Gallery)

99. Still, Clyfford

Painting-1951. Oil on canvas, $93\frac{1}{4} \times$ 75^{3}_{4} in.; 237×192 cm.

Detroit Institute of Arts, W. Hawkins Ferry Fund (photo courtesy of The Detroit Institute of Arts)

Kinetic Art

100. Le Parc. Julio

Continual Light, mobile, 1960. Polished metal, 36×36 in.; 91.5×91.5 cm. Private collection

101. Soto. R. J.

Vibration, 1965. Struction. Galerie Denise René, Paris (photo H. Gloaguen)

Pop Art

102. Hamilton, Richard

'Just what is it . . .', 1956. Collage, $10\frac{1}{4} \times 9\frac{3}{4}$ in.; 26×25 cm. Collection Edwin Janss Jr (photo Frank J. Thomas, Los Angeles)

103. Oldenburg, Claes

Soft Engine, Airflow 6, 1966. Stencil-led canvas, wood, kapok, $54 \times 72 \times 18$ in.: $137 \times 183 \times 45.5$ cm.

Collection Dr Hubert Peeters, Bruges, Belgium (photo John Webb, London)

104. Warhol, Andy

'Saturday Disaster', 1964. Acrylic and silkscreen enamel on canvas, 60×82 in.: 152 × 208 cm. Collection Rose Art Museum, Brandeis University, Waltham, Mass. (photo Rudolph Burkhardt)

Op Art

105. Vasarely, Victor

Zebra, 1938. Oil on canvas, $15\frac{3}{4} \times 23\frac{1}{9}$ in.: 40×60 cm. Galerie Denise René, Paris (photo André Morain, Paris)

106. Riley, Bridget

Shuttle I, 1964. Emulsion on board, 44×44 in.; 112×112 cm.

British Council, London (photo Robert Hornes)

107. Soto, R. J.

Un quart de bleu, 1968. Painted wood and metal, $42 \times 42 \times 6_4^1$ in.; $107 \times 107 \times 16$ cm.

Galerie Denise René, Paris (photo André Morain, Paris)

108. Soto, R. J.

Cinq grandes tiges, 1964. Painted wood, nylon threads and steel rods, 67×35^1_2 in.; 170×90 cm.

Galerie Denise René, Paris (photo André Morain, Paris)

Minimalism

109. Flavin, Dan

Monument for V. Tatlin, 1966. Cool white fluorescent light, 96×23 in.; 243.8×58.4 cm.

Collection Leo Castelli (photo Eric Pollitzer)

110. Stella, Frank Die Fahne hoch!, 1959

111. Andre. Carl

Lever, 1966. Firebrick, 4×360×4 in.; 10.1×914.4×10.1 cm.

Installation: Jewish Museum 'Primary Structures'

112. Judd. Don

Untitled, 1970. Anodized aluminium (solid blue). 8 boxes, each $9 \times 40 \times 31$ in. (9 in. between); $22.8 \times 101.6 \times 78.7$ cm. (22.8 cm. between)

Collection Leo Castelli (photo Rudoph Burckhardt)

113. Morris. Robert

Courtesy Leo Castelli Gallery (photo Rudolph Burckhardt)

Conceptual Art

114. Barry, Robert

Somehow, 1976. 81 slides projected at 15second intervals on carousel projector Collection, Australian National Gallery, Canberra

Courtesy Leo Castelli Gallery (photo Bevan Davies)

115. Kosuth, Joseph

One and Three Chairs, 1965. Folding wooden chair, photograph, blown-up dictionary definition; chair $32\frac{3}{8} \times 14\frac{7}{8} \times 20\frac{7}{8}$ in. $(82.2 \times 37.7 \times 53$ cm.); photo panel $36 \times 24\frac{1}{8}$ in. $(91.4 \times 61.2$ cm.); text panel $24\frac{1}{8} \times 24\frac{1}{2}$ in. $(61.2 \times 62.2$ cm.)

Collection, The Museum of Modern Art, New York. Larry Aldrich Foundation Fund

.

116. Bochner, Mel Axiom of Indifference (detail), 1973. Tape, coins, ink

117. Acconci, Vito

Seedbed, executed Sonnabend Gallery, January 1972. Wooden ramp, body, voice, visitors, fantasies, sperm Courtesy Sonnabend Gallery (photos Kathy Dillon)

118. Burden, Chris

Doorway to Heaven, 15 November 1973 Courtesy Ronald Feldman Fine Arts (photo Charles Hill)

119. Gilbert and George performing *The Singing Sculpture* at Sonnabend Gallery, 1971 (photo courtesy Sonnabend Gallery)

120. Dibbets, Jan

Daylight|Flashlight, Outside Light| Inside Light, 1971

12 colour photographs and pencil on paper, 20 × 26 in.; 50.8 × 66 cm. Collection the artist. Courtesy Leo Castelli Gallery (photo Nathan Rabin)

121. Opalka, Roman

Detail of painting from 1 to Infinity series, 1965. Acrylic on canvas, $77_4^1 \times 53_4^1$ in.; 196.2 × 135.2 cm. Photo courtesy John Weber Gallery

122. Darboven, Hanne

Untitled, 1972–3. Pencil on paper, each unit 69\(^3\) in. square; 177.1 cm. square Courtesy Leo Castelli Gallery (photo Harry Shunk)

123. Buren, Daniel

Piece No. 3 from his exhibition 'To Transgress', September-October 1976 Leo Castelli Gallery. Courtesy John Weber Gallery (photo John Ferrari)

Postmodernism

124. Schnabel, Julian

The Patients and the Doctors, 1978. Oil, plates, bondo on wood. 96×108 in.; 244×274 cm.

Julian Schnabel, New York

125. Schnabel, Julian

Jump, 1981. Acrylic on canvas 84×120 in.; 213.4×304.8 cm.

Courtesy Mary Boone Gallery, New York

126. Salle, David

Daemonization, 1980. Acrylic on canvas, 84×120 in.; 213.3×305 cm.

Courtesy Gagosian Gallery, New York

127. Salle, David

Savagery and Misrepresentation, 1981. Acrylic on canvas, 80×62 in.; 203.2×157.5 cm.

Courtesy Gagosian Gallery, New York

128. Chicago, Judy

Courtesy the Artist

129. Kruger, Barbara

130. Kruger, Barbara

Untitled (Your gaze hits the side of my face'), 1981. Photograph, 55×41 in.; 139.7×104.1 cm.

Courtesy Mary Boone Gallery, New York

131. Rolston, Adam

I am out therefore I am, 1989. Crack-andpeel sticker, offset lithography, $3_8^7 \times 3_8^7$ in.; 9.8×9.8 cm.

Photo from Crimp and Rolston, AIDS Demo Graphics, Bay Press, Seattle, 1990

132. Kruger, Barbara

Untitled (H shop therefore I am'), 1987. Photographic silkscreen/vinyl, 111×113 in.; 282×287 cm.

Private collection, photo courtesy Mary Boone Gallery, New York

133. Gran Fury

Read My Lips (boys), 1988. Poster, offset lithography, $16\frac{3}{4} \times 10\frac{3}{4}$ in.; 42.5×27.3 cm.

Photo from Crimp and Rolston, AIDS $Demo\ Graphics$, Bay Press, Seattle, 1990

134. Levine, Sherrie

After Edward Weston I, 1990. Photograph, 10×8 in.; 25.4×20.3 cm. Courtesy Marian Goodman Gallery, New York

135. Mapplethorpe, Robert

Charles, 1985. Platinum print, edition 3, $25\frac{1}{2} \times 22$ in.; 64.8×55.9 cm.

Collection of Edward Fisher and Dennis Peak

136. Gran Fury

RIOT, 1989. Crack-and-peel sticker, silk screen, $5\frac{1}{8} \times 3\frac{1}{9}$ in.; 13×8.9 cm.

Photo from Crimp and Rolston, AIDS Demo Graphics, Bay Press, Seattle, 1990

137. Haring, Keith

Ignorance = Fear, 1989. Sumi ink on paper, $24 \times 43_8^1$ in.; 61×109.5 cm. Collection the Estate of Keith Haring

138. Kiss & Tell

Drawing the Line, 1990. Photograph of the installation

Photo © Isabelle Massu 1990

139. Wojnarowicz, David

'Sex Series', 1990. 1 image of 8, edition of 12. Silver print, 15×18 in.; 38.1×45.7 cm. Courtesy P.P.O.W., New York

Selected Bibliographies

General

- ARNASON, H. H., A History of Modern Art (rev.), London/New York, 1989
- BOWNESS, A., Modern European Art, London/New York, 1986
- BRITT, D. (ed.), Modern Art: Impressionism to Post Modernism, London, 1989
- BÜRGEN, P., Theory of the Avant-Garde, Minneapolis, 1984
- CHADWICK, W., Women, Art and Society, London/New York, 1990
- CHIP, HERSCHEL B., Theories of Modern Art, Berkeley/Los Angeles/London, 1973
- CLARK, T. J., The Painting of Modern Life: Paris in the Art of Manet and His Followers, London/New York, 1990
- GABLIK, S., Has Modernism Failed?, London/New York, 1985
- GOLDING, J., Visions of the Modern, London/California, 1994
- HARRISON, C. and WOOD, P., Art in Theory – 1900–1990: An Anthology of Changing Ideas, Oxford, 1992
- HAUSER, A., The Social History of Art, London, 1962
- HERTZ, R., Theories of Contemporary Art, Englewood Cliffs, N.J., 1985
- HUGHES, R., The Shock of the New: Art and the Century of Change, London/ New York, 1991
- KRAUSS, R., Passages in Modern Sculpture, Cambridge, Mass./London, 1981
- KRAUSS, R., The Originality of the Avant-Garde and Other Modernist Myths, Cambridge, Mass., 1986
- LIPPARD, L., Changing: Essays in Art Criticism, New York, 1971
- LUCIE-SMITH. E., Movements in Art since 1945, London/New York, 1984
- MOSZYNSKA, A., Abstract Art, London/ New York, 1990
- NOCHLIN, L., Women, Art and Power and Other Essays, London/New York, 1989

- NOCHLIN, L., The Politics of Vision, London/New York, 1991
- POGGIOLÍ, R., The Theory of the Avant-Garde, Cambridge, Mass./London, 1968
- READ, H., Modern Sculpture: A Concise History, London/New York, 1964
- READ, H., Modern Painting: A Concise History, London/New York, 1975
- ROSENBERG, H., Artworks and Packages, London/Chicago, 1969
- ROSENBLUM, R., Cubism and Twentieth-Century Art, London/New York, 1961
- ROSENBLUM, R., Modern Painting and the Northern Romantic Tradition: Friedrich to Rothko, London/New York, 1978
- RUSSELL, J., The Meanings of Modern Art (rev.), London/New York, 1992
- SCHAPIRO, M., Modern Art, 19th and 20th Century: Selected Papers, London/New York, 1978
- SHATTUCK, R., The Banquet Years: The Origins of the Avant Garde in France, 1885 to World War I (rev.), London/ New York, 1968
- SILVER, K., Esprit de Corps: The Art of the Parisian Avant-Garde and the First World War 1914–1918, Princeton/ London, 1989
- STEINBERG, L., Other Criteria: Confrontations with Twentieth-Century Art, London/New York, 1972
- TUCKER, W., The Language of Sculpture, London/New York, 1985
- VARNEDOE, K., A Fine Disregard: What Makes Modern Art Modern, London/ New York, 1990
- VARNEDOE, K. and GOPNIK, A. (eds.), Modern Art and Popular Culture: Readings in High and Low, London/ New York, 1990
- WALLIS, B. (ed.), Art After Modernism: Rethinking Representation, Boston, 1984

WHEELER. D., Art Since Mid-Century, London/New York, 1991

Faurism

- BARR, A. H., Jr, Matisse, His Art and His Public, New York, 1951
- CRESPELLE, J. P., The Fauves, London, 1962
- DERAIN, A., Lettres à Vlaminck, Paris, 1955
- DIEHL, G., Derain, Milan, 1964
- DUTHUIT, G., The Fauvist Painters, New York, 1950
- Le Fauvisme français et les débuts de l'expressionnisme allemand, Paris, Musée d'Art Moderne, 1966. Exhibition catalogue

Expressionism

- BUCHHEIM, L. G., Der Blaue Reiter und die Neue Künstlervereinigung München, Feldafing, 1959
- BUCHHEIM, L. G., Die Künstlergemeinschaft Brücke, Feldafing, 1956
- DUBE. WOLF-DIETER, The Expressionists, London/New York, 1972
- GROHMANN, W., Wassily Kandinsky: Life and Work, London, 1959
- GROHMANN, W., Paul Klee, New York, 1954
- LANKHEIT, K. (ed.), The Blaue Reiter Almanac, London/New York, 1972
- MYERS. B., The German Expressionists, London/New York, 1957
- SELZ, P., German Expressionist Painting, Berkeley, California, 1957
- SHARP, D., Modern Architecture and Expressionism, London, 1966
- WHITFORD, F., Expressionism, London/ New York, 1970
- WILLETT, J., Expressionism, London, 1970
- ZIGROSSER, C., The Expressionists: A Survey of their Graphic Art, New York, 1957

Cubism

 $\begin{array}{c} {\rm APOLLINAIRE, G., } Les \, Peintres \, Cubistes, \\ {\rm Paris, 1913} \end{array}$

- BARR, A. H., Jr, Cubism and Abstract Art, The Museum of Modern Art, New York, 1936
- BARR, A. H., Jr, Picasso: Fifty Years of His Art, New York, 1936
- COOPER, D., The Cubist Epoch, London, 1971
- FRY, E., Cubism, London/New York, 1966
- GLEIZES, A. and METZINGER, J., Du Cubisme, Paris, 1912
- GOLDING, J., Cubism: A History and an Analysis, 1907–1914, London, 1959 (revised edition, 1968)
- GRAY, C., Cubist Aesthetic Theories, Baltimore, 1953
- KAHNWEILER, D. H., Juan Gris: His Life and Work, new enlarged edition, London, 1969
- ROSENBLUM, R., Cubism and Twentieth-Century Art, London, 1968
- WADLEY, N., Cubism, London, 1972

Purism

- JARDOT, MAURICE, Le Corbusier: Dessins, Paris, 1955
- NIERENDORF, K., Amédée Ozenfant, Berlin, 1931
- OZENFANT, AMÉDÉE, Mémoires 1886–1962, Paris, 1968
- OZENFANT, AMÉDÉE, Foundations of Modern Art, London, 1931
- OZENFANT and JEANNERET, Après le Cubisme, Paris, 1918
- OZENFANT and JEANNERET, Peinture Moderne, Paris, 1925
- Léger and Purist Paris, London, Tate Gallery, 1970. Exhibition catalogue

Orphism

- CAMFIELD, W. A., Francis Picabia, Princeton, 1978
- GREEN, C., Léger and the Avant-garde, Yale, 1976
- MLADEK, M. and ROWELL, M., Frantisek Kupka 1871–1957, Catalogue of the Retrospective Exhibition, The Solomon R. Guggenheim Museum, New York, 1975
- SPATE, V., Orphism, London/New York, 1979

Futurism

- APOLLONIO, U., (ed.), Futurist Manifestos, London/New York, 1973
- BALLO, GUIDO, Boccioni, Milan, 1964
- BANHAM. REYNER. 'Sant' Elia', Architectural Review, CXVII, 1955
- CARRIERI, RAFFAELE, Futurism, Milan, 1963
- MARTIN, MARIANNE, Futurist Art and Theory: 1909–1915, Oxford, 1968
- TAYLOR, J. C., Futurism, New York, 1961
- TISDALL, C. and BOZZOLLA, A., Futurism, London/New York, 1977

Vorticism

- BLAST, No I, 1914; No II, 1915, London
- BUCKLE, R., Epstein Drawings, London, 1962
- BUCKLE, R., Jacob Epstein, Sculptor, London, 1963
- CORK. R., Vorticism and the Birth of Abstract Art in England, London, 1973
- EDE, H. S., Savage Messiah (1930), London, 1971
- EPSTEIN, J., An Autobiography (Second Edition), London, 1963
- HAMILTON, G. H., Painting and Sculpture in Europe 1880–1940 (Section on Vorticism), London, 1967
- HANLEY-READ, C., The Art of Wyndham Lewis, London, 1951
- HULME, T. E., Speculations (1924), London, 1949
- LEVY, M., Gaudier-Brzeska: Drawings and Sculpture, London, 1965
- LEWIS, W., Tarr (1918), London, 1968
- LEWIS, W., Blasting and Bombardeering (1937), London, 1967
- LEWIS, W., Wyndham Lewis the Artist from BLAST to Burlington House, London, 1939
- LEWIS, W., Wyndham Lewis on Art, London, 1971
- LIPKE, W., David Bomberg, London,
- MICHEL, W., Wyndham Lewis: Paintings and Drawings, London, 1970
- ROBERTS. W., Paintings 1917–58, London, 1960

- ROBERTS. W., The Resurrection of Vorticism and the Apotheosis of Wyndham Lewis at the Tate, London, 1958
- ROBERTS, W., Cometism and Vorticism.

 A Tate Gallery Catalogue Revised,
 London, 1958
- WEES, W. C., Vorticism and the English Avant-Garde 1910–15, Toronto/ Manchester
- Wyndham Lewis and Vorticism. Catalogue, Tate Gallery, London, 1958

Dada and Surrealism

- ARP, HANS, On~My~Way, New York, 1948
- BRETON, ANDRÉ, Manifestes du Surréalisme, Paris, 1946
- BRETON, ANDRÉ, Le Surréalisme et la Peinture, Paris, 1965
- DALI, SALVADOR, The Secret Life of Salvador Dali, London, 1942
- ERNST, MAX, Beyond Painting, New York, 1948
- MOTHERWELL. ROBERT, Dada Painters and Poets, New York, 1951
- NADEAU, MAURICE, The History of Surrealism, London, 1968
- RICHTER, HANS, Dada: Art and Anti-Art, London, 1965
- RUBIN, WILLIAM, Dada and Surrealist Art, London, 1969
- SANOUILLET, MICHEL, Dada à Paris, Paris, 1965
- Dada and Surrealism Reviewed, Arts Council of Great Britain Catalogue, London, 1978

Suprematism and Constructivism

- BANHAM. R., Theory and Design in the First Machine Age, London, 1960
- GABO, N. (ed.), Circle, London, 1937 'Naum Gabo talks about his work'.
- Studio International, April, 1966
- GRAY, C., The Great Experiment: Russian Art 1863–1922, London, 1962
- GRAY, C., 'Alexander Rodchenko: A Constructivist Designer', Typographica II, London, June 1965
- LISSITZKY-KUPPERS, S., El Lissitzky, London, 1968

- MALEVICH. K., The Non-Objective World, Chicago, 1959
- MOHOLY-NAGY, LASZLO, Review of Lissitzky Exhibition, *Burlington Maga*zine, March 1966
- RATHKE, E., Konstruktive Malerei 1915–1930, Hanau, 1967
- Art in Revolution. Soviet Art and Design since 1917. Arts Council of Great Britain, 1971. Exhibition catalogue

De Stijl

- BANHAM. R., Theory and Design in the First Machine Age, London, 1960
- BRATTINGA, P., Rietveld 1924 Schröder Huis Quadrat Print, Hilversum, 1962
- BROWN, T. M., The Work of G. Rietveld, Architect, Utrecht, 1958
- HILL, A., 'Art and Mathesis: Mondrian's Structures', Leonardo, Vol. I, pp. 233– 42, Oxford, 1968
- LAERING, J. and BALJEU, J., Theo van Doesburg. Catalogue, Stedelijk van Abbemuseum, Eindhoven, 1969
- De Stijl 1 and 2, 1917–32 (complete reprint), Amsterdam, 1968
- De Stijl, Catalogue 81, Stedelijk Museum, Amsterdam, 1951
- Piet Mondrian, 1872–1944. Catalogue, Guggenheim Museum, New York, 1971
- Rietveld. Catalogue, Stedelijk Museum, Amsterdam, 1971–2; Hayward Gallery, London, 1972

$Abstract\ Expressionism$

- Artforum, September 1965; special issue on the New York School, including: Philip Leider, 'The New York School in Los Angeles'; Michael Fried, section on Jackson Pollock reprinted from the 'Three American Painters' catalogue: Lawrence Alloway, 'The Biomorphic Forties'; Irving Sandler, 'The Club'; Sidney Tillim, 'The Figure and the Figurative in Abstract Expressionism'; interviews with Matta, Motherwell and Dzubas.
- ASHTON, DORE, The Life and Times of the New York School, Bath, 1972

- GELDZAHLER. HENRY (ed.), New York Painting and Sculpture: 1940-1970, Pall Mall Press Ltd., London, in association with the Metropolitan Museum of Art, New York, 1969. Includes reprints of: Harold Rosenberg, 'The American Action Painters'; Robert Rosenblum, 'The Abstract Sublime'; Clement Greenberg, 'After Abstract Expressionism'; William Rubin, 'Arshile Gorky, Surrealism, and the New American Painting'.
- GREENBERG, CLEMENT, Art and Culture, Boston, 1965
- HESS, THOMAS B., Willem de Kooning, Museum of Modern Art, New York, 1968
- HESS. THOMAS B., Barnett Newman, Tate Gallery, London, 1972
- O'CONNOR, FRANCIS V., Jackson Pollock, The Museum of Modern Art, New York, 1967
- RUBIN, WILLIAM, Jackson Pollock and the Modern Tradition, Four-part article published in Artforum, February— May 1967
- SANDLER. I., Abstract Expressionism The Triumph of American Painting, New York/London, 1970
- Tuchman. Maurice (ed.), The New York School – Abstract Expressionism in the 40s and 50s, London, 1970. Essentially an anthology of contemporary criticism and artists' writings and statements, with a detailed bibliography.

Kinetic Art

- BANN, STEPHEN; GADNEY, REG; POP-PER, FRANK and STEDMAN, PHILIP, Four Essays on Kinetic Art, St Alban's, Herts, 1966
- CLAY, JEAN, 'Soto', Signals Gallery, Exhibition catalogue, 1965
- COMPTON, MICHAEL, Optical and Kinetic Art, London, Tate Gallery, 1967
- GABO, NAUM and PEVSNER, ANTOINE, Realist Manifesto, Moscow, 1920
- KEPES, GYORGY (ed.), The Nature and Art of Motion, New York, 1965
- MOHOLY-NAGY. LASZLO, Vision in Motion, Chicago, 1947

POPPER, FRANK, Origins and Development of Kinetic Art, London, 1968

RICKEY GEORGE, Constructivism: The Origins and Evolution, London, 1967 SELZ, PETER (ed.), Directions in Kinetic Sculpture, California, 1966

Pop Art

- AMAYA, M., Pop Art... and After, New York, 1965
- AMAYA. M., Pop as Art: A Survey of the New Super Realism, London, 1965
- BATTCOCK, G. (ed.), The New Art: A Critical Anthology, New York, 1966
- CALAS, N., Art in the Age of Risk and other essays, New York, 1968
- COMPTON. M., Pop Art, London, 1970
- CRONE. R., Andy Warhol, London, 1970 FINCH. C., Pop Art – Object and Image.
- FINCH, C., Pop Art Object and Image London/New York, 1968
- KOZLOFF, M., Renderings: Critical Essays on a Century of Modern Art, New York, 1969
- LIPPARD. L. and others, *Pop Art*, London/New York, 1966
- MELLY, G., Revolt into Style: The Pop Arts in Britain, London, 1970
- ROSENBERG, H., The Anxious Object: Art Today and Its Audience, New York, 1964
- RUSSELL, J. and GABLIK, S., Pop Art Redefined, London/New York, 1969
- WEBER, J., Pop-Art: Happenings und neue Realisten, Munich, 1970
- Catalogue of the Andy Warhol Exhibition at the Tate Gallery, 1971
- Catalogue of the Richard Hamilton Exhibition at the Tate Gallery, 1970
- Catalogue of the Roy Lichtenstein Exhibition at the Tate Gallery, 1968
- Catalogue of the Arts Council Claes Oldenburg Exhibition held at the Tate Gallery, 1970

Op Art

- BARRETT. C., Op Art, London, 1970 COMPTON. M., Optical and Kinetic Art, London, 1967
- RICKEY, G., Constructivism, London, 1967

- ROBERTSON, B., Bridget Riley, Retrospective exhibition catalogue, Hayward Gallery, London, July-Sept 1971
- SEITZ, WILLIAM C., The Responsive Eye, Catalogue to the exhibition at The Museum of Modern Art, New York, Feb-March 1965
- TAKAHASHI, MASATO, Gestaltung, Tokyo, 1968
- VASARELY, V., Victor Vasarely, Neuchâtel, 1965
- VASARELY, V., Victor Vasarely II, Neuchâtel, 1970
- WONG, WUCIUS, Principles of Twodimensional Design, Chinese University of Hong Kong, 1969

Minimalism

- BATTCOCK, G. (ed.), Minimal Art: A Critical Anthology, New York, 1968
- MCSHINE, KYNASTON, Primary Structures, New York, The Jewish Museum, 1966
- ROSE, B., A New Aesthetic, Washington Gallery of Modern Art, 1967
- Studio International, April 1969, Special issue on Minimalism, including Barbara Reise, 'Untitled 1969': a footnote on art and minimal stylehood; Dan Flavin, 'Several more remarks . . .'; Carl Andre, 'An opera for three voices'; Don Judd, 'Complaints part 1'
- TUCHMAN, M. (ed.), American Sculpture of the Sixties, Los Angeles County Museum of Art. 1967

Conceptual Art

- BATTCOCK, GREGORY (ed.), Idea Art: A Critical Anthology, New York, 1973 CELANT, GERMANO, Arte Povera, New
- York, 1969 KARSHAN, DONALD (ed.), Conceptual Art and Conceptual Aspects, New York, 1970
- LIPPARD. LUCY (ed.), Six Years: The Dematerialization of the Art Object from 1966 to 1972..., New York, 1973

- MCSHINE. KYNASTON (ed.), Information, New York, 1970
- MEYER, URSULA (ed.), Conceptual Art, New York, 1972
- SZEEMAN, HARALD (ed.), Live in Your Head: When Attitudes Become Form, Berne, 1969

Postmodernism

FERGUSON. RUSSELL. MARTHA GEVER, TRINH T. MINH-HA, CORNEL WEST (eds), Out There: Marginalization and Contemporary Culture, New York, 1990

- HERTZ, RICHARD (ed.), Theories of Contemporary Art, Englewood Cliffs, New Jersey, 1985
- RAVEN, ARLENE (ed.), Art in the Public Interest, Ann Arbor, Michigan, 1989
- RISATTI. HOWARD (ed.), Postmodern Perspectives: Issues in Contemporary Art, Englewood Cliffs, New Jersey, 1990
- SIEGEL, JEANNE (ed.), Art Words 2: Discourse on the Early 80s, Ann Arbor, Michigan, 1988, reprinted as Art Talk: The Early 80s, New York, 1988
- WALLIS, BRIAN (ed.), Art After Modernism: Rethinking Representation, New York, 1984

Index

Balla, Giacomo, 99, 102

Numerals in italics refer to illustration numbers

Iridescent Interpretation No. 1, 42 Acconci, Vito, 262, 266, 268 Seedbed, 117 The Street Light, 45 ACT UP (AIDS Coalition To Unleash Barlach, Ernst. 46 Baroque, the, 31 Power), 283-5 Agam, Yaacov, 219 Barrès, Maurice, 122 Barry, Robert, 260, 262, 263, 264, 265, and cinetic art. 241 268 AIDS, 280, 283-4, 285-6, 288, 289 AKhR (the Association of Artists of the Somehow, 114 Barzun, Henri, 89 Revolution), 167 Albers, Josef, 239, 240, 241 Baudrillard, Jean, 272, 278-9, 281, 282, Alloway, Lawrence, 225 Bauhaus, the, 47, 48, 107, 108, 166 Altdorfer, A., 31 Altman, Nathan, 164 Baxter, Iain and Ingrid, 263 Baziotes, William, 170, 176 Amaya, Mario, 234 American Pop Art, 225, 226 Beckley, Bill, 268 and sculpture, 237 Beckmann, Max, 45-6 European ancestry, 227 Family Picture, 13 Analytic Cubism, 59, 74, 75, 182 Bell, Larry, 246 Anderson, Laurie, 268 Bergson, Henri, 87, 89 Andre, Carl. 245, 247, 249, 250, 253 Berlin Neue Sezession, 37 Lever, 111 Bill, Max. 242 Blake, Peter, 32, 225, 235 Anuszkiewicz, Richard, 241, 242 BLAST Magazine, 106-8 Apollinaire, Guillaume, 23, 28, 29, 38 and Futurism, 101-2 BLAST (Blasts and Blesses), Pages from the first issue, 50a, 50band Orphism, 44, 85-9, 92, 93 Blavatzky, Madame, 139 Aragon, and Surrealism, 123 Blevl, Fritz, 35-6 Archipenko, 36, 68, 103 Arp, Hans, 42, 110, 111, 113-18, 122, Bloy, Léon, 13, 14 Boccioni, Umberto, 98-100, 103, 105 127, 131, 133, 153 and Kinetic Art, 213 Le Passager du Transatlantique, 54 Dynamic Construction of a Gallop: Art Language, 263, 264, 265 Art-Language group, 263, 264, 268 Horse and House, 38 States of Mind No. 1: The Farewells, 44 Art Nouveau, 33 The Street Enters the House, 39 Art world in Germany, 33-49 Artaud, Antonin, 123-4 Bochner, Mel. 259, 265, 269 Axiom of Indifference, 116 Asis, 219 Body Art, 256, 258, 266 Atkinson, Terry, 263 Automatism, in Surrealism, 128 Bomberg, David, 109 In the Hold, 52 Mud Bath, 51 Baargeld, Johannes, 118 Bonnard, Pierre, 25 Baldwin, Michael, 263 Bosch, H., 31 Ball, Hugo, 110-11, 113, 115, 116 'dream paintings', 131 early links with German Expressionism. 115 Boto, Martha, 221

Brancusi, Constantin, 103, 249

Braque, Georges, 12, 22, 28, 29, 44, 51,	Clark, Lygia, 222
73, 263	Classicism, 31, 32
and Analytic Cubism, 59–60	Cocteau, Jean, 79
and Surrealism, 127	Collage technique, 62, 63, 66
and Synthetic Cubism, 68, 70, 71, 76,	Collins, James, 268
102	Cormon, 13, 14
Bather's influence on Art, 49	Corot, Camille, 64
collaboration with Picasso, 55	Craven, Arthur, 113
monochrome palette, 57, 102	Crevel, René, 123
obsession with space, 57	Crimp, Douglas, 282, 283-4, 286, 287-8,
papier collé, 62–5, 182	289
Piano and Lute, 19	Cross, Henri-Edmond, 17
$Le\ Gu\'eridon,\ 20$	Cruz-Diez, 219
La Table du Musicien, 23	and cinetic art, 241
$Musical\ Forms\ (Guitar\ and\ Clarinet), 25$	
Breton, André, 64	Dada movement in Germany, 40, 45
and Dadaism, 111, 118	Dali, Salvador, 126, 130, 131
and Freud, 124–6	and Surrealism, 132, 133
and Surrealism, 122-4, 126, 130, 134,	Slave Market with the Disappearing
175	$Bust\ of\ Voltaire,\ 63$
collaboration with Soupault, 125	Darboven, Hanne, 267
Cadavre Exquis Landscape, 58	Untitled, 122
British Pop Art, 229–31	David's Classicism, 32
and sculpture, 237, 238	Davis, Stuart, 171, 175, 183
Brouwn, Stanley, 258	De Chirico, Giorgio, 127, 132
Bruce, Patrick, 94	De Kooning, Willem, and Abstract Ex-
Brücke Expressionism, 44, 45, 47	pressionism 169, 170, 172, 182, 183,
Burden, Chris, 266, 268	184, 187, 188, 200, 256, 269
Doorway to Heaven, 118	'form without content' ideology, 187
Bureau of Surrealist Research, the, 123 Buren, Daniel, 263, 268	influence on Pop Art in America, 225,
	234
Piece No. 3 from exhibition 'To Trans-	mythology, 185–6
gress', 123 Burliuk, David and Vladimir, 44	Excavation, 95
	Delacroix, Eugène, 18
Bury, Pol, and use of electric motor power, 217, 218	and Baroque Romanticism, 32
Busa, Peter, 175, 188	Delaunay, Robert, 38, 41, 42, 44
Dusa, 1 etel, 119, 166	and Cézanne's importance to, 89
Café l'Aubette, Strasbourg, 152–4	and Orphism, 85, 86–8, 90–4, 187
Calder, Alexander, 216, 217	relationship to Cubism, 79–80
Calle, Sophie, 278–9, 280	The City of Paris, 30
Camoin, 12	Simultaneous Windows, 31
Campendonck, Heinrich, 37	Sun, Moon. Simultaneous No. 2, 32 Delaunay, Sonia, 93, 94 (see also Sonia
Carrà, Carlo, 98, 100, 103	Terk)
Funeral of the Anarchist Galli, 40	De Maria, Walter, 264
Caulfield, Patrick, 230, 231	Denis, Maurice, 23, 25
Cendrars, Blaise, 89, 92	Derain, André, 11, 12, 14–16, 19–22,
Cézanne, 20, 24, 25, 28, 38, 42, 52	25-9
Chagall, Marc, 48, 74, 94	influence on the Germans, 40
Chicago, Judy, 277, 284, 285	pointilliste technique, 18
The Dinner Party, 128	Women in front of Fireplace, 6
Childs, Lucinda, 253	The Dance, 7

Der Blaue Reiter, 34, 37, 38, 40, 44, 47,	European Abstract art, 200, 201
48, 74	
almanach, 41, 42	Fahlstrom, Oyvind, 231
graphics, 45	Feininger, Lyonel, 34, 47
Der Sturm, 37, 44	Feminism, 274, 275–7, 279–80, 281–3,
Desnos, Robert, 123	284-5, 286-7, 289
Dibbets, Jan, 267, 268	Flavin, Dan, 244, 245, 249, 252, 253
Daylight/Flashlight, Outside Light/	Monument of V. Tatlin, 109
Inside Light, 120	Foster, Hal, 281, 282, 286
Die Brücke, Dresden Group of, 26, 34,	Frankenthaler, Helen, 284–5
35, 37, 46, 47	Friedrich, Caspar David, 32
Dine, Jim, 218, 229, 235	Friesz, Othon, 17, 22
collages, 230	Frost, A. B., 94
Happenings, 234, 258	Fulton, Hamish, 267
Dix, Otto, 46	Futurism, 74–5, 275
Dominguez, Oscar, 134	
'decalcomania', 130	Gabo, Naum, 166, 167
Donaldson, Anthony, 230, 231	and Kinetic Art, 213, 215, 216, 219
Duchamp, Marcel, 75, 84, 92	renunciation of mass, 214
and Conceptual Art, 256–8, 269	Garcia-Rossi, and spectator participa-
and Dadaism, 111, 119, 120, 227, 257	tion, 221
and Minimal Art, 248, 263	use of neon, 220
rotoreliefs, 242	Gaudier-Brzeska, Henri, 109
and Surrealism, 133, 175, 257	Gauguin, Paul, 15, 18, 19, 20, 24, 32, 38,
vibration-structures and metamor-	42, 56
	Gerstner, Karl, 242
phoses', 218	Gilbert and George, 266, 268, 275
Bottlerack, 55	The Singing Sculpture, 119
Dufy, Raoul, 17	Glaser, Bruce, 246
Dürer, Albrecht, 31, 44	
Dutch School, the 32	Glass, Philip, 252
D 41 270	Gleizes, Albert, 90
Earthworks, 259	Goncharova, Natalia, 44, 74
Elementarism in Germany, 45	Goodyear, John, 242
El Greco, 31, 51	Gordon, Bette, 278, 279–80
and Surrealism, 123	Gorki, Arshile, 134, 172, 173, 175, 183
Eluard, Paul, 128	Gottlieb, Adolph, 170, 172, 184, 188,
Ensor, 32, 37	189, 196
Epstein, Jacob, 109	pictographic paintings, 194
Ernst, Max, 118	Goya, Francisco de, 32
association with Surrealism, 120, 123,	Graham, John, 183–4
127, 128, 133, 134, 175	Gran Fury,
Dada collages, 121, 126	Read My Lips (boys), 133
'dreamed plastic works', 131	RIOT,136
experiments with dripped paint, 180	Greenberg, Clement, 173, 174, 188
frottage, 128, 130, 132	Gris, Juan, 59, 63, 69, 70, 75, 77
Habit of Leaves, 59	influence in European art, 73
$Tant \^ot \ nus, tant \^ot \ v\^et us \ de \ minces jets \ de$	$papiers\ coll\'es,\ 70,\ 71$
feu, ils font gicler les geysers avec la	space generating function of painting,
probabilité d'une pluie de sang et avec	186
la vanité des morts, 57	and Synthetic Cubism, 60, 70–2
Etchells, Frederick, 106, 108, 109	Glasses and Newspaper, 27
Progression, 48	L'Homme au Café, 26

Jeanneret, Charles-Edouard (Le Corbu-Gropius, Walter, 147–8 Hanging lamp, 77 sier). 79-84 Grünewald, Matthias, 31 and functionalism, 81 Guerrilla Girls, 289 'objets types', 81, 83-4 Guston, Philip, 170 Nature morte à la pile d'assiettes, 29 Jencks, Charles, 271 Haacke, Hans, 265, 266, 268 Johns, Jasper, 225, 228, 234, 246, 247, Hamilton, Richard; collage, 225 257, 275, 285 'Just what is it . . .', 102Johnston, Edward, 107 Pop Art, 228, 230, 233, 237 Jones, Allen, 225, 230 Happening, the, 233-4, 258 Judd, Don, 189, 238, 245, 246, 249, 250. Haring, Keith, 284-6 251, 252, 253, 261, 263 Ignorance = Fear, 137Untitled, 112 Hausmann, Raoul, 116 Jugendstil Centre, 43, 47 photomontages, 121 Healev's use of light, 221 Heartfield, John, 45, 121 Kahnweiler, D.-H., 91 Heckel, Erich, 35, 36 Kandinsky, Wassily, 37, 38, 40, 42-4, Herbin, Auguste, 73 47-9, 87, 88, 108, 166, 200, 201 Hess, Thomas, 184 subjectless art development, 41 Höch, Hannah, 121 Suprematism, 139 Hockney, David, 225, 229, 275 Improvisation, 9 Hofmann, Hans, 172-4, 180 Kaprow, Allan dripped and poured paint method, Happenings, 258 180 Kawara, On, 263, 267 New York School of Fine Arts, 173 Kelly, Ellsworth, 242, 246 Hölzel, Adolf, 47 Kelly, Mary, 280 Huebler, Douglas, 260, 262, 263, 265, Kemeny, Alfred, 216 Kienholz, Edward, 237, 261 Huelsenbeck, Richard, 45, 110-11, 116, Kinetic Art, definition, 223 120 - 1Kinetic construction and importance of Hugo, Valentine light, 215 Cadavre Exquis Landscape, 58 King, Philip, 237 Huszar, Vilmos, 141, 149, 150 Kirchner, Ernst Ludwig, 35, 36, 37, 40 De Stijl logotype, 68 Girl Under Japanese Umbrella, 10 Huyssen, Andreas, 274 Negro Dance (Negertanz), 11 Kiss & Tell, 289 L'Illustration pages from 4 November Drawing the Line, 138 1905. 2 Kitaj, R. B., 225, 228, 230, 234 Impressionists. Klee, Paul, 38, 40, 41, 44, 47, 48, 74, 94 ancestors of Op Art, 240 Klein, Yves, 250, 257, 258 Kline, Franz, 170, 172, 193, 225 Indiana, Robert, 228, 229, 285 Ingres, Jean-Auguste-Dominique, 32 Knutson, Greta Itten, Johannes, 47, 48, 147 Cadavre Exquis Landscape, 58 Kok, 141 Jacob, Max. 23 Kokoschka, Oskar, 34, 37, 38, 39, 40 Jacquet, Alain, 231 Kolbe, Georg, 46 Jaffé, H. L. C., 142 Kosuth, Joseph, 260, 261, 263, 264, 265, Janco, Georges, 110 Janco, Marcel, 110, 111, 114, 116 One and Three Chairs, 115 masks, 117 Krämer, 217 Javlensky, A. von, 40, 41 Krasner, Lee, 174

Kruger, Barbara, 280-3, 284, 286, 287	and Constructivism, 167
Untitled, 129	and Minimal Art, 244, 248
Untitled, 130	and Op Art, 239
Untitled, 132	and Suprematism, 138–40, 243
Kupka, Frank, 85, 86, 88, 89, 91, 93, 94	The basic suprematist element: the
Discs of Newton, 33	square, 65
	Suprematist composition conveying a
Amorpha, Fugue in Two Colours, 34	feeling of universal space, 66
Kuspit, Donald, 248	
	Suprematist composition: White on
Lamis, Leroy, 242	White, 67
Larionov, Mikhail, 44, 74	Malina and use of light, 221
Laurens, Henri, 68, 73	Manguin, Henri-Charles, 12, 14, 22
Léger, Fernand, 38, 84–7, 89–92	Manzoni, Piero, 257, 258
and Abstract Expressionism, 172, 175	Mapplethorpe, Robert, 288, 289
and Cubism, 73	Charles, 135
and Futurism, 74	Marc, Franz, 38, 39, 42–5, 74, 94
	animal painting, 41
Contrasts of Forms, 37	Marinetti, Tommaso, 97, 98, 100, 101,
Lehmbruck, Wilhelm, 46	105
Fallen Man, 16	Marisol, 237
Lenin Mausoleum, 165	Marquet, Albert, 12, 14, 22
Le Parc, Julio, 221	Marsh, Reginald, 273, 278
Continual Light, 100	Martin, Agnes, 246
Levine, Sherrie, 287–8	Martin, Kenneth, 217
After Edward Weston I , 134	Mason, Don, and use of neon, 220
Levinson, Mon, 242	Masson, André, 127, 133, 134, 175, 180
Lewis, Wyndham, 106, 107, 108, 109	and automatism, 128–30
Abstract drawing (The Courtesan), 46	Automatic Drawing, 60
LeWitt, Sol, 246, 261	Matisse, Henri, 11–17, 19, 20, 23, 24, 27–
Lichtenstein, Roy, 228, 229, 238	9, 42, 73, 257
Liebermann, Max, 37	and Abstract Surrealism, 171–2
Lijn, Liliane, 221	Baudelaire's influence on, 17–18
Lipchitz, Jacques, 68, 73	Cézanne's influence on, 24, 25
Lippard, Lucy, 276, 280, 283, 284, 288-9	
Lissitzky, El, 72, 107, 147, 148	influence on the Germans, 34, 35
and Constructivism, 161, 163, 166	juxtaposition of colours, 20
Proun style, 149, 163, 164	and primitive art, 22
The Story of Two Squares, 88	Joie de Vivre, 4
Rendering of architectural structure, 92	Luxe, Calme et Volupté, 1
'Proun - The Town', 93	Portrait of Madame Matisse, 3
Lissitzky's studio, 94	Still Life with Pink Onions, 5
Long, Richard, 267	Matta, Roberto, 134, 175, 178
Lunacharsky and Constructivism, 167	McCracken, John, 246
Dunacharsky and Constructivism, 107	McLuhan, Marshall, 233
	Meidner, Ludwig
Macdonald-Wright, Stanton, 94	Revolution, 12
Macke, August, 40-2, 44, 74, 94	Mendelsohn, Erich, 46
Mackintosh, Charles Rennie, 108	Sketch for Einstein Tower, 14
Magic Realism, 46	Metzinger, Jean, 73, 84, 90
Magritte, René, 133	Michelangelo, 31
The Human Condition, 64	Miro, Joan, 127
Malevich, Kasimir, 44, 72, 74, 107, 200,	and Abstract Surrealism, 171, 172,
201, 257, 259	175
economical de la compania	

and automatism, 128, 130, 131	Soft Engine, Airflow 6, 103
The Tilled Field, 61	Opalka, Roman, 267, 269
'Mobiles', 216, 217	Detail of painting from 1 to Infinity
Modersohn-Becker, Paula, 34	series, 121
Moholy-Nagy, László, 215, 216, 239, 248	Oppenheim, Meret, 134
Mondrian, Piet, 48, 72, 74, 85, 88, 201,	Orozco, José Clemente, 175
245, 257	OST (Society of Easel Painters), 167
and De Stijl movement, 141–7, 151,	Oster, Gerald, 242
155	Oud, J. J. P., 141, 144, 147
Composition in blue, 73	Owens, Craig, 282, 284, 286-7
Neoplastic and Neoplatonic geo-	Ozenfant, Amédée, 79–84
metry, 195	and Functionalism, 81
Pier and Ocean, 70	Flacon, guitare, verre et bouteilles, 28
Moreau, Gustave, 12, 13, 14	'objets types', $82–5$
studio 12, 13	
Morellet, and spectator participation,	Paalen, Wolfgang, 175
221	Paolozzi, Eduardo, 230
use of neon, 220	Papier collé technique, 62–5
Moretti, Alberto, 231	Pechstein, Max, 36, 37
Morris, Robert, 238, 245, 248, 250, 251,	Performance Art, 256, 258, 266, 283
252, 253, 267	Petrus Berlage, Hendrik, 142
Untitled, 113	Pevsner, Anton, 213, 214, 217
Motherwell, Robert, 170, 171, 172, 175, 181	Phillips, Peter, 225, 229
	Photomontage, 45, 121
collage, 176, 184 Müller, Otto, 36	Picabia, Francis, 86, 88, 91, 92, 93, 94,
Munch, Edvard, 32	111, 113, 117, 118, 119, 122, 128
Munich artists, 34	and Orphism, 85
Münter, Gabriele, 40	and Symbolists' influence, 89
munter, Gabriele, 40	Dances at the Spring II, 35
Nadelman, Elie, 237	Machine Tournez Vite, 56
Narrative Art, 256, 268	Udnie, American Girl (Dance), 36
Nauman, Bruce, 263	Picasso, Pablo, 14, 21, 23, 24, 28, 35, 38, 42, 44, 73, 75, 76, 257, 263
N. E. Thing Co., 263	and Abstract Expressionism, 171,
Neo-Impressionism, 19	172, 175
connection with Fauvism, 16	and African art, 52, 53, 58
Neoplastic movement, 141–55	and Analytical Cubism, 74, 184
Nevelson, Louise, 246	Cézanne's influence on, 52, 54–6, 58, 59
Newman, Barnett, 169–70, 172, 181,	collage, 62, 63, 66, 182
188, 189–93, 195–7, 201, 246, 275	Cubist sculptures, 67
number of variables, 198	Demoiselles d'Avignon, influence on
use of colour, 190	art, 49, 51, 52, 58, 59
vertical divisions, 193-4	Gauguin's influence on, 51
Vir Heroicus Sublimis, 96	monochrome palette, 57, 102
New Objectivity movement, Germany,	and Surrealism, 64, 77, 127
45	and Synthetic Cubism, 67, 68, 70, 71,
Nolde, Emil, 36, 37, 40, 189	102
Jestri, 15	Les Demoiselles d'Avignon, 17
	Le Toréro, 21
O'Doherty, Brian, 247, 248	Seated Woman (Seated Nude), 18
Oldenburg, Claes, 228–9, 237	Verre, Bouteille de Vin, Journal sur
Happenings, 234, 258	$une\ Table,24$

Violin and Guitar, 22 Poelzig, Hans, 46 Pollock, Griselda, 276, 277 Pollock, Jackson. and Abstract Expressionism, 169-70, 172-3, 175-6, 183-4, 187, 189, 195, 196, 198, 274, 275, 276 'all-over' paintings, 178, 179, 181 and automatism, 177 No. 32, 97 Poons, Larry, 242 Pop culture and Industrial Revolution, 'Post-Expressionism', 46 Post-Impressionists, ancestors of Op Art. 240 Pound, Ezra, 107, 108 Pousette Dart, Richard, 170 Pre-Raphaelites, 235 Previati, 99 Princet, Maurice, 69 Process Art, 259 Puy, Jean, 12, 21, 22 Rainer, Yvonne, 252, 253 Ratcliff, Carter, 269 Rauschenberg, Robert, 225, 228, 234, 246, 257, 258, 275, 285 Ray, Man, 111, 112, 127, 133 Reich, Steve, 252 Reinhardt, Ad, 170, 247, 272 Rembrandt, 31 use of colour, 32

Renaissance Humanism and Purism, 81 Richter, Hans, 111, 114-17, 147, 227 Rickey, George, 217 Rietveld, Gerrit, 141, 142, 144-50, 152 Berlin Chair, 80 Chauffeur's House, 82 Dr Hartog's study with hanging lamp, 78 House, elevation, 81 Red-blue chair, 76 Schröder House, 79 Riley, Bridget, 241-3, 284-5 Shuttle I, 106 Rivers, Larry, 235, 236 Roberts, William, 106, 109 St George and the Dragon, 47 The Vorticists at the Café de la Tour Eiffel: Spring 1915, 53

Rodchenko, Alexander, 107, 163 and Kinetic Art, 213 Compass and ruler drawing, 9θ Rodin, and modern sculpture, 33 Roh. Franz. 46 Rolston, Adam, 286 I am out therefore I am, 131 Romanticism, 32 Rose, Barbara, 248, 250, 252 Rosenquist, James, 228, 229 Rothko, Mark, and Abstract Expressionism, 169, 172, 175, 188-9, 195, 196, 199, 200 involvement with 'eternal symbols', 194, 196 use of colour, 190 watercolours, 195 Light Red over Black, 98 Rouault, Georges, 12-14, 22, 48 Rousseau, Henri, 42, 44 Rubens, 31 Russell, Morgan, 94 Russian poster, 89 Russolo, Luigi, 98, 100, 103 Dynamism of an Automobile, 43 Ryder, 188

Saint-Point, Valentine de, 101 Salle, David, 273, 274, 276, 277, 278, 280 Daemonization, 126 Savagery and Misrepresentation, 127 Salmon, André, 23, 49 Salon d'Automne, 1st German, 38 Sandler, Irving, 248 Sant'Elia, Antonio, 104, 105, 161 Schmidt-Rottluff, Karl, 35, 36 Schnabel, Julian, 272-4, 276, 277 Jump, 125 The Patients and the Doctors, 124 Schoenmaekers, Dr. 141-4 Schöffer, Nicholas, 217 use of light, 220 Schröder House, 150, 152 Scott, Tim, 237 Sedgley, Peter, 242 video-rotors, 221 Segal, Arthur, 37 Segal, George, 235, 237 Segantini, 99 Seitz, William, 239 Seligmann, 175

Seurat, Georges, 24 pointilliste technique, 17 theories, 19 Severini, Gino, 39, 99, 100, 103 Dancer-Helix-Sea, 41 Sherman, Cindy, 280 Siegelaub, Seth, 263 Signac, Paul, 17, 18, 19 Siqueiros's Experimental workshop, 179, 180 Smith, Alexis, 268 Smith, David, 183, 237 Smith, Richard, 235-7 Smith, Tony, 246 Soffici, Ardengo, 100 Soto, J. R., 241 and Op Art, 242 'vibrations-structures and metamorphoses', 218, 219 Cina grandes tiges, 108 Un quart de bleu, 107 Vibration, 101 Soupault, Philippe, 125 Soutine, Chaim, 48 Spectator participation and use of light, 999 Stein family, 20 Steinberg, Leo, 251 Steiner, Rudolf, 33, 43 Stella, Frank, 245, 246, 247, 262, 263 'black paintings', 247 'protractor series', 253 Die Fahne hoch!, 110 Stevenson, Robert, 242 Still, Clyfford, 169, 170, 172, 173, 188, 190, 195, 196 wall-sized painting, 189 Painting-1951, 99 Sturm und Drang movement, 33 Sullivan, Louis, 161 Sutherland, Graham, 48 Symbolists, the 23 relationship with Orphists, 88, 90, 94 Synthetic Cubism, 67, 68, 75 Tadasky, 243 Taeuber, Sophie, 114, 153 Takis and Magnetism, 217 Tanguy, Yves, 127, 175

Extinction of Useless Lights, 62

Tatlin, Vladimir, 163, 165, 166

and Kinetic Art, 213

Monument to the Third International, 91 Taut, Bruno, 47 Terk. Sonia, 93, 94 Tilson, Joe, 230, 231 Tinguely, Jean, 217 Tomlin, Bradley Walker, 170 Torres-Garcia, Joaquim, 194 trompe l'oeil effects, 65, 239 Trotsky, and Constructivism, 167 Tucker, William, 237, 251 Turner, 32 Tzara, Tristan, 79, 110, 111, 113, 115-17, 122, 125 Cadavre Exquis Landscape, 58 Vaché, Jacques, 112, 113 Valtat, Louis, 22 Van der Leck, Bart, 141, 143-7 Geometric Composition No. 1, 74 Van de Velde, Henry, 161 Van Doesburg, Theo, 79 and De Stijl movement, 141, 142, 145 - 55Café L'Aubette, Strasbourg, 87 De Stijl, logotype, 71 Meudon House. Elevation, 85 Meudon House, Interior, 86 Project for the interior decoration and modulation of a university hall, 84 Relation of horizontal and vertical planes, 83 Rhythm of a Russian Dance, 75 Van Dongen, Kees, 11, 22 Van Esteren, Cor. 143, 147-9, 152 Project for the interior decoration and modulation of a university hall, 84 Relation of horizontal and vertical planes, 83 Van Gogh, Vincent, 15, 20, 32, 42, 56 Van't Hoff, 141, 142, 144, 147 Huis-ter-Heide, 72 Vantongerloo, Georges, 141, 143, 147 Interrelation of Masses, 69 Vasarely, Victor, 219, 240-2 Zebra, 105 Venetian tradition and Expressionism, Viennese Art Nouveau, 38

Villon, Jacques, 75 VKhUTEMAS, 166 Vlaminck, Maurice, 11, 12, 14–16, 18–20, 22, 25–7
association with Derain, 21
influence on Germans, 34
influenced by African art, 21
Landscape with Red Trees, 8
Vollard, Ambroise, 20
Von Tschudi, Hugo, 42
Von Werefkin, Marianne, 40
Vorticism, 107, 108
Vuillard, Edouard, 25

Wadsworth, Edward, 106–9
Abstract Composition, 49

Walden Herwarth's Der Sturm, 37, 38
Warhol, Andy, 228, 229, 232, 275, 285
'Saturday Disaster', 104
Wegman, William, 268
Weiner, Lawrence, 259, 260, 263, 264, 266, 268
Wesselmann, Tom, 228
Weston, Edward, 288
Wilding, Ludwig, 243
Wils, Jan, 141, 144
Wojnarowicz, David, 288, 289
'Sex Series', 139
Worringer, Wilhelm, 42–5
Wright, Frank Lloyd, 142, 161